This book brings together a distinguished group of . . . . . . . . . . . . . . drama, poetry, performance art, religion, classics, and . . . . . . . . . . . . . gate the c. . . . . . . . . . . . . . . . . . . . . . . . . . . . . . . . . . . . . . . . authenticit. . . in the art. . . . . . . . . . . . . . . . . . . . . . . . . . . . . . . understandings of that relation, exam. . . . . . . . . . . . . . 2f. . . . . . . . the *Poetics*, the marriage of art with religion, the experiences of religious and aesthetic authenticity, and modernist conceptions of authenticity. Several essays then consider music as a performative art. The final essays discuss the link of authenticity to sincerity and truth in poetry, explain how performance, as an authentic feature of poetry, embodies a collective effort, and culminate in a discussion of the dark side of performance – its constant susceptibility to inauthenticity. Together the essays suggest how issues of performance and authenticity enter into consideration of a wide range of the arts.

CAMBRIDGE STUDIES IN PHILOSOPHY AND THE ARTS

*Series editors*

SALIM KEMAL *and* IVAN GASKELL

# Performance and authenticity in the arts

# CAMBRIDGE STUDIES IN PHILOSOPHY AND THE ARTS

Cambridge Studies in Philosophy and the Arts is a forum for examining issues common to philosophy and critical disciplines that deal with the history of art, literature, film, music, and drama. In order to inform and advance both critical practice and philosophical approaches, the series analyzes the aims, procedures, language, and results of inquiry in the critical fields, and examines philosophical theories by reference to the needs of arts disciplines. This interaction of ideas and findings, and the ensuing discussion, brings into focus new perspectives and expands the terms in which the debate is conducted.

# Performance and authenticity in the arts

*Edited by*

SALIM KEMAL

*University of Dundee*

*and*

IVAN GASKELL

*Harvard University Art Museums*

CAMBRIDGE UNIVERSITY PRESS
Cambridge, New York, Melbourne, Madrid, Cape Town, Singapore,
São Paulo, Delhi, Dubai, Tokyo, Mexico City

Cambridge University Press
The Edinburgh Building, Cambridge CB2 8RU, UK

Published in the United States of America by Cambridge University Press, New York

www.cambridge.org
Information on this title: www.cambridge.org/9780521147439

First published 1999
First paperback printing 2010

*A catalogue record for this publication is available from the British Library*

*Library of Congress Cataloguing in Publication data*

Performance and authenticity in the arts / edited by Salim Kemal and Ivan Gaskell.
p.   cm. – (Cambridge studies in philosophy and the arts)
Includes index.
ISBN 0 521 45419 0 (hardback)
1. Performance. 2. Authenticity (Philosophy)
3. Creation (Literary, artistic, etc.).
I. Kemal, Salim. II. Gaskell, Ivan. III. Series.
NX212.P45 1999
700'.1–dc21   98–39969   CIP

ISBN 978-0-521-45419-3 Hardback
ISBN 978-0-521-14743-9 Paperback

# Contents

# Contents

# Contributors

MALCOLM BUDD
*University College, London*

NICHOLAS DAVEY
*University of Dundee*

STAN GODLOVITCH
*Lincoln University, New Zealand*

PETER IVER KAUFMAN
*University of North Carolina at Chapel Hill*

JOSEPH J. KOCKELMANS
*Pennsylvania State University*

FRED EVERETT MAUS
*University of Virginia*

PETER MIDDLETON
*University of Southampton*

ALEX NEILL
*University of St Andrews, Scotland*

HENRY M. SAYRE
*Oregon State University*

GREGORY SCOTT
*New School University, New York*

MICHAEL TANNER
*Corpus Christi Cambridge*

# Acknowledgments

"Understanding Music" by Michael Tanner and "Understanding Music" by Malcolm Budd originally appeared in the *Proceedings of the Aristotelian Society*, vol. 59, 1985 and are reprinted here by courtesy of the Editor of the Aristotelian Society: © 1985. We are grateful to Dr Jonathan Wolff and Dr Majid Amini for their help.

We should like to thank Alex Neill, Nicholas Davey, and Peter Kaufman for their timely help and valuable advice. Jane Baston and Jane Whitehead are marvelous. This book is for Rahim.

# Performance and authenticity

SALIM KEMAL and IVAN GASKELL

Religious transcendence has provided one sense of authenticity for the arts. People maintain that great works are informed by a religious dimension, are ultimately "touched by the fire and ice of God."[1] In an older conception, people expected the authority of the Book, the Bible, to be matched by the finest literary expression in the King James version, providing language with its best use.[2] Consonantly, in the Qur'ān, speech and communication invoke a connection with truth in the analysis of its language. Only the unique literary quality of the holy book fully matched expression, subject-matter, and truth and so could claim authenticity as the holy word. Others wanted art to parallel religious practice. In the Florentine renaissance, paintings emphasized a subjective immediate experience of God and faith as a felt emotion when such immediacy also became important to ordinary experience.[3] The descriptive narrative interest and spontaneity of works had to fit the emotional and intellectual needs of spectators, drawing them to participate rather than commanding their awe.[4]

The reference to religion occurs in Athens as it does in religions founded in Jerusalem. Greek drama has one source in religious festivals, which give performances their purpose. This role may have become muted by the time of Aristotle's *Poetics*: – although the gods placed people in circumstances that led to tragedy, Aristotle was more concerned with the structure of tragic drama – nonetheless the *Poetics* did not entirely remove religious reference from the arts, and it still addresses questions, of the origin of the value of arts, to which religion provides one answer.

Transcendence, performance, and authenticity bear subtle relations to each other; and Jerusalem and Athens are important sources of concepts of authenticity. The present collection can offer only a

particular perspective on that source: the reflections in the first section, on performance, religion, and authenticity, raise questions about three aspects of that complex tradition. First it considers the role of performance. The *Poetics* has been among the most influential texts in forming our understanding of literature and poetry, and hence of our conception of authenticity in art. Yet that influence has not always followed Aristotle's own emphases. Perhaps this is because its influence has been indirect, through particular commentaries rather than directly through translations, and was sometimes based on misunderstandings.[5] In "The Poetics of performance: the necessity of performance, spectacle, music, and dance in Aristotlian tragedy," Gregory Scott proceeds through a close study of the surviving text to show that performance was crucial to Aristotle's conception of tragedy in the *Poetics*. This explanation raises a number of issues about traditional accounts of literature and poetry that other scholars might develop. We might consider what implications the centrality of performance in the *Poetics* has for other aspects of Aristotle's definition of tragedy, and how those elements, developed through the influence of the *Poetics* on later writers, poets, and playwrights, unconsciously carried resonances of a text about performance into literature and poetry.

From the primacy of performance in Aristotle's *Poetics*, this section turns to a second aspect of the relation between religion and performance: prayer. To say that works of art bear a religious reference says too little since religions often disagree about the meaning of authentic access to divinity. Luther wanted to strip worship of the church's customs, rituals, robes, priests, and so on, in order to give individuals a direct and authentic access to God through prayer. Similarly, the Chapel at Ely Cathedral as it now stands, freed of its stained-glass windows and minus the heads of saints, shows the Roundheads' aversion to some kinds of worship. In the second essay, "The 'confessing animal' on stage: authenticity, asceticism, and the constant 'inconstancie' of Elizabethan character," Peter Iver Kaufman takes up some of the issues raised by understanding prayer as performance, among other things to consider its claims to authenticity. Righteous people "needed only occasional instruction to climb to heaven," according to Roman Catholic practice, Kaufman suggests, while Calvin, Luther, Bucer, and Zwingli urged that only a serious faith in Christ's atonement for sinners generated righteousness. "Without a profound sense of their dreadfully depraved characters, the faithful would not be able to

comprehend the immense mercy of God." Only an appropriate mode of worship generates a sound sense of authenticity. Spectating on the rituals of the church had to give way to the performance of prayer in order for worship to gain authentic access to divine mercy. The contrast between ritualized worship and an authentic access to God that gives prayer performed by individuals its validity, appears also in drama. Puritan theatrics, based on a particular concept of worship, show us how to stage performances. Hamlet's soliloquies have occasionally rightly been performed as prayers, Kaufman points out, suggesting how *Hamlet* stages a distinctly puritan habit of mind, through which Shakespeare explains the potential of the stage performance to reform his spectators.

While the second essay reminds us of the complexities in art's religious reference, the last essay in this section provides a different perspective by examining a set of arguments for the connected but distinguishable experiences of authenticity in religion and aesthetics. In "Art, religion and the hermeneutics of authenticity" Nicholas Davey turns to one of the leading contemporary German philosophers, Hans-Georg Gadamer, and his study of how the two modes of experience "interfere" with one another. Davey contends that although Gadamer raises this issue and a set of pertinent questions, he does not explicitly resolve the issue – though his readings of Heidegger suggest how to do so. In strikingly clear exposition and argumentation, Davey emphasizes concepts of "the withheld," signs, and symbols, and provides a complex and subtle argument that reaches beyond Gadamer's stated position to explain the answer hinted at in Gadamer's work.

These three essays together consider important elements of a traditional account of authenticity. But by explaining the relation and distinction between aesthetic and religious experience, the last chapter also introduces questions about a distinctively aesthetic authenticity. The traditional conceptions of authenticity can seem a dull objective in these more plastic times. In one non-religious version, it gives rise to something always alien, always only remembered. Looking for *the* new true criterion, nostalgia for an authentic unified polis, or worry that an expanded canon can close minds to essential truths, all seem deeply conservative reactions, seeing in rapid recent changes the likelihood of a fallen state. All these may also misrepresent their origins. There never has been *the* criterion completely governing the complex weave of lived values. Nor did the polis guarantee intimate unity. Thucydides records the nu-

merous currents that formed the Greek response to invasion, and the last days of Socrates witness the deadly debates constituting the Athenian polis.

Other versions of authenticity emerge from a deep shift in understandings of art. Davey's essay shows how the aesthetic realm can become autonomous of religion. Not only has morality now often replaced religion, but art shares in the "disenchantment" characteristic of modernism, that separated the good, the true, and the beautiful. Authenticity in art cannot depend on values originating externally, in the moral or religious realm. Consequently, its traditional reference to religion cost authenticity its purchase in considerations of art. One solution has been to propose that authenticity must have a different sense to still be applicable. Previously art sought authenticity by reference to the divine origin of all things. Now authenticity retains a parallel with the traditional structure by still referring works of art to origins; but that reference is not external: art is authentic the more clearly it is autonomous, when its value is distinctive to its aesthetic character. Every art presupposes rules and standards by which it is made possible, and the authenticity of a work turns on its relation to and development of that origin. Art deals with aesthetic values, which require us to consider the object for itself, rather than for some further religious, moral, or pragmatic values it might serve.

This autonomy of art, the basis of its authenticity, still allows us to consider the power that particular art forms have to generate aesthetic values. Painting, music, and literature will still have their own integrity, depending on their material, instruments, and techniques. We now distinguish time-based arts from others; in significant ways we can separate performance art from music, drama, and other arts that we perform; and we continue to accept that the different arts have their own expectations, their own procedures for development and assessment, and their distinctive ways of transgressing rules.

To explore these issues, the second part of this book, "Understanding, performance, and authenticity," develops an argument that begins with a classical discussion between Michael Tanner and Malcom Budd on "Understanding music." We may listen to music; but we may argue that for our listening to have integrity, to be true to its object, we must understand the music we are listening to. Michael Tanner points out that people are hesitant to claim that they understand music, perhaps because they are uncertain of what they

think about issues in musical theory, or about the use of musical terminology, or about the connection between theory, musical terminology, and the usually "emotional" vocabulary in which they articulate their experience of music. Aspects of the disquiet people feel about these issues seem particular to music because of its discontinuity with the rest of our experience, and his essay argues that "[g]ranted that music is not a language, understanding it is a matter of seeing why it is as it is." Accordingly, "[o]ne has not understood [Schubert's Great C Major Symphony] unless one grasps at every moment the way in which the thematic material is undergoing constant transformation; if one does grasp that, in the fullest detail, and is exhilarated by its progress, then one has understood the movement."

Malcolm Budd proposes another sense of understanding music. His brief early comment on "the question of the adequacy of our language for describing musical experience" suggests that his argument is motivated by a particular approach to a "specifically musical understanding." He urges that "the truth of the matter is that what much specifically musical vocabulary enables one to do is to name or describe phenomena that someone without a mastery of the vocabulary can hear equally well." Yet ultimately "the musically literate listener is in a more desirable position than the illiterate listener, not with respect to experiencing music with understanding but in his capacity to make clear both to himself and to others the reasons for his musical preferences. At a level of explanation beyond the most crude the musically illiterate listener is not only condemned to silence: he is not in a position to comprehend his own responses to music."

Through considerations of what it means to understand, both these papers identify what makes for the integrity of an experience of music. If an ability to explain preferences is a necessary part of our understanding of music, then a musically illiterate response is inadequate because it does not articulate the relation between the experience of music and the origins of that music in the modes of its construction. In the next essay, "Musical performance as analytical communication," Fred Maus develops issues of understanding music. It seems hard to doubt that analytical awareness or understanding contributes decisively to the clarity and intelligence of performances. Conversely, listening to a musical performance can be bewildering if the audience cannot integrate aspects of the performance into a comprehensive understanding of the music. Maus

5

recalls attending a teacher's solo piano recital, which he found bewildering. "Another member of the audience, greeting the performer afterward, said that he wanted to talk later about one of the pieces on the program, to hear the pianist's ideas about it. I was surprised to overhear this remark, and wondered if it had been tactless. If one heard the performance, and still needed to talk to the performer about his ideas, did that not imply that the performance was a failure? Would a good performance not comunicate the performer's ideas adequately, all by itself?"

To understand this difficulty in establishing the connection between understanding the work and its performance, Maus begins with the "standard" account. This says that analysis discovers facts about musical works; performance means communicating facts about these works; and the facts that performers "bring out" about music are usually the same as the facts that analysts discover. But there are practical problems with this standard conception, Maus points out, and difficulties also in the account of "listening to music" that it depends on. Noting that "in an actual performance the composer's decisions blend with those of the performer, and often there is no way to tell, from listening, where the composer's creativity leaves off and that of the performer begins," Maus proposes that a more fruitful way of understanding performed music is to examine the analogy between performance and composition. "Performers are not fundamentally similar to analysts; rather the activities of performers, like the activities of composers, invite description and interpretation by musical scholars." We should then see performance as composition rather than as analytical communication, and our experience of the work will be the more true the better we incorporate these factors into our understanding.

In the next essay, "Performance authenticity: possible, practical, virtuous," Stan Godlovitch turns to another issue of authenticity in performance that has been important in studies of music. In detailed discussions recently, theorists have insisted that performance practice must respect the musical values of the original compositions, including the instruments they were originally written for. This could imply that if listening to music requires understanding it, and that depends on treating performance as composition, then we will gain an authentic grasp of a work only when we appreciate its original musical values by playing the music on original instruments according to something like an original "mind set." Skeptics have questioned whether such authenticity is ever possible, and God-

lovitch concedes that their doubts would undermine the pursuit of authenticity – if that pursuit is conceived in certain ways. We do not try to reproduce exactly a past we cannot have access to but rather seek to recover practices and their results. This does not promise that we can experience what an audience experienced in the past, but still gives us leave to think we can play music as they did and hear what they did.

The possibility of even this weak sense of authenticity raises questions about its purpose. Godlovitch suggests that authenticity carries its own warrant, since it connotes a quasi-moral "genuine-ness" and integrity: "without excessive melodrama, might we say that performance authenticity trumps the alternatives because ... it involves being true to the music?" he asks. This makes explicit some of the motivation to understand music and its performance that drove the earlier papers in this collection; but there are problems with so bald a statement, of course, since it is not clear why the "original" musical values must be the authentic ones. Godlovitch discusses issues of authenticity, and finally goes for a "thick" reading, using concepts that are "empirically much richer, more amenable to broad empirical characterization." Authenticity in performance, he concludes, is "bound up in the dynamic of an ongoing and largely experimental and exploratory practice to find out more about what we are and once were like."

To some the understanding of authenticity in terms of original instruments has seemed unnecessary, being unduly reductive of our capacity for experiencing aesthetic objects, of their location in the intersubjective and material circumstances of cultural practices, and of the notion of authenticity itself. Joseph Kockelman's essay exam-ines authenticity by returning to the issue of understanding music discussed in the first two essays in this section. He too wants to understand authenticity in terms of what we are and what music is. Where Tanner and Budd recognized that music was not a language or that language was inadequate to musical experience, but Tanner insisted on the use of musical terminology to understand music and Budd concluded that the musically illiterate listener "is not in a position to comprehend his own responses to music," in his essay Kockelmans asks a further complex question: "given that each genuine work of music in some form or other makes present some meaning, why is it that this meaning cannot be articulated by means of language? Why is it that whatever one says about a given work of music can never be a substitute for my listening to the work? Why is

it that whatever a given work makes present cannot be made present in any other ways?'

People have asked this set of over-lapping questions about the intransitivity of works of art generally; Kockelmans develops his question by reference to "absolute music" – "instrumental music of high quality written since the eighteenth Century," which "manifestly has no function beyond itself" – and by turning to discussions of the ontology of art works, especially in Heidegger's essay "The Origin of the Work of Art." "To answer the question of what art is," Kockelmans urges, "we must turn to that being in which art manifests itself, the work of art," where "the truth of beings comes-to-pass." He goes on to explain the latter by reference to "conservation" and "beholding" a work, proposing that specific works, while they are being performed, present the listener with a world or "totality of meaning." From this background, he argues that it is impossible always to be able to speak about the meaning which works make present: their temporality, their being a form of play, their origin in the past in most cases, the articulation of their structure, their references to their own world, the excess of meaning they contain, their necessary wholeness or unity, all show themselves in our responses to works – and they appear in a distinctive manner in music, which goes to explain the particular character of our appreciation of music.

Through the vocabulary of ontology Kockelmans develops an important feature of our grasp of musical performance and seeks to explain the autonomy of music. The latter again points to authenticity: the structure in which a work of art is shown to be possible for itself rather than for some other purpose it can be brought to serve. The essays in this section examined relations between our understanding of music, its performance, and authenticity. The next section develops the notion of authenticity in relation to other performative arts: poetry and performance art.

This third part, on authenticity, poetry, and performance, begins with Alex Neill's subtly argued essay on "Inauthenticity, insincerity, and poetry." The essay develops the concept of authenticity by raising issues about insincerity. Taking inauthenticity to mark a flaw or failing, Neill asks whether works of poetry can be inauthentic because they are insincere – when they express sentiments that the poet does not feel. The question is complicated by the fact that such insincerity might not be discernible, and Neill's focus is on whether and how such "indiscernible insincerity" might yet matter in our

engagement with a poem. This focus allows him to bring considerations of criticism into the ambit of authenticity and, through talk of origins, to expand the notion of expression beyond questions of the importance of the poet's intention to our understanding of the poem. He concludes that a poet's insincerity may be critically relevant, even when it is not discernible within the poem itself; and where it is relevant, it marks a flaw in the poem.

In Peter Middleton's chapter on "Poetry's oral stage" the section turns to consider one of the most famous of modern poetry readings, which included Allen Ginsberg reading *Howl*. Recognizing that a verbal performance transforms the written text, Middleton asks what point do poetry readings have in contemporary culture? What accounts for their popularity? He wants to uncover how the meaning of a poem is affected by performance, that seems to make performance indispensable to complex written texts. These concerns allow him also to raise theoretical issues about poetry. Literary theory would say that the real life of a poem begins when the text is ready for analysis by its readers, apparently seeing little significance in oral performances. Yet it is an inadequate understanding of poetry, Middleton suggests, depending on a model of reading, which most contemporary literary theory implicitly adopts, that "owes its outline to the epistemological project of Kantian philosophy as it has been mediated through its encounters with science, positivism, and linguistics." Looking to the case of poetry reading, acknowledging its distinctiveness from the merely literal text, "will show why recognizing the inescapably intersubjective, plural condition of reading is necessary for an understanding of the meanings which contemporary poets are allowed to produce.'

In clarifying this account of reading, Middleton develops – in a different medium – an account of the compositional elements of performance that Maus proposed for music. The "poet *performs* authorship," Middleton says, "becoming in the process a divided subject," and "suffus[ing] a text with the person and their relation to the listener." By situating poetry in this context, Middleton is able to draw in a number of threads. For example, he points to the basis of moral argument in "authentic feeling" as a model for the "local, momentary attempt to draw listeners in closer." By explaining that poetry readings are not simply "logocentric" he is also able to consider the implications of more recent critical theory. He is also able to argue that far from being a "mere regression to a . . . babble of sound," its oral performance is an authentic feature of poetry and

fulfills its potentialities. Contemporary poems and poets use the resources of reading "projectively just as composers anticipate performance in their scores," and readings embody a collective effort that produces "something out of written texts that is still unarticulated."

The last essay, "True stories: Spalding Gray and the authenticities of performance," by Henry M. Sayre, also takes up issues of sincerity, truth, and performance. He first considers the performance piece *Swimming to Cambodia* by Spalding Gray, and the moment "where the fabric of its authenticity – the warp and weft of its reality and truth – appears to unravel before your eyes." This is the moment when we can see through the film, when we must face its artifice and find its status as a representation of truth quite undermined. The film "looks real, but it is not. It is even less real than this ..." This moment of constantly deferred reality points also to our own spectator's position, which "is even more fragile" than Gray's because it does not belong in "the show."

These illustrations lead Sayre to examine the many resonances of the notion of performance and its relation to truth and authenticity. This is the dark side of performance, where it lacks measure, when it is only a performance, only an appearance and not clearly related to truth. In this hall of mirrors, which has been "the situation of the artist," "if authenticity is the name of what argues against this predicament, it is, today, a name usually invoked as an absence, as something that has 'withered away' ..." Sayre questions the power of the concept of authenticity, its relation to truth and evidence, and, in the case of photographic media – photography, video, film – points to the self-contradictory nature of authenticity. Art is close to artifice; performance is alienated from its origin; narrative is constructed: the notion of authenticity may here point to our recognition of this febrile state rather than consisting in an escape from performance into origins. Or perhaps in "story telling," in relating life, we can still hope to find the authenticity of performance.

This worry about the dark side of performance and authenticity brings the issues of this volume to a resolution without seeking a grand answer. The collection does not seek to present a focused argument for a particular conclusion but tries, instead, to mark an arena for debate and thought about performance and authenticity. This introduction sets out, briefly, some of the themes these essays contain; but it does not do justice to their complexities. Even this short linear presentation already points to the interplay between

essays. The chapters develop varied themes, sometimes replaying them in diverse media and in diverse voices to display the potential for further debate. They consider music, poetry, and drama, performance, understanding, and authenticity, issues in the voices of criticism, history, theory, philosophical aesthetics, in analytic and continental vein. They show the overlaps between music and poetry, that considerations of the one can illuminate the other, and together strongly suggest lines for further reflection on and questioning of performance and authenticity.

## NOTES

1 George Steiner, *Real Presences. Is There Anything In What We Say* (London, Faber, 1989), p. 223, and Roger Scruton, *The Philosopher on Dover Beach* (1989).
2 See Ward Allen, *Translating for King James, Notes Made by a Translator of King James' Bible* (Nashville, Tenn., Vanderbilt University Press, 1969) for an account of the aesthetic interests that informed the translation.
3 See Frederick Antal, *Florentine Painting and Its Social Background* (Cambridge, Mass., Belknap Press of Harvard University Press, 1986).
4 See for example *The Enigma of Piero*, by Carlo Ginzburg (London, Verso, 1985).
5 See Stephen Halliwell, *Aristotle's Poetics* (London, Duckworth, 1979) and John Jones, *On Aristotle and Greek Tragedy* (London, Chatto & Windus, 1962).

# Performance, religion, and authenticity

# The *Poetics* of performance

## The necessity of spectacle, music, and dance in Aristotelian tragedy[1]

GREGORY SCOTT

Aristotle is generally, if not universally, now held to support a literary view in the *Poetics*, which contains his most detailed treatment of dramatic art and its seemingly paradigmatic form, tragedy.[2] Such a view maintains that the language and ideas making up the plot, and perhaps any kind of ethical character consequently expressed, are the only crucial properties of tragedies. Performance and spectacle are considered to be incidental, although desirable, and, on one variation of this view, the physical appearance of the protagonists and their locations need only be imagined for us to have the full dramatic experience.

Contrary to this school of thought, I shall argue that performance and spectacle are always necessary for the kind of tragedy analyzed in the *Poetics*. My argument stems from Aristotle's definition of tragedy itself (which includes both "dramatic form" and μέλος, the latter of which I shall show is best translated as "choral composition" involving music and dance) and from his subsequent list of the six necessary elements, which includes spectacle. These elements provide compelling evidence that Aristotelian tragedy is more akin to our genre of serious Broadway musical than it is to any other twentieth-century practice such as non-musical drama or literary playwriting, all of which has interesting ramifications for the standard historical accounts of dramatic theory and of literary criticism. However, space considerations do not allow me to address those ramifications here. Rather, I shall show only that performance and spectacle, whatever their "look," are along with music and dance, always required for tragedy in the *Poetics*.

Two main reasons appear to be responsible for the deeply etched impression that Aristotle divorces performance from drama: (i) the *Poetics* seems at times to be primarily about poetry or literature in

our sense of the words, and thus about art forms that could use language exclusively,[3] and (ii) in the treatise itself, two oft-cited passages seem to indicate that performance and spectacle are dispensable for tragedy. According to typical translations, Aristotle says "the tragic effect is quite possible without a public performance and actors,"[4] and "tragedy can produce its own [effect] even without movement, as epic does, for it is obvious from reading it what sort of thing it is."[5] I shall begin demonstrating, however, in Part I, that (i) is false: in brief, I shall provide the grounds for my view that in the *Poetics* Aristotle is not really concerned with what he calls there "the nameless art of pure language," notwithstanding that he recognizes in the *Rhetoric* plays written only to be read. Instead, I shall show that he is really concerned only with the dramatic arts, which use language as a part but only as a part, and that, in this treatise "poetry" means centrally, if not exclusively, those dramatic arts. In Part II, I shall give the overwhelming evidence that "dramatic form" in the definition of tragedy indeed means performance, and not just, say, a certain style of writing, and that performance for Aristotle necessarily entails spectacle. With all of this understood, we shall easily be able to see in Part III not only the real meaning of the two oft-cited passages of (ii) above but their consistency with both the definition of tragedy and the "performance view" of the *Poetics*.

## I IS THE *POETICS* REALLY ABOUT LITERATURE, OR ABOUT CLOSELY RELATED ARTS?

A number of commentators have recognized that performance and spectacle are important for Aristotle's theory of tragedy, yet even they have finally accepted that the kind of tragedy analyzed in the *Poetics* can be a literary form in the sense suggested above, namely, a production exclusively composed of verse or prose, whether read silently or voiced.[6] The main reason, as indicated, is that at times the treatise seems to be about literary art. Those times appear to be four: the opening statement in Ch. 1, when Aristotle says that he will speak about the [art of] "poetry"; the emphasis in Chs. 6 and onwards on μῦθος, the primary meaning of which is speech, myth, or story, and which is often translated as "plot"; the comparisons of "poets" to non-fictional writers in Chs. 1 and 9; and finally, three chapters (Chs. 20–22) devoted to language and of one (Ch. 25) to literary criticism. Yet, in evaluating these points – which I shall do

in reverse order, from easiest to hardest – we shall see that they do not justify the generally accepted belief.

As many, if not all, specialists now agree, the *Poetics* was organized by a later editor, perhaps Andronicus of Rhodes in the first century BCE, and Ch. 25 appears to be an interpolation from the *Homeric Problems*.[7] This is because, among other reasons, the chapter breaks the continuity of Chs. 24 and 26, and because Empedocles is allowed to be a poet there (1461a24) when he had been expressly excluded in Ch. 1. Likewise, as scholars also often agree, Chs. 20 and 21, and perhaps a portion of Ch. 22, appear to be interpolations from other, strictly grammatical works.[8] However, whether Chs. 25 and 20–22 are interpolations or not, their inclusion in no way proves that the *Poetics* is necessarily about literature *per se*. This is because an analysis of language is equally needed in the *Poetics* if tragedy is considered to be a complex performing art that includes speech as a necessary part and only as a necessary part.

This point cannot be emphasized enough, and it is similarly applicable to the second of our four items at hand, regarding the contrast of poets both with philosophers who write in verse and with historians. Because the kind of poet that Aristotle is concerned with typically uses language as one of his ways of representation, the contrast made in Ch. 1 between "poetic" writers and Empedocles and between "poetic" writers and historians in Ch. 9 is indecisive in determining whether the *Poetics* is about pure dramatic literature or about performance drama that necessarily but only partially includes language. However, Aristotle clearly recognizes that a poet could present a tragedy without language, as the discussion of our next point, pertaining to μῦθος, reveals.

The well-known emphasis by Aristotle on plot throughout the *Poetics*, the claim in Ch. 6 that plot is the soul of tragedy (1450a38), and the tendency in ancient Greece to use μῦθος as story or speech strongly suggest that the plot for Aristotle can be given in the mere storytelling. Let us take a close look, though, at what Aristotle says in various places. In Ch. 6 he states that plot is the most important of the six necessary elements and he emphasizes that tragedy cannot exist without "plot-action" (πράξεως), even though he adds that it could exist without the second most important element, character (1450a23). However, he explicitly defines the plot as the arrangement of the actions (τὴν σύνθεσιν τῶν πραγμάτων, 1450a4–5), not the description in words of those actions.[9] It follows for Aristotle that poets might make a silent play with a plot – what we might call a

pantomime – even though typically they write scripts and even though he never considers in detail a pantomime. This is confirmed in Ch. 1 at 1447a28 when Aristotle says that dancers by their mere rhythmical figures show the character, "sufferings," and actions (πράξεις) of men. Aristotle employs the same word – πράξεις – that he does when claiming that tragedy cannot exist without "plot-action." Thus, Aristotle is using μῦθος not in the primary sense of speech or storytelling but in one of its legitimate secondary senses – the matter of the speech[10] – or in a technical fashion. Taking him at his word, μῦθος does not require language and only requires an arranging of actions (presumably on the stage in normal circumstances). Thus, his emphasis on plot is in and of itself no proof that the *Poetics* is about tragedy conceived as a pure literary form.

The fourth and final main reason why the *Poetics* has been thought to be about literature requires a longer discussion. Aristotle's opening statement that "[the art of] poetry" (ποιητικῆς) shall be discussed is extremely ambiguous. "Poetry" is a multi-faceted word in Greek, meaning something as broad as "(mere) production" or as specific as "the making of music and poems together."[11] It is not immediately apparent what Aristotle himself might mean by the term and it is not easy to determine: no intensional definition is given in the *Poetics*; no discussion of the meaning for Aristotle occurs anywhere else in his own corpus or in ancient sources (there are simply no extant commentaries from antiquity[12]); and the word could have a technical denotation, as crucial terms often have for him.

A very plausible approach, though, for determining the meaning of "poetry" in the *Poetics*, perhaps the best approach, is to examine the way the term behaves, that is, to mark the extension it acquires in the treatise itself. As a quick review of the whole work will attest, Aristotle is concerned with analyzing in detail only the dramatic arts: tragedy, comedy, and epic, the last of which is said by him to be dramatic in numerous ways.[13] Apart from a remark in Ch. 6 that I will examine in a moment, probably the most telling evidence of this emerges when Aristotle discusses the origin and history in Chs. 4 and 5 of "poetry as a whole" (ὅλως τὴν ποιητικὴν, 1448b4). There, he only covers significantly tragedy, comedy, and epic, and he not only completely leaves aside the bare literary forms but hardly touches on linguistic considerations such as direct or indirect speech, the development of various kinds of meter used by literary composers, and so forth.

In short, there is in the *Poetics* no real or promised analysis of any non-dramatic art.[14] Some of those non-dramatic forms – including the "nameless art of pure language" of 1447b6 that we would call literature – are mentioned briefly in the first two chapters. The mention has obviously caused readers to think that Aristotle is concerned with systematizing and ultimately analyzing all art forms or all literary art forms or with outlining a taxonomy.[15] But, as shall become clearer later, those various art forms are brought up *only* as examples to help explain the concept of mimesis and its three modes: the means, objects, and manners. We should not take the inclusion of these art forms to be anything more, and Aristotle's unwillingness to identify "the nameless art of pure language" with poetry when he is on the subject implies that poetry does not mean literature *per se*. All of this becomes more transparent at the beginning of Ch. 6. There, Aristotle says "the mimetic art in hexameters [epic poetry] and comedy will be discussed later on; but at this point I wish to speak about tragedy" (449b21ff). If Aristotle had intended to discuss the "nameless art of pure language" or any other art form in the *Poetics*, he presumably would have mentioned it along with epic and comedy.[16] Tragedy subsequently occupies Aristotle all the way to the end of the extant treatise, with the exception of Chs. 23–26, which deal with epic, or, as noted above, of Ch. 25, which, again, appears to be interpolated. Finally, one of the two oldest mss. seems to have as the final words in the whole treatise a reference to comedy, suggesting that other chapters deal with it. Thus, the *Poetics* ultimately is restricted to three art forms and only three: tragedy, epic, and comedy.

We must, then, be very careful not to impute a later meaning of "poetry," one that is wholly linguistic, to Aristotle, not only for the reasons given above but because of his closeness to, and perhaps sympathy with, the performing tradition that some scholars today call "primitivism." This primitivism, in which the various arts making up a complex artistic practice are ideally not separated, is one to which Plato alludes in the *Laws*, when speaking of the problem of words, dance, and music being presented independently of each other (Book II, 669e). More importantly, we must also be careful not in the name of Aristotle to impute strictly literary principles to art forms that may only include literary elements as parts, because he says in *Poetics* 25 that the arts have different principles from each other, just as art and politics do (1460b13–15). We cannot, therefore, assume that literary principles and dramatic

principles are always the same, even if there is significant overlap in the two fields, and, indeed, we shall see later when discussing the *Rhetoric* that these art forms are different for Aristotle. Based on the above considerations, the term ποιητικῆς in the *Poetics* seems to mean "[the art] of dramatic composition" or something similar, which fits exactly the scope of the three arts examined in any real detail in the treatise. If this is right, as I am persuaded it is, we have consequently no textual grounds for thinking that the original *Poetics* is about literary art *per se* because of Aristotle's use of "poetry," and, consequently, no reason for thinking that tragedy dispenses with performance and spectacle *on that basis.*

As mentioned, the other ground for thinking that Aristotle maintains a literary view of tragedy – the two oft-cited passages mentioned in my introduction – will be addressed in Part III.[17] However, because we will easier understand those passages if we first grasp more fully the precise statements indicating that tragedy is necessarily a performance art, let us shift to Aristotle's famous definition.

## II PERFORMANCE AS PART OF THE DEFINITION OF TRAGEDY

Aristotle says in Ch. 6:

Let us proceed now to the discussion of Tragedy; before doing so, however, we must gather up the definition (ὅρον τῆς οὐσίας) resulting from what has been said. A tragedy is a representation of an action that is serious, having a (certain) magnitude, complete in itself; in sweetened language (ἡδυσμένῳ λόγῳ), each kind brought in separately in the parts of the work; in a dramatic, not in a narrative form (δρνώτων καί οὐ δι᾽ ἀπαγγελίας); with incidents arousing pity and fear, in order to accomplish the catharsis of such emotions. Here by "sweetened language" I mean language with "rhythm" (ῥυθμόν) and harmony (ἁρμονίαν), that is, "choral composition" (μέλος), and by "separately" I mean that some portions are worked out with verse only, and others in turn with "choral composition."                                        (1449b21ff).

Probably the most crucial phrase of the passage for us is "in a dramatic, not in a narrative form," and I shall argue that this entails both performance and spectacle. To grasp completely the meaning of the phrase, though, and the related parts of the definition such as μέλος, which is usually and unfelicitously translated as a primarily musical notion such as "melody" or "song" and which I obviously have rendered as "choral composition," we need to understand how the definition has been gathered "from what has been said," that is, from a previous diaeresis.

Chart 1

---

ARISTOTLE'S DEFINITION OF TRAGEDY: PRELIMINARY DIVISION
FROM Chs. 1–3 OF THE *Poetics*
(following Bywater)

mimesis
/     \

| arts not using all three: dancing, music, "the nameless art" of language, etc. | arts using all three means of mimesis – ordered (body-) movement, language, and harmony [Ch. 1, 1447b25] |
|---|---|

/     \

| simultaneous use (dithyramb, nomes) | sequential use of the means: tragedy and comedy [Ch. 1, 1447b27] |
|---|---|

/     \

| object is "bad" men: comedy | object of mimesis is "good" men in action [Ch. 2]: tragedy and epic |
|---|---|

/     \

| not full-fledged "acting and doing": epic | manner of mimesis is "acting and doing": tragedy [Ch. 3] |
|---|---|

---

## The preliminary diaeresis of tragedy

According to Bywater and others, Aristotle in Chs. 1–3 defines tragedy by a dichotomous diaeresis, which is, as commonly known, a preliminary method to be used before the collection of traits in a final definition takes place (see Chart 1).[18] However, the divisions from Chs. 1–3 are only partial: "having a certain magnitude" and "complete in itself," two other conditions in Ch. 6, are obtained from divisions in Chs. 4 and 5 (1449a5; a15; a19; b12). Moreover, the conditions in the definition are arranged in a different order from the divisions,[19] and the final condition of catharsis has no previous mention, much less a previous division.[20] All of these facts throw into question the integrity of the whole definition of tragedy, because in the *Posterior Analytics* II 13, Aristotle says that when defining by division, one should admit only crucial elements, arrange them in the right order, and not omit any (97a22ff). However, Aristotle could be employing another kind of non-dichotomous diaeresis, either as found in the biological treatises or in other sections of the *Posterior Analytics*. Regarding biological division, Gerald Else thinks that

21

Aristotle uses the type discussed in *Parts of Animals* I 3, according to which one makes a series of different and separate mini-divisions before collecting all of the final characteristics.[21] A third kind of definition, sketched in the *Posterior Analytics*,[22] is akin to our necessary and sufficient conditions, and does not require previous divisions. In both of these non-dichotomous definitions, the order of the final collection appears unimportant as long as all the differentiae are collected. Thus, for reasons I will not present fully here, the integrity of Aristotle's definition, with the possible exception of the catharsis phrase, can be sustained; suffice it to say that the differentiae from the definition in Ch. 6 which concern us match the traits captured in previous mini-divisions. Leaving aside the problem of catharsis, we can begin determining the exact meaning of "dramatic form" and μέλος by examining those preliminary mini-divisions, which occur, respectively, in Ch. 3 and Ch. 1. (The object of mimesis – "noble" men – and its own related mini-division in Ch. 2 will not be problematic.) Let us start, then, with μέλος in Ch. 1.

## The means of mimesis

At the beginning of Ch. 1, Aristotle indicates that epic poetry, tragedy, comedy, and the dithyramb, along with music of the flute and of the lyre, are all, on the whole, mimesis (μίμησις). Since this last term is much discussed in the secondary literature, and since for our concerns the issue of its denotation is relatively insignificant, I shall do no more than say here that, for me, it is best translated as "representation" or "expression."[23] What is noteworthy is how Aristotle differs from Plato in the application of this term. Whereas Plato in *Republic* II and III offers an analysis of various mimetic arts, using "content" and "form" as his conceptual tools, Aristotle presents a new tripartite framework, which he calls the modes: the means, objects, and manners of mimesis. He proceeds contrapuntally in the first three chapters, not only explaining these modes but in the same space using them to set forth the divisions that will enable him to distinguish the specifically dramatic arts from the other arts and from one another. This, in my view, is as close as he gets to any systemization of the arts in the *Poetics*. As alluded to above, tragedy is defined in Ch. 6, epic in Ch. 23, and comedy in our *Tractatus Coislinianus*, if Richard Janko is right (see note 16), or in a lost book, assuming Aristotle fulfilled the promise from Ch. 6 that we noted above.

As we also noted to some extent above, the first division is introduced as follows. After indicating in Ch. 1 that there are three means of mimesis – "rhythm" (ῥυθμός), language (λόγος), and music (ἁρμονία) – Aristotle explains that they can be used singly or together. He introduces for the sake of illustration – and, I contend, only for illustration – the art of pure language. Then, towards the end of Ch. 1 he makes his first division, substituting verse (μέτρῳ) for language (λόγος) and tune (μέλει) for music (ἁρμονία) (1447b25), and demarcates the arts that use *all* the three means (1447b24). These arts are the dramatic arts – and only the dramatic arts – mentioned at the beginning of the chapter, except that the nome, a form almost identical to the dithyramb, is now added. Epic is not mentioned again here explicitly, but may be subsumed under tragedy, or may have been omitted because Aristotle is giving only a few examples or because it indeed is excluded and also he is not using dichotomous division but mini-divisions (see the previous discussion of definition and note 21). For his second division, Aristotle states immediately that one group of arts uses all the means simultaneously, while another group uses them separately (1447b27–28). It would have been common knowledge in Greece that, of the arts he has just mentioned, dithyramb and nome would be in the first category and tragedy and comedy would be in the latter, and some of what Aristotle says later confirms this, for example, "separately" is included in the definition of tragedy in Ch. 6.

The problem at this point, apart from readers often missing the meaning and importance of these divisions, is that ῥυθμός is translated usually as "rhythm." This term too frequently in the *Poetics* acquires the connotation of a musical, literary, or temporal ordering. Yet, for the following reasons, ῥυθμός actually means "dance" or "ordered body movement."[24] ῥυθμός by itself is practically identified with dance in the middle of Ch. 1, at 1447a26, a passage we noted before, when Aristotle says that dancers use only rhythm, and when he adds that they convey character, experiences, and events through their gestural-figures (σχηματιζομένων). Modern readers miss the identification of ῥυθμός with dance or ordered body movement in part because Aristotle had just indicated that flute- and lyre-playing involve harmony and "rhythm," and it is presumed that "rhythm" must as a result be "time-structuring" or something else that music and dance both have in common.[25] But, as Ch. 26 shows, when Aristotle criticizes not only the flute-players who are representing discus-throwers (1461b30–32) but the hyper-gesticulating singer

Mnasitheus of Opus (1462a7), musicians performed while dancing or moving. Hence, even in the passage dealing with music in Ch. 1, "rhythm" can connote *bodily* rhythm, if only the movement of the vocal chords, tongue, hands, or fingers that are needed to generate tones.[26]

In thinking of "rhythm" as dance or ordered body movement, Aristotle is following standard practice or at least standard philosophical practice. In the *Laws* II (665a), while discussing the training of children who are leaping chaotically, Plato says that "rhythm" (ῥυθμός) is the name for "ordered movement" (τῆς κινήσεως τάξει), "harmony" (ἁρμονία) for the ordering of the tones of the voice, and "choric art" (χορεία) for the combination of the two. Aristoxenus, a student and colleague of Aristotle, similarly says that "that which is 'rhythmed' are three: words, tones, and bodily movement (τρία εἰσὶ τὰ ῥυθμιζόμενα, λέξις, μέλος, κίνησις σωματική)."[27] These three rhythmizomena are obviously the three means of mimesis for Aristotle, except that at first he substitutes ῥυθμός for κίνησις σωματική; ἁρμονία for μέλος; and λόγος for λέξις. He employs, though, μέλος in lieu of ἁρμονία at the end of Ch. 1, as we just saw, maintaining the second term of Aristoxenus' triad, and in Ch. 6 he uses λέξις as a means of mimesis, identifying it, as I shall demonstrate below, with the λόγος of Ch. 1. So the correspondence with Aristoxenus is perfectly complete. Finally, treating "rhythm" equivalently to dance continues for a long time thereafter: Aristides Quintilianus, whose dates are unknown, writing as early as the first century AD but perhaps as late as the fourth, says that "rhythm (ῥυθμός) is, in itself (καθ᾽ αὑτὸν), observed in bare dance (ψιλῆς ὀρχήσεως)."[28]

All things considered, and because "dance" for us appears to be more restrictive than "rhythm" for the Greeks,[29] it is probably best to translate ῥυθμός as "ordered body movement," following Plato. If this phrase becomes cumbersome, I shall keep "rhythm," but it must always be kept in mind that this term for Aristotle refers fundamentally to a physical, bodily phenomenon and only secondarily to a tonal, linguistic, or temporal one.

The upshot of all of this is that tragedy as circumscribed by the divisions of Ch. 1 must contain ordered body movement and music, and therefore cannot be merely a literary form. This is confirmed by Chs. 4 and 5, in which Aristotle stresses the importance not only of the chorus, which sang and danced, but of the dance itself in early tragedy (e.g. 1449a23). This outcome is fortunate for an empiricist, because if Aristotle had omitted music and dance from the definition

of an artistic custom that any classicist knows placed great emphasis on the chorus, he would have committed an egregious error.

It strikes me that the foregoing is sufficient to show that tragedy, for Aristotle, must be performed. One might attempt to excise the passage on dance in Ch. 1 (as Else once tried)[30] or to re-interpret the meaning of "rhythm" for Aristotle, but the fact that music must be included still means that tragedy cannot be merely a literary form. However, there is then the possibility that tragedy for Aristotle is simply a lyrical practice, requiring only singing and language without performance and spectacle. We must continue, therefore, and examine the division of Ch. 3, regarding the manner of mimesis, to establish that "dramatic form" indeed entails performance.

## The manner of mimesis and the meaning of "dramatic form"

In Ch. 3, Aristotle introduces the last mode of mimesis, the manner, and uses it to distinguish tragedy from at least epic:

There is yet a third difference among these [arts], the manner in which each of them may be represented. For the means being the same, and the objects the same, one may represent by "narration" – by taking another personality as Homer [sometimes] does, or by speaking in his own person, unchanged – or by representing all the characters "acting and doing" (πράττοντας καὶ ἐνεργοῦντας τοὺς μιμουμένους).[31]

The representation, then, is distinguished in these three ways, as we said at the beginning, by means, objects, and manner. Thus, on the one hand, Sophocles would be the same kind of representer as Homer, for both represent "good" men; yet, on the other hand, he [Sophocles] would be the same as Aristophanes, since both represent people acting and doing (πράττοντας καὶ δρῶντας).

What does this whole passage, and especially the phrase "both represent people acting and doing" mean exactly? To begin with, "these [arts]" in the first sentence apparently refer to the arts Aristotle had just mentioned at the end of the previous chapter: tragedy, comedy, epic, and perhaps the nome and dithyramb, although these last two we have seen shall be inconsequential in the *Poetics*.[32] In any event, Aristotle indicates that the manners are as follows (I list them in a different order, from simple to complex): (i) narration, which is when the artist speaks "in his own person, unchanged"; (ii) dramatic impersonation (having all the characters act and do); and (iii) a mixture of both narration and dramatization, which is what Homer does as an epic creator.

As is made clear by Aristotle, tragedy as exemplified by Sophocles

and comedy as exemplified by Aristophanes are the arts that are presented dramatically, with the characters "acting and doing" (πράττοντας καὶ ἐνεργοῦντας τοὺς μιμουμένους). A very rare commentator seemingly thinks that this phrase means the characters are exhibiting the actions in front of an audience,[33] but almost always translators render the passage so that readers are left wondering about the status of performance. For instance, Janko writes "representing everyone *as in* action and activity [my italics],"[34] which could easily be taken to mean that it is the literary composition which is itself dramatic, using, we might guess, first person direct discourse, with minimal description of physical settings or of others' internal psychological states. D. W. Lucas, who interprets the *Poetics* almost always from a literary perspective, tries to explicate the idea behind Aristotle's phrase by recalling Dickens. This novelist's impulse, Lucas says, "is always to *present*, in dialogue and pantomime; instead of telling us *about*, he *shows* us."[35] Presumably, Lucas's statement is not meant to be taken literally, because Dickens wrote and did not give pantomimes, but the point, I take it, is that the language for Dickens is as akin to dramatic language as it could be in a novel. But is Lucas right? Is this all that Aristotle really meant by "the characters acting and doing"?

Unfortunately, Aristotle's explanation in Ch. 3 does not settle the issue. Recall that the tragic dramatist Sophocles is likened to the epic poet Homer in terms of the objects of mimesis (both represent good men), but then is likened to Aristophanes in terms of the manner of mimesis (both are dramatic). This contrast, though, could mean *either* that the two dramatists used full performance rather than Homeric partial performance such as mere gesture without costume *or* it could mean that the two dramatists wrote exclusively in dramatic fashion rather than in Homeric epic fashion, which itself involved only a partial dramatic style (of writing). Fortunately, however, we can establish that the first disjunct is correct and that "acting and doing" must involve performance by examining statements from the following sources: *Republic* III, the *Rhetoric*, and *Poetics* 1, 19, and 6.

In *Republic* III (392c), after discoursing on the "what" – the content – of mimesis, Socrates addresses the "how," that is, the form. He establishes a three-fold schema – (i) pure narration, (ii) dramatic impersonation, and (iii) a mixture of both (392d) – which is obviously the same schema Aristotle employs in the passage above. Socrates soon adds:

There is one kind of poetry and tale-telling which works wholly through impersonation (μίμησις) as you [Adeimantus] remarked, tragedy and comedy, and another which employs the recital of the poet himself, best exemplified, I presume, in the dithyramb, and there is again that which employs both, in epic poetry and in many other places, if you understand me.
(394c)[36]

The noteworthy point here, besides the similarity of the three-fold schema with Aristotle's, is that for Plato impersonation (μίμησις) in this entire section of *Republic* III is identical to a representation of voice *and gesture* (393c; 395d; 396a; 397a-b). He tends to concentrate on verbal or vocal impersonation – on "storytelling" – which subtly obscures the meaning of μίμησις as a total impersonation, and modern commentators too often, I believe, follow suit. Notwithstanding this, and in spite of Plato's linguistic favoritism, Aristotle, as we have seen, has no hesitation about using the same schema of narrative, drama, and a mixture of the two when discussing his own "how" – the manner of μίμησις. His copying of Plato's schema, then, implies that tragedy and comedy in *Poetics* 3 are also representations in both voice *and gesture*.[37]

The *Rhetoric* offers more evidence for this conclusion. After claiming at III 1 (1403b23) that the poets acted in earlier times in their own productions, Aristotle declares in III 12 that

The style of written compositions is most precise, that of debate is most suitable for delivery. Of the latter, there are two kinds, ethical and emotional; this is why actors are always running after plays of this character, and poets after suitable actors. However, poets whose works are only meant for reading are also popular, as Chaeremon, who is as precise as a writer of speeches, and Licyminus among dithyrambic poets. When compared, the speeches of writers appear meagre in public debates, while those of the rhetoricians, however well delivered, are amateurish when read. The reason is that they are only suitable to public debates ...
(1413b9ff, trans. J.H. Freese)[38]

As a literary theorist might initially be happy to see, Aristotle appears to recognize two genres of plays, one to be performed and another to be read.[39] Does this mean, however, that he treats both genres in the extant *Poetics*? More pertinently, is the literary genre the focus of Ch. 3 and of the phrase "acting and doing"?

The answer to both questions is surely no. As is obvious from Ch. 1, in which tragedy and comedy are said to use not only language but music and ordered body movement, Aristotle is dealing exclusively with the first genre in the *Poetics*. Because he has in no way restricted himself to purely literary forms in Ch. 3, we must

27

resist foisting an equivocation on him by assuming that he has switched senses of tragedy after the first chapter. Moreover, as is implied in the passage above from the *Rhetoric* – when Aristotle says that the speeches of professional writers sound meager in actual contests and that the speeches are thus unsuitable there – he would refrain at least at times from applying the principles of merely written drama to performed drama, and vice versa. This obviously entails that he would not treat both genres as substitutable in any context. Because Aristotle additionally illustrates his points in *Poetics* 3 with the older poets and not with those like Chaeremon, he appears to be only dealing with the traditional, performed sort of tragedy. Therefore, we may conclude that "acting and doing" is not merely a style of language, but is performance, involving both language and gesture.

Further support for this conclusion is given in Ch. 19, when Aristotle distinguishes dramatic action from speech:

the dramatic incidents should speak for themselves without verbal exposition, while the effects aimed at in speech should be produced by the speaker, and as a result of the speech. For what would be the function of a speaker, if the thought were made plain apart from what he says? (1456b6ff)

Aristotle is saying not only that the (silent) action on the part of the character has to be effective in and of itself but that the speech has its own, singular effects. He indubitably implies that the dramatic action is not an aspect of language, and his rhetorical question at the end of the quotation amounts to this: Why go beyond "mime" if the dialogue adds nothing to the stage-action? As James Hutton – who ironically usually takes a literary view of the *Poetics* – reminds us, "Cassandra throws her garland and her wand to the ground and crushes them, and it is the act that expresses her thought, not the statement that accompanies it (*Agamemnon* 1264–8)."[40]

Absolutely conclusive statements that "acting and doing" in Ch. 3 must involve not only speech but the gestural components of performance can be found in Ch. 6. Immediately after his definition of tragedy and the statement of the meaning of "sweetened language," Aristotle deduces the six necessary parts of tragedy, which first come in the following order: spectacle, "choral composition," language, action (i.e., plot), character, and thought.[41] As he says (and as I number):

Since in acting they make the representation (ἐπεὶ δὲ πράττοντες ποιοῦνται τὴν μίμησιν), it follows in the first place that [1] the spectacle (ἡ τῆς ὄψεως

κόσμος) must be some part of tragedy; and [2] in the second the making of the "choral composition" (μελοποιία) and [3] language (λέξις),[42] these two being the means of their imitation ... But further: the subject represented also is [4] an action; and the action involves agents, who must necessarily have their distinctive qualities both of [5] character and [6] "thought," since it is from these that we ascribe certain qualities to their actions.   (1449b31ff)

"In acting" (πράττοντες) clearly is a reiteration of the manner of mimesis, the "acting and doing" (πράττοντας) of Ch. 3. Aristotle rather plainly is deriving the requirement of spectacle from "acting and doing." He is saying that if people are acting, the costumes and scenery will be required. Thus, the manner of mimesis of Ch. 3, in "giving" us the spectacle, surely must be a performance condition, and not merely a certain style of writing.

All of this is substantiated in subsequent passages of Ch. 6. Aristotle re-orders the six necessary parts, stating that "every play contains plot, character, language, thought, spectacle, and 'choral composition'" (1450a9). Then he recalls his three modes of mimesis – of means, objects, and manner – and indicates at 1450a10–12 that two of the necessary parts are the means, one the manner, and three the objects of mimesis, what I shall call the 2–1–3 pattern. He does not say which of the six parts fall under which mode, even though he had just marked μελοποιία and λέξις as the two means. But once we figure out the rest of the 2–1–3 pattern, including the reason why he has gone from the three means of mimesis in Ch. 1 to two here, we will find that only spectacle can be the manner of mimesis and, thus, identical in some sense to "acting and doing," the manner of mimesis of tragedy in Ch. 3. We shall also see that the three means of mimesis are identical to the three Aristoxenian rhythmizomena mentioned before, that λέξις simply takes the place of λόγος/μέτρον of Ch. 1, and that two means of mimesis simply get subsumed under one broader term.

To understand completely Aristotle's 2–1–3 pattern and the related issues, we must first note that Aristotle does not explain the term "choral composition" (μελοποιία) because, he confidently declares, it "is too completely understood to require explanation" (1449b35). However, we ourselves do require explanation, and we therefore need to recall the statement given immediately before his confident declaration, one that arose in his definition of tragedy: λέγω δὲ ἡδυσμένον μὲν λόγον τὸν ἔχοντα ῥυθμὸν καὶ ἁρμονίαν καὶ μέλος [1449b28–29]. Some commentators translate this as follows: "I mean by 'sweetened language' that which has rhythm and harmony

29

and song." So καὶ μέλος becomes "and song" and "rhythm" gets treated as a musical, linguistic, or temporal aspect. In other words, "sweetened language" becomes language having rhythm and harmony plus song.[43] But this cannot be correct, for a number of reasons going beyond the proper meaning of "rhythm," which has already been clarified.

First, to translate μέλος as song is utterly redundant and in fact confusing, according to Lucas. The difference, he says, between ἁρμονία and μέλος when they are not synonyms is that the latter implies language, and Aristotle would be saying that sweetened language is language that has music and *in addition* song. As Lucas further notes, some editors have wanted to excise καὶ μέλος as a result. His own solution is to take καὶ μέλος as "that is, tune," invoking the equivalence of μέλος with ἁρμονία in Ch. 1, and taking καὶ to be explicative rather than conjunctive.[44] At first glance, this is quite allowable, although, because there has not been a problem about the meaning of ἁρμονία, utterly unnecessary on Aristotle's part. More crucially, as we shall see shortly, we would then doubly expect Aristotle to be keeping the same three means of mimesis for tragedy that he had listed in Ch. 1, including rhythm *qua* ordered body movement.

Alternatively, we could translate τὸν ἐχοντα ῥυθμὸν καὶ ἁρμονίαν καὶ μέλος as Janko does: "having rhythm and melody, that is, song."[45] However, this still ignores the correct meaning of "rhythm."

Optionally, we could take καὶ μέλος as I have: "that is, choral composition." Aristotle on this interpretation is, again with an explicative καὶ, merely summarizing the first two elements governed by τὸν ἐχοντα ("rhythm" and harmony), and the Greek can stand without modification. "Sweetened language," then, just means language with dancing and harmony – that is, language with choral composition. The μελοποιία simply means the making of the μέλος, and the reason Aristotle says the term does not require explanation is that *even uneducated Athenians would know that these occurred in tragedies in the choral sections*. And, in fact, the practice of using μέλος as choral composition and as a summary of "rhythm" and harmony is easily documented.

According to Liddell and Scott's *Greek–English Lexicon*, a μέλος means primarily a bodily limb, and secondarily a song, so for Aristotle to use μέλος as a combination of moving limbs and song is very natural. Furthermore, in *Republic* III (398d), Plato says that τo

μέλος – usually translated there also unfelicitously as "song" – has three parts: the words, tune, and "rhythm" (ῥυθμός). Here "rhythm" also means dance-figures, as the discussion of 399e–400a seems to prove in and of itself, and as the passage from the *Laws* II, 665a, which we noted before, would appear to confirm. So μέλος for Plato is synonymous with the choric art (χορεία). Finally, in the *Symposium* (187d), Plato suggests that men call practices like ῥυθμῷ and ἁρμονίᾳ the μελοποιίαν, which in essence is exactly what Aristotle is doing in the phrase under scrutiny. Thus, it appears that both Plato in the *Republic* and *Symposium* and Aristotle in *Poetics* 6 use μέλος or μελοποιία synonymously for the choric art (χορεία) of the *Laws*. Since it was the chorus that engaged in the dancing and singing, and since there seems to be no direct English equivalent for μέλος, I translate it as "choral composition." It might be added now that we cannot chide Aristotle for giving a different sense to the term μέλος in Ch. 6 than he had in Ch. 1 because he explicitly clarifies it in Ch. 6, in effect explaining there that it has become more than just a synonym for naked music, which is what it meant in Ch. 1.

In any event, no matter how one translates the term μέλος, if the "sweetened language" in the definition of tragedy does not have the language, ordered body movement, and harmony of *Poetics* 1, then tragedy no longer has the three necessary means of mimesis of the preliminary diaeresis. That tragedy, however, indeed still has the three means is surely confirmed by a remark in the definition itself, when Aristotle says that the parts of "sweetened language" are used separately. This condition without a doubt repeats the second division from Ch. 1, which we will remember stipulated that the three means be done not concomitantly, but separately.

We can now establish all of the six necessary parts of the 2–1–3 pattern, which, again, are organized by Aristotle in this way: two for the means, one the manner, and three the objects. The μελοποιία – understood now as the making of both the ῥυθμός and ἁρμονία – and the language (λέξις) are the two parts, as Aristotle says (1449b34), even though they had been, when uncompressed, the three means of mimesis of Ch. 1. Plot, character, and thought are usually, and correctly – insofar as this topic is ever addressed in the secondary literature – acknowledged to be the three parts, a detailed refinement of the "(good) men in action" that in Ch. 2 was the object of mimesis. Therefore, spectacle, the only remaining one of the six necessary elements, must be the one and only manner of mimesis of tragedy,

and thus somehow equivalent to "acting and doing," the manner of mimesis in Ch. 3. Consequently, without a doubt the dramatic manner of Ch. 3 must entail some performance and spectacle, and cannot be merely a linguistic feature.[46] Moreover, on the above reading, Aristotle maintains all the modes of mimesis in Ch. 6 that he had laid out in his preliminary divisions, which reflects a coherent and consistent theory and which is more evidence that such a reading is correct.

What other conclusions can be stated at this point regarding performance and spectacle in tragedy?

## *The role of essential conditions in a definition*

Obviously, when Aristotle collects the elements from his preliminary divisions for the final definition of tragedy in Ch. 6, he uses "in dramatic, not in narrative, form" to summarize his discussion in Ch. 3 of the manner of mimesis.[47] Moreover, as we have also already seen, Aristotle maintains in Ch. 6 that he is giving the definition of tragedy (ὅρον τῆς οὐσίας), literally, the "limit of the substance." It is common knowledge that for him the definition reflects, more than anything else, the nature of a particular thing and that the parts of the definition are essential properties.[48] It may not be common knowledge that he uses a similar phrase – "defining the individual" (ὁρίζοντά ... τόδε τι) – at *Metaphysics* V 8 (1017b19) to indicate that the destruction of a substance-part causes the destruction of the whole. In any event, it follows that tragedy would be destroyed as a whole for Aristotle if either of the two essential parts, the dramatic form (i.e. performance) or the "choral composition," was removed.[49]

The issue of spectacle is more complex, as it is merely a necessary condition, and not an essential one. The distinction between "(merely) necessary" and "essential" is a subtle one in Aristotle's theory, generating certain tensions, but it need not delay us now. There may be cases of dramatic performance without spectacle, as in rehearsal with street clothes or in the nude, which may be the reason that performance is, and spectacle is not, essential for Aristotle. Notwithstanding this, when a tragedy is normally performed the spectacle is included, and thus the latter feature arguably can be properly said by Aristotle to be necessary.

We now have, at least to me, the utterly decisive evidence for the

view that tragedy in the *Poetics* must be a performed art, and we can proceed to the two statements that have heretofore suggested the opposite.

## III THE TWO OFT-CITED PASSAGES

### *The passage in Ch. 6*

The first of the assertions that have camouflaged the performance approach in the *Poetics* comes at the end of Ch. 6. Let us examine Bywater's interpretation, as a way of introducing my own reading. He translates as follows:

| | |
|---|---|
| The Spectacle, though an attraction, is the least artistic of all the parts, and has least to do with the art of poetry. *The tragic effect is quite possible without a public performance and actors*; and besides, the getting-up of the Spectacle is more a matter for the costumier than the poet [my italics].[50] | ἡ δε ὄψις ψυχαγωγικὸν μέν, ἀτεχνότατον δὲ καὶ ἥκιστα οἰκεῖον τῆς ποιητικῆς· ἡ γὰρ τῆς τραγῳδίας δύναμις καὶ ἄνευ ἀγῶνος καὶ ὑποκριτῶν ἐστιν, ἔτι δὲ κυριωτέρα περὶ τὴν ἀπεργασίαν τῶν ὄψεων ἡ τοῦ σκευοποιοῦ τέχνη τῆς τῶν ποιητῶν ἐστιν. (1450b16ff) |

The statement that the tragic effect is possible without a public performance and without actors appears, of course, to contradict the previous inclusion both of performance in the definition of tragedy and of spectacle in the list of the six necessary parts. We might, though, simply reject this statement that dispenses with public performance, because an incidental remark would have less weight in Aristotle's theory than part of a definition, or we might distinguish between tragic effect and tragedy and argue that Aristotle somehow is not necessarily addressing tragedy itself when he targets tragic effect. However, a better way of proceeding in my opinion is as follows. We should start by recognizing that the seemingly contradictory statement comes in a clause beginning with "because" (γαρ), which Bywater has dropped in his translation. This γαρ-phrase justifies the previous clause, which itself states that spectacle is *least* germane to the poetic craft. Aristotle's implication here is surely that spectacle is still germane *to some extent*. Hutton correctly notes:

Aristotle says little about Spectacle and Melody (music) because this treatise is about the poet's work, the poem, and [because] spectacle and music were largely the work of the stage personnel and the musicians. But he expresses

himself with care ... spectacle is the part least essential to the art of the poet, but it is not inessential; the "machine" is used at the end of Euripides' plays because the poet planned it so.[51]

We can easily resolve the surface inconsistency between the confusing passage and the definition of tragedy by translating properly the phrase ἄνευ ἀγῶνος καὶ ὑποκριτῶν as "apart from a *contest* and the *competing* actors." The ἀγών suggests both a public performance and a prize-winning, and, indeed, Aristotle uses the form ἀγωνίσματα in Ch. 9 at 1451b37 when he discusses poets stretching out plots for the sake of actors in the competitions.[52] The implication, therefore, of Aristotle's remark is not that performance and hence spectacle are unnecessary. Rather, the implication is that the tragic *dunamis* can *also* be given in private performance, or in rehearsal, or in minor public performance, none of which has the grand trappings or the best actors that accompany the contests. Aristotle is in effect suggesting that spectacle is the least artistic element in a list of necessary conditions *because* (γαρ) we can acquire the effect of tragedy even when the staging elements are minimal. Perhaps Aristotle was annoyed at the predominance or misuse of costumes, scenery, or "special effects" in some Greek tragedy. Whatever his reason, he is trying to balance his appraisal that spectacle is ranked lowest on a list with his avowal that the list is a special one, comprising necessary conditions.

Aristotle continues, "besides, the getting-up of the Spectacle is more a matter for the costumier than the poet." This statement has also been taken to signify that spectacle is not necessary for tragedy. However, Aristotle says only that the execution of the masks (or stage-properties) is *more* the job of a costumier, and he still implies that the maker of tragedy is at least partially responsible for the stage-properties, whatever the poet's primary function. According to Istros, Sophocles "invented the white boots which actors and members of the chorus wear,"[53] and according to Aristotle's own history of the development of "poetry" in *Poetics* 4, Sophocles also introduced scene-painting (1449a18), a fact better omitted if spectacle were unnecessary. Hutton again supports all of this with an example from the *Frogs*, stating that:

[Procuring pity and fear by means of spectacle] is still within the poet's art, since he plans the spectacular effect; but it is the less so in that its final success depends on the *skeupoios* who provides the necessary props ... [Nevertheless] *Aristophanes regards the poet as responsible for spectacle when he ridicules Euripides for clothing Telephus and others in rags.*[54]

## *The passage in Ch. 26*

At 1462a11 we find the second and last of the passages that provide
any substantive support for the literary view of the *Poetics*. Aristotle
says: "tragedy can produce its own [effect] even without movement,
as epic does, for it is obvious from reading it what sort of thing it is"
(ἡ τραγῳδία καὶ ἄνευ κινήσεως ποιεῖ τὸ αὑτῆς, ὥσπερ ἡ ἐποποιία· διὰ
γὰρ τοῦ ἀναγινώσκειν φανερὰ ὁποία τίς ἐστιν).[55] Although there is a
similarity with the passage just discussed from Ch. 6, there is a
notable difference. Now Aristotle says that the effect can be given
without *any* movement, which, if he means the *entire* effect, is a
much stronger statement than the earlier one. As such, the new
statement would rule out any performance whatsoever and conse-
quently any spectacle. Does Aristotle, then, contradict his definition
of tragedy? Let us see by examining the context within which the
new statement occurs, namely, the extended dialectic answering the
question "Is epic or tragedy better?"

As Aristotle reports at the beginning of Ch. 26, epic is sometimes
claimed by others – perhaps by some Platonists[56] – to be addressed
to a more cultivated audience because it does not need all of the
ways of representation (ἅπαντα μιμουμένη), whereas tragedy ad-
dresses an inferior audience because it does. This suggests that
tragedy is being attacked by Aristotle's opponents for having at least
one of the two ways of representation that epic has been said by
Aristotle to lack: the choral composition (μελοποιία) and spectacle
(ὄψις).[57] In any event, a few lines later in Ch. 26, Aristotle describes
his opponent's position as deriding gestural-movement (σχημάτων),
which we will remember in Ch. 1 was what allowed the dancers to
represent character, experiences, and actions.

Aristotle now rebuts the whole argument, yet rebuts it not by
acknowledging that tragedy can dispense with gesture, an acknowl-
edgment that would level the argument immediately. Instead, he
unravels two separate strands of the position – namely, that the art
which uses (i) more vulgar movement (κίνησις) or (ii) merely some
movement, is worse – and he replies to each of them. Aristotle's
reply to the first strand is completely transparent. He says that the
charge against tragedy is really against poor acting, because there
can be overdone gestures also in epic and in singing, as by Sosis-
tratus and by Mnasitheus.

Aristotle's reply to the second strand may not be as obvious, but is
clear enough. He says, "not all movement (κίνησις) is to be rejected,

unless dance (ὄρχησις) is to be too, but only that of inferior people ..." (1462a8). He implies that dance is not to be rejected, and it is at this point that he says that tragedy can accomplish its effect in reading, as epic does. Aristotle immediately proceeds after this to state the conclusion that delimits one whole stage of argumentation: "if in all other respects tragedy is superior, this [having bad movement or having some movement?] is not inherent in it" (1462a13) – a passage for which the antecedent of "this" has been never convincingly articulated, to my knowledge.[58]

Let us take stock of the results so far. There is no question that Aristotle is trying in Ch. 26 to counter the two claims that *(i) tragedy is worse than epic* because *(ii) tragedy has bad movement or some movement.* Moreover, there is also no question that epic is partly dramatic, at least in terms of voice and gesture: Aristotle's remarks from Chs. 3, 23, 24, and 26 prove this beyond doubt. Still further, Aristotle's reply to the second strand indicates that dance or some movement is to be kept in tragedy.

All of the above, then, allows us to resolve definitively the meaning of the ambiguous antecedent for "this" in the conclusion mentioned a few sentences back. Given that some movement must be kept, when Aristotle says "if in all other respects tragedy is superior, this is not inherent in it" he must mean "... this [having bad gesture] is not inherent in tragedy." He is thus switching back in this conclusion to the first argument-strand.[59]

We can also now see without distortion that the definition of tragedy is not necessarily contradicted by the proposition "tragedy can produce its own [effect] even without movement, as epic does, for it is obvious from reading it what sort of thing it is." There are, it seems to me, at least three ways of interpreting this while remaining consistent not only with the goals of Ch. 26 but with that definition.

*Option 1.* Aristotle may be conducting his comparison of tragedy and epic counterfactually, as if neither of them had any movement, just because it is clear from the passages regarding Sosistratus and from Chs. 3 and 6 that tragedy must be performed and that epic is also partially performed. Because epic and tragedy are different genres, and because epic has only four of the six parts of tragedy,[60] Aristotle thereby finds a common denominator between the two genres – the language – in order to allow a direct comparison.

*Option 2.* Aristotle is writing elliptically when he says "tragedy can produce its own effect" and denoting a partial effect, following his own lead when he speaks, for instance, of the effect of speech in Ch. 19 at 1456a35. On this option, Aristotle means in Ch. 26 that tragedy can produce its own (literary) effect even without movement. Yet this need not imply that the literary effect is the whole effect of tragedy.

*Option 3.* The last solution could be considered a variation of option 2 and pertains furthermore to Aristotle's claim in Ch. 24 that epic can present many events happening simultaneously, which add to its dignity and diversion and which gives it an advantage over tragedy, because tragedy itself is limited to the action of the actors on the stage (1459b25–38). If the claim that tragedy can produce its effect merely in the reading entails that tragedy can dispense with performance, Aristotle generates a serious difficulty for himself. If both tragedy and epic are only composed of language, the comparison results in epic with its dignity and grandeur being ranked higher than tragedy, which would violate the whole thrust of Aristotle's argument in Ch. 26.

Thus, Aristotle may well be supposing that we remember an almost identical use of the puzzling phrase that we are scrutinizing, which occurred in Ch. 6 at 1450a8. Aristotle states there that "all tragedies have six necessary elements, *which makes tragedy a certain sort*" (ἀνάγκη οὖν πάσης τῆς τραγῳδίας μέρη εἶναι ἕξ, καθ' ὃ ποιά τις ἐστιν ἡ τραγῳδία.) Plot, of course, is the first element, and is explicitly said to be the arrangement of *the actions* (1450a4–5). Not surprisingly, action is movement,[61] which is our current focus in Ch. 26. In saying that it is obvious what sorts of things tragedy and epic are in the reading, Aristotle may well be indicating that we recognize their nature to be representations in words of actions or movements. And this does counter the second argument-strand which supports epic, because the ramification is that epic with, say, its heroes in battle, can suggest more action than tragedy, and so the issue of mere movement cannot be, or should not be, a pivotal one even for those who favor epic over tragedy.

## CONCLUSION

I have shown that the two puzzling statements of Chs. 6 and 26 are actually consistent with the definition of tragedy as a performance

art. There are no other passages in the *Poetics* that would seriously threaten that definition, nor is it easy in any event to imagine how a remark could overturn an essential condition in a definition for Aristotle.[62] In the last part of Ch. 26, he corroborates that tragedy is a performed art when he gives the other reasons why tragedy is superior to epic. Among these reasons, he says that tragedy is better "because it has all the epic elements ... with [in addition] the "music" (μουσικὴν) and spectacular effects (ὄψεις) as not small parts (οὐ μικρὸν μέρος) that produce the most vivid of pleasures" (1462a15). It would be pointless for him to use spectacle and music to rank tragedy higher than epic if they were only incidental. Consequently, we have another piece of evidence that Aristotle is maintaining his definition of tragedy of Ch. 6, including performance and "music," until the very end of his treatise.

## NOTES

1  In a previous form, this essay formed part of my Ph.D. dissertation for the University of Toronto, "Unearthing Aristotle's Dramatics: The Lack of Literary Theory in Aristotle's Poetics," 1992, Toronto, Ontario, Canada. In the dissertation I argue for a more extreme thesis than the one offered here, namely that drama, as represented paradigmatically by tragedy, is not considered by Aristotle even to be a species of literature. One might agree with my conclusions in this article regarding the necessity of performance, spectacle, music, and dance and yet still claim that the literary element is the most important or the most fundamental of the required elements of tragedy. I deny this in the dissertation and present the evidence from the *Poetics* that language, while necessary, nevertheless is not the most important element. I am grateful to my ex-supervisor, Francis Sparshott.

2  Ample examples will be forthcoming. For the moment, I simply note these passages from Leon Golden and O.B. Hardison, Jr., *Aristotle's "Poetics": A Translation and Commentary for Students of Literature*, (Tallahassee, University Presses of Florida, 1981):

[W]e can expect the *Poetics* to yield insights into literary problems of general significance instead of being restricted to Greek and Roman literature (p. 62). [Later they add:] Melody is mentioned [by Aristotle] as "the greatest of the linguistic adornments." The term "adornment" emphasizes the fact, evident in the gradual decay of the chorus throughout the history of tragedy, that melody is not essential. Spectacle is dismissed as the "least artistic and least essential part" [of tragedy] ... It is present in the text but its effect is brought out in

performance ... The relative insignificance of spectacle is clear from Aristotle's remark, "the power of tragedy is felt even without dramatic performance and actors." (p. 132)

3 "[Aristotle's] love of logical distinctions ... is shown even in the province *of literary criticism* by the care with which in the *Poetics* he maps out the subordinate divisions ... [my italics]" S.H. Butcher, *Aristotle's Theory of Poetry and Fine Art* (1911: 4th ed., New York, Dover, 1951), p. 113.

"The *Poetics* ... consists largely of what most commentators have seen as literary theory or literary criticism" Jonathan Barnes, *Aristotle* (Oxford University Press, 1982, repr. 1992), p. 83. The alternative for Barnes, however, is not to see the treatise as a "dramatics" necessarily involving performance, which is what it is for me, but rather "as a contribution to 'productive' science – its aim is to tell us not how to judge a work of art, but how to produce one" (p. 83).

"Aristotle was describing literature as he knew it in Greece ...," Humphrey House, *Aristotle's "Poetics"* (London, Rupert Hart-Davis, 1964), p. 13.

"He [Aristotle] is not analysing the religious drama ... he is analysing the ... literature of the 4th century," R.G. Collingwood, from *The Principles of Art*, in *Aesthetics*, ed. George Dickie and Richard Sclafani (New York, St. Martin's Press, 1977) p. 116.

"The earliest sustained work of literary criticism in Western culture is Aristotle's *Poetics* ..." Joyce Carol Oates, *New York Times*, "Confronting Head On ..." Feb. 19 (1995), p. 22.

See also, for example, Elder Olson, *Aristotle's "Poetics" and English Literature*, (Chicago, University of Chicago Press, 1965), especially the introduction.

4 1450b18ff, tr. Ingram Bywater, *The Basic Works of Aristotle*, ed. R. McKeon (New York, Random House Press, 1941).

5 1462a11ff, tr. Richard Janko, *Aristotle: Poetics* (Indianapolis, Hackett Publishing Co., 1987).

6 See, e.g., Aryeh Kosman, "Acting: Drama as the Mimesis of Praxis," in *Essays on Aristotle's Poetics*, ed. A. O. Rorty (Princeton University Press, 1992), especially pp. 57 and 70.

To my knowledge, Stephen Halliwell gives the fairest discussion of spectacle in *Aristotle's Poetics* (University of North Carolina Press, 1986) in his appendix, "Drama in the Theatre," pp. 337ff, although he ultimately remains in my view too neutral. He starts off:

> Aristotle ... seems to sanction a clear separation of the playwright's art as such from its embodiment in the theatre. A cursory reading of the *Poetics* is likely to leave the impression that its author's interest in theatrical production was slight; but closer attention ... will prompt some qualification on such a conclusion. (p. 337)

In conclusion, though, Halliwell says:

> If ... we read the *Poetics* as a text which belongs to a philosophical system, with all the pertinent presuppositions of that system latent in it, we should not have any difficulty in seeing the significance of Aristotle's attempt to turn the poet into an artist who is the maker not of materials for the theatre (though he may be incidentally that in practice) but of poetic constructs, *muthoi*, the experience of which is cognitive and emotional, but not directly dependent on the senses, *as it would have to be if drama could only be fully realised in acted performance* [my italics]. It is this philosophical enterprise which accounts for the strong thrust in the *Poetics* towards a theoretical separation of poetry from performance, drama from the theatre. (p. 343)

Victor Goldschmidt offers similar qualifications after stating:

> Le spectacle, note Aristote, semble tout à fait étranger à l'art poétique; il relève des acteurs et du metteur en scène. Or l'effet propre à la tragédie ne dépend pas de la représentation matérielle; la simple lecture peut suffire." (*Questions Platoniciennes.* [Paris, J. Vrin, 1970])

> [The spectacle, Aristotle states, appears quite foreign to the poetic art; it depends on the actors and the stage designer. Indeed, the proper effect of tragedy does not require material representation; simple reading can suffice.]

Finally, Ingram Bywater, in addressing Aristotle's statement in Ch. 26 that tragedy in reading can show what sort of thing it is, claims:

> though Aristotle draws a line between tragedy as literature and its stage presentation (comp. 14, 143b2), he has no idea of a reading as distinct from an acting tragedy; a tragedy with him is essentially something to be acted. The notion of a reading play has been found in Rhet. 3. 12, 1413b12 ... [but] merely denotes a fact of style ...

> (*Aristotle on the Art of Poetry*, [Oxford, Claendon Press, 1909], p. 356)

Unfortunately, Bywater never seems to have developed this insight, and actually gives contradictory impressions in his discussion of earlier chapters, when he argues that spectacle and music are mere accessories, thereby suggesting they are unnecessary: see pp. 162 and 174.

Thus, even thorough commentators like Halliwell, Goldschmidt, and Bywater leave the literary approach intact, after they come very close to dispelling it.

7 See D. W. Lucas, *Aristotle's Poetics* (Oxford, Clarendon Press, 1968, repr. 1988), p. 232, for some background of the *Homeric Problems*. Lucas's text has become probably the standard edition for scholarly work on the *Poetics*. Gerald Else, who has published one of the most comprehensive commentaries on the *Poetics*, himself thinks that Ch. 25 is "relatively independent" (*Aristotle's Poetics: The Argument* [Cambridge, Mass., Harvard University Press, 1957], p. 632).

8 Ch. 22, which deals with poetic language, may belong to the treatise now

called the *Poetics*, or to another of the almost dozen that Aristotle wrote on the same topic or on similar ones. For the list of those works, see Diogenes Laertius in *The Lives of Eminent Philosophers* V, Section 22–27, trans. R.D. Hicks, Loeb Classical Library (London, W. Heinemann Ltd., 1925), pp. 464ff.

9 Aristotle says just before the definition of plot that "the plot is the representation of an action." Because "representation" (μίμησις) here might be taken to mean "literary representation," it might also be assumed – and surely has been assumed – that plot is still a description in words. I give later, however, some of the reasons why "representation" here cannot be confined to merely linguistic representation.

10 H. G. Liddell and R. Scott, *Greek–English Lexicon*, 7th ed. (Oxford University Press, 1983).

11 The cognate ποίησις, which in Greek culture meant simply "making," is said by Plato in the *Symposium* to be either any kind of artistic creation or specifically creation using music and meter (205c). At *Gorgias* 502C, though, after just discussing dithyramb and tragedy, which both have dance, he indicates that poetry has speech, music, meter, and "rhythm," which presumably would mean body movement in his context, as I discuss later.

For a fuller analysis of this issue, see Golden and Hardison, *Aristotle's Poetics*, p. 63ff.

12 Francesco Robortello produced the first European commentary in 1548 in Florence, *In Librum Aristotelis De Arte Poetica Explicationes*. The Arabic versions that preceded appear to be virtually worthless as a tool for understanding Aristotle's thought, although admittedly valuable as a way of helping settle disputes regarding differences in manuscripts.

13 When defining epic in Ch. 23, 1459a17ff, Aristotle says that the plots should be constructed in dramatic fashion. Other remarks showing that epic is at least partly dramatic are given in Ch. 3 (epic is said to have a mixed manner, dramatic and narrative); at Ch. 4, 1448b38ff (epic is the less developed stage of tragedy); and at Ch. 5, 1449b15ff (epic and tragedy have the same parts on the whole and whoever knows about good tragedy therefore knows about epic).

14 J. Barnes says, "Our text [of the *Poetics*] promises a discussion of *all* types of poetry and breaks off after discussing tragedy and epic [my italics]," *The Cambridge Companion to Aristotle* (Cambridge University Press, 1995), p. 272. However, there is no word for "all" in the Greek (at the beginning of Ch. 1, to which Barnes is surely referring). One might translate περὶ ποιητικῆς αὐτῆς τε καὶ τῶν εἰδῶν αὐτῆς as "regarding [the art] of poetry in general and of its kinds," but even that reading, given the meaning of "poetry" for us as a purely literary form, is questionable if ποιητικῆς is a technical term for Aristotle, meaning "the dramatic arts."

15 Three of the classifications are presented by Margaret Pabst Battin, "Aristotle's Definition of Tragedy in the *Poetics*," *The Journal of Aesthetics and Art Criticism* 33 (1974), Part 1, and 33 (1975), Part 2, 162–65.

16 The very end of the text is corrupted but, as Janko discusses, it is fairly clear that the word "comedy" is included and that Aristotle is proceeding onto it. See his *Aristotle on Comedy* (Berkeley, University of California Press, 1985), esp. pp. 63ff, for the precise reasons and for why the *Tractatus Coislinianus* may be the lost second book.

17 There are actually a few other ways in which diehard supporters of the liaterary view might argue that the *Poetics* is necessarily about literary arts and only literary arts, e.g., by taking mimesis to mean necessarily *literary* representation. I cover these in my dissertation.

18 I. Bywater, *Aristotle on the Art of Poetry*, p. 98. Bywater, however, treats rhythm as meter in Ch. 1, which is a serious mistake for which there is no textual justification in Ch. 1 – rather, meter is treated there as equivalent to λόγος (cf. 1447a22 & b25). Admittedly, meter is said in Ch. 4 to be a part of rhythm (1448b21), which would lead one to think that rhythm could be used interchangeably with λόγος in Ch. 1. But once we see what rhythm really means – and that it is set against verse in Ch. 1 – we will be able to see that Bywater's equivalence is unwarranted. Meters can be part of rhythm because meters are fundamentally physical: think of a simple march, and of the musical and literary forms that might correspond.

Battin presents a diaeresis in "Aristotle's Definition of Tragedy," (p. 167), which, with the possible exception of her interpretation of "poetry-in-general," is satisfactory.

19 Battin, "Aristotle's Definition of Tragedy," (p. 295) says "the order of the differentiae is slightly changed, but this of course has no effect upon the accuracy of the definition." However, this claim ignores the passages from the *Posterior Analytics*, where Aristotle stresses the importance of maintaining the order of the terms in a "strict" division.

James Hutton (*Aristotle's Poetics*, [New York, W.W. Norton & Co., 1982], p. 13, also does not seem to acknowledge the conflict between the definition of tragedy and the *Posterior Analytics* but reaches basically the same conclusion as Battin, explaining away the elements that actually come from Chs. 4 and 5:

> We may surmise that the *diaeresis* of Chs. 1 through 3, which has successfully provided a rational background for the "parts," was set up chiefly for that very purpose. To supply all the *differentiae* that would yield a stringent definition of tragedy, though theoretically possible, would be tedious and impractical ... Accordingly, Aristotle has not scrupled to add to the definition the properties or qualities that are requisite for tragedy.

As we will see, though, the final few differentiae require neither a tedious nor an impractical discussion.

20 The preliminary discussion of the concept of catharsis is missing entirely (*pace* Golden and Hardison, Jr., who discuss the issue on pp. 114–15), which is strong evidence that it was inserted later (perhaps not even by Aristotle). In a forthcoming paper, "Catharsis and the *Posterior*

*Analytics*," I discuss how the inclusion of the catharsis phrase generates very serious, if not fatal, inconsistencies for his own theory in ways apparently not made known before. In any event, the catharsis passage has no significant bearing on the issue of this essay.

For what is, in my view, a profound revision of the typical understanding of the catharsis passage and some of the problems with the traditional reading, see Alexander Nehamas, "Pity and Fear in the *Rhetoric* and the *Poetics*," in *Essays on Aristotle's Poetics*, ed. Amélie O. Rorty (Princeton University Press, 1992), esp. pp. 303–08.

21 *The Argument*, p. 16. Else rejects the "Platonic dichotomy," saying that epic cannot be included in the right-hand division of the first two "cuts' because it has no song, that is, μέλος (p.67). But epic may have music in that it has accompaniment, even if it does not have full song, as is suggested by Book 8, lines 250ff, of the *Odyssey*: the assembled guests must wait while the poet Demodocus gets a lyre before reciting. Moreover, it is extremely doubtful that μέλος means "song" in *Poetics* 1, for it is used interchangeably with ἁρμονία there, just to mean "tune" (cf. 1447a22 and b25).

For some other intriguing connections to biological topics, see David Gallop, "Animals in the *Poetics*," in *Oxford Studies in Ancient Philosophy*, vol. VIII, ed. Julia Annas (Oxford, Clarendon Press, 1990, pp. 145–71).

22 *Posterior Analytics* II 13, 96a24–96b24 and esp. 97b7–39.

23 Plato in the *Republic*, Book III, had used the term μίμησις first as "impersonation" and, then, in Book 10, more broadly as "imitation." In the original sense of "impersonation" it denotes the "miming" or mimicking of movement, posture, voice, etc. For the origin of μίμησις as a full or physical impersonation, see Hermann Koller, *Mimesis in der Antike* (Bern, A., Francke Publ., 1954) in series Dissertationes Bernenses Historiam . . ., fasc. 5.

For a very good discussion of mimesis (with which, however, I am not entirely in accord), see Paul Woodruff's "Aristotle on *Mimēsis*," *Essays on Aristotle's Poetics*, ed. A. Rorty, pp. 73–96.

24 Those commentators who translate, or cash out, ῥυθμός as dance include Pierre Somville, *Essai sur la Poétique d'Aristote*, Librairie Philosophique (Paris, J. Vrin, 1975), p. 15 (Somville actually earlier translates as "rhythm" but then indicates that this means "dance"); M. E Hubbard, translation of the *Poetics* included in D. Russell's *Ancient Literary Criticism* (Oxford University Press, 1972, pp. 85–86; and Andrew Bongiorno, *Castelvetro on the Art of Poetry*: An Abridged Translation of L. Castelvetro's *Poetica d'Aristotele Vulgarizzata et Sposta*, Medieval & Renaissance Texts and Studies (Binghamton, NY, 1984), especially pp. 6–8 and 53–55.

D. S. Margoliouth, working from the Arabic translation, says that rhythm "in this treatise . . . appears . . . applied mainly to the dance," *The Poetics of Aristotle* (London, Hodder and Stoughton, 1922), p. 127. Note

also *Avicenna's Commentary on the Poetics of Aristotle*, annotated translation by Ismail M. Dahiyat (Leiden, E.J. Brill, 1974), p. 71.

Thomas Twining sheds some light – some of it unfortunately refracted – on the basic problems of the passages on dance, *Aristotle's Treatise on Poetry, Translated with Notes* (London, 1789, republished 1972, Gregg International Ltd.), pp. 148–50.

25 Bywater, *Aristotle on the Art of Poetry*, for instance, says rhythm here "is properly "time" or "pace" (p. 103).

26 Some excellent scholars have also missed the correct meaning of "rhythm" because they note that Aristotle says in Ch. 4 that meters are "parts of rhythm" (1448b21), thinking that this must entail that "rhythm" means time-ordering or something similar. However, they miss in Ch. 20 that Aristotle says the elements of language (letters or syllables or words) differ according to the forms of the mouth, aspiration, etc (1456b31), with the implication that language is created by ordering body parts (in movement). Thus for Aristotle rhythm as ordered body movement is necessary for speech, is more fundamental, and can be considered the genus of verse (or, by the way, of purely musical meter). For a recognition of the importance of the oral tradition for the Greeks, see Jaakko Hintikka, *Time and Necessity* (Oxford University Press, 1973), pp. 88ff.

Another explanation for the problem of the meaning of rhythm in Ch. 1 is that the music passage was interpolated later. Arguably, the inclusion of the examples of music in Ch. 1 has confused readers as to the focus of the whole *Poetics*, and once those examples are taken away it is very clear in the first few paragraphs that Aristotle only wishes to focus on the dramatic arts in the treatise. Whether this means that the examples of music were imprudently added (even by Aristotle, who might have attempted to justify the resulting ambiguity because of the greater explanatory value of the broadened notion of mimesis) is a good question. Finally, Aristotle may be using rhythm equivocally in Ch. 1 and in Ch. 4.

27 Aristoxenus, *Fragmenta Parisina*, Cod. bibl. imp. Par. 3027, fol. 33; also in *Elementa Rhymthica, lib. 2*, 3.19 l. 16.

28 *Aristides Quintilianus, On Music – in Three Books*, trans. and comm. Thomas Mathiesen, Book I, 13, 1. 26 (New Haven, Yale University Press, 1983); also pp. 15, 18, and 35. See also, William Mullen, *Choreia: Pindar and Dance* (Princeton University Press, 1982), esp. pp. 3–6, 12, 20–21, 52–53, and 225–28.

29 See Lillian Lawler, *The Dance in Ancient Greece* (Middletown, Conn., Wesleyan University Press, 1964), and Graham McFee, *Understanding Dance* (London, Routledge 1992), especially pp. 285–86.

30 Else gives the reasons in *Aristotle's Poetics: The Argument*, p. 34, and he also deletes the relevant passage in his translation *Aristotle's Poetics* (University of Michigan Press, 1967), p. 16, with accompanying reasons in note 4, p. 80. Daniel de Montmollin to some extent counters Else's

claims in *La Poétique d'Aristote* (Editions Henri Messeiller, Neuchâtel, 1951), pp. 273 and 335, note 259, and my own essay should put Else's related claims forever to rest.

31 1448a19ff. This statement has been the source of much philological controversy, being read either in a bipartite or tripartite fashion. Nothing hinges on this controversy for this article. On either reading, there is no question that Aristotle ultimately identifies tragedy with the type of mimesis involving the agents "acting and doing," and this is all that I need to proceed.

For a discussion of the controversy, see de Montmollin, *La Poétique d'Aristote*, pp. 30–31, and Else, *The Argument*, pp. 91ff. Contrary to many contemporary translators, both accept the tripartite reading. Finally, Paul Woodruff presents some of the Platonic background regarding this controversy as part of his "Aristotle on *Mimēsis*," pp. 78ff. I follow Woodruff by including "sometimes' in brackets in the passage under discussion, as required by the sense of the Greek.

The entire passage is also vexing because of the grammatical function of key terms; see Lucas, *Aristotle's Poetics*, pp. 67–68, for the related reasons.

32 The arts to which Aristotle is referring is under dispute. Some think that he is referring to all the arts, including music, that have been mentioned in the previous two chapters. Woodruff reveals the problem with this latter view, "Aristotle on Mimesis," p. 80. In my opinion, the most intriguing question that results from all of this is not why Aristotle does not care about the purely literary arts, but why he never chooses in the *Poetics* to analyze the dithyramb and the nome, which are also dramatic arts for him. The issue is touched upon in Ch. 1 – the dithyramb and nome involve the three means of mimesis simultaneously, whereas tragedy and comedy use them sequentially (1447b24ff) – but it is hard to see how this would explain Aristotle's omission. My guess is that he drops the dithyramb because it is an "immature" form of tragedy (cf. Ch. 4, 1449a10ff), notwithstanding similar statements about epic.

33 Butcher, *Aristotle's Theory of Poetry*, for instance, translates the passage "[the poet] may present all his characters as living and moving before us."

34 Janko, *Aristotle: Poetics*, p. 3.

35 The words given by Lucas are actually (stated by him to be) a citation from Wellek and Warren; see Lucas, *Aristotle's Poetics*, p. 69.

36 Translated by Paul Shorey, Loeb Classical Library (Cambridge, Mass., Harvard University Press, 1956).

37 Of course, because of a change in conceptual framework, Aristotle may have modified the signification of the manner of mimesis. But then Aristotle would presumably have taken some pains to note the difference.

38 Aristotle, *The Art of Rhetoric* (London, W. Heinemann, 1926).

39 Eric Csapo has actually questioned in discussion whether the Greek can mean that plays were written only to be read, and naturally I would be attracted to his view. Nevertheless, I accept Freese's translation for the sake of argument.

40 James Hutton, *Aristotle's Poetics*, p. 103.

41 These six elements, including spectacle, are introduced as such for the first time in Ch. 6. Curiously, Richard Eldridge says, in "How Can Tragedy Matter for Us," *The Journal of Aesthetics and Art Criticism*, vol. 52, 3 (Summer, 1994), p. 287 that "Chs 1 to 5 of the *Poetics* survey the form or structure and the matter of tragedies, including plot, character, thought, melody, diction, and spectacle." Such a statement, though, suggests a casual reading on Eldridge's part.

42 The term λέξις is often translated as "diction," but this is too narrow for a number of reasons. Suffice it to say here that because the elements of the definition have come from the previous chapters, λέξις must be synonymous with the means of mimesis listed in Ch. 1, which was "language" there (λόγῳ at 1447a22 and μέτρῳ at 1447b25).

43 For instance, Kosman says ("Acting," p. 57): "The mimesis ... is said to be accomplished in "sweetened" language, by which Aristotle explains he means language such as we might call *poetic* language."

44 Lucas, *Aristotle's Poetics*, p. 98.

45 Richard Janko, *Aristotle: Poetics*.

46 Actually, Else has doubted it, and tried to make spectacle part of the language (as have Golden and Hardison, *Aristotle's Poetics*). Else says:

> notice that [in speaking of the presentation of a drama as an action performed by (dramatic) persons] I say *"persons,"* not "actors"; for the point at issue is not performance on a stage, by living actors, but a feature inherent in the drama as such. (*The Argument*, p. 234)

Else stresses that it is the "concept" of the character, not the character that we see in real-life performance, that is important, and he goes on to treat *elements such as dramatic form and spectacle (ὄψις)* as part of the literary expression. But to use spectacle in this way is utterly bizarre and to adapt Aristotle's saying, Else is holding onto an argument no matter what the cost. Proof of this is Aristotle's own statement in Ch. 24 that "tragedy will not permit simultaneously the representation of many parts of the action, but only the one on stage (ἐπὶ τῆς σκηνῆς) involving the actors" (1459b23–26). If the character, form, and spectacle were only conceptual or literary aspects, tragedy, like epic (or modern novels), would not be constrained in terms of the temporal sequence of the scenes.

47 The inflected form δρώντων stems from δρᾶν, and δρᾶν and πράττειν are, respectively, the Dorian and Athenian words for "to act" (Ch. 3, 1448b1). Even according to Else, the term δρώντων is a formulation of the principle espoused in Ch. 3, and "seems to represent the germinal idea of 'drama'" (*The Argument*, p. 224).

48 Cf. *Metaphysics* VII 4, especially 1030a1ff, and *Posterior Analytics* II 10

& II 3, especially 90b23. For the doctrine that essential properties are more important than "accidents," which may or may not be life-long, see *Topics* I 5, and that essential properties exist necessarily, see *Posterior Analytics* I 4, 73b24.

49 According to Twining, *Aristotle's Treatise on Poetry*, p. 244, the Abbé Vatry, in *Sur la recitation des Tragedies anciennes*, "undertook to prove ... that the Greek Tragedies were *sung* ... like our operas," and my conclusion might be taken to support Vatry's view. However, we need only re-examine the second condition of the diaeresis of tragedy, that the means were employed sequentially, to realize that the song was employed only intermittently (normally, we may gather, by the chorus). This is one of the reasons I suggested that Aristotelian tragedy is closest to the serious Broadway musical in "look." For one account of the development of modern opera, and its relation to ancient drama with music and to the medieval and Renaissance practices that were closest to it, such as the Sacre Rappresentazione, see "Opera," *The International Cyclopedia of Music and Musicians*, vol. 2, 11th ed., ed. Oscar Thompson (New York, Dodd, Mead & Co., 1985).

50 Bywater, *The Basic Works of Aristotle*. p. 1462.

51 Hutton, *Aristotle's Poetics*, p. 90.

52 In Hesychius' *Lexicon* [equals Suda and Photius], s.v. *nemeseis hypokriton*, it is said:

> The poets used to get three actors (ὑποκριταί) assigned by lot to act the dramas. Of these the winner was entered in the competition of the following year, bypassing the preliminary selection.

This suggests that the ὑποκριταί were, if not professionals, then of the calibre to be used in the best competitions.

53 *Tragicorum Graecorum Fragmenta*, Vol. 4, Testimonia no. 1, lines 27ff, *Life of Sophocles* (Istros was active in the mid-3rd century BC).

54 My emphasis, Hutton, *Aristotle's Poetics*, p. 96.

55 1462a11ff. "Effect" is presupposed: that ποιεῖ τὸ αὐτῆς implies "effect" (or "work" or "function" or something similar) is supported by many other instances in the corpus. Note *De Caelo* III 4, 302b23; *Rhetoric* III 10, 1410b15 and III 12, 1413b18; and Alexander, *Aristotelis metaphysica commentaria* 79, 6. I owe this point to Janko.

56 Plato has ranked the arts on at least two occasions. In the *Laws* II (658D), he subscribes to the view that the reciter of the *Iliad* triumphs over tragedians. In the *Republic* III (397D), either epic or the dithyramb is best.

57 Ch. 24, 1459b9–10. Also see note 60.

58 See Lucas, *Aristotle's Poetics*, p. 254.

59 So those, like Lucas, who are disposed to literary interpretations, and who attempt to argue that the phrase in question means "having some (gestural-)movement is not inherent in tragedy," have missed the precise sense of Aristotle's argument.

60 See Ch. 5, 1449b16ff; Ch. 26, 1462a14–15.

61 "Action is movement" (ἡ δὲ πρᾶξις [ἐστί] κίνησις) (*Eud. Ethics* II 3, 1220b26).

62 Ch. 14, 1453b3–10, is sometimes cited (e.g., by Goldschmidt, *Questions Platoniciennes*, p. 112) but that passage is easily handled by the kind of arguments I have given.

# The "confessing animal" on stage

authenticity, asceticism, and the constant "inconstancie"
of Elizabethan character

PETER IVER KAUFMAN

I

For persons persuaded by the rhetoric of sixteenth-century religious reformers, authenticity was a complex matter of access to the reality of divinity. George Levin's paper on empiricist "habits of mind" seems a strange place to start elaborating on that observation, for such "habits" look to be worlds apart from what I study, the sixteenth-century Calvinist adaptations of patristic and medieval ascetic spirituality. Yet Levin maintains that he has identified empiricism's near-ascetic techniques. "To know nature," he claims, "one must make it alien ... and deny one's own desire." If he is correct about "the programmatically self-alienating" character of "the positivist model of knowledge" and about the empiricist assumptions it extends and refines, then perhaps asceticism, Calvinism, empiricism, and positivism someday will file companionably through sweeping histories of the human imagination. If he is correct, that is, and if the historians of that someday are still reupholstering old ideas and long-standing "habits of mind." I cannot pronounce authoritatively on the first condition and am only slightly tempted to guess about the second. Not so George Levin, who crosses cavalierly from self-alienation to self-annihilation, sure that "the religious/moral implications of that tradition of self-annihilation continue to thrive in the practice of science and the language of the social sciences."[1]

"That tradition" interests me as it does a small army of others who are fascinated by the alienation and alleged self-annihilation on the Elizabethan stage. Obituaries in scholarly journals announce the death by disintegration of "Renaissance man." Possibly the same passion for denial and deconstruction that prompted them also

influenced Levin. To be sure, it has generated a number of intriguing studies of late Renaissance, specifically Elizabethan, culture. They are undeniably and wondrously provocative, but are they sound?[2]

*Hamlet* is a favorite hangout. Annihilators lingering there say that scripted hyper-reflexivity left (and leaves) performers no choice but to dramatize disintegration, to document the loss or absence of the protagonist's unified sense of self. In what follows, I hope to restore choice and to suggest a contextually sensible alternative to soliloquacious self-cancellation. True, Hamlet casts off Elsinore's "inauthentic exterior"; true, he seems to want to cast off from the roles assigned him: dutiful son, lover, avenger. Also true, his efforts to probe conscience, intention, and character were ultimately unsuccessful efforts to constitute them. But must we therefore agree with Francis Barker that "at the center of Hamlet, in the interior of his mystery, there is, in short, nothing," that sincerity and authenticity were simply what idealist critics projected on the characterless character set before them?[3]

Bert States recently scolded the scholars who dwell on dissolution, who sense that a character's pelting self-criticism leaves nothing at the center. States suggests that colleagues of that stripe misunderstand "the art of dramatic characterization."

In my experience, most "modern" protagonists from Hamlet through Camus's Caligula spend much of their time wondering who they are while undergoing the agony of disillusion and loss of self ... lead often to madness or suicide. But to assume the character-entity that does all this wondering and agonizing doesn't project a more or less continuous and reliable personality, in most cases, at least, seems a remarkable confusion of the qualitative persistence of behavior, on the one hand, and identity as an immutable essence (whatever that may be) on the other. The consequence of throwing personality out with the bath water of identity is that we are left with nothing human to talk about and criticism becomes an excursion into pure textuality and the perils of signification.

The point is well taken, but if only because nimble annihilators could conceivably celebrate as an interpretive advance precisely what States sees as "a remarkable confusion" and that "excursion into pure textuality," a *con*textual perspective seems advisable. We will listen to the devotional performances of the late Tudor Calvinists to learn how their "soliloquies" deploy disintegration in the regeneration of character.[4]

## II

Faith, grace, justification, salvation: all were given by God to the undeserving rather than earned and accepted as the rewards for virtue. Any synopsis of Calvinist – for that matter, of Protestant – doctrine would have to make that point clear. For Calvin and for reformed orthodoxy, human righteousness was a fiction. It was widely assumed, to be sure, and the assumption that righteous men and women needed only occasional instruction to climb to heaven underwrote much of Roman Catholic polity and practice, according to Rome's reformed critics. John Calvin countered, as had Martin Luther, Martin Bucer, and Huldrych Zwingli, that only through the faith that Jesus atoned for their sins – a faith given them and not achieved by them – could sinners cling to an imputed or "alien" righteousness. The Calvinists had learned from the apostle Paul (Romans 11:32) that they and all others were irrepressibly wicked. They had nothing to show for themselves or to offer God, save their insolvency and insolence. Better by far, then, to contrive no excuses, to confess personal and pervasive depravity, to accentuate the negative, and to turn inward, becoming intimately acquainted with the sordid and sorry self that God sees and pardons. Better by far, that is, to play their bad hands than to bluff, because absolute disgrace, Calvin confirmed, led to religious knowledge. Without a profound sense of their dreadfully depraved characters, the faithful would not be able to comprehend the immense mercy of God.

Calvin commended self-examination and self-criticism. Reformed Christians must confront their utter insolvency and ardently regret their "emptiness," he counselled. They should be "consumed," "swallowed up" by disgrace and despair. Seventeenth-century spiritual autobiographies of several prolific English Calvinists seem to have plumbed the shallows and raked the muck, probably more than Calvin would have wanted. They are well known, often studied. But recently Tom Webster re-catalogued that "ego-literature" and discovered that the ordeals of self-criticism, variously described by Calvin's English admirers as "stripping," "ripping," "battering," and "beating," colored an assortment of devotional manuals, pastoral letters, books, "lean-to lives" appended to funeral sermons, and commonplace books, all the narratives that charted the way that faith in Jesus's atonement issued in assurance of salvation.[5]

Readers and auditors were told or shown how to dramatize "godly sorrow" for their sins. William Perkins, the most widely read

Calvinist of his generation and for many years thereafter, preached often in Cambridge from the late 1580s to his death in 1602. He was intent on turning the faithful from spectators into performers, and, to that end, he stressed the difference between "unfeigned repentance" and "feigned righteousness." God, he said, would not allow the latter to pass. Humanity was too keenly aware of its wretchedness to keep up the act, ashamed of its outlandish transgressions of God's laws and, less daring perhaps but no less serious and self-important, its remorseless and "ever repining at [God's] arrangement of human affairs." On the other hand, Perkins knew that "unfeigned repentance" was the one chance to turn shame and disgrace into assurance of election and salvation. Agonizing self-analysis was not just an occasion to apprehend the immensity and gratuity of divine mercy. It also attested the analyst's (and analysand's) standing "in the estate of grace." By all accounts, the elect were unlikely to be assured instantly. But questioning or doubting their standing was the very same as reconfirming it. So Perkins required reformed Christians to "feele continually the smart and bitternes of their owne sinnes." "Unfeigned repentance" unsettles, he said, and "the meanes to attaine to the sight of sin is by a diligent examination of a man's owne selfe ... which ransacketh the heart to the very quicke."[6]

To illustrate, Perkins staged an encounter between a pastor and parishioner. The latter had just learned of the magnitude of his offenses and consequently began to doubt the sufficiency of his faith. He feared that God had rejected him, and the more he tried to assure himself, the more achingly he was assured of his damnation. Yet Perkins's pastor put a very different spin on the parishioner's despondency; for faith "feeleth many doubtings and waverings," the pastor interjected, "even as the sound man feeles many grudgings of diseases, which if hee had not health, he could not feele." Shrewdly put, but the parishioner's doubt, fears, and general dis-ease persisted. The pastor seemed unable to comb away snags and suspicions, and the impression that Perkins wanted it that way is not without warrant. "Sighes" and "groans," the author editorially pronounced, were indispensable constituents, reliable symptoms of one's assurance of election. However many hours the elect logged in self-analysis and in conference with their pastors, the dis-ease hung on and ought not to be wished away because "the perfection of a Christian man's life stands in the feeling and confession of his imperfections," in his feeling "continually the smart" of his sins and self-reproach.[7]

Katharine Maus lately revisited William Perkins's theological anthropology, claiming interiority was increasingly important to him even as the late Renaissance was generating misgivings about the extent to which one could say anything definite about inner reality. For Perkins, she went on, "subjectivity becomes part of the proof of God's existence" and "the structure of internal experience is thought necessarily to imply observation by a divinity." Individuals were objects of what Maus calls "double scrutiny." Others saw fallibly and superficially; God watched infallibly and with penetration. The problem that obsessed the prolific Perkins, however, was self-analysis and the difficulty of devising indispensable techniques of meditation, "excavation," and introspection to enable the faithful to perform, as well as to understand, the dramas of their "unfeigned repentance."[8]

A few unrestrained Calvinists made spectacles of their self-reproach. Until he met William Hacket in 1590, Nicholas Copinger importuned leading Calvinist divines at every opportunity to ask whether God's work in conscience may not be accompanied by signs and wonders. Hacket was the answer he was looking for, because Hacket's virtuosity in prayer and self-recrimination proved to him that God still worked miracles. So Copinger coaxed friends, acquaintances, and strangers in the streets of London to follow him to Hacket's lodgings and hear the miracle of Hacket's prayer and prophesy. Job Throckmorton complained that Copinger just about dragged him to performances where Hacket "used many ... ohes, loude sighes, and groninges." The prayers, Throckmorton said, were not "squared after the rule of knowledge"; each was "like the wildgoose chase, [with] neither head nor foote, rime nor reason." And each prayer was "stuffed and interlarded with sundrie bitter imprecations." Hacket raved against himself: "let vengeance consume me"; "let the earth open and swallow me." Perkins probably would have cringed and thought the performance "feigned." Copinger was obviously and absolutely enthralled. Throckmorton let on to authorities that he had been appalled.[9]

After Copinger and Hacket staged an impromptu public demonstration and were charged with treason, Throckmorton strenuously tried to dissociate himself from that fanatical fringe of the reform party. For when Copinger recruited Henry Arthington, the ecstatics' belligerence increased. Arthington even challenged Archbishop Whitgift to "a combat of praier," which should, he said, be staged in the queen's presence,

wherein ... I will first begin to pray against my selfe that if he be not as deeply guiltie as I have charged him [Whitgift], then that God's vengeance may presently consume me, both body and soule into hell for ever ... But if he see me leape up for joy as one that discovered him to be a traitor, then, if he dare fal down in like sort and make the same praier, that the like vengeance may fal upon himself if he be so deeply gilty as I have charged, and if God's vengeance fall not upon him before he depart out of her presence, let me be hanged, drawn, and quartred for laboring to empeach a counsellor's credit.[10]

Calvinists more openly devoted than Throckmorton and Perkins to the prevailing ecclesiastical order caught the scent or stench of sedition in "extraordinarie gifts" and derided the dissidents' "dexteritie in conceiving extemporall prayers." Richard Cosin did not accept a plea of insanity, claiming at length that Copinger and Hacket were revolutionaries. Cosin probed Hacket's past with the tenacity of an investigative reporter. He published accounts of "trayterous imaginations [and] compassings," as if informants were all along reporting on the "conspiracie." (Henry Arthington did, in fact, "turn state's evidence," so to speak, though only after his associates had taken to the streets and were caught.) Matthew Sutcliffe branded the dissidents "new upstart divines," preferring, he said, that they not pray at all rather than pray so extravagantly. Sutcliffe added that he had come across pared-down versions of the ecstatics; he saw "like disorder" and heard "like outcries" in a number of churches: "people upon very small occasion, yea upon no occasion, will take upon them suddenly to powre forth ... prayers, scarce knowing the difference betwixt Christian praying and bitter cursing." Cosin agreed, noting that "execration against oneself" widely passed as "a noble vertue" and as "a matter of rare zeal."[11]

Little is left of the performances that annoyed Sutcliffe and Cosin. Impromptu, unscripted prayers, for obvious reasons, have not survived. All we have is the evidence of contemporary disagreements between reformers and critics like Cosin. Hacket was an extreme case. He seems to have been less interested in argument than in performance. Unconcerned with the proprieties and deportment that mattered much to Sutcliffe, he prayed with abandon and stormed heaven with his sins. He prayed from the scaffold, warning God that if he were denied redemption he would "fire the heavens" and even "teare thee from thy throne with my hands."[12] Other, more moderate reformers, defended the "extemporall" and claimed that set or scripted prayers were no prayers at all. Prescribed prayers, they said, were "stinted"; scripts prohibited energetic self-analysis. John

Greenwood, for example, contended that it was impossible to examine oneself and give voice to one's sorrow with sentiments and supplications one borrowed from books. Yet George Gifford answered that the words of others often prompted a "deeper sighing and sorrowing" than the "frantike" prayers of independent, arrogant Christians who "imagine they knowe more than all the churches of God in the earth." Gifford, Greenwood's colleague in the Essex ministry, persuaded himself that the advocates of "conceived," impromptu prayer, if they had their way, would substitute bedlam for the harmony of interests enshrined in set liturgies.[13]

For all that divided Gifford from Greenwood – and both from Hacket and Copinger – one could say that they formed a very loose federation on the left of the reformed ranks. They required that standard ascetic themes be prayerfully – and publicly – performed. There was no scriptural warrant for confining contrition to the confessional, they said, no closets alongside the Jordan River, where sinners confessed and were baptized by John (Matthew 3:6) and no secrecy at Ephesus, where the sorcerers confessed to the apostle Paul and burned their books "in the sight of all" (Acts 19:18). Perkins repeated Paul's wishes, "I desire that in every place the men should pray" (1 Timothy 2:8), and argued that all "religious distinction of places" be "abolished." Neither those closets (confessionals) nor even churches should be considered the required rigging for remorse. Assurance of election was on offer wherever the faithful performed their rituals of self-examination or "descents," as Perkins referred to them.[14]

"In every place," he said, but not at any time. Moderate Calvinists tried to control prayer, in part, by placing it in tandem with preaching. The prayerful self-evaluation and self-incrimination that authenticated election followed sermons and, Henry Smith proposed, showed how well the preachers' doctrines were "digested." William Harrison independently developed the same simile, memorably describing prayerful self-inventory as mastication, as chewing a wholesome cud, privately retrieving and re-preaching what had been heard from the pulpit so that lessons might "work more effectually upon emotions." Preachers were told to get sinners to fret about their "estates," to "ransacke" and "rippe" the wicked self, fashioning "godly sorrow" and a better self, to boot. "Rebuke them sharply," the apostle Paul advised (Titus 1:13), advice that Calvinists explained with some care, for the purpose was not to make parishioners "live like pettie angels [who had] dropped out of the cloudes."

Instead, sermons were to work on auditors' consciences to sustain "good motions," which Richard Greenham defined as "a sweet disliking of sinne" and "an irking of ourselves for the same." The "irking" and a correspondent dis-ease were expressed in prayer. But Greenham knew that soul-searching infrequently followed even the finest sermons, wherein God, with the preacher's indictments, "commeth downe into the church, as it were, among us,"

and when we pray, we mount up, as it were to heaven, among the angels. . . . Fools thinke they have done well . . . never preparing their hearts or examining their owne wants. But we must learn truly to search our selves. . . . For, alas, what precious seede is cast on the high wayes side because by meditation it is not laide up, but the devil is suffered to come and steale it from us? To what end is the word, if we live not according to that which we have learned, if every man shall enter thus unto himself: O Lord, how many sermons have I heard, but how little I have profited by them? How long have thy ministers preached, but how slenderly have I practiced?[15]

Prayers "laide up" the seed. The best prayerful performances exhibited near operatic remorse for evildoing and doubt, for that "remnant of unbeleefe which yet hangeth upon us." It was patently unnatural to despair of nature's ways, namely to regret one's sin and skepticism. Therefore, to "complaine of lumpish, earthly, and dead spirits," as Greenham obliged, was to show the leaven in the lump and to confirm that the complainants were neither altogether earthly nor dead. While William Perkins taught a few miles away in Cambridge, Greenham preached a few sermons each week through the 1580s in the village of Dry Drayton. From both lectern and pulpit, then, reformed Christians heard the same message, the "most righteous are their own greatest accusers."[16]

### III

For three acts and into the fourth, Hamlet does little but accuse himself. He complains about his delinquency, grumbles over his predicament, to a point, at which we may be excused now and then for expecting him angrily to quit his play. But he stays and manages to keep most theatergoers in their seats. Shakespeare mastered the challenge that baffled many other authors of revenge drama: he got his play and protagonist from injury to retaliation without losing audience interest. Hamlet is what Greenham would have called a "lumpish" character, but there is much leaven in that lump. Hamlet rises to each occasion, but his every rise follows and precedes a fall.

One might say that the alternating spasms of desperation and resolve supply the play's suspense and entertainment. Unlike Hamlet, Thomas Kyd's Hieronimo stews for a short time ("I will rest me in unrest"). The playwright got his *Spanish Tragedy* from first crime to last by posting a number of murders along the route.[17] Violence in *Hamlet* holds interest as well. Meddling Polonius is stabbed. Rosencranz and Guildenstern are executed offstage. But the violence is eclipsed by Hamlet's self-analysis and self-accusation, which sprawl across the play, assessing the meaning of action, virtue, intention, and identity in an imperfect world.

Hamlet's ups and downs, punctuated by those soliloquacious assessments, are now taken as symptoms of identity diffusion or dissolution. Historians of subjectivity think the destabilizing unprecedented, but I believe David Aers is right: that novelty, in the eyes and arguments of the beholders, attests "one of the most monumental pieces of amnesia in the radical histories of the subject."[18] Aers specifically refers to an Augustinian tradition of inwardness that cultural historians apparently have forgotten or overlooked. Their late sixteenth century looks new because the medieval centuries look flat and uninteresting to them. Petrarch, for instance, is seldom sited within reach of the early modern subject. And students of Hamlet's soliloquies seem not to have factored the influence of Augustine's fourth-century *Soliloquia* or other sources to which Richard Rogers appealed when he called Calvinist meditations "soliloquies" in treatises published early in the seventeenth century. Rogers mentioned similarities between Calvinist "soliloquies" or "intermissions" and Cicero's sessions, wherein the orator typically and temporarily retired from public life to reflect on public virtue and public service. But Rogers also noted a colossal difference: reformed Christians, heirs of Augustine, pondered weightier, personal matters, contemplating salvation and their "inconstancie, weaknesse, and wavering" in response to God's love. Calvinists' soliloquies, therefore, were not sanctuaries for afflicted souls. Instead, their intermissions were miniature revenge dramas, for puritan preachers spoke about complaint and self-criticism as revenge. Roger Fenton suggested that Catholic confessors required too little and were satisfied with "sleight humiliation" and "small griefe." He told reformed Christians to "work revenge upon [them]-selves for offending such a gracious God." Their soliloquies must be ordeals, as profoundly disorienting as Augustine's in the *Confessions* yet as informative and therapeutic as his *Soliloquia*.[19]

Did Hamlet's soliloquies resemble those commended to English Calvinists? He brooded about "human inconstancie, weaknesse, and wavering" for over four acts but without any idea or intelligence of God's love. And he was oddly unrepentant, expressing little regret for dispatching Polonius and less for having Rosencranz and Guildenstern done to death, "not shriving time allowed." Indeed, Hamlet confided in Horatio that the sad fate of his former friends was "not near my conscience" (5.2.58). No wonder, then, that a number of contemporary critics shut their gates to the prince of Denmark. They think him cruel and selfish, possibly spry but befuddled and sick, at best. All agree that he is angry. He learns immediately after his mother's wedding to the murderer that his father's death had been no accident. Her remarriage and the apparently counterfeit character of the newlyweds' grief for his father, their "seeming," sicken him. One might imagine him hurling La Rouchefoucauld's maxim into the wedding festivities: "nothing so much prevents our being authentic as our efforts to seem so." Instead, he soils his slate at the start, strenuously protesting his authenticity, "I know not seems" (1.2.76).[20]

Protests of that sort, geyser-like eruptions of passionate discontent, periods of sullenness and self-absorption: symptoms such as these were frequently found in diagnoses that had little to do with drama or divinity. A major medical publication of the time, Timothy Bright's *Treatise of Melancholie*, distinguished an anguished response to corruption from the moods of melancholy, asserting that medical discourse only suggested natural causes for the latter "that hath no sufficient ground of reason." For Bright, anguish was not illness and dis-ease was not disease. Though Elsinore might consider Hamlet a melancholic, a misfit, muttering unintelligibly to and about himself, playgoers heard the soliloquies as extended asides, betraying an anguish which had "sufficient ground of reason," what William Perkins termed the soul's "proper anguish." One could argue that "sufficient ground of reason" for Hamlet's anguish was the ethical dilemma posed by the directive he received from the ghost to avenge his father's murder. But I am persuaded by James Calderwood's fine study of Hamlet's delays to extend that "ground of reason" far enough to cover the protagonist's encounter with the riddling prospect that any and all action contaminates character, that action necessarily implicates character in a corrupt world and compels actors to trade worthy intentions for unforeseen, usually unwanted, consequences. Hamlet, then, looks to be "undergoing the

agony of disillusion," as States acknowledged, but the Dane's is a reliably principled dissent, and indeed a "descent" inward, as Perkins and other Calvinists mapped it, to locate the source of his principles.[21]

> Sir, in my heart there was a kind of fighting
> That would not let me sleep. Methought I lay
> Worse than the mutinies in the bilboes. Rashly
> And praised be rashness for it – let us know
> Our indiscretion sometimes serves us well
> When our deep plots do pall, and should learn us
> There's a divinity that shapes our ends,
> Rough hew them how we will.

(5.2.4–11)

The final lines seem to nod more or less acquiescently to the Christian doctrine of providence. Hamlet's stoic companion Horatio possibly heard more Cato than Calvin there, but related remarks unmistakeably allude to the Christian scriptures, to "a special providence in the fall of a sparrow" (5.2.208–09). As for the first lines, they have only recently been related to the puritans' prayerful performances. And it is proper to do so, for Richard Greenham stipulated in no uncertain terms that "amongst the many testimonies of our estate in grace and favour with God, there is none more evident than is that conflict which we find and feele in ourselves." Whether one referees Hamlet's "kind of fighting" or reviews the "conflict which we find and feele" in puritan "descents," narratives of intrapsychic struggle seem to suggest self-catharsis rather than self-cancellation.[22]

The possibility that *Hamlet* was camouflaged Calvinism has not been and ought not to be taken seriously. I started out to restore an important part of the play's environing culture, to attend to soliloquies in the play and in the devotional dramas scripted by the more "advanced" English Calvinists during the last decades of Elizabeth's reign. I learned that the puritans bred a new strain of what Foucault had called "the confessing animal" and that they circulated instructions for staging its recuperations. The plural is appropriate because, as reformed Christians understood, every recovery was complicated, requiring repeated effort. The faithful were ceaselessly tempted to barter heavenly reward for worldly success. "Lord, how will we labour, toile, travel, go, run, ride, speake, sue, and sue again," John Stockwood exclaimed in a London sermon delivered nearly twenty-five years before Shakespeare gave *Hamlet* to the Globe. As for the preacher's antidote to the obsessions of his parishioners, Stockwood

commended what Richard Rogers later recognized as a soliloquy or
"intermission": "let us therefore enter deeper into a consyderation of
our selves and into a thorough examination of our owne soules and
consciences."[23] Stockwood's "consyderation" was relatively tame
and typical of the 1560s and 1570s. Had the self-scrutiny of Hamlet
been scripted and staged at that time, perhaps the performances
would have been less turbulent. For in the early decades of Eliza-
beth's reign, calls to prayer yielded no sense of the tolls that Phillips
(torment), Fenton (revenge), Greenham (conflict), and Perkins (des-
peration and misery) hoped that prayerful self-examinations would
exact. But the demands on prodigal sinners intensified during the
1580s and 1590s, and we need not search far for the explanation.
Church and government officials were increasingly successful in
stifling radicals' initiatives to reform discipline more thoroughly; as
radicals realized that their petitions and admonitions were unlikely
to move the authorities to scrub their churches of such "Catholic"
accretions as episcopacy, they turned instead to scrub the slums of
their souls. They turned inward, that is, with a vengeance.

I already agreed with David Aers: this inward turn marks no
sudden, sensational change. Still, the change I identified above and
located in late Tudor religious culture affected perceptions and
performances of subjectivity. Granted, "we need to write a 'history'
which does not know, before the exploratory work has been done,
that there was a totally new and far greater sense of 'interiority' in
1600 than in 1380 or 1400."[24] But we also need to know that
devotional literature during the 1580s and 1590s consistently inter-
iorized the drama of deliverance. The aim was to reconcile the
irresistibility of grace with the "inconstancie and wavering" experi-
enced by the elect. Calvinists learned that God only appeared to
forsake the faithful, who only appeared to fall from grace. The
ordeals of the elect were signs of God's presence and favor. Doubts
and despair about "inconstancie" were therapeutic. They thumped
the conscience, Perkins warranted, "to quicken and revive" "the
hidden graces of the heart."[25]

"Hidden graces" is a suggestive phrase; it connects English Calvi-
nist or puritan pietism to the confessional autobiography of an
earlier age, to Augustine's *Confessions*, to name the specimen most
often cited. For Augustine was also sure that God chastened to
strengthen and hid to be found. Reformed Christian soteriology
seemed to gravitate toward late antiquity, if only to distinguish the
personal consequences of its exegesis from those of Catholic,

unreformed practice. Even now some scholars advance distinctions that the Calvinists could have sanctioned. Medieval exegetes read the Bible, according to Barbara Lewalski, to discover what to do, whereas reformed exegetes read the Bible to discover what God was doing in, and for, them and only then to "assimilate [themselves] into God's typological design." The elect were unfaithful; Israel was unfaithful. They were reclaimed and rededicated as Israel was reclaimed and recovenanted. The psalmists' sorrows became sorrows of the late sixteenth-century prodigals. Patriarchs', prophets', and apostles' struggles were the struggles of the elect as well. When they read of patriarchs, prophets, and apostles submitting to God's will, the elect sought an identical outcome. And the lesson to be derived from Jesus's question from the cross was that the inconstancy of the elect authenticated their election. Puritans read about despair and doubt in the Scriptures and in the diaries and journals they kept to repossess and recapitulate their experience of assurance. It could be said that the English Calvinists performed their perseverance whenever they revisited and revised their journals, the material sites of their self-fashioning.[26]

Puritans reread to reenact. At prayer, they improvised or recited from scripts to recover assurances of their election. In consequence, devotional practice, much as theatrical performance, served as "a vehicle of inward change."[27] Elizabethan Puritans, as petitioners, were unlikely to assume that their prayers would change God's mind and their destinies. Changes of that kind were inconceivable, given what preachers of their "practical divinity" said about the prevenience and finality of divine design. No, the puritans prayed to change themselves, and Huston Diehl now claims that by staging a "distinctly puritan habit of mind" in *Hamlet*, William Shakespeare was looking to change more than the antics of his actors. "In privileging interiority and self-reflexivity over the theatrics of the court and the spectacle of earlier modes of drama," Diehl says, "Shakespeare explores the potential of the stage to reform his spectators."[28]

Perhaps so, but I am less concerned with the playwright's explorations than with the "descents" of his Calvinist cousins, and I am interested in affinity rather than in influence. Those "questions of theatrical or intellectual influence in the narrow sense," as Katharine Maus put it, seem less fascinating (to Maus and me) than "questions about the general disposition of early modern culture." Puritans' preoccupations with and performances of "inconstancie" memorably, if not also comprehensively, yield information about that

"general disposition" and thus about the spread of Hamlet's "kind of fighting."[29]

Do puritans' preoccupations and performances suggest stage directions as well? Hamlet's soliloquies are occasionally played as prayers, as abstracted and nearly absent-minded asides rather than as a cathartic "kind of fighting" – one learns as much from that colossal catalogue of performance alternatives compiled in 1992 by Marvin Rosenberg, and one discovers that there has been startlingly little theatrical interest in the *echt* Hamlet, that is, in a performance's plausible reconstruction of the original. Indeed, playgoers have come to expect militant anachronism, and much of it is marvelously done. But should impresarios rally to summon the Elizabethans' Hamlet from the hinterlands of history texts, if trends continue, they may be left with decentered and detached or disoriented Danes, and playgoers will have to settle for melancholic protagonists droning soliloquies in voice-overs. My vote goes to Stanislavsky. He knew nothing of the Calvinists' prayers, but he discountenanced undemonstrative Hamlets, stating his preference for "passionate and intensive self-searching" and for soliloquies "full of anxiety and exaltation."[30]

## NOTES

1 George Levin, "By Knowledge Possessed: Darwin, Nature, and Victorian Narrative," *New Literary History* 24 (1993), 369–73.

2 See Francis Barker, *The Tremulous Private Body: Essays on Subjection* (London, Methuen, 1984); Catherine Belsey, *The Subject of Tragedy: Identity and Difference in Renaissance Drama* (London, Methuen, 1985); Jonathan Dollimore, *Radical Tragedy* (Chicago: University of Chicago Press, 1984); *idem*, "Desire is Death," in *Subject and Object in Renaissance Culture*, ed. Margreta de Grazia, Maureen Quilligan, and Peter Stalleybrass (Cambridge, Cambridge University Press, 1996), pp. 369–86; Franco Moretti, *Signs Taken for Wonders: Essays in the Sociology of Literary Forms* (London, Verso, 1983); and my *Prayer, Despair, and Drama: Elizabethan Introspection* (Chicago, University of Illinois Press, 1996), particularly pp. 32–36, 107–11. "Inconstancie" extends the argument of *Prayer* and addresses the issues raised in the literature that subsequently came to my attention, notably the work of Bert States, Katharine Eisaman Maus, Huston Diehl, Tom Webster, David Aers, and Ramie Targoff.

3 Barker, *Tremulous*, pp. 35–37; and Moretti, *Signs*, pp. 70–72.

4 See Bert O. States, *Hamlet and the Concept of Character* (Baltimore, Johns Hopkins University Press, 1992), p. 202 and, for the theatricality of

Calvinists' devotions, Ramie Targoff, "The Performance of Prayer: Sincerity and Theatricality in Early Modern England," *Representations* 60 (1997), 55–58.

5 Tom Webster, "Writing to Redundancy: Approaches to Spiritual Journals and Early Modern Spirituality," *The Historical Journal* 39 (1996), 35–36. Quotations are drawn from Calvin's *Institutes of the Christian Religion* 3.14.5 and 4.16.30, accessible today in John T. McNeill's edition, 2 vols. (Philadelphia, The Westminster Press, 1977), and accessible to Elizabethans in several editions, for which see *A Short-title Catalogue of Books Printed in England, Scotland, and Ireland and of English Books Printed Abroad*, ed. A.W. Pollard and G.R. Redgrave (London, The Bibliographical Society, 1986), pp. 195–96.

6 William Perkins, *A Treatise tending unto a Declaration whether a Man be in the Estate of Damnation or in the Estate of Grace*, in *Works*, vol. 1 (London, 1616), pp. 364–65; *idem*, *A Golden Chaine* (London, 1591), sigs. Q5v–Q6r; and, for "every repining," Alan Sinfield, *Faultlines: Cultural Materialism and the Politics of Dissident Reading* (Berkeley, University of California Press, 1992), pp. 152–59.

7 Perkins, *Treatise*, pp. 409–13.

8 Katharine Eisaman Maus, *Inwardness and the Theater in the English Renaissance* (Chicago, University of Chicago Press, 1995), pp. 8–11.

9 See *The Defence of Job Throckmorton against the Slaunders of Maister Sutcliffe* (London, 1594), pp. 3–7.

10 Arthington's challenge is quoted by one of Whitgift's former students, Richard Cosin, in *Conspiracie for Pretended Reformation* (London, 1592), pp. 64–68. Also see Matthew Sutcliffe, *An Answer unto a Certaine Calumnious Letter* (London, 1595), fos. 62v–64r.

11 See Cosin, *Conspiracie*, pp. 5, 35, and 85; Matthew Sutcliffe, *A Treatise of Ecclesiastical Discipline* (London, 1590), pp. 199–202; and Sutcliffe's *Answere*, fos. 60v–61r.

12 Cosin, *Conspiracie*, pp. 71–72.

13 See George Gifford, *Sermons upon the Whole Book of Revelation* (London, 1599), pp. 189–90; Gifford, *A Short Treatise against the Donatists of England whom we call Brownists* (London, 1590), pp. 22–25, 42–43; and especially Gifford, *A Plaine Declaration that our Brownists be Full Donatists* (London, 1590), p. 105, against Greenwood, *A Fewe Observations of Mr. Giffard's last Cavills about Stinted, Read Prayers and Devised Leitourgies*, in *The Writings of John Greenwood and Henry Barrow, 1591–1593*, ed. Leland Carlson (London, Allen and Unwin, 1970), pp. 56–57.

14 William Perkins, *Exposition of the Symbole or Creed of the Apostle*, in *Works*, vol. 1 (London, 1616), pp. 284, 293–94 and Perkins, *A Commentarie or Exposition upon the first five chapters of the Epistle to the Galatians*, in *Works*, vol. 2 (London, 1617), p. 182. Also consult the work of John Phillips, specifically *The Perfect Path to Paradise* (London, 1588), sigs. E11r–E12r and *The Way to Heaven* (London, 1625),

pp. 42–43; and see George Gifford, *Foure Sermons uppon the Seven Chiefe Vertues* (London, 1584), sigs. E8v–F3r. Cultural and literary historians write of the generation of contrition in Calvinism as "inculpation," *culpabilisation*, for which see Jean Delumeau, *Le pêche et la peur: la culpabilisation en Occident, XIII au XVIII siècle* (Paris, Fayard, 1983), pp. 244–45, 315–16; Jean Deprun, *La philosophie de l'inquietude au XVIII siècle* (Paris, J. Vrin, 1979), specifically pp. 123–28; and John Stachniewski's *The Persecutory Imagination: English Puritanism and the Literature of Religious Despair* (Oxford, Clarendon Press, 1991). My reservations are recorded in Kaufman, "Religion on the Run," *Journal of Interdisciplinary History* 25 (1994), 85–94.

15 Greenham, *Very Godly Meditations on the 119th Psalm*, in *The Works of the Reverend and Faithfull Servant of Jesus Christ, M. Richard Greenham*, ed. Henry Holland (London, 1605), pp. 676–77; William Harrison, *The Difference of Hearers or an Exposition of the Parable of the Sower* (London, 1614), pp. 40–41, 194–98; and *The Works of Henry Smith*, 2 vols. (Edinburgh, J. Nichol, 1866–1867), 1:499; 2:59–61; and 2:84–86.

16 See Greenham's sermon on Proverbs 28:15, in *Works* (1605), pp. 797–801 and *A Letter Consolatorie*, in *The Works of the Reverend and Faithful Servant of Jesus Christ, M. Richard Greenham*, ed. Henry Holland ((London, 1612), pp. 872–73. Also see the *Sweet Comfort for an Afflicted Conscience*, in *Works* (1612), p. 103.

17 Kyd's *Spanish Tragedy* is available in a superb critical edition, edited by Philip Andrews and reprinted in 1988 by Manchester University Press.

18 See Aers, "A Whisper in the Ear of Early Modernists; or, Reflections on Literary Critics Writing the History of the Subject," in *Culture and History, 1350–1600: Essays on English Communities, Identities, and Writing*, ed. David Aers (New York, Harvester, 1992), p. 182.

19 Roger Fenton, *A Perfume against the Noysome Pestilence* (London, 1603), sigs. B7r–B8r. Also see Nicholas Bownde, *Sermon containing many Comforts for the Afflicted in their Trouble*, appended to John More's *Three Godly and Fruitfull Sermons* (Cambridge, 1594), particularly pp. 23–25, and Thomas Wilcox, *Discourse Teaching the Doctrine of Doubting* (Cambridge, 1598), pp. 290–91. For Calvinists' soliloquies and ordeals, see Rogers, *Seven Treatises* (London, 1610), pp. 407, 411–13.

20 Parenthetical citations in the text refer to act, scene, and line from the accessible *Complete Pelican Shakespeare*, following the so-called good quarto edition of 1604–1605 (Q2) and including important additions from the folio edition. For brief discussions of the textual variations, see R.A. Foakes, *'Hamlet' versus 'Lear': Cultural Politics and Shakespeare's Art* (Cambridge, Cambridge University Press, 1993), pp. 90–97. And for Hamlet's cruelty and bewilderment, see D.W. Robertson, "A Medievalist looks at *Hamlet*," in *Shakespeare's Christian Dimension: An Anthology of Commentary*, ed. Roy Battenhouse (Bloomington, Indiana University Press, 1994), pp. 410–11.

21 See James Calderwood, *To Be and Not To Be: Negation and Metadrama in "Hamlet"* (New York, Columbia University Press, 1983). For the differences between melancholy and Hamlet's "descents," see Perkins, *Treatise*, p. 365; Timothy Bright, *Treatise of Melancholy* (London, 1586), pp. 184–94; and my discussion of Robert Burton's *Anatomy* in *Prayer*, pp. 122–24.

22 See Greenham, *Letter Consolatorie*, p. 879, and Kaufman, *Prayer*, pp. 112–27, 139–43.

23 See John Stockwood's *Sermon Preached at Paules Crosse* (London, 1578), pp. 30–31, 66, 113–15, and 134.

24 Aers, "Whisper," pp. 196–97.

25 Perkins, *Treatise*, p. 420.

26 See Webster, "Writing to Redundancy," pp. 47–52 and Barbara Kiefer Lewalski, "Typological Symbolism and 'the Progress of the Soul' in Seventeenth-Century Literature," in *Literary Uses of Typology from the Later Middle Ages to the Present*, ed. Earl Miner (Princeton, Princeton University Press, 1977), pp. 82–85, 90–92, for medieval reading and early modern "assimilation."

27 See Targoff, "Performance of Prayer," pp. 62–63, although she wonders whether the few instances of "hypocritical inwardness" in *Hamlet* suggest it "ultimately privileges outwardly convincing appearance" rather than "inward change."

28 See Huston Diehl, *Staging Reform, Reforming the Stage: Protestantism and Popular Theater in Early Modern England* (Ithaca, Cornell University Press, 1997), pp. 90–91. Diehl's conclusions about the play's "privileging" seem sounder than Targoff's (note 27), but he also appears to me to be overly inclined to "Calvinize" the play and playwright.

29 Compare Maus, *Inwardness*, p. 36.

30 For Stanislavsky and related choices, see Marvin Rosenberg, *The Masks of Hamlet* (Newark, The University of Delaware Press, 1992), pp. 466–73.

# Art, religion, and the hermeneutics of authenticity

NICHOLAS DAVEY

My concern as a philosopher is ... to sound a warning that the customary ways of thinking will no longer suffice
(Hans-Georg Gadamer, "The Religious Dimension" 1981.)[1]

## INTROIT

The subject-matter of this essay concerns the question of authenticity and its links with aesthetic and religious experience. It is our contention that an analysis of hermeneutic experience reveals that authenticity, religious, and aesthetic experience are significantly interconnected. Establishing the intimate connections between these modes of experience offers a significant opportunity to document the poignant parallels between Gadamer's approaches to aesthetic and religious experience. This chapter is a response to a key question which Gadamer raises in one of his most recent essays on art: how might the intimate relationship between aesthetic and religious experience be thought?[2] If these two modes of experience "interfere" with one another, as he argues, what feature is it that they share which simultaneously draws them toward and yet repulses them from one another? Although Gadamer bids us think about this question, his writings never directly answer it. Yet his sensitive reading of Heidegger's aesthetics suggests how we might formulate an answer.

The key to our argument concerns the connections between the concept of authenticity and the notion of the withheld. This notion can refer to the implicit meanings presently held within an artwork which have yet to be disclosed and to the future revelations of meaning which a religious faith promises but acknowledges as being presently withheld from us. The outline of our argument is as

follows. First: we maintain that religious experience involves a responsiveness to a prophetic call which invites us to have faith in a meaning for existence, a meaning yet to be revealed. Second: we contend that Heidegger's account of authenticity as that existential condition in which we acknowledge the presence of unrealized possibilities for our being, clears a pathway to an understanding of the nature of the withheld in both aesthetic and religious experience. Heidegger's account of authenticity presents the withheld not as that which is merely hidden or absent but as that which is felt to be present by virtue of its absence. Third: we will show how the centrality of the withheld within Heidegger's concept of authenticity has a direct bearing on the principal question of how we might think the intimate relationship between religious and aesthetic experience. Because aesthetic experience involves the disclosure of previously withheld meanings which were nevertheless present in an artwork, aesthetic experience offers to religious experience concrete instances of how, in the future, presently withheld meanings can be disclosed. We shall also indicate how the hermeneutic fusion of the question of authenticity with religious and aesthetic experience has direct implications for how the concept of performance can be articulated.

Our argument is presented in three parts. Establishing the historical and conceptual hinterland of an argument is of paramount importance for hermeneutic thought. Part I will outline how Heidegger's notion of openness to the questions of religion shapes Gadamer's account of aesthetic experience. Part II documents the broad connections between the aesthetic and the religious in Gadamer's thought. These connections have not as yet been properly mapped and it is important that they should be, as his arguments concerning the revelatory and transcendent aspects of experience, his account of the function of signs and symbols in art and his comments on the social dimension of aesthetic experience are significant elements in both understanding and formulating a response to the question of how the link between aesthetic and religious experience can be thought. Part III argues that when the aforementioned elements of Gadamer's thinking are combined with Heidegger's account of authenticity, the connecting concept of the withheld allows the similarities and differences between religious and aesthetic experience to be articulated in a way that Gadamer's thinking has to date only hinted at. Before we unfold our argument, a comment on the nature of its ambition is appropriate.

What is the question which Gadamer's writings on the religious

and the aesthetic is asking? In the essay "Aesthetic and Religious Experience" Gadamer speaks of the "mutual interference" of poetic and religious speech (RB 150). The phrase is telling. It intimates two modes of speech which "strike" (*ferire*) against one another and yet, by so doing, manage to bring each other to light. Thus, an inquiry into the one promises to reveal something of the other. That Gadamer avoids reducing the religious to the aesthetic is well-judged, for were one to displace the other productive "interference" would cease. The term "interference" betrays an Hegelian disposition in Gadamer, namely, a speculative attempt to discern the identity and non-identity of religious and aesthetic experience.[3] Thus, given the interference between aesthetic and religious experience, what is it in aesthetic experience which gives rise to thoughts of its other (the religious) and what is it in the otherness of the aesthetic that religious experience seeks out? How do these two modes of experience interfere with and yet infer each other?

That Gadamer never adequately answers these questions does not imply that his thinking is weak or implausible. We will contend, in a way which is appropriate to our subject-matter, that a forceful answer is held within Gadamer's thinking but, somehow, he does not seem to be aware of it. When in *The Critique of Pure Reason* Kant declared that philosophical interpretation endeavors to know an author's arguments better than the author,[4] he announced a theme which, unbeknown to him, was to became crucial to the development of hermeneutics: philosophical arguments entail rich veins of unarticulated meaning which, when mined, can prove more influential than the original, explicitly stated, position. The principle that *the life of a concept surpasses an author's understanding of it* was formalized by Schleiermacher and succinctly expressed by Ernst Cassirer:

The history of philosophy shows us very clearly that the full determination of a concept is very rarely the work of the thinker who first introduced that concept ... It must become explicit in order to be comprehended in its true meaning and this transition from an implicit to an explicit state is the work of the future.[5]

In approaching the question "how might the intimate relationship between aesthetic and religious experience be thought?" we suggest that there is a complexity and subtlety of argument which reaches far beyond Gadamer's stated position. It is this unspoken but implicit dimension of his thinking which we shall draw out. Gadamer's discussion of how the use of sign and symbol hints at how our

central question might be answered. We suggest that it is only when Gadamer's discussion of the different deployments of sign and symbol in aesthetic and religious practice is set in the context of Heidegger's reflections on authenticity and the withheld that the full force of the answer hinted at by Gadamer's thinking can be brought out.

Before we embark upon the first part of our argument, we have one final introductory word on the notion of the withheld. It has various temporal connotations. Concerning a past withheld, the hermeneutic principle that the life of a concept surpasses an author's under-standing of it is associated with the practice of retrospectively amending an original argument with the benefit of critical hindsight. The withheld within a previous argument is retrieved and thereby disclosed. The notion of a present withheld – the undisclosed mean-ings of an enigmatic artwork or the as-yet undisclosed revelation of a prophecy – is central to our argument. What is of special importance for hermeneutics about the notion of a present withheld is its implied anticipation of a future disclosure of its content. Both the theological hermeneutics of Wolfhart Pannenberg and the critical hermeneutics of Habermas exhibit "speculative" or "anticipatory" versions of this principle. It projects a horizon of meaning whereby the incoherent and presently fragmented aspects of a work or argument might achieve an envisaged but as-yet-to-be-attained co-herence. We shall argue that both the retrospective and anticipatory modes of the withheld are central to Heidegger's account of authen-ticity and of critical importance to Gadamer's attempt to differentiate aesthetic and religious experience.

## I TELLING QUESTIONS

In the wake of the death of God, godless theology appears to be more open to the possibility of God than onto-theology.[6]

The question of how religious and aesthetic experience both inter-fere with and yet infer one another assumes a common field of engagement. How do Gadamer's aesthetics and Heidegger's theology interconnect? To appreciate the connection we must understand that Heidegger's religious thought attempts, as John Peacocke has sug-gested, not an onto-theology but "a respiritualisation of the secular by (way of) reawakening us to the language of the spiritual dimen-sion of human existence."[7] Gunter Figal has gone so far as to argue

that "Heidegger grounds religious experience in art to understand art solely on the basis of the religiousness articulated through it."[8] As we shall see, Gadamer's approach to aesthetics interlinks with Heidegger's consideration of the theological because Gadamer too seeks to awaken us to the spiritual, that is, to the spiritual dimension within aesthetic experience.

Gadamer's reflections upon religious experience are profoundly shaped by both his professional involvement with theologians such as Karl Barth, Rudolph Bultmann, Gerhard Ebeling, and by his deep friendship with Martin Heidegger. That Gadamer should be disposed to understanding theology as *theo-logos* (the task of understanding the *word* of God) is not surprising: "modern hermeneutics" (which embraces languages as the medium of experience) "springs from the protestant art of interpreting scripture" (TM 332). Heidegger's influence is evident in the primacy Gadamer attaches to the "question of God."

It is enough to know that religious texts are to be understood only as texts that answer the question of God. [Such texts presuppose] that human existence as such is moved by the question of God. This presupposition is obviously held only by someone who already recognises the alternative of belief or unbelief in the true God. (TM 332)

This is not a dogmatic presupposition for such theological understanding ...

... really risks itself. It assumes that the word of Scripture addresses us and that only the person who allows himself to be addressed – whether he believes of doubts – understands. Hence the primary thing is application. (TM 332)

Gadamer dwells at length on a passage from Heidegger's *Holzwege* where Nietzsche's madman is described in a way which indicates Heidegger's view of the piety within Nietzsche's nihilism.[9]

The one who is searching for God, "knows of God." Those who attempt to prove his existence are those who kill him ... seeking presupposes measuring, as measuring does knowing, that which is absent. But that which is absent is not not. It is there "as" absence. (HW 179)

To be *open* to the question of God is already to be responsive to its claim. Such responsiveness brings us into the region wherein and wherefrom the question speaks. Faith for Gadamer is not a matter of doxological incantation but of accepting our vulnerability to the question of God and what it opens us to.

Gadamer is aware of Heidegger's conviction that Nietzsche's

critique of Christian metaphysics does not mark the end of theology but only of one way of thinking of God. Heidegger believed that the task theology "had to find its way back to, was searching for that word capable of beckoning one to and preserving one in faith" (HW 29). Heidegger "took issue with those wishing to interpret him as if he meant that metaphysics had been overcome and tossed away" (HW 185), for his radical questioning of Being strives to let the answers of metaphysics and theology *speak anew* (HW 185). Gadamer describes such "thinking anew" in the following terms:

Just as one can know of the divine without grasping and knowing God, so too is the thinking of Being not a grasping, a possessing, or a controlling. Without forcing the parallel with the experience of God or the Second Coming of Christ, which can indeed be thought more correctly from this vantage point, one could say that Being is more than simple "presence" ... it is also just as much "absence," a form of the "there" in which not only the "there is" but also withdrawal, retreating, and holding-within are experienced. "Nature loves to conceal itself" – these words of Heracleitus were often drawn on by Heidegger. They do not invite one to attack and penetrate: rather, the invitation is for waiting ... Heidegger (also) spoke of remembrance, which is not only thinking about something that was, but also thinking about something that is coming, something that allows one to think about it – even if it comes "like a thief in the night."[10]

Heidegger's radicalization of the three hermeneutic themes – (i) the questioning which risks, (ii) the word which is capable of beckoning to one and holding one in faith and (iii) the mode of recollection which awaits what has yet to come to be – set the theological context for Gadamer's reflection upon aesthetic and religious experience. Let us now turn to the broader features of Gadamer's reading of the religious elements within the aesthetic experience. We shall be concerned with four themes: revelation, transcendence, the differentiation between sign and symbol, and the relation between performance, observance, and the festive.

## II REVEALING EXPERIENCE

The theological legacy of art consists in the secularised revelation which is the ideal and the limit of every work.[11]

Revelatory experience is of fundamental importance to aesthetics and religion and is at the core of hermeneutics itself. In aesthetics and religion, revelatory experience has centrifugal and centripetal moments. The centrifugal concerns how contemplation of the

71

particulars within a work can impel us toward thinking about the universal subject-matter which transcends and yet unites them in a new and significant way. The centripetal or epiphanic moment beloved of Hegel and Heidegger concerns the reverse movement of the universal into the particular by means of which an idea emerges into the particularities of sensuous appearance.

Of revelation, three things can be said. First, it is an event of (objective) Being. Gadamer celebrates the revelatory nature of aesthetic experience as affirmation of the "mystery" of our being. Such experiences *happen to us* contrary to our willing and doing. The understanding they occasion, their significance and consequence, is unpredictable and cannot become the result of methodical prediction.[12] Second, the occasion of revelatory experience may seem *ex nihilo*, but what it occasions is a recognition (or rather a new cognition) of what we previously knew or were acquainted with, but now know in an entirely transformed state. Of a work of art, Gadamer states,

[such] a work ... can be understood only if we assume its adequacy as an expression of the artistic idea. *Here too we have to discover the question which it answers* if we are to understand it as an answer. This is an axiom of all hermeneutics. (TM 370 emphasis added)

Aesthetic revelation shows something to us "in its rightness against the truth and certainty of what is proved and known" (TM 485) and must "assert its own merit within the realm of the possible and the probable" (TM 484). The most powerful aesthetic revelation will not only present a convincing answer to its focal question but, in so doing, will also transform our understanding of what was held in that question. Third, if by answering a question persuasively, an aesthetic or religious revelation expands our understanding of what was asked in the first place, then there is no strict difference between truths of revelation and truths of discovery. Andrew Louth comments,

there cannot be pure truth of revelation: for to apprehend a truth which is received is to relate it to what we know already, to make it one's own ... Truth of revelation remains inert till it has been appropriated by a human working of recognition.[13]

If the mutual interference of the aesthetic and religion suggests that from the one we can infer something of the other, then from the above we can conclude that aesthetic and theological experience are both modes of interpretive appropriation ("application," cf.TM 332)

and that revelatory experience is not a special kind of experience but a hermeneutical experience of meaning and significance characteristic of any intense involvement with a subject-matter whether it be religious or aesthetic.

## Experience as transcendence

The experience of being directly addressed by a work can be momentous. Because it always "disturbs the horizons which had until then surrounded us," such experience can be highly provocative. It stands out and "presents a special task of hermeneutical integration" (TM 486). From these experiences we learn of the "finiteness of human life" which is "ultimately, a religious insight" (TM 357). The revelatory does not so much concern the subject-matter of an artwork as it does the sudden unexpected turn of experience itself, for it is such turns which constitute the experience of transcendence.

Transcendence does not involve passing beyond all limitation but in being brought to see the limits of our immediate horizons. Only an acquaintance with what transcends our horizon enables us to see that horizon as an horizon. The experience of transcendence is not an experience of a special order but of our perspectival horizons significantly expanding, a characteristic of all profound understanding.

The centrifugal force of transcendence flings us out beyond ourselves. This is not an extra-linguistic experience but an intrinsic feature of living within language's embrace. The anticipation of an "ideality of meaning" is central here.

Gadamer maintains that though all religious and artistic works address a central subject-matter, the historicity and finitude of our understanding prevent an exhaustive utterance of such subject-matter. This limitation is grasped positively, for it implies that there is always more to be said of that subject. This negativity conditions the possibility of transcendence. With regard to the limitations of linguistic expression, Gadamer remarks,

The occasionality of human speech is not a causal imperfection of its expressive power: it is rather the expression of the living virtuality of speech which brings *a totality of meaning into play*. All human speaking is finite in such a way that there is laid up within it an infinity of meaning to be explicated and laid out.                    (TM 458, emphasis added)

Achieving aesthetic or religious understanding is not arriving at the

dogmatism of "meaning-in-itself" (TM 473) *but* experiencing an opening out on to the meaningful. To understand what a work says is to become aware of how "what is said" "is said together with an infinity of what is not said." Profound understanding can therefore entail a hermeneutic experience of transcendence: not just knowing but experiencing how an understanding of the said or the seen leads one toward a more complete, though never complete, appreciation of the presence of yet further horizons of meaning. *Transcendence is thus of the essence of religious and aesthetic understanding.* The ability to move between horizons of meaning is for Gadamer constitutive of the life of the spirit (RB 10).

Transcendence is therefore a key element within Gadamer's hermeneutics. It does not betoken any commitment to mystical experience but only to the wonder of aesthetic and religious experiences themselves. Inasmuch as the latter involves horizons of meaning opening out before one, transcendence is intimately connected with the anticipation of a completeness of meaning. Though we may never be able to complete it, it nevertheless acts as a guiding fore-conception for our interpretation. This fore-conception of meaning's completeness (TM 293) is of decisive importance in Heidegger's concept of the authenticity.

## Significant symbols: "And let this be a sign unto you"

That "a work of art always has something sacred about it" (TM 150) suggests a connection between certain religious concepts and art's ontological status (TM 150). Gadamer remarks,

As we know, only the *religious* picture displays the full ontological power of the picture. For it is really true that the divine becomes picturable only through word and image. Thus the religious picture has an exemplary significance. *In it we can see, without a doubt, that a picture is not a copy of a copied being, but is in ontological communion with what is copied.* It is clear from this ... that art, as a whole and in a universal sense, increases the picturability of being. Word and image are not merely imitative illlustrations, but allow what they present to be for the first time fully what it is.

(TM 143, emphasis added)

This passage is at the heart of Gadamer's crucial differentiation between presentation (*Darstellung*) and representation (*Vorstellung*) in which the mutual "interference" of religious and aesthetic thought is most intense. The polarities of this interference emerge in the contrasting functions of sign and symbol.

The traditional doctrine of artistic representation awkwardly implies that what art "shows" is something other than or distinct from what it re-presents. It is a late outcome of Plato's prejudice that artistic appearance is secondary to the real. The notion of *darstellen* (to present) has altogether another connotation. It suggests a placing (*Stellung*) *there* (*da*), before us, of what an art work *presents* or of what "comes to picture" in a work. Gadamer remarks,

The ideality of the work does not consist in its imitating and reproducing an idea but, as with Hegel, in the "appearing of the idea itself. (TM 144)

Such "appearing" is not secondary to the subject-matter but is a coming into presence of something that essentially is that subject-matter (TM 147).

A work of art belongs so closely to what is related to it that it enriches the being of that as if through a new event of being. To be fixed in a picture, addressed in a poem ... are not incidental and remote from what the thing essentially is; they are presentations of the *essence* itself. (TM 147)

This differentiation between *darstellen* and *vorstellen* sustains Gadamer's distinction between sign and symbol.

Unlike the sign, the symbol is not arbitrarily chosen or created but presupposes a metaphysical connection between the visible and invisible (TM 73). A symbol is the coincidence of sensible appearance and supra-sensible meaning (TM 78).[14] The symbol does not point to something other than itself, but both means and is the very thing that appears.[15] The nature of the symbol is thus easily accommodated within the ontological framework of *darstellen*, whilst the concept of sign is more akin to the language of *vorstellen*. A sign always points beyond itself to what it signifies. The sensible appearance of a sign is one thing, whilst its ideative meaning is another.

When both sign and work function "as a means, like all means, they lose their function when they achieve their end" (TM 138). Thus, it can be forcibly argued that all signs in art have a precarious existence. The more the *artistic* quality of their deployment becomes prominent, the more their *communicative* function is compromised. The *raison d'être* of the sign is the same as artistic re-presentation: to point to something other and beyond itself whether that other be a sign or the idea represented. Whereas a symbol allows the meaning symbolized to come into presence *within* it, the sign *defers* to a meaning beyond its own presence. Yet are matters so simple? Cannot symbols also function as signs?

There may be no difference between a symbol and the meaning it

brings into presence but no meaning can be brought to definitive presence. Gadamer insists that the *Sache* (subject-matter) which an art work addresses can never be exhausted by interpretation or instanciation. There must be therefore a degree of difference between the symbol and what it symbolizes. Unlike the sign, the symbol is indeed what it means but, like the sign, neither is it self-referential nor is it completely identical with what it means.[16] Precisely because the symbol also points beyond itself to a subject-matter, a symbol can also function as a sign. Rather than weakening the distinction between *Darstellung* and *Vorstellung*, the fact that a symbol can also function as a sign emphasizes the true significance of the difference.

The notion of *Vorstellung* is associated with the classic opposition between the particularities of sensuous presentation and the intelligible generalities of concepts and universals. Not only does this schism deprive the world of appearance of having any intelligible meaning but it prevents such theological terms as "eternity" or "infinity" from acquiring any concrete instanciation. If a symbol can also function as a sign, that is, be the same as and yet different from what it symbolizes, then the realm of *Darstellung* is not totally opposed to the world of ideas but allows it, in Hegel's phrase, to come into sensuous appearance. Thus, as Gadamer remarks,

> The symbol does not merely dissolve the tension between the world of ideas and the world of the senses: it points up a disproportion between form and essence, expression and content. In particular the religious function of the symbol lives from this tension. The possibility of the ... coincidence of the apparent with the infinite in a religious ceremony assumes that what fills the symbol with meaning is that the finite and infinite (though by no means identical) genuinely belong together. (TM 78)

The working of the artistic symbol offers us a concrete grasp both of how that which is not of this world – the divine – might gain a presence in it, and of how the sensuous particulars of this world can be imbued with the meaning and dignity of a universal.

This discussion of *Darstellung* and the symbol reveals in part why aesthetic and religious experience interfere with each other. By suggesting a communion between how an art work or symbol brings what it means into sensuous appearance, the notion of *Darstellung* offers an analogue for thinking both how a supra-sensuous divinity can manifest its presence in the world and how the sensuous in art can be imbued with a meaningfulness which transcends particularity. Thus in order to lift itself above beyond being the merely

sensuous experience of the moment, aesthetic experience requires communion with the supra-sensuous and, likewise, in order for religious ideas to gain a presence in the world, they need art's ability to sensuously embody them. *Each mode of experience requires the other in order to understand itself.*

## Performance, observance, and the festive

Regarding the notion of "performance," we can assert that unexpected connections are the very stuff of Gadamer's hermeneutics. Hermeneutic cognition entwines the concepts of experience, interpretation, and performance in at least four ways. First: both performance and aesthetic experience *risk* a certain conception of a work. Risk is built into the notion of experience ( *ex* + *peril, periculum* implies being risked or attempted). In German, *Fahr* is the root both of *Gefahr* (danger) and *Erfahrung* (experience).[17] Second: aesthetic experience and performance are intensely temporal modes of experience which bring something-into-form (*per-form*). In his "transformation into structure argument," Gadamer maintains that the experience of an art work brings us to recognize how unarticulated possibilities within actuality are brought into the fulfilment of articulate form.[18] Presentation and performance are proclaimed synonymous. Third: both aesthetic experience and art performance are transformative modes of interpretation, for neither are secondary commentaries upon an otherwise finished work but continuing realizations of what is held within it. Both increase the being of that work. Gadamer states, "Every performance is an event, but not one in any way separate from the work – the work itself is what 'takes place'."[19] Thus, the art work "has its being in its presentation" or "performance" (TM 476). Gadamer's conception of the performative dimension of interpretation attuning itself to the subject-matter of a work is akin to Heidegger's conception of meditative thinking as a non-forced and non-coercive activity. Such thinking seeks to set free what is within a work, to allow it to be what it is. As we shall see, this connects with the concepts of *theoria* and *theoros* discussed below. Fourth: by drawing us back to recognize what it has already set in play, musical performance can anticipate the futurity of its end. Such moving-toward-recognition is central to Gadamer's account of aesthetic experience. The tension of the performative moment – the decisive standing between what was and what will be – is, moreover, fundamental to Heidegger's account of authenticity.

Turning to the notion of spectatorship, Gadamer is too much of a Hegel scholar to overlook the fact that the individual experiences of revelation and transcendence must have a communal correlative in the social dimensions of religious and aesthetic practice. His observations are several. When he speaks of *theoros* and *theoria* he reminds us that the disciplined looking of the aesthetic observer is not an isolated individual act but was originally connected to the public task of witnessing and partaking in a religious festival. Individual participation was a condition of something objective (the event) taking place. One may only intend to attend church as an onlooker but one's presence nevertheless adds to the congregation and its witness. Contemplative participation in the presentation or performance of an art work is also a condition of the work bringing into being a certain meaningfulness. The subjective intensity occasioned by a viewer standing before an art work has, as its objective corollary, the "cultic ceremony" which, according to Gadamer, "is the most original and exemplary manifestation of the self-fulfilling moment" (RB 63).

Festivals of art and religion reveal to their individual participants that despite the subjective differentiation each may feel, taken together they nevertheless constitute a community. Gadamer comments that "Festive celebration [reveals] ... the fact that we are not primarily separated and divided but gathered together" (RB 40). The emergence of a communal sense has therefore something of a religious dimension to it, for by becoming involved in the festive, the individual comes to participate in the actuality of a more universal life. The festive can also be grasped as the outward form of individual aesthetic experience as in it too, the individual begins to participate in a more universal life, that is, the life of an art work's subject-matter.

Let us review our case so far. We have gained entry to the conceptual territory which shapes Gadamer's question of how the relationship between religious and aesthetic experience might be thought. We have argued that because it attempts a respiritualization of secular experience, Gadamer's approach to aesthetics can clearly link up with Heidegger's religious thought, since Gadamer also seeks to awaken us to the spiritual dimension within aesthetic experience. The discussion of revelation, transcendence, the relationship between sign and symbol, and the character of the festive has articulated Gadamer's understanding of the spiritual in our experience of art. We will now show that the two related ideas which link

Gadamer's aesthetics to Heidegger's religious thought, concern the questions of authenticity and the withheld. Having set the terms for our argument, let us return to Gadamer's essay "Aesthetic and Religious Experience."

## III AUTONOMY AND AUTHENTICITY: A QUESTION OF STANDING

In this essay Gadamer takes it as given that art works and religious texts *address* us: they do so because "aesthetic and religious experience both seek expression in language." How then are we to differentiate between poetic and religious modes of address (RB 142)? Without directly answering the key question – how are we to think the relationship between aesthetic and religious experience? – Gadamer presents his readers with two items: a discussion of the autonomous or eminent literary text and the suggestion that religious and aesthetic experience might indeed be differentiated by the way they deploy signs and symbols. Gadamer's intentions are clearly stated: "I would like to supplement the concept of the symbolic, which already plays a central role in the theory of art as well as in the phenomenology of religion, with the counterconcept of the sign, which I would like to endow with a new dignity" (RB 150). The questions we shall now apply ourselves to are twofold: (i) how does the discussion of the autonomous text (and indeed of the authentic artwork) relate to the question of how the relation between aesthetic and religious experience might be thought? And (ii) how does the problem of the sign emerge from and significantly clarify the terms of that question?

Gadamer's characterization of the "eminent" text provocatively juxtaposes the terms autonomous and authentic in relation to the art work. An autonomous or eminent text is one which speaks by virtue of its own power. It does not refer back to some more original saying. A genuine text is "a woven texture that holds together ... in such a way that it 'stands' in its own right and no longer refers back to an original, more authentic saying, nor points beyond itself to a more authentic experience of reality" (RB 143). By not referring to an original saying, the autonomous text operates in a way analogous to the visual art work. Aesthetic experiences are not "disappointed by a more genuine experience of reality" nor lose their truth on (our) awaking from their grasp (TM 75). Aesthetic experience is thus an authentic experience of the autonomous, for in the autonomous art

work "something comes to stand in its own right" just as in the autonomous text something "stands written" (RB 142).

The phrases "coming to stand" and "stand written" are telling. "It stands written" (*es steht geschrieben*) is a prominent figure of speech in the Lutheran Bible. More poignant is Heidegger's phrase "bringing something to stand" and the particular significance which Gadamer accords it.[20] Gadamer writes,

No one can ignore the fact that in the work of art, in which a world arises, not only is something meaningful given to experience that was not known before, but also something new comes into existence with the work of art itself. *It is not simply the laying bare of a truth, it is itself an event.*

(HW 105, emphasis added)

In "speaking to us" an art work reveals something. It "brings something forth from unconcealedness" but "the emergence into light" is not the annihilation of concealment *per se* but the revelation of *a continued sheltering in the dark*. Gadamer comments,

There is clearly a tension between the emergence and the sheltering that constitutes the form *niveau* of a work of art and produces the brilliance by which it outshines everything else. Its truth is not constituted simply by its laying bare its meaning but rather by the unfathomable depth of its meaning. Thus by its very nature the work of art is a conflict between ... emergence and sheltering. (HW 107)

The art work's revelation of emergence *and* sheltering is a disclosure of "the essence of Being itself" for the conflict of revealment and concealment is (allegedly) "the truth of *every* Being" (HW 107). This is reminiscent of Adorno's conception of the enigmatic quality of art: "Art ... hides something whilst at the same time showing it" (AT 178). Heidegger does not articulate the conflict of revealment and disclosure as an enigma but as that which "comes to stand," a "standing-in-itself." Gadamer comments,

What Heidegger means can be confirmed by everyone: the existing thing does not simply offer us a recognisable and familiar surface contour: it also has an inner depth of self-sufficiency that Heidegger calls its "standing-in-itself." (TWA 107)

What comes to stand in an art work is a thing or world which is sufficient unto itself. The autonomy of the art work lies in its ability to reveal the extent to which it also remains concealed in itself. We might even say that the phrase "coming to stand" means a thing coming to stand in the fullness of its being where fullness is not a laying bear of its meaning but a revelation of what has as yet has to

be revealed. Coming to stand does not indicate a condition of disclosure as opposed to a state of hiddenness but the process whereby a thing – precisely because it partially comes forward into disclosure – also reveals the extent to which part of it *remains* undisclosed. Gadamer remarks:

> Hence the closedness and withdrawnness of the work of art is the guarantee of the universal thesis of Heidegger's philosophy, namely, *that beings hold themselves back by coming forward into the openness of presence*. The standing-in-itself of the work betokens at the same time the standing-in-itself of beings in general. (TWA 108, emphasis added)

Coming to stand does not therefore oppose the intelligible dimensions of a thing against its mysterious aspects for, as Adorno rightly contends, the task of understanding dissolves and yet preserves art's enigmatic quality (AT 177). In Heideggerian terms, it is precisely because certain aspects of a work can be rendered intelligible that the unseen presence of the full mystery of a work can be brought to light.

An aspect of what Heidegger means by coming-to-stand resounds within Gadamer's account of language and transcendence which we discussed above. Understanding what a work says involves an awareness of how "what is said" "is said together with an infinity of what is not said ... to which it is related by summons and responding" (TM 458). Thus for Gadamer the authentic text is one in which the said and the unsaid "come to stand" in the full dimensionality of their meaningfulness. The "word" stands. These comments brings us to the edge of a number of insights concerning the autonomy and authenticity of an art and how they have a bearing upon our central question of how the relationship between aesthetic and religious experience might be thought.

Our remarks on the eminent text and the art work as that in which a world is brought to stand suggest a certain congruity between the conceptions of the autonomy and authenticity of an art work. Heidegger and Gadamer would appreciate how the suggestion gains support from language itself. Autonomy implies a being possessed of its own law (from the Greek *autos* [self] plus *nomos* [law]) whilst authentic suggests something of independent (autonomous) origin [from the Greek *authentikos* (meaning, one who does, a thing itself)]. The autonomy of the art work is that it "possesses its own original worldliness and (is) thus the centre (the origin) of its own Being" (HW 192). A genuine or authentic art work is always "more than" –

and is never to be measured against – the original way it was said or presented (RB 146), for "in coming to stand" the art work reveals an ideality of possible meanings which "cannot be obviated by any possible realisation" (RB 146). The hermeneutic principle identified in our introduction – *the life of a concept or work surpasses an author's understanding of it* – is thus integral to the notion of an art work's autonomy. Furthermore, the fact that of itself the work brings a world to stand is also a guarantee of its authenticity, that is, that what originates or comes-to-be within it, resists, and is never to be captured or exhausted by interpretation. The authenticity of art therefore entails a certain enigmatic residing-within-its-own-possibilities which, by defying our attempts at understanding, remains free from our will. Gadamer remarks, "the artwork cannot be considered an object, as long as it is allowed to speak as a work of art and is not forced into alien relationships such as commercial trade and traffic" (HW 192). Now we are in position to draw a parallel between what we have understood as the "authenticity" of a work and Heidegger's earlier ethical deployment of the term.

The connection between aesthetic and ethical authenticity is noted by Paul Taylor, who argues that "the virtues emphasised by the ethical ideal of authenticity (a life which avoids externally imposed forms and standards of behaviour and [which] requires that individuals discover through their personal circumstances how to live and what to value) appear to be taken for granted as the virtues of artistic practise."[21] We look to authentic artists "to 'make it new' and to use their unique perspective and experience to confront us with the ambiguous and the unexpected."[22] Heidegger's deployment of authenticity is altogether sharper.

In *Being and Time*, authenticity (*Eigentlichkeit*) is connected to dispositions of resistance and resoluteness. Heidegger characterizes our everyday-life as pushing us into a state of fallenness, as a being tempted away from facing up to the call of our inner possibilities and losing (or rather forgetting) ourselves in a plethora of immediate concerns. Authenticity involves a resolute remaining within one's own possibilities, a resistance to becoming absorbed in the states of mind and projects characteristic of the everyday. A connection between the ethical and aesthetic deployment of the authenticity emerges. In ethical authenticity it is we who come to stand, we who seek to reside in a condition which is open to the withdrawnness of our possibilities and we who resist capture by the mundane. In aesthetic authenticity, it is the art work which comes to stand and, in

so doing, comes to reside in the closedness of its possibilities and resists capture by our interpretive projects. The authenticity of that which "comes to stand" therefore involves a being open to the call of closure, not a prising open of the closed but an openness to what is (still yet) withheld within the closed. Having linked "coming to stand," aesthetic authenticity, and autonomy, we can now articulate a strong connection between religious and aesthetic experience.

In the resistance of the authentic artwork to our interpretive probings, philosophy meets with the inexplicable and extraordinary.[23] As a mystery it "does not present itself to us as a datum of which there might be complete, objective knowledge."[24] It is not to be explained away but *discerned* as a limit to our present understanding which calls for a yet deeper, profounder understanding. Coming to recognize art's withdrawnness is to acknowledge the mystery of what comes to stand. As this acknowledgment entails a recognition of a limit, we return to what Gadamer describes as *an essentially religious experience* (TM 357). To recognize a limit to our understanding is to confront our human finitude. We acknowledge standing in the presence of something that stretches beyond us. This does not, however, suggest a realm from which we are in principle excluded.

"Coming to stand" does not oppose the art's intelligible dimensions with its mysterious aspects, since it is precisely the intelligible dimensions which bring art's withheldness to light. That which is withheld is precisely the totality of actual and possible meanings which underwrite our linguistic or artistic utterances and which only the latter reveal. Although that which sustains our articulations cannot as a totality be the subject of articulation and as such is withheld from us, the withheld nevertheless upholds the meaningfulness of our articulations. As the condition of the spoken, the notion of the withheld invokes a hermeneutic conception of *hypostasis* (*hypo* meaning that which is below or hidden whilst *stasis* infers a being brought to a "standing" state). The connection with Heidegger's notion of "coming to stand" hardly needs spelling out. Furthermore, the religious shading of such thinking is clear: the explicable in both art and our own being reveals the inexplicable networks of meaning which both we and art are grounded in. The inexplicable addressed by Heidegger and Gadamer invokes a hermeneutical trinity: the inexplicable totality of meaningfulness is withheld from us but remains the ground if not the "host" of the explicable and as such resides within us.

Such thinking reveals something of Heidegger's account of "the call" and how it stands in relation to Gadamer's analysis of the claim of art. These discourses about the autonomous text, existential authenticity, and the authenticity of the art work are woven together by the language of withdrawal and holding within. If understanding the questions of God and of art is to be open to their claims, what would it mean to be put on call by that which is withdrawn and to have a claim put on us by the absent and presently inexplicable? Now we come to a key stage in our argument: how are we to articulate the notion of the withheld? Heidegger's notion is straightforward: that which is absent is not *not* (HW 179).

## Incoming calls

The totality of meaning which both art and language invoke may be withheld from us but it is never fully absent, for it remains present in underwriting and upholding what we recognize as the explicable. We are thus already acquainted with that which is absent. Heidegger and Gadamer believe we respond to the call of the absent because we are, in part, being already acquainted with it. It is because our immediate perspectives are grounded in more extensive horizons of meaning that by means of those perspectives we can open beyond them toward what is already latent within them, namely, those other possibilities for meaning. In other words, we open toward the withheld in exactly the way Gadamer conceives of different linguistic perspectives opening toward linguisticality *per se*. The withheld is "not *not*." By revealing that which was withheld, art's actualization of a potential meaning reveals the very presence of both the withheld as such and the possibility of other yet-to-be-revealed life-shaping perspectives within it. Thus "the word beckons to us," because it uncovers a previously hidden aspect of our being. The word also "preserves one in faith" because it bids us to keep faith (i.e. remain open to) the potentialities for our being presently within the withheld.

Heidegger's argument might seem to be circular: "to respond to the call of God is already to know of God." Yet to read Heidegger this way is to miss the hermeneutical logic of recognition which animates his thinking. His argument alludes to the experience of being drawn (perhaps contrary to our expectancy) to a message and discovering, to our surprise, that the historical and cultural horizons which have shaped us have rendered us more susceptible to religious and

metaphysical questions than we would ever have imagined. Thus, the prophetic word relocates us within the fundamental questions it transfigures. If we respond to the call, we must thereby have recognized that religious questions have not only shaped our self-understanding but remain open.[25] Yet, as Heidegger's notion of *Andenken* makes clear, to remain open to such questions is to keep faith with the possibility of an answer.[26]

We come to the final two sections of our argument. At the outset of this essay, we argued that the claim that aesthetic and religious experience "interfere" with one another supposes that both share a common element which simultaneously draws them to, and yet repulses them from, each other. Our discussion of authenticity establishes that it is the notion of the withheld which is shared by both modes of experience. Religious experience anticipates a future revelation of a present withheld whilst aesthetic experience offers actual instances of how aesthetic responses to a work reveal a past withheld. And yet what is shared by both modes of experience also differentiates them. Religious experience looks toward a future disclosure of meaning, whilst aesthetic experience offers concrete examples of how past withhelds can be presently disclosed. And yet it is precisely this differentiation which allows aesthetic experience to illuminate how religious experience can credibly retain its faith in a promised but not as yet given answer. It is these elements of sameness and differentiation within religious and aesthetic experience to which we shall now turn.

## Answers on hold

Heidegger's account of "the call" reveals a decisive difference between religious and aesthetic experience. "The kind of familiarity upon which the act of (aesthetic and religious) recognition rests is in each case fundamentally different" (RB 151). To accept the question of God as a legitimate question is to receive a question which puts our understanding of our Being at risk. And yet to accept the question's legitimacy is also to accept the legitimate possibility of an answer. The *New Covenant* is based upon the promise of such an answer which, though not yet given, is nevertheless anticipated by and held within the positing of an original question. Yet why risk waiting "in vain for the decision of the Word" if the answer lies in the withheld?[27] What is at issue here is not a matter of blind faith but a matter of *keeping faith* with the speculative nature of *experience*.

Our responsiveness to the prophetic call and to art's revelation of previously unrecognized meanings discloses that *we have actual experience of the withheld being disclosed to us*. Our aesthetic and religious responsiveness reveal *post factum* that that which was withheld from our subjective awareness was nevertheless objectively present in shaping and sustaining that subjectivity. Thus, the experience of our responsiveness to the prophetic call brings us to the retrospective realization that though we did not know it at the time, we have actual experience of being upheld by the withheld. Art's revelation of meaning also shows how we have lived within the withheld. That potentialities for meaning were withheld from us does not imply that they were not effectively present, for how else could an art work have brought them to fruition? Insofar as aesthetic experience is the experience of a past withheld being revealed to us, it gives actual reason not to disparage the thought that what is presently withheld from us will also be revealed. Aesthetics lends experiential substance to religion's hope. Furthermore, if the notion of question presupposes an answer, to deny the possibility of a presently withheld answer is to deny the credibility of the very questions of meaning which open us toward existence in the first place. To believe in the possibility of an answer is, however, to keep faith with both the authenticity and open speculative character of experience itself.

## Signs of things to come

The suggestion that aesthetic and religious experience interfere with one has prompted our reflection upon their shared attributes but what of their difference? In his discussion of the *tessera hospitalis*, Gadamer eases open the defining difference:

When a symbol is used as a sign of recognition between separated friends or the scattered members of a religious community to show that they belong together, such a symbol undoubtedly functions as a sign. But it is more than a sign. It not only points to the fact that people belong together, but demonstrates and visibly presents the fact. The *tessera hospitalis* is a relic of past life, and its existence attests to what it indicates: it makes the past itself present again and causes it to be recognised as valid. (TM 153)[28]

Here we gain a hint both as to what the difference between the two kinds of familiarity upon which aesthetic and religious recognition rest actually is, and of how the relationship between aesthetic and religious thought might be thought.

Art allows us to recognize within its unexpected answer, past questions, fragmented ideas, or unfulfilled potentialities, transformed and made whole. By returning to us one half of the token, art makes us realize that in the untransformed we already unknowingly possessed the other half of the token. Thus art does not so much complete a circle of meaning as enable us to recognize that circle as a circle for the first time. The recognition which the prophetic facilitates also transforms our forgotten understanding of those religious questions which have shaped our being but it does not answer them, that is, it reminds us that the answer which the questions anticipate have yet to come. By bringing us to recognize the formative questions of our being as one half of a *tessera hospitalis*, the prophetic insight reminds us that we are still in wait for the other half of the token to come to us. The art work is not an answer-in-waiting but an answer-actualized. This is made clear by Gadamer's transformation-into-structure argument.

"Reality," Gadamer argues, "always stands in a horizon of ... undecided future possibilities of meaning" (TM 122). What will come to pass in reality is already at play within the withheld. Art's genius is to seize hold of the untransformed and bring to light not another world but what was hidden in this world. Art is the "self-realisation" and "fulfilment" of what is at play within actuality.[29]

From this viewpoint "reality" is defined as what is untransformed and art as the raising up of this reality into its truth (TM 113). Thus by means of art, the world as it were undergoes an increase in its being. (TM 141)

Thus, in relationship to the world, the art work proves to be the redeeming portion of a broken *tessera hospitalis*. The art work thereby makes whole and allows us to recognize as a whole what we had previously known only in a fragmented fashion. Art *brings* us to know more than we were previously familiar with (TM 114) and thereby allows the world to *become* more essentially what it is. Here we have then the decisive difference between aesthetic and religious experience. Aesthetic experience retrospectively expands our sense of what is entailed within our being-in-the-world whilst religious experience anticipates answers to what being-in-the-world means.

Yet the decisive difference between religious and aesthetic experience also uncovers the character of their mutual dependence. Whilst aesthetic experience reveals a completion of meaning and religious experience anticipates it, it is aesthetic experience which

reveals that the hope of religious experience is not vacuous. First: although the prophetic call is a sign of a meaning yet to come, the way open lines of meaning (past yet to come) complete themselves in an art work suggests that we at least know the form of the as-yet-withheld answer, that is, it would have to follow hermeneutical figures of recognition and transform something that we are already acquainted with but have not recognized as such. Second: precisely because we have actual aesthetic experience of past withhelds being disclosed to us, we have reason to keep faith with the possibility of a present withheld (the anticipated answer) being disclosed to us in the future. Furthermore, because art's completion of a circle of meaning allows us to recognize how lines of meaning in a past present were moving towards completion in a then unrealized future, aesthetic experience offers us a concrete example of what the prophetic call bids us keep faith with, namely, that present lines of unresolved meaning are now moving towards an anticipated future. Third: if, as was argued above, a symbol may also function as a sign so a sign may also function as a symbol. This point will prove a decisive turn in the argument.

By pointing beyond its immediate presence to a totality of meaning which is its subject-matter, a symbol may also function as a sign. Yet because that sign is also a symbol, it allows that which it points to beyond itself to come to a presence within itself. Now if religious imagery functioned solely on the level of signs and their meaning depended upon eschatological realization of what they pointed to, until the moment of such realization there would be little hope of knowing or even recognizing their meaning. What reason would there be for retaining faith in the meaningfulness of such religious signs? One answer is that, once again, aesthetic experience gives us instances whereby deferred or postponed meanings become redeemed within the symbolic. The transformation-into-structure argument portrays the meaning of the everyday as open and unde-cided. The everyday is therefore portrayed as a sign pointing beyond itself to its as yet unrealized meaning. However, when art transforms the everyday into a meaningful structure, art turns life into a symbol. Thus art offers us instances of how signs can also function as symbols; for what we initially took as signs pointing to meanings beyond themselves turn out also to have had a symbolic valence in that the meaning the signs anticipated was not beyond them in any transcendental sense but within or rather amongst them. Once again, aesthetic experience serves as an analogy for what it might mean for

the signs of religion to be redeemed. Such optimism is not invulnerable to challenge.

If a symbol can function as a sign, then the beyond which the sign aspect points to (the future redemption of its meaning) must in a certain sense already be held within the symbol. Does it not follow then that a sign can also function as the symbolic presence of what it refers to? Cannot the symbolic aspect of such a sign not simply point towards a meaning but also be the vehicle through which the meaning which is held within it presents (*darstellen*) itself (RB 349)? Yet does this not lead to an impasse? If the meaning of a sign lies beyond itself and the meaning which the symbol presents comes to presence within it, how can the symbol present what remains beyond itself and how can the sign also be the presence of what it signifies? If we return to Heidegger's notion of authenticity, what presently appears as an impasse reveals itself as a final, decisive, speculative turn.

As a dwelling between past and future possibilities, authenticity involves a being open to the call of the withheld, not a prising open of the withheld, but a remaining open to and a holding with that which is still withheld from us. Although the authentic attitude anticipates a completion of meaning, it is protected from despair since its withheld is not the absence, postponement, or deferral of all meaning. The meaning within the withheld, though withheld from us, is "not *not*." The argument concerning the symbolic valence of the sign comes to its proper fruition. If signs can also function as symbols, then does not the symbolic aspect of such a sign not merely point towards a meaning but also become the vehicle through which the meaning which is held within it presents (*darstellen*) itself in the world? The sign does not just defer and postpone: it is also the symbolic presence of that which is yet to come.

Let us venture three concluding remarks. First: the fusion of aesthetics and the hermeneutics of authenticity suggests that the relationship between aesthetic and religious experience should indeed be thought of as one of speculative interference. Thus it is not a question of differentiating aesthetic from religious experience but of allowing the aesthetic to become more itself by thinking of itself from within the perspective of its other. If religious experience did not remind us of how artistic symbols also function as signs, aesthetic experience would lose its transcendent capacity and tend to dwell only on what was immediately before it. If aesthetic experience did not equally demonstrate how religious signs can also

operate as symbols, religion would be deprived of the means whereby its ideas could come into sensuous presence. Second: because we have gained real experience of how an art work can transform anticipated (deferred) meaning into meaning realized, the actuality of aesthetic experience implies that the hope that religious signs might also be redeemed is not unthinkable. Third: aesthetics and the hermeneutics of authenticity suggest that we do not have to think of the religious as merely waiting for the withheld. If a religious sign can also function as an artistic symbol, aesthetic experience reveals to religious experience how we can indeed be both in the presence of and sustained by that which is held within the withheld. As was implied at the beginning of this essay, the life of understanding always surpasses itself.

## NOTES

1 Gadamer's essay "The Religious Dimension," appears in the text in *The Heidegger's Ways*, ed. D. J. Schmidt (Albany, State University Press of New York, 1994). In following references this text will be cited as HW with the appropriate page number.

2 See Hans-Georg Gadamer, "Aesthetic and Religious Experience," in *The Relevance of the Beautiful*, ed. R. Bernasconi (Cambridge University Press, 1986), pp. 140–53. In following references this text will be cited as RB with the appropriate page number. The original essay "Asthetische und religiose Erfahrung" appeared in the *Nederlands Theologisch Tijds-chrift*, 32 (1978), 218–30. It is now published in Hans-Georg Gadamer, *Gesammelte Werke* (Tübingen, J. C. B. Mohr, I993).

3 In his discussion of Hegel, Gadamer describes a thought as being speculative in the following way: "And a thought is speculative if the relationship it asserts is not conceived as a quality unambiguously assigned to a subject, a property given to a thing, but must be thought of as a mirroring in which the reflection is nothing but the appearance of what is reflected, just as the one is the one of the other, and the other is the other of the one." The reference for this statement is *Truth and Method*, trans. J. Weinsheimer (London, Sheed and Ward, 1989), p. 466. From now on this text will be referred to in the body of this essay as TM and will be followed by the appropriate page number.

4 "I need only remark that it is by no means unusual, upon comparing the thoughts which an author has expressed in regard to his subject, whether an ordinary conversation or in writing, to find that we understand him better than he understood himself": Immanuel Kant, *The Critique of Pure Reason*, trans. N. K. Smith (London, Macmillan, 1970), A314, p. 310.

5 Ernst Cassirer, *The Philosophy of Symbolic Forms* (New Haven, Yale University Press, 1980), p.1.

6 John Peacocke, "Heidegger and the Problem of Onto-theology" in *Post-Secular Philosophy, Between Philosophy and Theology*, ed. Phillip Blond (London, Routledge, 1998), p. 191.

7 *Ibid.*, p.188.

8 Gunter Figal, *For a Philosophy of Freedom and Strife: Politics, Aesthetics, Metaphysics* (Albany, State University of New York Press, 1998), p. 133.

9 The essays which are of particular relevance with regard to Gadamer's appraisal of Heidegger's religious thinking are "The Truth of the Work of Art" (1960), "The Marburg Theology" (1964), "The Religious Dimension" (1981), and "Being, Spirit, God" (1977). They collectively appear in Hans-Georg Gadamer, *Heidegger's Ways*.

10 HW 180. The phrase, "like a thief in the night" is taken from First Epistle of St. Paul to the Thessalonians.

11 Theodor Adorno, *Aesthetic Theory*, trans. C. Lenhardt (London, Routledge, 1994), p 178.

12 Hans-Georg Gadamer, "Theory, Technology and Praxis," in *The Enigma of Health* (London, Polity, 1996), p. 24.

13 Andrew Louth, *Discerning the Mystery: An Essay on the Nature of Theology* (Oxford, Clarendon Press, 1989), p. 55.

14 Gadamer's argument is all the more potent in the case of religious art and iconography where the images are known to lack any objective correlative. The face of God cannot be depicted or re-presented (*vorstellen*) since no known artist has access to the original and, furthermore, if an absolute God were to exist, it would be unlikely to possess facial features characteristic of a species with evolving needs. Such arguments, however, miss the point. Religious art cannot offer literal depictions, but occasions for metaphoric transfer. If the divine exists, its presence will be trans-spatial and trans-temporal. Yet for the human mind such a presence is almost impossible to grasp. Thus for such a presence to show itself, it cannot reveal *its* actual face (it has none) but can only come forth *as* a face. Indeed, for the human being it is invariably the face which reveals the gaze of the other, albeit the face of a transcendent other. Religious art is not a depiction but a coming into picture of a divine presence. It is interesting to note in this respect that Gadamer – himself a devout Protestant – offers an intriguingly ambiguous position *vis-à-vis* the old argument between Protestants and Catholics over the status of religious iconography. On the one hand his argument suggests that the Protestant condemnation of religious iconography as idolatry is faulty. Idols are not depictions and therefore cannot be "false" gods. If religious iconography is the means whereby the divine appears to us in our terms, such iconography does occasion a divine presence. If so, the Protestants were committing sacrilege when they defaced religious iconography. When, however, early Christians defaced Nordic images they were not necessarily wrong in their understanding of religious iconography, for they understood that images are presences though, in this instance, of

other unwanted gods. The destruction of the image destroys the ability of that which comes to presence in the image to reveal itself. Where the Protestant would be right, however, would be in his or her insistence that what comes to presence in an image does not come into exhaustive presence.

15 Joel Weinsheimer, *Philosophical Hermeneutics and Literary Theory* (New Haven, Yale University Press, 1991), p. 91.

16 *Ibid.* p. 101.

17 The connection between *Gefahr* and *Erfahrung* is undoubtedly the basis of Gadamer's oft-stated remark that the openness of experience will always place our prejudices (assumptions) at risk (*ins Spiel bringen*) (TM 299).

18 Gadamer's "transformation-in-structure" argument is discussed in *Truth and Method*, pp. 99–108.

19 See TM 147. The relationship between an art work and its interpretation on the one hand, and a poem or symphony and its reading (performance) on the other, follows Heidegger's account of the relationship between interpretation and understanding. Whereas for Wilhelm Dilthey the interpretation of a finished work gives rise to an understanding of it, for Heidegger interpretation draws out latent possibilities which are always at play (and therefore never finished or resolved) within a work and what we already understand of it. In *Being and Time*, Heidegger comments, the "development of the understanding we call 'interpretation'. In it the understanding appropriates understandingly that which is understood by it. In interpretation, understanding does not become something different. It becomes itself. Such interpretation is grounded existentially in understanding; the latter does not arise from the former. Nor is interpretation the acquiring of information about what is understood; it is rather the working-out of possibilities projected in understanding" (Oxford, Basil Blackwell, 1960), p. 188.

20 For Heidegger's account of "coming to stand" see in particular the section "The Work and Truth" in *The Origin of the Work of Art*, translated by A. Hofstadter, in *Martin Heidegger, Poetry, Language, Thought* (New York, Harper and Row, 1985), pp. 39–57.

21 Paul Taylor, "Authenticity and the Artist," in *A Companion to Aesthetics*, ed. D. Cooper (Oxford, Blackwell, 1992), p. 29.

22 *Ibid.*

23 J. Habermas, *Postmetaphysical Thinking* (London, Polity Press, 1992), p. 51.

24 Andrew Louth, *Discerning the Mystery*, p. 145.

25 The pattern of Heidegger's thinking is very close to Gadamer's description of Hegel's phenomenological stratagem, i.e. to discover in all that is subjective the substantiality that determines it (TM 302). As, in this instance, the substantialities which shape our subjectivity are questions which remain open, their continued wellbeing requires that we continue to respond and extend them. So subjectivity comes to knowingly

mediate the substantiality that underwrites it. Thus, Gadamer remarks, to have come "to understand the questionableness of something is already to be questioning" and thereby to be extending the questions which uphold our horizons (TM 375).

26 Not only does Heidegger's account of the call link with his notion of *Andenken*, but both areas of thought connect with his earlier account of authenticity: the authentic mode of consciousness recognizes how it is shaped by the projects it finds itself set within and seeks to remain open to the future possibilities that are contained within those projects. Gabe Eisenstein has noted how the apocalyptic character of Heidegger's approach to authenticity suggests that answering the call is a necessary "preliminary to the circumstances of its fulfilment" (see "The Privilege of Sharing: Dead Ends and the Life of Language," in *Dialogue and Deonstruction*, ed. D.P. Michelfelder and R.E. Palmer [Albany, State University Press of New York, 1989], p. 275).

27 See Hubert L. Dreyfus and Paul Rabinow, *Michel Foucault: Beyond Structuralism and Hermeneutics* (Brighton, Harvester Press, 1982), p. xix.

28 Gadamer also writes, "What does the word 'symbol' mean? Originally, it was a technical term in Greek for a token of remembrance. The host presented his guest with the so called *tessera hospitalis* by breaking some object in two. He kept one half for himself and gave the other half to his guest. If in thirty or fifty years time, a descendant of the guest should ever enter his house, the two pieces could be fitted together again to form a whole in an act of recognition ... something in and through which we recognise someone already known to us" (RB 31).

29 Two examples drawn from current literary practice might be cited in support for Gadamer's view. Jeanette Winterson writes, "Against daily insignificance, art recalls us to possible sublimity. It cannot do this if it is merely a reflection of actual life. Our real lives are elsewehere. Art finds them out" (*Art Objects, Essays on Ecstasy and Effrontery* [New York, Vintage, 1966], p.59). In *The English Patient*, Michael Ondaatje describes one of his characters listening to a woman reading a story from Herodotus to a fire-side group: "This is a story of how I fell in love with a woman, who read me a specific story from Herodotus. I heard the words she spoke across the fire, never looking up, even when she teased her husband. Perhaps she was just reading to him. Perhaps there was no ulterior motive in the selection except for themselves. It was simply a story that had jarred her in its familiarity of situation. *But a path suddenly revealed itself in real life*" (London, Picador, 1993), p. 233.

# Understanding, performance, and authenticity

# Understanding music

## MICHAEL TANNER

I

Most people who care a lot about music would nonetheless be hesitant in claiming to understand it. Their hesitation has several sources. In the first place, they know that there is a great deal of musical theory, though they are likely to be vague about what it consists of; they may know that there are competing musical theories, and wonder what they compete about. Second, they know that there is an enormous amount of musical terminology which is to a large extent independent of, or common to, opposed musical theories, but which again they have at best only a tenuous grasp of. Or, to move to a slightly more sophisticated sub-set of music-lovers, they know quite a range of musical terminology but are not able to apply it to pieces of music they know or even play. And thirdly, they are made most uneasy by the fact that their responses to music are articulated, if at all, in terms which may very roughly be designated "emotional," and that there seems to be an unbridgeable gap between talking about music in the way that they do and talking about it in the way that, for example, Donald Francis Tovey, or Charles Rosen, let alone the awe-inspiring Heinrich Schenker, most characteristically do, though none of those authors eschews emotion-language completely. But such writers contrive to give the impression, though it may not be wholly intended, that one's only right to use emotion-terms comes as a result of the kind of purely musical understanding which they manifest. To put it at its crudest, there seems to be the implication that unless one understands how music works, one is not entitled to say what it expresses, conveys, or whichever favored term in that area one uses.

## II

The disquiet that many of us – I include myself among the musical majority – feel on these issues is not something that is typically felt about the other arts. There are three possibilities of explaining that: first, that though we do not feel it about the other arts, we should. Second, although we do feel it about music, we should not. Third, that music is in a significantly different position or category from the other arts, and that therefore a different manner of approach is appropriate to it. The third possibility is not implausible. As one contemplates the varied aesthetic productions of mankind, music may well strike one as the most mysterious. The needs that literature and the visual arts answer seem to be, at least in broad outline, obvious, though of course there is no end to the elaborations that may legitimately be indulged in explaining fully the roles that they play in our lives. But before these elaborations get under way, we can point out that the various forms of literary and visual art all begin by being continuous with non-artistic activities of talking, writing, and representing for different purposes. And though there have been and still are many attempts to locate a specifically literary use of language, attempts which in my view are happily doomed to fail, and correspondingly attempts to differentiate the ways in which we perceive objects for practical purposes and for purely aesthetic ones, these attempts are not of the same kind as that involved in discovering what it is to hear something as music, for the reason that, with marginal exceptions, the only things we hear as music are pieces of music. Music, at least as we know it in the West, is not continuous with other series of sounds, as literature is continuous with other modes of speech and writing. This means that we inevitably regard it as *sui generis*, a law unto itself, etc. And the borderline cases are not all that common and not all that worrying. I realize that this general claim about music is controversial, but I shall not attempt to enlarge on it, since I want to discuss other matters. If you disagree with it, it may still be interesting to see what follows from holding a certain false position.

## III

Granted, then, the discontinuity of music with the rest of our experience, it is not surprising that it should be regarded as being in some way hermetic. What is perhaps more puzzling is that it should

play so central a role in so many people's lives, so that the prospect of living without it is for them appalling. One might wonder how something that is so artificial, and the production and performance of which is the result of such refined expertise, should simultaneously be so indispensable. Once more, the importance of literature and the visual arts in people's lives seems much less problematic, and there are several venerable theses which claim to show, especially in the case of literature, how it can organize experience for us in a way that nothing else can, and large numbers of witnesses to testify that one or another of these related theses is correct – that they (the witnesses) do get a better grasp of their experience through literature. By contrast, the general theories that have been put forward to explain the importance of music tend to have a disturbingly vague, elusive, or extravagantly metaphysical air about them. There is no central tradition of humane theorizing about music, as there is about literature, and equally no corpus of respected critical work, as there is of literary criticism, with most of which one may disagree, but which is nevertheless profoundly impressive and enduringly valuable because it shows what the impact of great literature was on minds impressively susceptible to it, so that the criticism itself becomes a kind of literature.

## IV

The dearth of valuable music criticism has led some people to the suspicion that music critics have not yet found their proper vocabulary, which is tantamount to claiming that they have not yet found the right way of appreciating music. Since no amount of purely musical description or analysis will ever show that a given piece has a particular emotional quality, or demonstrate the value of a work, and conversely (it is often thought) no amount of descriptive emotional exegesis or commentary will ever be other than subjective, there should be another set of terms which is both appropriate to our experience of music, and also serves genuinely to characterize it. But it should be clear that there can be no such mediating language. It is not that we have not yet hit on it, and that at least some of our perplexities about music would be solved if we do, but that there are no features of our experience of music that elude our present vocabularies – or at any rate not to any greater extent than that to which our experience of the world in general, that is to say, in all its particulars, eludes our linguistic resources. The problem is still the

one from which I began: to what extent can we link up our two vocabularies, and how serious a deprivation is it if one is only able to employ the emotional one? Alternatively one might ask of someone who confined himself rigorously to the purely musical vocabulary, as Stravinsky at one time affected to believe one should do, beginning with talk of pitches, timbres, intervals, chords, modulations, and so on, and moving into much more sophisticated description and analysis, what the point of his enterprise was.

## V

People who are only able to speak of music in emotional terms – or, to put it more fairly, in non-technical terms, where technicality enters as soon as one begins to talk in terms specific to music – are liable to feel anxious both on the grounds that all such non-technical description is purely subjective, or anyway cannot be rationally argued about, and on the ground that if they do not experience music in a way that more or less demands the employment of technical terms, they must be missing a lot of what is going on, at least in the case of pieces of a complexity greater than that of an unaccompanied simple melody. The first ground seems to me a mistake of a sufficiently familiar kind to be left to look after itself. The second is much more interesting, if only for novelty value. Take the case of someone listening to a work as complex as Brahms's Fourth Symphony. He may listen to it many times, and be able to talk about it in considerable detail; and it would be unlikely that if he did so he would not at least have to use clumsily periphrastic terminology if he had not bothered to learn any musical jargon. It would be impossible to speak of the work in any detail without, in the first place, mentioning various instruments; different tempi; varying dynamics; and so on. It would be a strange kind of linguistic puritan who was not prepared to learn musicians' names for these, so that he could refer to passages of syncopation, modulation, alternation between winds and strings, and so forth. The writers of even the most elementary program notes assume that their readers will be able to follow such terminology. And the point of writing program notes such as one encounters at the concert hall is to enable listeners, in the first place, to notice the musical phenomena as they occur, so that they can follow the progress of the work. What one tends to find in these notes is a quasi-narrative account of the work, in which it is explained how it begins with a yearning, lyrical theme

in which the interval of a major third predominates, and which gradually gains impulse and momentum, leading to a figure which receives sharp rhythmic delineation. Such commentaries usually mix non-musical and musical vocabularies in a way calculated to enable the listener to keep track of both (the music and the commentary), to match them. Thus: "A sombre, noble variation of the passacaglia theme on the trombones is quietly accompanied by violins and 'cellos, and leads to a shattering restatement by the full winds in the tonic, accompanied by violent figuration in the strings" is staple writing of this genre, and though it is easy to feel that it is tiresome, redundant, or mildly comic, it should not be despised for the help that it gives to the first- or second-time listener. It is after all possible to listen to the last movement of Brahms's Fourth Symphony without realizing that it is a free passacaglia, or perhaps worse, realizing that it is but not managing to keep up with the variations. I think no one would disagree that it is a minimal requirement of understanding that movement that one know that it *is* a passacaglia (even if one cannot call it by that name) and that one can tell when one variation is followed by another. Simply to report that one found it a very powerful piece, even a very powerful tragic piece, but to be able to say nothing more about it, not only means that one cannot say anything helpful to anyone else, but also shows that, however imposing its impact may have been, one has no more understood it than one has understood a mountain at which one may have gazed with awe. If I appear to be making a meal of this point, that is because I have often found a stubborn insistence that one can perfectly well understand music without any knowledge of how it works, the ground for this being that what goes on "in the kitchen" should have no bearing on how one finds the meal. I shall return to that point later. A less truculently produced claim is often made, that once one agrees with even such limited and rudimentary points as I have made about that passacaglia one is on a slippery slope which will lead to the unpalatable conclusion that really to understand a piece of music one has to be able to specify all the key-relationships, thematic derivations, rhythmic devices, etc. that it contains, together possibly with the relationship of that piece to others in the composer's *œuvre*, and even to the whole tradition in which it is written.

## VI

What makes that conclusion unpalatable is partly that it would restrict the genuine understanding of most music to a handful of musicologists, leaving the rest of us as hapless dilettantes, a view congenial in Faculties of Music, but not elsewhere; and partly that it is clear, without indulging in any dubious intentionalism, that composers have not usually written their music for the benefit of professional analysts. Of course understanding music, like understanding many other kinds of thing, is a matter of degree and it may be that a certain grasp of a piece qualifies as genuine, or adequate understanding, without going to the extremes that Schenker does in his book on Beethoven's Ninth Symphony, or Norman del Mar, in a very different way, in his book on Mahler's Sixth Symphony. One might ask what is added to one's grasp of a piece by being able to specify, or follow someone else's telling one, exactly what is happening, in musical terms, at every point. So long as in listening to a piece one can feel why it is the way it is and not otherwise, does it matter in what terms one characterizes it, or whether one cannot characterize it at all, but merely point to various parts of it, or whistle salient sections? And, moving from the defensive to the gently offensive, one might ask what is gained by describing or analyzing a piece in exhaustive detail. For analysis is valuable only insofar as it either helps us to understand in one idiom what we are able to experience and to some extent articulate in another, or enables us to get a grasp on something that we find baffling by revealing, for instance, a structure that we had not apprehended. Dangerous as it is to use the word "meaning" in musical contexts without arguing at length about the fundamental nature of music, there is at least one way in which it can be employed harmlessly: that is when one is able to grasp most of what is going on in a piece one hears, but finds that a certain passage, or perhaps just a chord, simply does not seem to fit in – meaning as cohering, that is. At such times an indication of the connection between it and other parts of the piece may help one to see that it *is* coherent, or alternatively fail to persuade one that it is. Coherence can never be established by any amount of musical analysis. Furthermore, our preparedness to accept that something does fit in is sometimes indistinguishable from mere familiarization. For example, most people who listen to Mozart's String Quartet in C Major, K.465, are at first completely bewildered by the introduction, those twenty-two notorious bars that

have led to its being called universally the "Dissonance Quartet." The introduction in no way sets the mood for the rest of the quartet, and even if the lynx-eyed analyst is able to spot – and it would be his eyes rather than his ears that did the spotting – harmonic and thematic connections with the main body of the movement, the introduction still remains, partly because it comes first and is wholly uncharacteristic of its composer, completely enigmatic. What listeners tend to do is to listen often enough to it to get over its mere shock-value, while remaining thrilled by its daring and its bizarreness. But to be content with that seems to me to be decidedly lax, and any attempt to see it as integrated with the rest of the work is a failure. It certainly is not a joke, as many of Haydn's introductions are, producing a comic contrast between the expectations they set up and what comes after. For one thing, it is far too sustainedly portentous and disorienting to be an element in a joke – one of its oddities is that in its dislocated chromaticism it does not set up any expectations, as the passionately expressive and tragic introduction to the last movement of the G Minor String Quintet, K.516, certainly does, only to be contradicted by the cheerful-seeming theme that launches the main part of that movement. And there is a problem there too, which some commentators have tried to solve by arguing that Mozart, having set a tragic question, confesses himself incapable of answering, the total effect being as much as to say that since life is so appalling we may as well be as superficially cheerful – that is, as superficial and as cheerful – as possible. Other commentators have claimed, much more plausibly I think, that though the main body of the music is *prima facie* light-hearted, it soon reveals itself to be a fragile and unconvinced affair. Whatever the truth, it is clear that one feels a tension between the adagio opening and the allegro, and that there are ways of exploring that tension so that a total understanding of the movement, though tenuous, is possible. But one cannot even try with the "Dissonance Quartet"; it does not establish a mood which is brushed aside. It seems rather to grope toward, or more precisely around, a mood which is not located, and hence one ceases to remember it actively while listening to the main body of the quartet. But as I have indicated, familiarity breeds acceptance, and people tend to point to it as a demonstration of how progressive Mozart could be. If it were not so weird, it would not command so much interest. But we should beware of letting our interest slip into admiration, and of our bewilderment becoming an expansive celebration of the incomprehensible – which, to return to my earlier

103

point, cannot be made comprehensible by analysis – the more ingenious the worse. To take one further example from the classic chamber-music repertoire: in the last movement of Bartok's Fifth String Quartet there is a celebrated passage marked *"con indifferenza, meccanico."* It perpetually comes as a shock; and I would like to add parenthetically here that anyone who has a rudimentary grasp of what art can achieve should regard with contempt the put-down, often quoted as final, from Peacock's *Headlong Hall.* Mr Gale the landscape gardener says, as he shows the guests round his latest achievement, "I distinguish the picturesque and the beautiful, and I add to them, in the laying-out of the grounds, a third and distinct character, which I call *unexpectedness*," to which Mr Milestone delivers the allegedly withering reply: "Pray, sir, by what name do you distinguish this character, when a person walks about the grounds a second time?" That art can be perennially surprising is one of its distinguishing features. To return to Bartok: that passage is disconcerting to a degree, more so even than the opening of the "Dissonance Quartet," since it enters in the course of a tense, hard-driven presto. The best that Peter Cahn, who writes the liner-notes for the Vegh Quartet's recording of the work, can say is: "This part has found various interpretations: Matyas Seiber drew a comparison to the collage technique of surrealism, while others saw in it an unconscious caricature [what of?] or even a grimace at those listeners who found his music too difficult. One will have problems coming to terms with Bartok's artistic seriousness with such a superficial perception of a puzzling phenomenon so unique in his work." Quite so; but one will have problems in any case, and I have not heard any account of a non-superficial perception of this phenomenon. The passage in the quartet continues to startle, and if its puzzling irrelevance ceases to puzzle that is again because one has permitted habituation to take the place of understanding. Since the work is, like the "Dissonance Quartet," by a master, and an impressive achievement, we tend either to feel that there must be a good reason why the passage is there, or that it would be a pity to allow it to spoil our enjoyment, so we say that we accept if for what it is, having no idea what that may be.

## VII

What I have been saying in the last couple of pages presupposes that we have a general notion of what understanding a piece of music

amounts to, and that might be challenged. But since the kind of experience that I have been dealing with in the cases of Mozart and Bartok Quartets is common, it is evident that however problematic the concept of understanding may be, there certainly is one, which we employ unselfconsciously. To single out the *con indifferenza* passage in the Bartok is to imply that one understands the context in which it is located; otherwise it would not be puzzling. And the kind of puzzlement one feels there is of the same kind as one feels when someone whom one knows quite well says or does something which is highly untypical of him, or for which the motive is inscrutable. It is not at all like not understanding a word or phrase in a sentence, where all one has to do is look it up in a dictionary. Nor does such a situation ever arise in music, which should by itself be enough to refute the idea that music is a language. If it is not agreed that that is enough, the disagreement might spring from two grounds: first, it may be pointed out that one often finds oneself not understanding a phrase in a poem, when one understands each of its constituent words but does not understand what the phrase is doing there, or what the particular word is doing in the phrase. Equally, one might fail to understand a passage in a novel or play – for instance, be wholly baffled as to why Edgar conceals his identity from the blind Gloucester in *King Lear*, or as to what some of the Fool's rhymes and other utterances mean, while grasping what each phrase or sentence means. But this has no bearing on music's being a language; rather it shows that our failure to understand some linguistic performances is similar to our failure to understand non-linguistic ones. In the case of Edgar failing to reveal himself, indeed, we have a non-linguistic performance, though one that is all set out in the text of the play. This is not a difficult point, but I suspect that the recurrent tendency to assimilate music to language may be partly the result of missing it; it is a fairly smooth transition from failing to understand a piece of music wholly or in part to failing to understand an utterance, and since even now the paradigm of understanding is often thought to be understanding linguistic performances, it has not sufficiently oc-curred to people that failure to understand the latter is often better to be assimilated to failure to understand non-linguistic behaviour than vice versa.

The second reason for disagreeing with my claim that if music were a language, there would be no excuse for its not possessing a dictionary, is that there could be a dictionary, but no one has got round to producing one yet. Actually the last assertion is not wholly

true: Deryck Cooke in his *The Language of Music*, that much-abused work, attempted to do exactly that, and indeed did produce what he called the elements of a musical vocabulary. The attempt, though heroic, is widely agreed to be a failure, though Cooke was not shaken by the criticisms that were made of it. But that it must be a failure is demonstrated by the method which Cooke employed in order to show that it could work. For he ransacked Western music of the last millennium to provide the strongest inductive support for the claim that, for example, a minor ninth always possesses diabolic implications, or that a rising phrase from dominant to tonic, and then up a major third, is expressive of outgoing joyfulness, and so on. There is an obvious snag in this procedure, as there is in M. C. Beardsley's inductive arrival at the canons of unity, intensity, and complexity as constitutive of great art. Unless one were able to tell in a single case that a minor ninth had diabolic connotations, the multiplication of cases would have no confirmatory force; and if one can tell in a single instance that property does inhere in a minor ninth, further examples are redundant. It might be replied that Cooke merely mistook the nature of his task, being philosophically naive, and that he could have saved himself the bother of collecting so many cases and simply listed the emotional quality of intervals or series of intervals, hoping that other musically sensitive people would agree, and that the formidable lists of examples could serve the purpose of persuading doubters that he was right – especially in the case of vocal instances, where the view that music has no emotional connotations is bound to come to grief, since we all agree that some settings of words are appropriate, and others not. Thus if one feels that Donna Elvira's aria "Mi tradi" in *Don Giovanni* is a failure, since one would never guess without knowing the words that she was complaining about the Don's betrayal of her, one can point out that the opening phrase of the aria is precisely expressive of joyfulness. One does not need other examples of the same series of notes to confirm that, but if one wanted them they are there to be found in many other places. In any event, the scope of such an enterprise as Cooke's is limited, and his attempts to demonstrate the large-scale workings of his musical vocabulary in detailed analyses of Mozart's Fortieth and Vaughan Williams's Sixth Symphonies are failures. It is easy to see why, though it would need to be spelled out at greater length than I have at my disposal. One conclusive point is that the context in which a musical phrase occurs has a determining effect on what the phrase is expressive of. It is a common procedure

to claim, for example, that the interval of a falling minor second is expressive of grief or depression, because it is like a sigh or other drooping sound of someone being vocally miserable; and then to instance the third and fourth, then the eleventh and twelfth notes of Tchaikovsky's Sixth Symphony, where deep gloom is unquestionably what is conveyed. But there are millions of falling minor seconds in traditional Western music where no such impression is conveyed, though that does not mean that the reason that the beginning of the "Pathétique" expresses gloom so successfully is something other than its series of brief phrases, many of which culminate and conclude with a minor seconds. In fact the second phrase ends with a major second, but in the context it is no less depressed. And when the *allegro non troppo* begins, the chattering theme again concludes with minor second, but the effect is quite different, partly owing to the tempo. Cooke was no fool, and I think he would concede this, but it renders his procedure invalid.

## VIII

I think that probably one of the reasons why music has seemed to many people to be a language built up out of expressive units which operate like the words in a sentence is that, especially during the nineteenth century, there are certain paradigmatically powerful works which include, often begin with, an extremely arresting phrase which has a strong expressive force. Thus there are the opening bars of Beethoven's Fifth Symphony, than which there could be nothing more assertive; the opening bars of *Tristan*, the *ne plus ultra* of passionate yearning; the opening bars of the "Hammerklavier Sonata," definitive of heroic resolution. It is no coincidence that program notes of the kind I referred to earlier are most readily produced for characteristic products of the nineteenth century, because its most celebrated symphonic and, in general, instrumental achievements are, roughly speaking, emotional narratives which it is possible and sensible to provide an account of, an account which will enable the listener to know where he has got to in these epics of the inner life. Nor is it surprising that Thomas Mann's *tours de force* of description of imaginary musical works in *Buddenbrooks* and *Doctor Faustus* are of late Romantic and post-Romantic works, just as the equally remarkable accounts of actual pieces that he gives in *Doctor Faustus* are of Beethoven's Sonata Opus 111 and of the Prelude to Act III of *Die Meistersinger*, the first a spiritual pilgrimage

and the second a psychological portrait. Such feats would not have been performable on *The Art of Fugue* or most of Haydn's instrumental works, for instance, not because they are not great and expressive, but because they are not concerned with the kind of struggles, the resolutions of violently opposed elements, and so forth, which are typical of, indeed define, the Romantic era in music as in much besides. When Bach wants to express the sinful soul's struggle to achieve salvation and its impotence to do so without lavish helpings of the Saviour's blood, he writes a cantata in which the words (few and frequently embarrassing) tell all that is required. Mendelssohn's often – too often – quoted remark about music not being too vague, but too precise to be put into words would not have been necessary a century earlier. Music either set words or, if it was instrumental, then with a few exceptions (quasi-pictorial, such as the opening of Haydn's *The Creation*) there would have been no question of putting it into words, even in the most approximate way. Who would attempt a program note of the kind I gave a mock example of for a Bach solo 'cello suite, or a Handel Concerto Grosso? – which is not to deny that Bach's cantatas, and some of the Chorale-preludes where the title is, as it were, the "theme," are rich in pictorial and other illustrative effects.

## IX

Understanding something is a matter either of being able to see or feel what its sense is, or what it refers to, or why it is as it is. The question I began with was how one can be said to understand music. Granted that music is not a language, understanding it is a matter of grasping why it is as it is. And I said that our most pressing question in this area is how we are best to express our understanding of music (by which I mean individual pieces of music). I think that there are both degrees and levels of understanding, though it is artificial to separate them as I am going to do for the purpose of clarity. I want to claim that something approaching a full understanding at one level may entail nothing as to understanding at another. For instance: the music-lover who finds that Schubert's Great C Major Symphony (usually referred to nowadays as number Nine) is a great and profound masterwork may be able to say very little, if anything, that would interest a musicologist, but might nonetheless be said to have a full understanding of that work at a certain level – it would be invidious to call the levels "lower" and "higher"; so by referring to

this first level as Level 1 I do not mean to say that it is "primitive" in any sense other than that it is the level at which it is necessary to understand a work if the other levels are to be of any aesthetic, as opposed to technical, interest. An elementary degree of understanding at Level 1 is a matter of sensing what the nature of the thematic material is, though I have deliberately chosen a work which has a very marked individuality but one which, at least for long periods, would not be at all readily characterizable in emotional terms. None of the material of the first movement, for example, is obviously cheerful, triumphant, foreboding, melancholy, or anything else out of *that* repertory. The hushed opening is gently lyrical, but as is the way in this work, is soon transformed into something much more emphatic, as it moves from individual instruments or groups of instruments to the full orchestra. The character of the main part of the movement is superabundant energy, with strongly inflected themes (rather than the melodies that one expects from Schubert) alternating with easy-going, swaying themes notable, again, more for their rhythmic nature than their melodic one. Certainly as the movement accelerates toward its close, and the opening andante theme is stentorianly announced, it acquires a triumphant character, but the triumph is that of something which, initially tentative in form, achieves a force which makes it a fitting climax to the enormous and wide-ranging movement. One has not understood it unless one grasps at every moment the way in which the thematic material is undergoing constant transformation; if one does grasp that, in the fullest detail, and is exhilarated by its progress, then one has understood the movement. I shall not continue in this vein, apart from briefly contrasting the second movement, which begins in a carefree way, with one of Schubert's "strolling" melodies, and has as its central feature the transformation of this comfortable melody into something strident and menacing, so that the climax of the movement, followed by two bars of silence, is of shattering intensity. If, as is conceivable, one did not realize that the dotted rhythm of the huge climax is derived from the opening nearly-but-not-quite jaunty theme, one would undoubtedly have missed the movement's point. The symphony is a crucial work partly because, as I said, it does not have a marked emotional character – or its constituent elements do not – but neither does it lack one. It is magnificent, sublime, one of the pinnacles of musical achievement. Yet in being so un-*weltanschaulich*, its importance cannot be accounted for in the way that one might try to account for that of the *Eroica*, say: which may or

may not indicate that the way in which the *Eroica*'s importance is most often explained is not the true ground of its greatness. Anyway, it seems to me that a full appreciation of the greatness of Schubert's Ninth Symphony leaves us with virtually nothing to say about what makes it so great; hence our understanding of at least some music comes to a sharp halt, unless we either move in the direction of natural science and find out what it does to us at a level that we have no direct knowledge of, say the neuro-physiological (and this may not be counted as a contribution to understanding its greatness at all), or else into the metaphysical zone in which the impact of such a work is explained in the *kind* of way that Schopenhauer explained the greatness of all music, though his explanation is no good, mainly because his metaphysics is faulty, but also because within his metaphysics music is allotted a place which is not, in detail, intelligible.

## X

I repeat that the level I have just been talking at and about is the primary one: if one does not respond to Schubert's Ninth Symphony in the kind of way I have sketched, one may as well not listen to it. The next level – Level 2 – is that at which one begins to explain its workings by talking of modulations, inversions, counterpoints, and the rest. I have said earlier that it would be absurd to deny oneself access to this vocabulary – in other words, to remain at Level 1 – because unless one recognizes the occurrence of the phenomena that are most efficiently designated in Level 2 terms one will not be hearing what is going on in the piece. I did nothing to settle earlier the question of the extent to which one should be able to specify at any given moment what is happening, or to give a more comprehensive account of the structure of a piece, in technical terms, and I am not at all clear as to the answer. It varies according to the type of music one is listening to. If it is a Bach fugue, then at least part of the effect is lost if one does not realize that Bach is, for example, combining at a certain point the opening subject in the bass with its inversion in the treble, and its retrograde inversion in the middle voice. And yet even if you are given that mildly alarming information, and understand what those terms mean, it may be impossible for you to hear it as that, because the retrograde inversion of a theme is for most people too unlike the original in most cases for the relationship to be aurally recognizable. It is tempting to say, if one

cannot hear such things, that they are a matter of the skill with which the work is constructed, not part of its artistic effect. But that distinction is not an easy one to sustain. Someone who can hear the retrograde inversion as that is likely to reply that part of his aesthetic satisfaction in the fugue comes from recognizing the skill which combines economy and diversifying ingenuity in the way that Bach does. And when something is pointed out that one *can* hear, it does tend to add to the satisfaction that the work gives. If someone said that it merely explained the effect that the work already had on him, but did not enhance it, I would be inclined not to believe him. But I would not be sure. By contrast, there are many works where the gap between the effect itself and how it is achieved is manifestly larger than it is in a Bach fugue, and while that is no doubt one reason why such works are more popular with the musically uneducated, I do not see why it should be taken as a reason, as it frequently is, for them to be less popular with the musically educated. There is a danger that if one is able to analyze music in great detail, and has a sharp ear for the results, one will prefer the music which lends itself to the most elaborate analysis, or analysis of a certain sort. And in the age of hi-tech criticism in which we live, that danger is particularly pronounced – it is also of course very evident in some species of contemporary literary criticism. However, there can be few of us who are unable to practice that kind of expertise who do not envy those who can, even if it does lead to a prejudice against the simple or otherwise unanalyzable.

### XI

Level 3 takes us from the realm of the technical – which naturally involves a certain amount of theory – into that of the explicitly theoretical. In this area, where the going can get rough, we encounter views which claim to explain, insofar as that can be done, what makes great music great, both in general and in particular cases. A specimen theory, stated much more simply than anyone who espouses any of these views would put it, might run as follows: a piece of music consists of background and foreground. The background consists of the common stock of rules and idioms in which the music of the time is written, and is presupposed by the piece, which will inevitably employ these rules extensively. The foreground is what the piece actually consists of. Expectations are formed for the competent listener by the rapidly recognized idiom of

the piece. If all one's expectations are fulfilled, it will be a mere collection of cliches, the musical small-talk of the time, and as boring as the average concerto by Vivaldi – wholly dependent on background – is. If none of one's expectations is fulfilled, it will be equally boring because wholly baffling, and one will rapidly cease to have any expectations at all, so there can be no such thing as surprise, fulfillment, and so forth (it will therefore have the same effect as a piece of music will have on a wholly incompetent listener, or one incompetent in that idiom). Hence successful music will strike a just balance between background and foreground: one will recognize the idiom, acquire expectations which will be partially fulfilled and partially pleasurably disappointed.

A full understanding of such a piece will involve seeing what the precise balance of background and foreground is, and in exploring the relationship between the two. Further, since a work's unity is a crucial concern, it will be necessary to investigate how what appear at first to be quite disparate melodic units, say, are in fact manifestations of an underlying single element; so one looks for a germ from which all thematic elements of the work derive. This highly condensed sketch is of a theory similar to that which Hans Keller has been propounding for the past thirty years, and it also has connections with the work of both Scheker and Hugo Leichtentritt. I am not concerned with its validity, but only with pointing out that it does operate at a different level from the other two. Like other theories of the general type, it is open to abuse and question. If a piece of music strikes one as powerful and unified, but there is no single thematic germ from which all its material can plausibly be derived, I cannot see that one should withdraw one's original estimate. But it is an attractive kind of theory nonetheless, with some intuitive plausibility.

## XII

Firm dividing lines are not to be drawn between the levels, though it will usually be clear to which level a given remark belongs. I hold quite strongly the view that a keen music-lover will certainly operate at Level 1, will often need to invoke items belonging on Level 2, and should be interested in theories of Level 3, without finding them necessary to his appreciation. But in this difficult and so far as I know unexplored area of musical aesthetics I have not been able to do more than raise issues which I think are of crucial importance,

and which are usually neglected for other issues, also crucial but possibly deserving a rest, and certainly not to be engaged in at the expense of what I have been discussing – especially since my subject has practical implications for the enjoyment of music, and ones urgently in need of further investigation.

# 6

# Understanding music

MALCOLM BUDD

I

Michael Tanner's interesting and wide-ranging essay raises a large number of issues: how the discontinuity of musical experience with the rest of our experience is compatible with music's importance to us; whether music is a language or a set of languages; whether our musical vocabulary, by itself or in conjunction with our non-musical vocabulary, enables us to characterize our experience of music adequately; what the relation is between technical and non-technical characterizations of music, and how important each of these is in the appreciation of music; what it is for a musical work to be fully coherent, and whether the coherence of one part of a work with the rest of the work can be established by musical analysis; what the understanding of music consists in and whether there are different kinds of understanding of a musical work; what determines the musical value of a piece of music. I shall not be able to take up each of these issues. I shall concentrate upon one of the topics that lies at the heart of the aesthetics of music: the nature of the experience that a listener has if he hears a musical work with understanding. And I shall begin by making two general points about the somewhat nebulous and polymorphous concept of understanding music. These points do not go against any of Tanner's suggestions – on the contrary, they are congenial to his approach.

II

The first point is this: a person's understanding of music can be assessed along a number of different dimensions. His understanding of a particular piece of music can be more or less deep and it can be

more or less accurate (or precise); and his understanding of music in general can be more or less extensive and it can be more or less subtle. I shall now explain what I mean by these categories.

Someone's understanding of a musical work can be said to be superficial if, although he can follow a performance of the work without feeling lost, he fails to hear much of the significant detail or structure of the work. His understanding of a musical work can be said to be inaccurate (or imprecise) if, although he can follow a performance of the work well, he has a mistaken (or only a rather indefinite) conception of how the music should sound, and so how it should be performed. This defect in musical understanding is naturally most apparent in someone who does perform music: it is often true that someone can experience a performance of work with understanding and yet have an incorrect (or imprecise) understanding of the work itself, as is manifested in the way he plays the work or thinks it should be played. He is blind to subtle but all-important features of a composer's style and, as we say, he has little feeling for the music of that composer. Accordingly, one aspect of musical understanding – understanding a particular musical work – is knowing how the work should sound in performance. And this understanding is open to someone who cannot perform the work, just as much as to someone who can. The third category of understanding is this: someone's understanding of music can be said to be narrow if it covers few kinds or styles of music, either in the sense that he is not able to follow most forms of music, or in the sense that he is not able to appreciate most forms of music, i.e., to see what there is of value in them. Finally, someone's understanding of music can be said to be primitive if he can respond only to the simplest musical relations and structures. There are, of course, connections between these various aspects of musical understanding, but I shall not elaborate them.

In some respects, the idea of understanding a work of art resembles the idea of understanding a game – a game of tennis, for example. A spectator who understands the rules of tennis can have a more or less refined understanding of any game that he watches; and since the rewards of a refined understanding are not the same as, and are not essentially linked to, those of a coarse understanding, the preferences amongst games of tennis of those with a refined understanding will not be the same as those with a coarse understanding. A coarse understanding does not appreciate the finer points of a player's skill, tactics, and so on: it neither realizes that, nor understands how, a

115

player played a certain shot (e.g., with topspin), nor does it understand why the player played that particular shot – what the player was attempting to do, and why that particular thing and not something else. Consequently, the manner in which someone with a coarse understanding of the game perceives the game will not be the same as that in which someone with a refined understanding perceives the game: the concepts that inform the perceptions of someone with a refined understanding – the concepts under which he perceives various occurrences in the game – will not inform the perceptions of someone with a coarse understanding. And, hence, a game that someone with a coarse understanding finds unrewarding may be found rewarding by someone with a refined understanding, and vice versa. Artistic understanding, and musical understanding in particular, is susceptible of refinement (and so of education) in a similar fashion. The question of *which* concepts must inform someone's experience of musical work, and the way in which they must inform it, if he is to understand the work, or to understand it in a refined manner – in particular, whether these include technical concepts of musical theory – is something I shall return to later.

### III

The second general point is this: the kinds of condition that someone's experience of a musical work must satisfy if he is to experience the work with understanding vary from work to work. It follows that it would be wrong to identify the idea of musical understanding of a work with the idea of understanding a work's intrinsic, intramusical, non-referential meaning, where such understanding consists in being able to follow the work's specifically musical development. Musical understanding does not have this as its essence. For musical works differ from one another in the kinds of aspects of music that they utilize and in the exploitation of the possibilities open to a composer. Hence, what is necessary for the appreciation of one work is not always necessary for the appreciation of any other (and not just in the trivial sense that the experience of one work will not be the same as the experience of a work that composes tones in a different manner from that of the first work). There is no illuminating general answer to the question "How must someone hear a piece of music if he is to appreciate its appeal as a piece of music?"

It is of course easy in particular cases to specify necessary conditions of someone's understanding a musical work. The point is that

in some cases these conditions will not be applicable to many other musical works, for there are features of some pieces of music which are such that their recognition or realization is essential to the music's appreciation, but which most pieces of music lack. For example, a musical work may contain a specific reference to another piece of music (as in musical quotation, for instance), or it may make a specific reference to a particular composer's work (as in one kind of musical parody), or it may make an indefinite reference to music of a certain kind (as in another kind of musical parody). Thus: a phrase in the thirteenth variation of Elgar's *Enigma Variations* is a quotation from Mendelssohn's *Calm Sea and Prosperous Voyage* overture: Casella's *Entr'acte pour un drame en préparation* is a parody of Debussy; Mozart's *A Musical Joke* is a parody of the crass and mechanical application of eighteenth-century formulas to trivial and ridiculous material – it is deliberately infelicitous, as some music is non-deliberately infelicitous. In each of these cases there is a specific intention of the composer that a listener must recognize if his understanding of the work is not to be incomplete: he must realize that the quotation *is* a quotation and that Elgar intended that the listener's response to the music should be mediated by his familiarity with Mendelssohn's work: he must realize that Casella's intention was to construct a work that imitated certain features of Debussy's style of composition; he must realize that Mozart intended the listener to be amused at what would be the work's musical faults if the work were intended as a serious composition and not as a joke. And the listener is in a position to appreciate the value of these works only if he does not merely recognize the composer's intention but possesses the familiarities or responses that the works presuppose.

In each of these cases the music refers to something outside itself – to other musical works or to other kinds of music – and it is integral to the understanding of the music that it should be experienced with recognition of the composer's intention that the music should make this reference. And there are many other ways in which a musical work can make an essential reference to other music. But not all music refers (in this sense) to other musical works or to other kinds of music, or even to anything outside itself. Hence, the recognition of the composer's intention that his work should not just be music but should refer to other music is sometimes, but not always, a necessary condition of understanding the work. And of course there are many other kinds of condition that are in some but not all cases necessary conditions for understanding a musical work.[1]

But the fact that musical understanding does not have an essence does not imply that it does not have a common core – the understanding of music's intrinsic, non-referential nature. It is clear that it is this specifically musical understanding that Alban Berg is referring to in the following passage from his essay "Why is Schönberg's Music so Difficult to Understand?":

> to recognise the beginning, course and ending of all melodies, to hear the sounding-together of the voices not as a chance phenomenon but as harmonies and harmonic progressions, to trace smaller and larger relationships and contrasts as what they are – to put it briefly: to follow a piece of music as one follows the words of a poem in a language that one has mastered through and through means the same – for one who possesses the gift of thinking musically – as understanding the work itself.[2]

If we wish to grasp the heart of musical understanding we must identify the basic aspects or elements of music and consider what is involved in understanding a musical work insofar as it consists of constructions or compositions of these elements or aspects.

IV

Before I consider the idea of specifically musical understanding, I wish to make a brief comment on the question of the adequacy of our language for describing the experience of music, where the experience of music is understood as the auditory experience of music and does not include any emotional response, for example, to what is heard. It is clear that it is no more possible to describe in detail the nature of a musical work (and so also the nature of our experience of the work) without using the vocabulary of musical theory than it is possible to describe in detail the nature of a painting without using color vocabulary. But this does not imply that the vocabulary of musical theory is sufficient to describe all the musically relevant relations between the items for which the theory has names or descriptions, any more than the corresponding fact about painting implies that color vocabulary is sufficient to describe all the aesthetically or artistically relevant visual relations between colored items. Nevertheless, in each case, for any artistically relevant relation that the vocabulary in question cannot specify the vocabulary can in principle be supplemented by a name of that relation. The new vocabulary may contain terms of a different nature from those of the original vocabulary and so may constitute a new or mixed kind of vocabulary; but the inadequacy of the original vocabulary is not

irremediable. It is a moot point how adequate the vocabulary of musical theory is to its object. For example, some people believe that there are important audible features of musical works that this vocabulary does not have the means to describe, and that if we are to talk about these features we must have recourse to our non-musical language used figuratively. This is the position of those who maintain that the application of emotive words to music is to be understood metaphorically, as a means of drawing attention to purely audible features of music which we have no other more direct or more suitable means of indicating. Of course, if this were so, and if this were the sole function, or the only proper function, of emotive terms when applied to music, there would be no reason in principle why our musical vocabulary should not be supplemented by terms introduced as names of these features of music and the metaphorical use of emotive terms dispensed with. This would be an application of the general principle that mere inadequacies of vocabulary are remediable. It is an important issue whether the use of emotive words to characterize music should be understood in this eliminable way. But I do not wish to enter once again this familiar territory and I shall say nothing about the description of music by terms drawn from the language of the emotions. Instead, I shall consider a different issue about the connection between musical experience and metaphor, an issue that returns us to the topic of identifying, and perhaps analyzing, the fundamental features of musical understanding. What I propose to do is examine the claim articulated by Roger Scruton in his account of understanding music that metaphor lies at the heart of musical experience and cannot be expelled from it.[3] An examination of this claim helps to clarify an important characteristic of musical understanding. It will be necessary for me to present Scruton's position in a highly schematic form, but one which, I believe, does not misrepresent it.

V

Scruton distinguishes two modes of understanding something (a sequence of sounds, for example): scientific understanding and intentional understanding. Whereas scientific understanding is concerned with the world as material object, and attempts to explain the world's appearance to people, intentional understanding is concerned with the world as intentional object, and confines itself to the nature, not the explanation, of the world's appearance. In fact,

intentional understanding of something consists in a certain kind of experience of that thing. In this experience the thing appears a particular way, and it is this appearance that provides the essence of the intentional understanding of the thing. The understanding of music – as it is realized in experiencing a (performance of a) musical work with understanding – is a form of intentional understanding. Hence, an account of musical understanding will be a description of the nature of the required or appropriate appearance: at the most general level, it will describe the kinds of experience someone has when he experiences sounds in one or another of the ways in which it is necessary that he should if he is to hear the sounds as music, and, at a more specific level, it will describe the experience that someone must have if the sounds he hears are to appear to him in the way in which it is necessary that they should if he is to experience them with full understanding as (a performance of) the work they compose.

For Scruton, the fundamental distinction that needs to be clarified in an account of musical understanding is the distinction between hearing sounds only as sounds and hearing sounds as tones. This distinction can be represented as the distinction between hearing sounds only as sounds and hearing sounds as having melodic, rhythmic, or harmonic implications. Accordingly, the basic elements of musical understanding are the experiences of melody, rhythm, and harmony. Hence, if we are to have an account of musical understanding, it is necessary to describe the nature of the experiences of melody, rhythm and harmony. Scruton maintains that these experiences can be described, but only by means of metaphors. These metaphors transfer extra-musical ideas to the experience of sound and convert the experience of mere sound into the experience of the elements of music. It is when, and only when, sounds are experienced in accordance with these metaphors that they are experienced as music. The extra-musical ideas that occur in these metaphors inform the experiences of melody, rhythm, and harmony – they form part of the content of these experiences – but only in a metaphorical sense; and it is the metaphorical incorporation of these extra-musical ideas that distinguishes the experiences of the basic elements of musical understanding from experiences that are perceptions of the same sounds but which do not involve experiencing the sounds as music. The extra-musical ideas contained within these metaphors are mainly spatial concepts. Thus: to hear a melody in a series of sounds the sounds that compose the melody must be heard

as moving (in space); to hear a rhythm in a series of sounds the sounds must be heard as moving in a particular manner, namely, as if they were dancing; to hear harmony in sounds the sounds must be heard as chords, and chords must be heard as spaced, open, filled, or hollow, for example, and as involving tension, relaxation, conflict, and resolution. But the sounds in which melody, rhythm, and harmony are heard do not literally move, dance, and so on – they move and dance only metaphorically.

It is clear that we must distinguish two theses – the one uncontroversial, the other problematic – that Scruton tends to run together in his account. The uncontroversial thesis is:

(i) There is more to the perception of melody, rhythm and harmony in a succession of sounds than the perception of the succession of sounds.

This thesis is uncontroversial, since it is certainly not a sufficient condition for someone to perceive melody, rhythm, and harmony in a succession of sounds that he should perceive a succession of sounds in which these musical phenomena can be heard. The problematic thesis is:

(ii) The perception of melody, rhythm and harmony in a succession of sounds is distinguished from the mere perception of the succession of sounds by the fact that the former perceptions involve the metaphorical transference to the sounds of the idea of movement (and so of space), the idea of dancing and the idea of composite three-dimensional spatial entities in various conditions of stress. This metaphorical transference is an ineliminable feature of the experience of melody, rhythm and harmony.

I believe that Scruton's problematic thesis is vulnerable in two different ways: there is an objection of principle to the kind of account he proposes – an account that assigns a crucial role to the notion of metaphor – and there are objections to the details of his account, which credit spatial concepts with an irreplaceable significance in the description of musical experience. The objection of principle is as follows. Even if the arguments Scruton advances were sufficient to establish an essential relation between the experience of melody and the concept of movement, or between the experience of rhythm and the more specific concept of dancing, and so on, to call the description of the nature of these experiences by means of the related concepts *metaphorical* is not to specify the alleged relation: the relation between the experience and the property signified by the concept, or the way in which the concept informs the experience of

121

the sounds, is not illuminated by the notion of the metaphorical transference of the concepts or properties to the experience. For any metaphor stands in need of interpretation; a metaphor is susceptible of indefinitely many interpretations; and an interpretation of a metaphor is the injection of significance into it, not the extraction of significance from it. But not only does Scruton fail to suggest an interpretation of the metaphors that are supposed to lie at the heart of musical experience, he appears to hold that an interpretation is both unnecessary and unavailable. An interpretation is unavailable because the characterization of musical experience by means of the concepts in question is – even though metaphorical – ideally specific: they specify properties of musical experience that cannot be characterized adequately without the use of these concepts. And this position is incoherent: musical experience cannot have a merely metaphorical essence (or an essence part of which is merely metaphorical).

This conclusion might be resisted in the following way. It is often true that when someone utters a metaphor he has not already thought what its exact significance should be. Accordingly, if someone thinks in metaphor it can be true that his state of mind can be specified adequately only by means of the metaphor in the terms of which he thinks. Hence, if an uninterpreted metaphorical thought were to be embedded in some way in a perceptual experience, it would be essential to the complete specification of the experience that it should use the embedded metaphor. And if this were to be the fashion in which metaphors lie at the heart of musical experience, musical experience would have a merely metaphorical essence. But I believe that this mode of resistance to the conclusion would be unfounded. An initial difficulty with this suggestion is that it is unclear how a metaphor could be part of the content of a perceptual experience. But even if this difficulty were to be overcome the suggestion would not be acceptable. For it is clear that it is unnecessary to think the (metaphorical) thoughts "These sounds are moving," "These sounds are dancing," "This sound is hollow and tense (say)" in order to experience melody, rhythm, and harmony in the sounds heard.

It follows that if the concepts Scruton highlights are integral to musical experience, they must enter the experience of music in some other fashion than by metaphorical transference. But in fact the thesis that these concepts inform the experience of the basic elements of music, and the arguments Scruton advances in its

support, are unconvincing. I shall confine attention to the case of rhythm, where Scruton's position is conspicuously weak.

The claim that the experience of rhythm must be described in terms of the concept of dancing is unattractive, if for no other reason than that the concept of dancing contains the concept of rhythm: someone dances only if he moves rhythmically. Hence, the concept of dancing, rather than being used to explain the concept of rhythm – albeit by a metaphorical use – presupposes the concept of rhythm. And the claim is unwarranted. Scruton is led to adopt it partly because he sees it as the solution to the problem of distinguishing the experience of rhythm from the experience of a temporal pattern. But this solution is desperate and unnecessary. For the experience of rhythm in a sequence of sounds and rests can be adequately characterized in the following manner: (i) it does not require that the sounds should be heard as differing in pitch, timbre, duration, or loudness, and (ii) the sequence must be heard as grouped into units in which one element is heard as accented (prominent, salient) relative to the others.[4] And the different rhythms are the different ways in which unaccented elements are heard as grouped in relation to an accented element. Hence, we can agree with the thesis that the experience of rhythm in music is (in Scruton's terminology) a form of intentional understanding of sounds, whilst rejecting the view that the experience of rhythm must be explained by reference to the idea of dancing and the notion of metaphor. And I believe that a similar conclusion holds for the corresponding claims about melody and harmony[5] In particular, the notion of movement in space is not integral to the experience of melody and harmony.

A more perspicuous way of expressing the nature of the experience of rhythm is available if we make use of the distinction between sensational and representational properties of perceptual experiences, in the sense given to these notions by Christopher Peacocke.[6] For rhythm is a sensational, not a representational, property of the experience of a musical work.[7] The familiar facts that Scruton adduces in support of the uncontroversial thesis that there is more to the perception of rhythm in a succession of sounds than the perception of the succession of sounds – especially the fact that the world can be represented to the perceiver as being exactly the same in two experiences, only one of which involves the experience of rhythm, or both of which involve the experience of rhythm but the rhythms experienced are different – show at most that rhythm is not a representational property of musical experience. And the facts used

to support the uncontroversial theses about melody and harmony show only that melody and harmony are not representational properties of musical experience. From the fact that we describe music in metaphorical terms, and the uncontroversial thesis that when we hear sounds as music the music is (in Scruton's terminology) the intentional object of our experience, Scruton reaches the conclusion that the essence of the intentional object of musical experience is constituted by the metaphorical transference of extra-musical ideas to sounds. And this step is facilitated by his undiscriminating concepts of appearance and intentional object. For the notion of appearance can cover either the representational or the sensational properties of perceptual experience or both kinds of property. If we consider the question of how sounds must appear to someone if he is to hear them as music, and if we are not careful to distinguish what someone's experience represents to him as being the nature of his environment from what else may be true of the experience, then the recognition that sounds heard as music do not thereby present the illusion of movement and that we speak metaphorically of movement in music can encourage the view that the distinction between sounds heard as music and sounds not heard as music is that in the former case the sounds do appear as moving, *not literally but only through the veil of metaphor*. But this would be false encouragement. The right interpretation of the situation is this: when sounds are experienced as music the experience possesses various sensational properties, and these properties are sometimes referred to by the use of metaphor.

It is, I believe, the fact that the most fundamental features of musical experience – those that lie at the heart of musical understanding – are not representational but instead sensational properties of the experience, and that these are not experienced at all, or only with rare exceptions, or only in non-composite forms outside music that explains the inclination to think of music as essentially an abstract art only loosely rooted in the extra-musical world. But whatever the value of this suggestion, an important part of the answer to the question "What is involved in experiencing a musical work with understanding, in so far as it consists of compositions of the basic elements of music?" is that the experience consists in experiencing the work in such a manner that the experience possesses not just the representational but the sensational properties required by the work (if, indeed, the performance allows this to take place). To the degree that it is difficult for a listener to experience a work with the right sensational properties, the work is difficult for

him to understand. It is, of course, a matter to be decided by musical criticism what the required properties are in the case of any specific musical work.

<div align="center">VI</div>

I now turn to the question whether it is necessary that someone should possess specifically musical concepts, or a mastery of specifically musical terminology, if he is to be able to experience a musical work with full understanding.

The possession of a concept that applies to musical events is not the same as the ability to classify musical events on the basis of their sound by using the concept: someone can possess a musical concept and yet be quite unable to apply the concept to music as he listens to the music. Now in general neither the lack of a certain concept of a particular phenomenon nor the inability to recognize instances of the phenomenon as falling under the concept prevents a person from being sensitive to the presence of the phenomenon in a work of art and alive to the aesthetic or artistic function of the phenomenon in the work. In the case of music, a listener does not need to have the concept of, say, a dominant seventh chord, that is, the concept of a major triad plus the note which forms with the root of the triad the interval of a minor seventh – a chord that in a major scale can be built only on the dominant – in order to have a full sensitivity to the harmonic implications of such a chord in a work he is listening to. And since he does not need to possess the concept, he does not need to bring the chord under the concept when he hears the chord if he is to experience the work with understanding.

The truth of the matter is that what much specifically musical vocabulary enables one to do is to name or describe phenomena that someone without a mastery of the vocabulary can hear equally well. The relation between the experience of music and the vocabulary designed to describe music is in one respect the same as the relation between the experience of lingual taste and the words used to describe taste. Just as someone's ability to characterize the variety and complexity of the tastes he experiences can fall far short of that variety and complexity, so someone's ability to characterize his experience of musical works can fail to do justice to many of the features of the experience. In both cases, whether through ignorance of the available words or through inability to identify instances of the phenomena they designate, a person's linguistic resources can be

<div align="center">125</div>

inadequate to the articulation of his experience. And the inarticulacy in the face of experience is of the same order: in neither case does it limit the person's experience to what he can articulate. It is true that inarticulateness is often a result of lack of vividness or delicacy of perception. And, as Collingwood insisted, a person's experience can be transformed by his coming to be able to express it. But neither of these is inevitable: an experience that someone cannot articulate need not lack strength or detail, and no transformation of the experience needs to occur if its subject acquires the capacity to render it in words.

To experience music with musical understanding a listener must perceive various kinds of musical processes, structures, and relationships. But to perceive phrasing, cadences, and harmonic progressions, for example, does not require the listener to conceptualize them in musical terms. A listener can experience these phenomena whether or not he hears them under the description they are given in a correct analysis of the music. This description applies to the experience of a listener who experiences the music with understanding; but the listener does not need to recognize this fact in order to have the experience it describes. Hence, the value to the listener of a mastery of musical terminology is not that it enables him to have an experience that is denied to someone who lacks the mastery: the experience of listening to a musical work with musical understanding. It is true that the acquisition of a musical vocabulary, especially if it includes the ability to recognize by ear the phenomena that the terms designate, is likely to involve an enhancement of the understanding of music: the sensitivity of the ear to musical patterns and relationships can be increased. But the ability to articulate music in musical terms is essential not in order to experience music with understanding but to understand and engage in the practice of musical analysis and criticism. The task of musical analysis is to explain, first, what the relationships among events in a particular musical work are, and, accordingly, how they are experienced by a listener who experiences a correct performance of the work with understanding; and, secondly, why the music is as it is, for example, what the structure and function of a particular harmonic progression is, whether a tone or harmony is structurally essential or ornamental, why a theme is to be phrased in a certain way, why the music must be taken at a particular tempo. And this task can be discharged only by the use of technical terms that have been developed to describe

the nature of musical events in detail. Consequently, perceptive criticism of a musical work, which must be based not only upon accurate perception of the nature of the work but also on accurate and detailed description of this nature, must be technical. Hence, the musically literate listener is in a more desirable position than the illiterate listener, not with respect to experiencing music with understanding but in his capacity to make clear both to himself and to others the reasons for his musical preferences. At a level of explanation beyond the most crude the musically illiterate listener is not only condemned to silence: he is not in a position to comprehend his own responses to music.

## NOTES

1 It is true that these conditions could be made universally applicable by writing them in a hypothetical form. But this does not affect the point that the requirements imposed on understanding a musical work can be more or less demanding and can be of diverse kinds.
2 Alban Berg, "Why is Schönberg's Music so Difficult to Understand?" in Willi Reich, *The Life and Work of Alban Berg* (London, Thames and Hudson, 1965).
3 Roger Scruton, "Understanding Music" in his *The Aesthetic Understanding* (London and New York, Methuen, 1983).
4 Compare the account of rhythm in Grosvenor Cooper and Leonard B. Meyer, *The Rhythmic Structure of Music* (Chicago, University of Chicago Press, 1960). The concept of rhythm in music can be understood in a number of ways. The account I have offered applies to the concept Scruton is concerned with. It is of course true that the nature of the rhythm we experience in a sequence of sounds that exhibit differences in one or more of the variables of pitch, timbre, duration, or loudness is dependent upon these differences. But the experience of rhythm does not itself require that any such differences should be heard, or should seem to be heard, in a sequence of sounds that is experienced as rhythmically organized.
5 In fact, a relatively unified musical work is essentially a hierarchical structure of temporal groupings. It consists of phenomena grouped into units that are more or less complete in themselves, but which are combined with other units to form higher-level groupings with a more inclusive sense of completeness, thus making the work a composition of elements on different hierarchical levels. The importance of this kind of organization in music, and its significance in the understanding of music, is illustrated exceptionally well in Leonard B. Meyer, *Explaining Music* (Berkeley, Los Angeles, and London, University of California Press, 1973), Chapter 4.

6 Christopher Peacocke, *Sense and Content* (Oxford, Clarendon Press, 1983), Chapter 1. The terminology of "representational" and "sensational" properties of experience, although more discriminating, and hence more perspicuous, than the terminology of "intentional" object might be misleading in either of two ways. First, it might suggest that sensational properties of experience are properties of the same kind as those that are definitive of bodily sensations. Second, it might suggest that the class of sensational properties is more homogenous than in fact it is. Neither of these suggestions is intended to be carried by the term "sensational property." The essence of the distinction is that between properties an experience has in virtue of the fact that it represents the environment as being a certain way and properties it has in virtue of some other aspect of the experience. [Added 1999: I had ceased to believe that rhythm, melody, and harmony should be thought of as sensational properties of musical experience even before the original publication of this essay.]

7 Peacocke regards "grouping" phenomena, of which rhythm is a particular instance, as sensational properties of experience. One of his reasons for this view is that grouping properties can be found in experiences which have no representational properties. But I do not find his example convincing: my experience in listening to the rhythms produced by a solo drum-player is *not* lacking in representational properties.

# Musical performance as analytical communication

FRED EVERETT MAUS

## PUZZLING EXPERIENCES

In my first year as a graduate student of music theory, I took a seminar on the relation between analysis and performance of classical music. The topic intrigued me; I had known of some writings on the subject, but I had not devoted sustained thought to the interaction of analysis and performance before. I was eager to understand the relations between two activities, each of which had already engaged me deeply.

The class meetings usually involved detailed analytical discussion of a piece, along with comments on the implications of the analysis for various performance decisions. The analyses covered a range of topics, but voice-leading, phrase structure, meter, and rhythm came up frequently. After the analytical discussion, there would be performance of some or all of the piece, typically by the teacher but sometimes by students. (Parts of the piece might be performed during the analytical discussion, also, but the most significant performances came after we reached analytical conclusions and derived some consequences for performance.) Performances led to further conversation, evaluating their success in responding to the analytical discussion.

I found the class exciting. Often, the performances seemed magically illuminating, and it was hard to doubt that analytical awareness contributed decisively to their clarity and intelligence. I praised the course highly to one of my undergraduate teachers, telling him that after such a course one simply did not hear music the same way.

A few months after the course ended, the teacher gave a solo piano recital. I had not heard him perform except in the classroom, and I was eager to hear him play a whole program in public. I did not

know what to expect. But I thought that the recital, at best, would offer a prolonged experience of the remarkable lucidity that had characterized many performances during the seminar.

Instead I found the concert bewildering. Many details of performance choice took me by surprise and, to my consternation, I was unable to integrate them into a comprehensive understanding of the music. For some of the pieces on the program, I already had analytical ideas and performance habits of my own; the differences between the way I had played or imagined the music, and what I heard in the concert, made it difficult to take in the performance. But even when I was not fighting off preconceptions, I still found that the performances fell far short of the lucid exposition that I thought I might hear. The difference between the impact of performances in the classroom and this public performance was striking.

How was I to understand this disappointing experience? Perhaps the performances at the recital were just not very good. But this was the same pianist whose performances in class had seemed so articulate. Perhaps the performances were fine, and I was just a bit slow at getting their point. But I had not been slow to understand the performances in the classroom.

Another member of the audience, greeting the performer afterward, said that he wanted to talk later about one of the pieces on the program, to hear the pianist's ideas about it. I was surprised to overhear this remark, and wondered if it had been tactless. If one heard the performance, and still needed to talk to the performer about his ideas, did that imply that the performance was a failure? Would a good performance not communicate the performer's ideas adequately, all by itself?

The conjunction of an apparently successful seminar on analysis and performance with my unsuccessful attempt to recover analytical insights from a performance was thought-provoking. What was going on in the classroom when we were discussing analysis and performance? During the course, I thought I knew what I was learning; now I was less sure.

## THE STANDARD CONCEPTION

The ideas I encountered in my first course on analysis and performance were not idiosyncratic; the conception of the relation between performance and analysis that guided that course pervades published writings on the subject. It is common enough that I shall

refer to it as "the standard conception" of this relationship. Charles Burkhart's essay on "Schenker's Theory of Levels and Musical Performance" can provide a clear illustration.[1]

Burkhart notes that "Schenker saw his theory as revealing the music's 'content'." By revealing this content, the theory "provided the performer with valuable objective information applicable to performance, thereby decreasing the performer's need to rely on guesswork and personal fancy (96)." Burkhart considers several examples in light of this attitude. His discussion of a moment in the third movement of Beethoven's Sonata, Op. 7, will show the approach. (Example 1 gives a score of the movement.)

Burkhart observes that there are no legato slurs in the melody at mm. 61 and 62; the performer must decide how to relate the successive melodic notes at these points. Then, in order to address this necessary decision, Burkhart provides an analytical observation. He suggests that mm. 58 – 68 present an enlarged form of the motive that first appears in m. 4: e♭ – g – ♭♭ expands and alters to become the e♭ – g♭ – a of the later passage. Burkhart continues by indicating the implications for performance: "Now the 'hard' advice that this analysis gives to the performer must surely be to 'bring out' this enlarged motive somehow. There are various ways to do this, but a very direct one would be to lift the right hand before striking the e♭ in bar 62. Slurring into the e♭ can easily obscure the motivic relationship (102)." Having made an analytical observation, Burkhart moves to performance instructions by assuming that the performer should somehow "bring out" the same features as the analytical claim.

This reasoning reflects a general position that Burkhart shares with other well-known writers on analysis and performance. I can summarize the general position in three claims. (1) Analysis discovers facts about musical works. (2) Performance is a means of communicating facts about musical works. (3) The facts that performers "bring out" are, at least in a range of important cases, the same as the facts that analysts discover.

Since Burkhart's essay concerns Schenker's views on analysis and performance, one might assume that this general position is distinctively Schenkerian. William Rothstein summarizes Schenker's views in very similar terms: "To [Schenker's] way of thinking, performance is the means of making audible that which is already objectively there in the work ... [But the performer should not] assume that the structure of the work will express itself adequately without his help.

Example 1

Rather, he must seek those means that will communicate the structure and the affect of the work as clearly as possible."[2] For Schenker, something is true of the work, and the performer's task is to find a means of communicating it.

But the position I have summarized is shared by writers who differ on many other theoretical matters, and who differ from Schenker in other important areas of theory. It dominates a well-known non-Schenkerian book on the topic, Edward T. Cone's *Musical Form and*

*Musical Performance.*[3] In the book, Cone asks how one can "achieve valid and effective musical performance (12)," and answers: "by discovering and making clear the rhythmic life of the composition (31)." Or, as he puts it in another formulation, "valid performance depends primarily on the perception and communication of the rhythmic life of a composition (38)." Both formulations emphasize a cognitive component (perception or discovery) and a communicative component. Analysis, on Cone's view, should uncover facts about the rhythmic life of the piece, and the performance should communicate these facts.

The conception of performance as a kind of discourse about the piece leads Cone to write about performance in linguistic metaphors. He writes that "the more complex ... the composition, the more relationships its performance must be prepared to explain (33–34)," as though a performer, like an analyst, explains the relationships in the piece. With reference to a piece by Mozart, he writes of a "kind of performance" that "emphasizes the fact that the melodic descent to the tonic is, in such a position, only a local detail (44)," as though a performer, like an analyst, issues factual statements about the hierarchical relations of events.

Similarly, Peter Westergaard devotes a chapter of his textbook on tonal theory to "some of the means the performer can use to make the structure of a passage clear to his listener."[4] Westergaard summarizes the performer's tasks: "It is up to the performer to use not only any means specified by the composer, but also whatever other means he needs to make the sense of the passage clear to his listener. In other words, he must not only understand the sense of the passage, but be able to decide which means are best suited to project that sense." Westergaard's formulation brings out with particular clarity the basic dualism that underlies this view of performance, the distinction between the "what" and the "how" of a performer's communicative act. One thing, the sense of a passage, is communicated by means of something else, the details of the particular performance.

Again, Wallace Berry explains the contribution of analysis to performance: "The musical experience is richest when functional elements of shape, continuity, vitality, and direction have been sharply discerned in analysis, and construed as a basis for the intellectual awareness which must underlie truly illuminating interpretation." Berry continues with an encapsulation of his view: "In that sense, a good performance is a portrayal, a critical discourse on the conceived meaning of a work ..."[5] And again, Nicholas Cook

writes warmly that, for Furtwängler, "tempo modification was the primary means for creating what are, in effect, analyses in sound."[6]

The position these writers share is that the performer is like an analyst, except that the performer conveys analytical information by performing rather than by talking or writing. Performance decisions translate analytical insights into a kind of sonic code, and presumably listeners who understand the code can recover the analytical points.

Performance as analytical communication: this conception has the pleasantly paradoxical quality of many good metaphors. But it also might shape evaluations of theory and performance in certain ways. If performance amounts to a form of analytical discourse then performers, like analysts and other scholars, would appear to be in the highly respectable business of cognitive communication. This idea might enhance the intellectual prestige of performers, at least in circles where scholarly pursuits are more prestigious than practice or craft. Alternatively, in a setting such as a conservatory, where performers have high status and the role of theorists may seem obscure, the standard conception might enhance the musical prestige of theory teachers. It guarantees the relevance of required courses in theory and analysis, in a remarkably direct way; the standard conception gives an answer to the student or performance instructor who asks about the value of theory and analysis.

## Practical problems with the standard conception

But it is not easy to work out the details of this conception in a plausible way. To see some of the problems, we can return to Burkhart's performance suggestion about Beethoven's Op. 7. It is worth lingering over this example because it is typical of much writing about performance and analysis, no better or worse than many other examples one could find.

In particular, if there is any problem with Burkhart's performance advice, the problem does not arise from the analytical point, which is attractive: it is pleasing to hear mm. 58 – 68 as a slow, smooth, filled-in version of the abrupt, jumpy motive from m. 4. In fact, one can take the point further. Much of the movement can be heard as a series of responses to the first four-measure phrase, which juxtaposes the smooth, gentle motion of mm. 1 – 3 with the somewhat inappropriate-sounding figure that ends the phrase; mm. 58 – 68, then, can be heard as an extreme attempt to modify the character of the motive.

Example 2a

Example 2b

But, in general, it is not obvious that motivic relations require that a performer somehow "bring them out," and sometimes it seems that special emphasis on a motivic connection would be a mistake. Donald F. Tovey provides a nice illustration of this point in his performance notes on the first movement of Beethoven's Sonata, Op. 109.[7] Example 2a shows a passage near the end of the movement. At m. 78, marked with an arrow, a long phrase begins; the phrase includes material from an earlier phrase, shown in Ex. 2b, but the long phrase in mm. 78 – 85 begins before the citation and continues after it. Beethoven's slur begins with the g♯ in m. 78; that is, the slur does not reflect the beginning of the motivic material. Tovey instructs the performer: "Begin your legato on the first of the bar as Beethoven tells you, neither joining it to the previous chords nor separating it from the c♯ which initiates an allusion to [the] figure … of bars 21 – 25." And Tovey continues, somewhat testily: "The joints of melodies and of other living things are not served up at table." Tovey implies, correctly I think, that an articulation,

intended to "bring out" the motivic relation, would be unattractively didactic.

Perhaps the passage from Op. 109 is different from the passage Burkhart discusses; the motivic connection in Op. 109 is pretty hard to miss, after all, and it might be that Burkhart's point needs a little more help to come across. (And there does not seem to be any serious musical cost to following Burkhart's performance advice!) But once I have understood Burkhart's point, I have little difficulty in hearing the motivic relation he identifies. I hear the melody as oscillating between eb and gb in mm. 58 – 62, then filling in a span from gb down to a in mm. 62 – 68. And I regard the oscillation between two pitches as a variant of a simple skip, and the stepwise descent as an elaboration of a skip between the notes that form its beginning and end. Thinking of the passage that way, I hear a resemblance to the opening quite readily, and I can do this without any special assistance from a performer. That is, contrary to Burkhart's suggestion, I do not find that a performer who slurs across the whole eleven measures will prevent me from enjoying the motivic aspect of the passage.

But perhaps Burkhart is not primarily concerned with a listener who has already understood the analytical point. Rather, the advice to the performer may be designed to help a listener discover the motivic relation. By breaking before the eb in m. 62, a pianist will draw attention to the note, and it is true that this might help a listener recognize the motive. A fresh start in m. 62 creates a slightly shorter version of the motive, which can be heard as extending between mm. 62 – 68. Thus, a listener would have to identify only a seven-measure expansion of the original figure. Having recognized the motive, a listener could retrospectively identify mm. 58 – 61 as a preliminary attempt to state the motive, a sort of false start, and thus could recognize the complete eleven-measure form of the figure.

Even so, it is not clear whether most listeners would be led by such an articulation to an identification of the motivic recurrence. In fact, a listener could easily understand an articulation between mm. 61 – 62 in some completely different way. For instance, a listener might hear the break before m. 62 as undermining the sense of a cadential resolution from m. 61 into m. 62; thus, the listener would hear two incomplete gestures, mm. 58 – 61 followed by mm. 62 – 68. Hearing the music that way, one might or might not also notice a motivic relation to m. 4.

So it seems that Burkhart's performance inflection is not needed

by a listener who already understands the motivic relation, and might not succeed in communicating the motivic point to someone who has not already noticed it. As a mode of analytical communication, an articulation before m. 62 seems inefficient and unreliable! The problem in Burkhart's performance advice come from the fact that he does not consider the position of a listener. Burkhart moves directly from analysis to performance advice without asking how a listener might construe the resulting performance.[8]

Here is another example of a possible analysis-based performance decision, this time dealing with large-scale form. Example 3 gives a score of the first Prelude from Bach's Well-Tempered Clavier; Example 4 summarizes aspects of Schenker's attractive analysis of the piece.[9] On Schenker's account, the first large section of the piece elaborates the opening sonority, transferring it down an octave. A dominant divides this span but, as the upper part makes clear, this dominant is internal to a long tonic prolongation. Thus, for over half its length, the piece is relatively static in its basic pitch structure. Then, the piece approaches a dominant, with the second scale degree in the soprano, by way of remarkable chromaticism. Only at the end of the piece, in the next-to-last measure, does the upper line recover its original register, in order to lead the line from the second degree down to the final tonic.

Now if we ask what "hard advice" this analysis yields for performance, on the assumption that the performance will somehow communicate "the same facts" as the analysis, the advice is presumably to perform the opening span rather placidly and, in particular, to make the arrival at its intermediate dominant relatively unemphatic. The approach to the subsequent lower-register dominant should give greater weight to that moment; of course there are various ways that this might be accomplished, and the chromaticism and fuller sonority will contribute to the effect. In approaching the final cadence, a performer might want to focus the gesture on the high d's (they will receive some emphasis from their metrical position in any case). And a performer influenced by Schenker might avoid excessive emphasis on the chord four measures before the end, the deceptive resolution of the V, in order to save the sense of resolution for the final chord.

If there is any theorist whose ideas contrast with those of Schenker, it is Walter Piston, and as it happens Piston published an analysis of the same Prelude.[10] As one might anticipate, Piston indicates the harmony of each measure with roman numerals. He also supplies

Example 3

Example 3, continued

Example 4

formal comments in a series of footnotes to the score. At the early cadence to a tonicized G, he identifies "the first sign of cadential formula strong enough to mark the end of a phrase." A few measures later, when the piece reaches the C major triad in the lower octave, he writes that "The cadence here is the exact parallel to the one at the eleventh measure, and marks the end of the second phrase. The main body of the piece is now finished, the remainder being a coda." The contrast with Schenker is stark. Where Schenker finds a prolongation of the opening chord, preceding the most significant structural activity, Piston finds "the main body of the piece"; where Schenker finds the essential motion toward closure, Piston finds a coda.

Drawing on these analyses, one can imagine an encounter between two musicians. One has been trained in Schenkerian analysis, the other has been trained in accord with Piston's views; call the two musicians "Sam" and "Pat." Suppose that Sam wants to expose Pat to Schenker's views, using this Prelude as an example. Sam might produce Schenker's graphs, or present the analysis verbally. But perhaps Sam will try, instead, to communicate the analysis by playing the piece. What will happen?

Pat will be able to describe the performance without abandoning Piston's analysis. The piece can be heard, in Piston's terms, as including a complete structure, formed by a pair of relatively simple

phrases, followed by a remarkably eventful passage that is, in a sense, structurally gratuitous. What is wrong with that? Why not praise the bold imagination of a composer who can take off, in such a splendid way, after the main action of a piece is complete? Anything a performer does to place the weight of the piece near the end can be heard as an enhancement of this beautifully elaborated coda.

Once again, performance turns out to be a rather feeble means for communicating beliefs about musical structure. They are only two examples, but, more generally, I do not think that theorists know very much about the extent to which performance details can actually communicate analytical information.

## Listening, according to the standard conception

What would a listener need to do in order to infer analytical claims from performance details? Recall the basic dualism that I mentioned before. In order to interpret a performance as an analytical communication, a listener must ascribe two things to the performer: a set of analytical beliefs, and a set of beliefs about the meanings of performance decisions. Thus, the interpretation of a performance in terms of analytical claims is like the solution of an equation with two variables. Confronted with an equation like $x + y = 10$, different combinations of numbers can satisfy the two variables, and one cannot give a definite value for one variable unless a value for the other variable is settled. Analogously, given a performance detail of some sort, one can suggest different explanations of the performance, since the explanations involve two interacting factors. This is not just a matter of abstract principle, but describes a completely realistic possibility of multiple interpretation. Thus, in the case of the Bach Prelude, one might ascribe to the performer a belief that intensification of performance tends to signal structural weight, and therefore also ascribe an analytical claim that the main structural activity of the Prelude occurs near the end. But it is also possible to ascribe to the performer a belief that intensification tends to signal something beautiful and unexpected, along with an analytical claim that the end of the Prelude is an elaborate, structurally unnecessary coda. Likewise, one can interpret Burkhart's suggested phrasing as demarcating a melodically significant unit, and ascribe to the performer a motivic claim, but one can instead ascribe a belief that the phrasing prevents a feeling of cadence, along with an analytical belief that the phrase reaches an interrupted cadence and begins over again.

141

Some philosophers have made similar points about the interpretation of assertions.[11] In order to interpret an assertion, one must ascribe beliefs to a speaker and meanings to a speaker's words. The ascriptions of beliefs and of meanings are relative to each other; what I take someone to believe, on the basis of an assertion, is relative to the meanings I attribute to the words used; and what I take the words to mean is relative to the beliefs that I attribute.

In fact, the interpretation of performance, as it has usually been construed by music theorists, is virtually an instance of the interpretation of assertions. This is not surprising: the whole point of the metaphor of performance as analytical communication is to liken playing a piece to making statements about a piece. Ascribing beliefs about structure is just an instance of ascribing beliefs. And construing performance details as ways of communicating about structure is like assigning meanings to words: according to the standard conception, performance nuance, like speech, uses sounds as a code to communicate beliefs. So perhaps further attention to the interpretation of assertions, as described by philosophers, will help us in thinking about musical performance.

Interpretation eventually yields an interlocking account of meanings and beliefs, and therefore the same utterances might be explained by different combinations of meanings and beliefs. But it is possible to limit the possibilities if either meanings or beliefs can be given some degree of stability. (Then, completing the interpretation is like solving the equation $x + 2 = 10$ rather than $x + y = 10$.)

Roughly speaking, one could take either meanings or beliefs as the main starting-point in moving toward an interpretation of utterances. Typically, in interpreting an assertion, I find that the speaker is using familiar words; so I can ascribe beliefs, including complex or mistaken beliefs, on the basis of the words spoken. But in more unusual circumstances, I might not be able to start from a knowledge of meanings. Suppose I encounter a completely unfamiliar language (suppose, for instance, that I am an anthropologist encountering people with a previously unknown language). I would have to begin somehow to associate meanings with words, without relying on previous knowledge of the correlations. I would do so by trying to guess the meanings of particular utterances; this requires that I assume that the utterances are mostly appropriate to the circumstances in which they occur, and try to guess what beliefs the speaker is expressing. Then I can start trying to understand the sounds as words that communicate those beliefs.[12]

This distinction between two starting-points in interpretation brings out a startling fact about discussions of analysis and performance. Such discussions tend to imply that interpreting a performance is like interpreting an utterance in a familiar language. The performer's nuances, like the speaker's words, should be familiar, intelligible signals for the listeners, who will then be able to infer the performer's analytical beliefs. That would seem to be the point of the analogy with analytical discourse. But the actual presentation of discussions of analysis and performance, in seminars and also in professional discourse, tends to move in the opposite direction! That is, fairly early in the exposition, one typically encounters an analysis, and the theorist moves subsequently to a discussion of the performer's possible responses to the analysis. In a live presentation, the discussion often culminates in a performance. (As I mentioned before, this succession of events was characteristic of the course I took on performance and analysis.) Such presentations are supposed to demonstrate the ways that performers can convey analytical information. But what they actually show is that a group of musicians who adopt a shared analytical understanding of a passage can then understand and enjoy a performance that responds to that analysis. Interpreting a performance, in such a context, is not like assuming an understanding of words and inferring beliefs; it is more like assuming shared beliefs and inferring meanings of words. For such an activity, it therefore becomes irrelevant whether the performance decisions conform to a code that would permit reliable communication outside the immediate context of the performance. With a shared understanding of the analysis in place, listeners can enjoy the performer's responses to analytical points without wondering what the performance would sound like to an outsider, that is, without asking whether the performance, by itself, can communicate the analysis. Indeed, it would be possible to enjoy a performer's responses to a shared analytical perspective even if the responses are quite idiosyncratic.

Now I can return to my opening anecdote, and the question to which it led: what was going on in the classroom when we were discussing analysis and performance? We thought we were in a sort of laboratory situation, where our discussions and experimental performances would show us something about the nature of performance in less academic settings. But our experimental procedure was lamentable. We thought we were exploring the ways that performance can communicate analysis. But we always began by

informing the experimental subjects – ourselves – of the analysis that we would then claim to infer from the performance. No wonder these experiments were poor at predicting my subsequent experience of the teacher's recital.

This description might suggest that the course was a failure. And in terms of its stated aim, the objective scholarly study of the nature of musical performance, it certainly was. But we were doing something valuable, even if we did not understand what it was. Like any good analysis seminar, we created a small "interpretive community" in which the contingencies of our ongoing conversation created a heightened awareness of certain aspects of music and a sense of the salience of shared reference points, the analyses that we had moved through together. Hearing performances in the context of our analytical discussions, and talking about our reactions to those performances, were ways of further developing and confirming our mutual understanding. Someone who walked in on one of our performances, without having our common history, would not have heard it the way that we did, but that does not really take away from the experiences that we shared. It is ironic that, as we created a collective understanding together, forging an intimate community that allowed us to develop complex, private musical pleasures, our self-conception did not allow us to recognize and value the experiences for what they were.

I have not yet given an adequate account of what those experiences were: in particular, one might begin to question whether the performances in class were – redundantly – communicating the same analytical facts that we had already expressed verbally. Perhaps our pleasures in the classroom came from hearing a "translation" of analytical talk into performance nuance; but perhaps our pleasures came from something else! I have left this issue open, for the present, by adopting a vague locution in which performances "respond to" analytical points.

## WHAT ABOUT CARNEGIE HALL?

We need to ask, now, what relevance analysis might have in the preparation of performances that will take place in less intimate settings. My redescription of the analysis and performance seminar might provide a basis for extrapolation to the more public context of professional music theory. What is going on in the lecture hall, at a conference of the Society for Music Theory, when a speaker presents

an analysis and comments on its implications for performance? In that community, with its widely shared knowledge of certain analytical approaches, an analytical exposition can establish a shared understanding of a passage of music, and then everyone present can enjoy a performance that (as I am putting it) "responds somehow" to the analysis.

But how should one move further, to performance outside academic settings? In a public concert, a performer normally cannot establish, in advance, a detailed analytical understanding of the music to be played. Nor do performers normally display any desire to do this![13] To achieve something like the communication we had in the classroom, without actually giving the audience an analysis lecture, a performer would need to identify the analytical beliefs that the performer and audience are likely to share. These might include analytical beliefs about a familiar composition, and also theoretical beliefs that would lead to particular analyses in the presence of a less-familiar composition. Then the performer could choose performance details that will make sense in relation to the anticipated way of understanding the piece. So, rather than using analysis to discover facts about the piece, and using performance to convey those facts to the audience, a performer could use analysis in the construction of a hypothetical listener whom the performance can address. However, this account, an attempt to extrapolate from the seminar room to the concert hall, is beginning to seem like fantasy. What are the "analytical beliefs" and "theoretical beliefs" that have been attributed, in this attempt, to concert audiences? Who are the members of the audience supposed to be? It seems strange to attribute explicitly formulated analytical and theoretical beliefs to most members of concert audiences; certainly, most music-lovers do not talk about music in the same analytical vocabulary as many academic music scholars. Perhaps the response could be that ordinary listeners hold their theoretical and analytical beliefs implicitly, without a capacity to formulate them explicitly; but this begins to seem mysterious, and suspiciously convenient for someone who wants to believe that academic analysis is directly relevant to most people's musical experience.

In one aspect of music, it does seem that academic language matches the perceptions of ordinary listeners. Analysts often describe boundaries between musical sections, or the segmentation of music into spans, or grouping, and no doubt listeners typically recognize such aspects of music. And listeners can express them-

selves about many aspects of segmentation or grouping, even though
they may not do so in technical or academic language: most music-
lovers think of a piece as having different "parts" (favorite parts,
dreary parts, short parts, long parts, quiet parts, slow parts ...) and
can describe, in various ways, beginnings and ends of parts.[14]

This shared conceptualization gives special plausibility to the
idea of non-verbal communication about the parts of musical
compositions. So, not surprisingly, some of the most plausible
accounts of performance as analytical communication focus on this
aspect of music. Westergaard's account of performance is one
example. He addresses decisions that skillful performers make
intuitively, and deals with relatively small-scale issues such as the
articulation of metrical and phrase boundaries. Cook, in an essay on
Furtwängler's interpretation of Beethoven's Ninth Symphony, pro-
vides another, more ambitious example.[15] Cook suggests that
Furtwängler's rhythmic manipulations define sections and climaxes
in much the same way as Schenker's analytical monograph on
the piece; since other performances do not match Schenker's
account in this way, Cook argues that Schenker's ideas influenced
Furtwängler's performances.

To fill out an account of performance for these cases, one could
say something like this. Performers and listeners share a general
theory that extended passages of music typically divide into shorter
spans. Under the influence of this theory, audiences listen for
boundaries of spans and, relatedly, for internal events such as
climaxes that contribute to the identity of individual spans.
Knowing that listeners possess this general theory, a performer will
adopt specific analytical beliefs about the segmentation of a piece
into spans, and perform in such a way that the listeners understand
the performer's segmentation of the music. Sometimes the performer
will simply confirm boundaries that are already unambiguous; but
very often the performer will reach decisions about the placement of
boundaries that are ambiguous in the composer's score, especially in
deciding whether, or how, to hierarchize different articulations (for
instance, decisions about grouping three phrases as [A + B] + C or A
+ [B + C]). In both cases, it seems possible to describe the performer
as communicating about articulations, asserting, in effect, "Here is
where one thing ends and another begins."

I think communication about internal boundaries is the most
plausible example of performance as analytical communication in
the context of public performance; I think, too, that one might feel

some disappointment at this conclusion. On the one hand, claims about segmentation are not the only kind of analytical claim; nor, despite their importance, are they the central subject of analytical thought. It remains obscure whether other kinds of analytical insight can be communicated to audiences through performance. On the other hand, decisions about segmentation are not the only kind of performance decision; nor, despite their importance, are they uniquely central in the decisions that performers typically make. It remains obscure whether the many other choices that shape a performance can be understood as analytical communication. Unless a much wider range of examples can be given, the concerns of analysis and performance seem basically to diverge rather than to coincide.

But further, even in this favorable case, there is distortion in describing a performer's articulations as analytical communication. The description implies that the performer is, in effect, referring to a certain moment in the music and asserting that it is a boundary between spans. This suggests a certain gap or distance between the performer and the music. But this suggestion of a gap is strange. The performer is not somehow apart from the music, pointing to it; the performer is playing the music, making it, bringing it into being.

Perhaps, though, my references to "the music" are too vague. Of course, in the standard conception the performer is not supposed to communicate about "the music," in just any construal of the term, but specifically about the composition, the musical work. The performer, and the performance, are supposed to stand apart from the composition in such a way as to provide a commentary on it. However, two important considerations undermine the clarity of this separation between the performance and the composition, as two distinct objects of an audience's attention.

First, the score must be the object that establishes the identity of the composition, as understood in the standard conception of performance and analysis. But apart from some professional musicians, music students, and other specialists, almost nobody studies scores. Normally, most members of a concert audience know a composition only from performances. I suggest that such ordinary listeners, not the specialists, provide an appropriate norm if one wants to think about mainstream public performances of classical music. Such listeners may be interested in comparing different performances, intensely interested, but the notion of a separate composition, a possible object of analytical commentary, is probably

abstract and indefinite for such listeners. And it seems reckless to assume that a classroom of analysis students, looking at a score and talking about it, gives a useful model for understanding the experience of a listener who "knows a piece" from hearing several different performances of it.

And second, the notion of a performer set apart from a composition, commenting on it, exaggerates the difference between the activities of composers and performers. The similarities are more illuminating. A composer creates a composition by specifying features such as pitches, rhythms, timbres, and dynamic levels. The composer does this only up to a certain degree of specificity, as embodied in the score (along with some set of standard interpretations of the notation). The performer continues the process, eventually granting full specificity to the pitches, rhythms, timbres, and dynamic levels of the piece. A performer does this in two stages, first in the decisions that constitute planning a performance or arriving at an interpretation, and second in the actual performance that brings the sounds to full determinacy.[16]

The similarity of composition and performance shows why someone who "knows a piece" from performances is not likely to identify "the composition" in the same way as someone who has studied the score: while a score records the composer's decisions as distinct from the performer's, in an actual performance the composer's decisions blend with those of the performer, and often there is no way to tell, from listening, where the composer's creativity leaves off and that of the performer begins.[17] And the similarity of composition and performance shows why the image of a performer standing apart from a composition, commenting on it, seems so inaccurate.

## PERFORMANCE AS COMPOSITION

These last points suggest that the analogy between performance and analysis may be less helpful than an analogy between performance and composition. One could think of a performer, then, as a kind of composer, a partner in an act of collaborative composition. Performers are not fundamentally similar to analysts; rather, the activities of performers, like the activities of composers, invite description and interpretation by musical scholars.

This suggests further redescription of what we were doing in the class I took on performance and analysis. We shared analyses, and then we enjoyed listening to performances that the analyses had

shaped. Rather than saying that we understood the performances as, somehow, saying the same things that we had already said in our analytical discussion, it seems more accurate to say that we heard the performances as creative responses to the analysis. More precisely, our conversation had established a shared description of some aspects of the composer's contribution to a collaborative enterprise, and this made it very engaging to hear a performer bringing the collaborative effort to full determinacy.

It is possible, also, to redescribe the activity of a performer who "brings out" an articulation between sections in a piece, or who resolves, or chooses not to resolve, an articulative ambiguity. Suppose, as seems inevitable, that ordinary listeners' "theory of articulation" applies, not primarily to the data found in scores, but to the sounds experienced in performances. Then a composer's score will determine some of the information that listeners need in order to identify sectional articulations, but aspects of a performance not determined by the score will also be pertinent to the identification of musical boundaries. A performer who "brings out" an articulation may be described as collaborating with the composer in the creation of an unambiguous boundary. Performers create boundaries in the performed sound; or sometimes they may refrain from creating boundaries, creating sounds that the listeners' "theory" will not interpret as an unambiguous articulation.

## COMPOSITION AS PERFORMANCE

The conception of "performance as composition" seems more promising than that of "performance as analytical communication," but the two analogies share a problematic aspect: they describe, and implicitly praise, performance by likening it to another activity, a more prestigious activity (in some circles), and thereby they reinforce the prestige of that other activity, suggesting that performance has no independent, distinct identity or value. My final move, then, will be to suggest a reversal of the last analogy.[18] Rather than regarding performers as composers, one might regard composition as an activity that has as its goal the production of performances, and thus as, itself, an odd kind of musical performance. Composers are performers who go only part-way toward the creation of a performance; or, one could say, they are performers who create classes of performances, leaving it to their collaborators to bring the instances to full determinacy.[19] Perhaps such a conception would begin to

give performance the centrality, in our theorizing, that it already holds in our musical practices, our musical pleasures.

Performances, on this conception, not scores or works, would be the basic goal of musical creativity, formed in collaboration by composers and performers, contemplated, pondered, and enjoyed by audiences.

I believe this conception gives a good account of the activity of performers, but that is not to say that it records the existing self-perception of performers. On the contrary, performers sometimes offer a self-description that resembles the standard conception that I have criticized. While recognizing this fact, one need not simply accept such self-descriptions: in fact, there might be good, practical reasons for performers to hold misleading conceptions of their own activity.

Some remarks of Josef Hofmann – a pianist with a strikingly individual style of performance – can illustrate this last possibility. In his advice to piano students, Hofmann emphasizes the importance of careful score-reading: "Learn the Language of Music, then, I repeat, through exact reading! You will then soon fathom the musical meaning of a composition and transmit it intelligibly to your listeners."[20] Here, once more, is a duality between perception of facts (about musical meaning, in this case) and communication of those facts. But another passage reveals the pragmatic basis of this advice. Hofmann warns against the intentional cultivation of individualistic interpretation: "A purposed, blatant parading of the player's dear self through wilful additions of nuances, shadings, effects, and what not, is tantamount to a falsification." However, the alternative is not, or not simply, a self-effacing respect for the composition: "The player should always feel convinced that he plays only what is written. To the auditor, who with his own and different intelligence follows the player's performance, the piece will appear in light of the player's individuality. The stronger this is the more it will color the performance, when unconsciously admixed (54)." Hofmann distinguishes between the performer's self-conception and a listener's more accurate perception of the performance. The performer, acting under the influence of something like the standard conception, attempting to "transmit" the meaning of the music, will actually, though unconsciously, create something that reflects the performer's individual sensibility. That is, in my way of putting it, the performer will collaborate in producing an event that results from both the composer's and the performer's musical creativity.

All this suggests the possibility of a kind of critical description that I believe would correspond to the experiences of many listeners, though it is not familiar in academic discourse: the descriptions I have in mind would articulate the qualities of a particular performance event, without immediately focusing on the distinction between the contributions of composer and performer. (Perhaps, before thinking about the details of the collaborative interaction, it would be good to have a description of the result of the collaboration!)

I began with a story about the consternation that an actual performance produced in me. It is extraordinary that my semester-long course on performance and analysis proceeded with no reference to recordings; it was as though, armed with our analytical ability and our own, mostly amateurish, performance skills, we no longer needed Furtwängler, Toscanini, Schnabel, Hess, Busch, Landowska, and so on to pursue our inquiry.[21] But our independence of evidence from distinguished performers resulted entirely from our conception – standard but arrogant – of analysis as an alternative authority on performance, a source of instructions, the conception I have questioned throughout this essay. Surely the deepest motivation for reflecting on musical performance comes, not from musical analysis, but from wonder at the achievements of the most wonderful performers. The data of their creativity should provide the basis for serious reflections on performance, reflections to which the present, largely negative essay may constitute a useful prologue.[22]

## NOTES

1 Charles Burkhart, "Schenker's Theory of Levels and Musical Performance," in *Aspects of Schenkerian Theory* ed. David Beach (New Haven, Yale University Press, 1983).
2 William Rothstein, "Heinrich Schenker as an Interpreter of Beethoven's Piano Sonatas," *19th-Century Music*, vol. 8, no. 1 (summer 1984), 10.
3 New York: W. W. Norton and Company, 1968.
4 Peter Westergaard, *An Introduction to Tonal Theory* (New York, W. W. Norton and Company, 1975), p. 409.
5 Wallace Berry, *Musical Structure and Performance* (New Haven, Yale University Press, 1989), p. 6.
6 Nicholas Cook, "The Conductor and the Theorist: Furtwängler, Schenker and the First Movement of Beethoven's Ninth Symphony," in *The Practice of Performance*, ed. John Rink (Cambridge, Cambridge University Press, 1995), p. 120.

7 *Beethoven, Sonatas for Pianoforte*; phrasing, fingering, etc. by Harold Craxton; commentaries by Donald Francis Tovey (London: The Associated Board of the Royal Schools of Music, 1931), vol. 3, p. 192. William Rothstein has also emphasized that performers should not always try to bring out motives; see "Analysis and the Act of Performance," in Rink, ed., *The Practice of Performance*.

8 Jerrold Levinson, "Performative vs. Critical Interpretation in Music," in *The Interpretation of Music* ed. Michael Krausz (Oxford, Oxford University Press, 1993), makes similar points about the indeterminacy of performance as a means of critical communication. In general, his sharp distinction between performance and criticism is in accord with my ideas in this essay.

9 Heinrich Schenker, *Five Graphic Music Analyses* (New York, Dover Publications, 1969; originally published 1933), pp. 36–37.

10 Walter Piston, *Principles of Harmonic Analysis* (Boston, E. C. Schirmer Music Co., 1933), pp. 54–57.

11 The following account draws on the tradition of Willard Van Orman Quine, *Word and Object* (Cambridge, Mass., MIT Press, 1960), and Donald Davidson, *Essays on Actions and Events* (Oxford, Oxford University Press, 1980).

12 Davidson, in a beautiful and controversial essay, has questioned the importance of fixed meanings in interpretation, suggesting that interpreters can always revise their theories about meaning in order to make more sense of their interlocutors. "A Nice Derangement of Epitaphs," in *Truth and Interpretation: Essays on the Philosophy of Donald Davidson* ed. Ernest LePore (Oxford: Basil Blackwell, 1986).

13 Program notes sometimes include some technical description, but probably such program notes have little effect and, in any case, they do not typically represent the performer's ideas.

14 The same day that I wrote this paragraph, my six-year-old son complained to me about a folk song that his two-year-old sister especially likes: "It has too many parts," that is, too many short verses.

15 See note 6. An unpublished essay by Joseph Dubiel, from the early 1980s, introduced me to the idea that grouping might be the meeting-place of analysis and performance.

16 Someone who thinks that a performer does not contribute to the specification of pitches may be thinking of piano performance, which is abnormal in this respect, but not of the voice or most instruments.

17 At any rate, this conception of a score determines the mainstream contemporary practice of scholarly editing. Nineteenth-century editions, though, often obscure the difference between the contributions of the composer and the editor (perhaps a distinguished performer such as Von Bulow), just as performances obscure the difference between the composer's and performer's contributions.

18 My final move in this essay, that is! Obviously the considerations to which I have led are fresh starting-points rather than conclusions.

19 See Richard Rudner, "The Ontological Status of the Esthetic Object," *Philosophy and Phenomenological Research*, vol. 10, no. 3 (1950). Benjamin Boretz's remarks are pertinent here: "Composing, as we know it, is oddly located as a speculative notational act prior, and abstractly general in its relation, to the actual musical act itself of realization in sound, performance." "If I am a musical thinker ...," *Perspectives of New Music*, vol. 20, nos. 1–2 (fall–winter 1981, spring–summer 1982), p. 500.

20 Josef Hofmann, *Piano Playing, with Piano Questions Answered* (New York, Dover Publications, 1976; first published 1920), p. 55.

21 It is possible, in fact, to consult recorded performances while still clinging to the standard conception, as Cook and also Joel Lester have done (in their contributions to Rink, ed., *The Practice of Performance*). Lester begins, attractively, by observing that actual performers and performances have been oddly absent from discussions of "performance and analysis." But his main strategy for including them is to translate recorded performances into analytical claims, thereby allowing performers to enter into analytical dialogue with music theorists. The "standard conception" shapes and survives this strategy.

22 I have learned about musical performance from many people, over many years. Some of the most important contributions came from Suzanne G. Cusick, Joseph Dubiel, Charles Fisk, Martin Goldray, Elizabeth Hudson, and (long before the others) Alfred Mouledous; the contribution of my parents, reflective classical musicians, is indescribably deep and pervasive. I presented a first version of the present essay at the joint meeting of the American Musicological Society and the Society for Music Theory, Austin, Texas, 1989; I revised the essay in 1997–98.

# Performance authenticity

## possible, practical, virtuous

STAN GODLOVITCH

The word "authentic" is semantically lush, and this has, no doubt, influenced many often heated debates over the status of the early music revival and over any morals to be drawn therefrom for music as such. Some disputes are about the very import of "authenticity," particularly as regards how thinly or thickly the concept is to be read.[1] Other disputes reflect broader philosophical concerns about knowledge, action, and experience.

In what follows, I am principally interested in some of the purposes to be served by paying special heed to what we have come to know about past performance practice. What survives is a thick reading of "authenticity" which raises no substantive philosophical puzzles, and which makes explicit certain musical values which the pursuit of authenticity exemplifies. Briefly, (a) in many significant ways, a number of efforts to achieve authentic performance are fully practicable if only because they are no more constrained than any of a number of other ordinary efforts at revival, renewal, and restoration; and, (b) as practically achievable, such efforts contribute to our understanding of music-making generally and thereby embody certain musical virtues, even though such efforts do not nor are meant to displace or undermine what we already acceptably do.

If the notion of authenticity developed here seems inordinately tame, that may be due to the brash claims made in its name and immoderate expectations arising therefrom.[2] More directly, the value of the pursuit of authenticity lies principally in its achievable purpose; namely, to renew musically rewarding opportunities for performance via an increased understanding of past practice. Whatever success is achieved is unlikely to have any wholesale revolutionary effect upon existing performance practice and even less likely to upset any general philosophical accounts of action and

experience. The very persistence and workability of current performance practice, and the hard limits set by the boundaries of action and experience, constitute standing constraints upon any ambitions the pursuit of authenticity may reasonably entertain. We can no more instantaneously overturn culturally stable musical expectations nor break out of our late-twentieth-century aesthetic and perceptual skins than we can, in our present state, turn the world into a fully egalitarian utopia or enter, first-person, into the visual field of a bumblebee. But we certainly can, however imperfectly, implement some egalitarian practices locally, and we have learned a great deal, third-person, about the bumblebee's world. By parity, given our successes in instrumental and interpretive revival, we thereby open musical opportunities hitherto dormant and unavailable, and we provide ourselves with a modest kind of active observer status in some other place and time. Further, our successes are catchy. They create curiosity in both players and listeners who start, perhaps for their first time, to wonder about musical options they never before wondered about. If none of this were good to do or, worse, possible at all, it would make an utter mystery of history, if not an outright nonsense.

Part of my case draws upon personal contact with the plucked string music of the sixteenth and seventeenth centuries. The contact was close in that I wanted not only to make their music mine, but to do so as much as possible from the inside, from the shop-floor. This drew me not only into the particulars of past notations and into the trials of trying to make an unfamiliar family of instruments behave, but, for me most revealingly, into finding out how those very instruments worked by building them from scratch. In my exploration, I fell in with a varied crowd – librarians, archivists, musicologists, notation specialists, collectors, lutenists, singers, wind and bowed-string players, audiophiles, luthiers, string-makers, cabinet-makers, tool-makers, hardwood dealers, not to mention John Park, polymath guitarist, guitar-maker, and natural-born engineer extraordinaire with whom I trekked into the eastern slopes of the Rockies in search of that special Engelmann spruce which, when felled, sectioned, split, dried, and aged, would yield just the perfect tonewood for soundboards.

However amateur my capacities, I had no aesthetic or conceptual hang-ups in all this very purposive business. I figured that there were things to be learned and ways, however imperfect, to learn them. What was this for? To find out how certain things were done,

how they worked. Never did I suppose that there was any great problem in principle about figuring out how to put together a reasonably functional, reasonably respectable lute, one that would have raised no howls of laughter or scowls of incredulity from the likes of John Dowland or Ennemond Gautier. By exactly the same token, I reckoned that there could not be any problem in principle about figuring out how to put together a reasonably presentable rendition of a Dowland galliard. Certainly, it could not have occurred to me that, in putting together a decent playing version of a late Elizabethan lute piece, I was undertaking something momentously and mysteriously different in kind from building a decent lute.

This, of course, was not to deny that I could botch up both projects. Just as I knew full well that there were a number of builders who made some of my work look like a weekend rush job to get that picnic table ready,[3] so too there were a number of players who made me grateful that I was able to earn my keep teaching philosophy. My limited successes were clearly not caused by some limit inherent within the ventures themselves. They were due entirely to differences between me and others I met in the venture. What distinguished us? On both counts, information, skill, expertise, experience, and occasionally those inarticulable intuitions that make one person able to smell out a great tonewood in a log which another person would cut up for kindling. In a word, practical knowledge – nothing more, and nothing less. Is practical knowledge a worthy pursuit? At first blush, knowledge trumps ignorance, and more knowledge is better than less. If nothing else, we come to understand better how much we share with our predecessors and where we have moved on. We cannot imagine what such understanding is like unless we have some idea of what went on in the past; and we cannot have any such idea unless we bring as much of the past as we can into full view. The successes of the pursuit of authenticity are intrinsically, if not exclusively, *knowledge- and skill-laden*. That is what an interest in authenticity demands. Because it relies on practice, the central issues of authenticity lie squarely within the province of practitioners – scholars, players, builders – and not especially within the aural space of the relatively passive listener.

## SKEPTICISM ABOUT POSSIBILITY AND PROPRIETY

To highlight this practice-centered approach, I will examine skeptical concerns about the very possibility of authenticity in perfor-

mance, and about its propriety. Starkly put, the pursuit of authenticity faces two skeptical challenges: can we actually achieve anything like an historically authentic performance, and, supposing we can, what merit does it have?

For the skeptic, an historically authentic performance is *possible* only if it meets at least two success conditions; namely, that (a) it provides for us now something like the proper ambience of earlier music as well as a fitting experience of that music, and, further, (b) that we can adequately verify the accuracy of that ambience and experience. For the skeptic, neither condition can be satisfied. Regarding (a), we now have an ineliminable modern perspective, the result of an accumulation of musical practice and listening experience which creates an unbridgeable experiential, and a fortiori practical, gap between us and the practitioners and audiences of the past. Regarding (b), there is so much underdetermination of the realities of past practice and experience by the evidence to hand, that we face an unbridgeable evidential gap and thus can never be reasonably certain enough to know whether or not we have re-created anything of substantial past musical relevance. Regarding (a), the gap dooms us forever from the possibility of making relevant contact, while the gap in (b) ensures that we cannot adjudicate authoritatively between rival re-creations and so leaves us forever short of knowing whether we have made the right choices.

Skepticism about possibility scuttles efforts to give any prior performance practice the normative edge in our present musical choices just because we have nothing but ineliminably contemporary musical choices to make. But even supposing that we have sufficiently accurate access to past practices and preferences, a normative question of *propriety* still arises; namely, what authority or privilege attaches or should attach to past practices and expectations? Why should we now care enough about what our predecessors preferred to allow their preferences to determine what we now do and thus possibly to override our own preferences? Surely, the only operational authority resides in our present choice between (a) our now doing what those in the past liked best, and (b) our now doing what we like best, whatever the consequences. That sort of choice cannot be based merely upon the fact of past preferences. We are not under any obvious and overriding obligation to give precedence to someone else's preferences, and we cannot be made to prefer what someone else preferred. By ignoring past practitioners, it is not as if

we repudiate their choices or violate their authority. There is no substantive matter of deference to anyone because, literally, there is no one left to whom we can fail properly to defer. Further, we are not forced to acknowledge, given the viable variability of our current preferences, that there must be some hidden root to the matter, some fundamental truth or resolution about the music, to which we must ultimately appeal and defer. This reflects not so much an acceptance of the ultimate rootlessness (and therefore arbitrariness) of musical preference as it does a lack of any hard indication as to why any special weight is or should be attached to certain prior preferences or to any views about what music essentially is.

## POSSIBILITY AND AUTHENTICATION REVIEWED

Skepticism undermines the gains and merits of the pursuit of authenticity only if the aims of that pursuit are conceived in certain ways. The problem of possibility emerges in various vexed questions: How can we now produce a performance which sounds as it sounded to an audience four centuries ago? However accurate the resources used in performance, how can we *hear* early music as it was originally heard; for example, as fresh, daring, religiously uplifting? In a word, how can we re-create the *experience* of early music? The argument runs thus:

(1) Authentic re-creation requires the re-creation of past experiences.
(2) Neither past experiences nor their quality can be re-created nor enjoyed by present listeners.
Therefore, authentic re-creation is impossible.

A companion doubt concerns verification or authentication: anyway, how could we now *know* (be sure, verify, confirm) that we have so re-created these experiences? In brief:

(1) There is no authentic re-creation without authoritative authentication.
(2) Authoritative authentication is, in principle, unachievable.
Therefore, authentic re-creation is impossible.

But why, one might ask, should the re-creation of the experience of a former music listener or even composer be a goal of the pursuit of authenticity? If another sort of re-creation is sought, why should a certain kind of experience be a criterion or test of its success? Any primary concern with the re-creation of experience – call it "internalism" – is as misplaced as asking how one can create in the contemporary aficionado of the late Cretaceous the kind of fear

experienced by a hadrosaur upon encountering a menacing tyranno-saur, or, for that matter, the kind of awe experienced by a courtier in the presence of a sixteenth-century monarch sincerely believed to be divine.

The pursuit of authentic performance cannot have as its purpose the re-creation of former experiences, for, if it were, we would have got nowhere so far. But we have got a long way along. We know massively more about past practices than we did fifty years ago, and our knowledge improves continuously in such a way as to inform and improve current practices. We now do things rather well we did only indifferently a few decades back, like produce extremely fine instances of once extinct musical instruments with which we try, ever more competently (because informedly), to make music. The point of the pursuit is to make past performance practice accessible. "Re-create" is a confusing term. Our job is to renew and restore, to reconstruct, to revive, to rebuild – with luck, to re-vitalize.

All our progress is beholden to the past. If this were all arbitrary make-believe, a constructivist's mere "construction," and not the scholars', builders', and players' re-constructions, then so too are the rebuilt cave kivas and re-glued pottery of the pueblo people who lived, worked, and died in Frijoles Canyon, New Mexico. The complaint that there is "no unmediated access to the past. All 'pasts' are constructed in the present"[4] misses the mark. Of course, there is no such unmediated access. We have no time machines. Of course, our present reconstructions are present reconstructions. When else could they take place? The proper questions to ask are: are they good or defensible reconstructions of former practice? Have we generated the most probable hypotheses with the best evidence to hand? Can we improve on them? Have we left anything important out? To these, there are methods of inquiry and non-arbitrary ways of adjudicating between the answers these methods propose.

Internalism draws largely upon listener-centered values, for the sounds are often all the listener immediately experiences and cares about. This is a recipient's and not a participant's focus, and correspondingly has its local object. But even if one persists in centering the issue on "inner" experience, it is fair to remark that the listener as such does not have the visceral and tactile experiences of those involved in music-making. Music-making is primordially a hands-on manual or glottal affair. Surely, modern players on early instruments share many music-making experiences with those who came before. Our physiology is the same. The performer's bodily

responses cannot vary significantly. Otherwise, we would have to find troublesome the thought that, even digging up a field with a bodily drawn plough, we cannot know at all what it felt like for the original ploughmen to dig up their fields. True, we may miss the deadening fatigue of the ancient ploughman, but we do not miss everything. If the problem of other minds seeps over into the problem of other ploughs, experience generally must become utterly perplexing.

A related species of internalism needs mention; namely, the reconstruction of the composer's inner interests regarding a work. How did John Dowland really want his *Forlorne Hope Fancy* to sound? Here authenticity purportedly hinges not on the quality of the recipient's experiences but on the content of the composer's mind. The supposition is that we misrepresent the work without such information, and that that is a bad thing. We can approach this in a few ways, but none displays any special problems for authenticity as such. Briefly, this may just be a special case concerning the interpretation of any text, and may be dealt with exactly as one deals with the relevance or irrelevance of the intentions of any author, living or dead. Concern about the composer's wishes addresses not so much the possibility of our knowing what these are, but the weight to be attached to them; that is, how much is owed to the composer, and how much does diminished attention to the composer's wishes lessen authenticity? This involves the propriety of authenticity which I take up later on. Secondly, we may have here a special case of concerns about access to the content of other minds. Here the gap yawns as widely between oneself and one's best friend as it does between oneself and a long-dead stranger. If a problem at all, it is not one unique to authenticity.

Anyone searching for some ever-elusive (because illusory) experiential transport always hits a gap while failing to note that perfectly relevant goods have already been delivered, just those which the pursuit of authenticity aims for. The skeptic's conundrum is a chip off a familiar block; namely, the problem of meaning and translation. Like relativists, skeptics appeal to radical untranslatability and incommensurability which are used here to close off access to alternative musical schemes, whatever the primordial musical content. But, if "meanings ain't in the head,"[5] then neither supposedly are the analogous musical schemes; that is, our ways of interpreting and making music.

How, then, do we bridge the gap? Think of the pursuit of

performance authenticity as analogous to a form of translation which entails building a theory about past musical practice. Theories are exploratory trials which aim to maintain coherence. This involves establishing the best fit between accumulating evidence and the working content of the theory itself. Obviously, theories undergo continuous modification as changes in the evidence dictate. Paraphrasing Davidson, we interpret what we encounter – the notation, the treatises and anecdotes, the settings of performance, the physical structure of the instruments, the past agreements and debates, and more – in such a way as to maintain a reasonably coherent theory of past musical practice and expectation. To develop and maintain such a coherent theory, we apply a principle of charity; namely, by assigning to notations and discussions of previous works (the counterpart to a speaker's sentences) conditions of acceptable performance practice (the analogue to truth) that actually obtain just when the previous players, composers, and commentators hold those conditions acceptable. "Charity is forced on us; whether we like it or not, if we want to understand others, we must count them right in most matters."[6] We determine what counts as right for them by trying to make maximally consistent what they say and do.

Who constructs and tests such theories? Appropriately and collectively, the scholars, builders, and players; that is, those wishing to understand by way of attaining fluency in the language of the past. Here we have theory in and through practice. Can we get it wrong? Certainly we can, but that just motivates us to modify our theory for a better fit as the evidence builds. Are we doomed to get it completely wrong? Only if we have no matches whatsoever, no indices of correctness. Still, the massive quantities of evidence are charitably and rationally to be taken as evidence for something coherently informative about past practice. As to varying interpretations, different takes on the evidence, Davidson sensibly advises that "the method is not designed to eliminate disagreements, nor can it; its purpose is to make meaningful disagreement possible, and this depends entirely on a foundation – *some* foundation – in agreement."

The workaday pursuit of authenticity involves recovering practices and their results. Once the question of re-creating past experiences is sidelined, the issue of authentication becomes merely and determinately practical. Here are two examples, one drawn from the search for authentic cuisine, and the other about lute music.

On historical cuisine, *Pleyn Delit: Medieval Cookery for Modern*

*Cooks*, a collection of recipes and menus drawn from fourteenth-
and fifteenth-century sources, aims "to produce a large and represen-
tative collection for practical use in the kitchen." From the four-
teenth-century *The Forme of Cury* comes this recipe for a salad:

Take parsel, sawge, garlec, chibollas, onyons, leeks, borage, myntes, por-
rectes, fenel, and ton tressis rew, rosemarye, purslyne. Lave and waishe hem
clene; pike hem, pluk hem small with thyn honde and myng hem wel with
rawe oile. Lay on vynegar and salt, and serve it forth.[7]

The authors comment that the herbs and greens "were undoubtedly
intended to be fresh from the garden or field ... 'Garlec' may have
meant the shoots or bulbs of wild garlic, which are much milder
than the usual kind." There are known degrees of uncertainty
regarding relative proportions of ingredients, the strength and quan-
tity of the vinegar, and the precise varieties of herbs and greens.
Such uncertainties prompt empirical inquiry which may uncover
further evidence about which exploratory hypotheses may be enter-
tained. Such hypotheses are refined as further information accumu-
lates. Hopefully, we get closer to the traditional mix. What matters is
that our pursuit generates questions which, in turn, stimulate us to
look further and deeper. No abyssal gap blocks our way. Why?
Because we are not tracking down the taste sensation of a fourteenth-
century salad-eater. The recipe never promises that we can taste
what they tasted. It does, however, give us good reason to think that
we can at least prepare salad much as they did, and eat what they
ate; and so the cook's-eye view of authenticity.[8]

Interest in authentic performance of early music spreads across a
number of semi-independent problem-solving domains involving
early instruments, instrumental techniques, notation, manuscript
sources, not to mention inquiries into interpretation, analysis, and
history. All of it matters, however impossible it is for any one person
to grasp the total picture emerging. The first ingredients are curiosity
and captivation. In England, for example, small numbers of enthu-
siasts – players, scholars, and builders – notably, the dedicated
Diana Poulton – had revived an interest in the Renaissance lute
since the 1940s and 1950s. Later, from the 1960s on, large audiences
were exposed to the Renaissance lute through the concerts and
recordings of the musically incomparable Julian Bream.[9] Bream
brought to the field his brilliant musicianship, but much of the spirit
of the lute was awaiting further recovery. How so? Bream is a
guitarist, and his first instrument, heavily constructed, fitted with

fixed frets, nylon strings, a single second course, a saddle bridge, and an inset rose, was built by Gough, a harpsichord-maker. As a first pass, Gough got much of it wrong. Bream, too, using right-hand fingernails and post-Tárrega guitar technique, got much of it wrong. All that said, Bream inspired many guitarists to explore the lute and so helped to create livelihoods for a new generation of luthiers. Certainly, the 1960s and 1970s saw a rapid increase in the number of professional players and builders. Thanks to the virtuosic brilliance of Paul O'Dette, Hopkinson Smith and others, and to the magnificent playing machines of Lundberg, Elder, and others, we are so much closer to getting it right.

Renaissance lute music was conceived on the Renaissance lute and meant for it. The expressive and technical compass of the music lies fully within the expressive and technical resources of the instrument. To understand lute music and to try to get it right, one must investigate its instruments. Not to mention long-standing German work, organologists and builders in English-speaking countries presented their research not only *in concreto* via their instruments, but also through such periodicals as the *The Galpin Society Journal* (from 1947), *The Lute Society Journal* (from 1958), and the *Journal of the Lute Society of America* (from 1967). Extant instruments have been carefully studied (and X-rayed) for overall dimensions, wood, glue and joint types, thicknesses, repair work, and other fine structural details.[10] The building community is small, close, and cooperative enough to ensure a rapid dissemination of available information. Among others, I was able to get copies of luthier Robert Lundberg's very accurate, full-size drawings of many museum instruments. Once the physical details are known, further steps involve studying past construction techniques and securing representative materials.

Having identified past builders who were highly renowned in their day amongst the best players, some modern builders make close copies of specific old instruments. Amongst the star builders, for example, was the Tieffenbrucker dynasty based in Padua and Venice. But old lutes are notable for their variation in dimensions. There was no one rigid scale or size, nothing like the scalar conformity which typifies the modern classical guitar and violin.[11] Wood for the bowl varied, as did the number of ribs. This is as one would expect, given the following tutorial advice by a famous player printed in a successful anthology of the day. In a section titled "To chuse a LVTE for a learner," he writes:

First and formost chuse a Lvte neither great nor small, but a midling one, such as shall fit thine hand in thine owne iudgement. Yet I had rather thou didst practise at first on a Lvte that were somewhat greater and harder, vnlesse thy hand be very short: because that is goode to stretch the sinewes, which are in no sort to be slackned.[12]

Through copying, one learns not only how to build, but what decorative and structural styles were valued. Imitation, however, serves primarily to inform and must never become slavish. Extra-polating from this understanding, one may then diversify by building instruments to fit the hands of individual players, and develop one's own style, thus extending and re-vitalizing the known traditions of lute-making. Disciplined latitude makes for further informed experiment.

There are, expectedly, universal structural features in this family of instruments; for example, all had rounded backs (or bowls), carved roses, tension bridges, gut strings and moveable frets, odd numbers of bowl ribs, a limited range of courses and string-lengths, and a generic profile preserving a rough proportionality in the soundboard (or belly) between length and width. Most had parchment-reinforced rib joints, unvarnished soundboards, peg-boxes set back within a narrow range of angles, and so forth. Most prominently, by modern standards, all these instruments were extra-ordinarily light. The ribs and soundboards were scraped down very thin, the gluing surfaces were very narrow, the bowl woods used among the lightest (e.g., yew). Among wooden instruments, the lutes were much more fragile than, for example, the robust modern violin and guitar. For solo playing, one recommendation was to crank the top string as high as it could go before breaking and to tune the others in the relative descending intervals. Lute soundboards were thus under considerable tension, especially given the bridge design which, lacking a saddle to divide forces downward as well as laterally, directed all forces laterally. Indeed, lutes were relatively unstable structurally, and were regularly in for repairs. Professional players went through many instruments in a playing career. Such structural realities have pronounced implications for sound and technique. The sound is light and thin because of the weak funda-mentals and dearth of lower partials. Gut, of course, lends its own distinctive "nutty" timbre. There is virtually no treble sustain; hence the "plinky" or "airy" quality to the sound, and, though the trebles project or "cut" well, there is little overall volume, and a limited dynamic and timbral range by modern standards. Play the lute in a

large hall or one with otherwise unnoticed ambient noise (air-conditioning, faint background traffic), and one loses the subtler flavors, rather like the difference in taste between an apple picked ripe from the tree and one refrigerated in nitrogen for a month. As for technique, such instruments impose certain constraints. Righthand fingernails damage and even shred gut strings. Tone color and volume variations work within very close limits. Lutes do not deliver vibrato. Given standard instructions to place the little finger on the bridge (confirmed as well in paintings of lutenists), the right hand must be cupped claw-like. This greatly influences the sound produced. Playing near the bridge – where the string tension is at its greatest – further limits timbral variety. Lutes and lute strings cannot stand anything like the physical shock often endured by modern string instruments at the hands of "expressive" players. Indeed, any modern player taking up the lute has to *lighten up* – as does any modern singer wanting to master the lute song by learning how to collaborate with and not dominate the lute.

Should this sound like multiple punishments endured by our predecessors, suffice it to say they preferred it this way. They then also built more robust, louder, flat-backed, wire-strung instruments (e.g., the orpharion, bandora, and cittern) but these were usually relegated to subsidiary musical roles. Further, "[t]he lute was the piano of its day: most composers wrote for it, most musicians played it, it had a huge solo repertoire," the extant English sources from 1540 to 1620 numbering some two thousand pieces, three times the surviving pieces by the English school of virginalist composers.[13]

Many further details are available, and knowledge increases apace. The emphasis here is on the prime relevance and success of authentication in the authenticity question. Further, it should be clear why there is little point in making the quality of the subjective experience of the modern listener as a criterion of authenticity. Why should we even want to reconstruct an Elizabethan listener's experience? What ultimately count are the hypotheses about practices and practice norms, the strength of the evidence for them, and evidence for the convergence of hypotheses drawn from different aspects of past practice.[14] Clearly, we can form very credible hypotheses about the qualities of sound and about the options open to the player just by becoming familiar with the equipment they then used and, obviously, chose to use. One may be prone to dismiss this all as museum lore, having as much to do with Art as dinosaur bones have to do with Life. If this is more serious than an appeal to some

necessarily elusive and undeterminable quality (no more helpful than Moore's characterization of goodness as an immediately apprehendable non-natural property), my advice would be to sound out just what the paleontologists have brought back to life from those very dry bones.[15]

Before turning to the value of authentic performance, I must address a putative asymmetry between bringing back the period's musical sound, on the one hand, and restoring the period's notation and instruments, on the other. Consider Taruskin: "Some writers, myself among them, have proposed that talk of authenticity might better be left to moral philosophers, textual critics, and luthiers."[16] The existentialist's authenticity aside, Taruskin's worries about performance authenticity concern the underdetermination of performance norms by the evidence at hand and the damage caused to musical imagination by observing such norms too stringently. Regarding the latter, he deplores the "destructive authoritarianism" of "Papa Doc, the musicologist," and advises us that the job of the musician "is to discover, if they are lucky, how we really like" the music we listen to.[17] I heartily applaud the spirit of openness appealed to here. The same, I daresay, applies to "Papa Doc, the luthier" as well. But Taruskin cannot have it both ways. If underdetermination of our theories about past practice by the available evidence is a problem, then there cannot be a corresponding problem about authoritarianism. Why? Because the authoritarianism becomes interestingly objectionable only if it draws upon a very secure source. Otherwise, it is simple irrational power-mongering which, however deplorable, is always dull. As to the underdetermination question, most interesting and creative theoretical ventures – the prime purpose of which is to try to say intelligently and cogently more than we know – whether in science, history, lute-making, or performance practice are underdetermined by the evidence. Given the limitations on the availability of evidence of all sorts, we have always to be open to revising our theories depending upon what the world next turns up. There will be greater and lesser degrees of confirmability and evidential assurance, to be sure, depending upon how modest or bold our theories happen to be, but this is, as ever, a matter of degree. So, if past performance practice can be authenticated at all – and there seems no reason to deny this – then, though it may be less decisively authenticatable than certain other domains of theory, it falls no less into the class of theories to which belong the speculations of the textual critic and luthier.

## PROPRIETY AND PRIVILEGE REVIEWED

The skeptic's case against the propriety and privilege to be attached to authentic performance practice works rather more persuasively than that against possibility and authentication. The questions it leaves, however, are bothersome; namely, does it prove too much, and what really hangs on it?

Issues of propriety flow from questions like these: is it better, more fitting, preferable, to adhere as closely as possible to the instrumental and interpretive norms and traditions of the repertoire typical of the time and cultural context of the repertoire? Is it best to structure one's performance of an earlier piece against the performance standards and expectations of the time and place in which the piece first emerged?

Taken one way, such questions beg for details which play into the hands of the relativist; for example, better, more fitting, preferable in what respects? For whom? On whose authority? For what purpose is this to be done, to suit whose ends? One working assumption is that all these concerns must be pegged against specific preferences and plans. Besides "The Show Must Go On," there are no categorical imperatives in performance practice; only the satisfaction of certain preferences. Another working assumption is that, at best, there are no stated preferences which in themselves automatically trump any other stated preferences. Any *de facto* ranking of preferences is itself just an index of second-order preferences. There is nothing anchoring these choices other than preference and opportunity themselves.

To provide a reason why preference should be given to authentic performance practice requires a further appeal. Authenticity may seem to carry its own warrant. for not only does it connote "accuracy," it also connotes a quasi-moral "genuineness." The latter sense arises in crises of personal integrity where one anguishes over being true to oneself and sticking up for one's deepest, self-defining convictions. To fail in such steadfastness is to compromise oneself. Now, compromise often involves subduing one's bull-headed, self-centered, self-righteousness, and acceding in part to the interests of others. This is often a good and civilized thing. In authenticity contexts, however, compromise is unequivocally lower down morally than being properly and truly oneself. Without excessive melodrama, might we say that performance authenticity trumps the alternatives because, analogously, it involves being "true to" the music?

167

Have we here the very categorical imperative we seek? There are problems, of course, about what sort of obligation this creates and why it should be overriding. To what are we meant to be true? Have we the "pure music" imperative: be true to the music? Perhaps we mean the "past culture" imperative: to their own music, be true? We may even mean something very personal: be true to the music in you yourself. After all, authenticity in this sense carries no integral historical sense. Historically construed, are we to be true to the composer's expressed or inferred wishes, the past listener's aural and emotional expectations, the past player's practice routines? More rarefiedly construed, are we to be true to the abstract work of music itself, the best possible rendition of the work, the ideal listener's experience, the perfect performer's offering? Having to choose among these often conflicting masters forces one to re-visit the plurality of preferences problem such authenticity was meant to solve.

Is being true to the music like being true to one's faith or to one's profession which are matters of fidelity and obligation, or more like being simply truthful, that is, accurate, not as a response to some higher calling or duty but as a satisfaction of certain accuracy conditions? If the former, whence come these musical obligations? From the role or job musicians *qua* musicians necessarily perform? Does someone become a bad musician by somehow "breaking faith?" But does this not come down simply to playing badly? If that is what it amounts to, all we can reasonably demand of any musician is the satisfaction of certain accuracy conditions. Accuracy with regard to what? We are again back to the plurality of preferences. It is not as if there is some abstract work which broadcasts unequivocally the conditions of its exemplification. Even if there were, it is unclear what properties come bundled essentially into musical works. Musical works have, at best, shifting Lockean nominal essences. There may be certain core properties, but these will be very sparse indeed and certainly leave open the issue of just how much history and tradition need be consistently heeded. This laxity must be commonly acknowledged, for otherwise we would be regularly perplexed about identity conditions for exemplifications of works; that is, regularly unsure as to whether we have in a given case an instance of a given work. But we are not generally so perplexed. What counts as Bach's *Toccata and Fugue in D Minor* comes through loud and clear whether on organ, full Stokowskian orchestral extravaganza, or on synthesizer – so long as most of the notes are

there in the right order and within tempi which enable recognition of the basic themes. One may say, if one wishes, that there is one proper version and any number of simulacra and partial derivatives. Some people may even dictate precise parameters, but adherence to them comes as a response to power rather than truth.

In the end, the question of propriety or privilege comes to this: if we somehow must, when possible, adhere to the original directives as closely as possible, that "must" hangs either upon an appeal to identity conditions drawn from some real essence of works, or from a fixed obligation to some power, lawgiver or authority who lays down musical law. But neither the Essence nor the Law seems very compelling. So there is no internally or externally justified necessity in adhering as closely as possible to all original directives.

I have no special quarrel with the leveling aspects of this sort of skepticism. Musical practice, as Taruskin candidly observes, regrettably suffers its rigid, doctrinaire, self-important corporate bosses as do many other areas of human business, and they deserve all the opposition they get. Luckily, as Kuhn observes with science bosses, they all get old and disappear from the scene leaving ever-renewed hopes for a less dogmatic future. But I have two reservations about this skeptical attack: (a) if taken too earnestly, it may have us suppose too many musical choices to be simply arbitrary; and (b) by overplaying the hardness of the line between musical right and wrong, it may lead us to underestimate, if not to ignore, the value in authentic performance practice.

Regarding (a), I have elsewhere argued that musical choices emerge from within highly structured adjudicatory and pedagogical communities, the limits upon which make ongoing musical traditions possible.[18] Outside of these structures and traditions, music as we know it evaporates. As for (b), the pursuit of authenticity is one of many musical virtues. Such a pursuit re-establishes links with our musical past and refreshes our sense of the continuity of musical tradition. Considering the value of authenticity in terms of priority and privilege, we may unfortunately think ourselves forced into talk of musical rightness and propriety, as if these were categorical matters of correctness akin to truth. Such hard-edged talk must invariably and fruitlessly endure the conflicts it creates among competing notions of aesthetical correctness. We should not even think of the pursuit of authentic performance as a *prima facie* duty, one which obliges us to follow suit when we can in the absence of overriding obligations and contingencies. Instead, the pursuit should

be seen as a musical virtue; that is, one which makes for goodness of musical character, or one which marks its enthusiasts as pursuing one of a number of musically worthwhile lives, and which restores, renews, and expands opportunities for appreciation. If music itself is a good, it cannot be ill-advised to follow the eudaimonistic dictum: try to appreciate that which is good in as many ways as one can. This may be a weaker conclusion than some may wish to draw, but it is surely less vulnerable and objectionable than any position so strong that it requires raw faith amongst its defenders.

## AUTHENTICITY THICK AND THIN

At the start I alluded to thick and thin readings of the concept of authenticity. In the moral sphere Williams distinguishes notions like "good," "right," and "wrong" as thin from thick notions like "cruel," "wise," "dishonest," and "kind-hearted." More generally,

[T]hick concepts have a higher empirical content [than thin ones] ... When we think about thick concepts, statements containing such concepts manifestly satisfy the minimalist conditions (they fall in very easily with the surface facts) – but seemingly they display *more*. They seem to display the opportunity for a larger set of the notions associated with truth and indeed the value of truth. For instance, they involve the application of the concept of knowledge. They invite us to think that, with regard to statements involving these concepts, it might be helpful to say that some people as opposed to others might *know* ... If we concentrate on thick concepts, we do indeed have something like the notion of a helpful informant. We have the notion of a helpful advisor. This is somebody who may be better at seeing that a certain outcome, policy or way of dealing with the situation falls under a concept of this kind, than we are in our unassisted state, and better than other people who are less good at thinking about such matters.[19]

Thin concepts like "good" are relatively empty empirically, or at least lacking in anything like substantive empirical content (and so are attractive to those seeking moral essences), while thick concepts like "charitable" are empirically much richer, more amenable to broad empirical characterization, and more uncontroversially applied. Unlike attributions of pure goodness, one can more comfortably say that one has evidence for someone's being, say, charitable, kind-hearted, or cruel. This approach distinguishes ethical theories looking for the core of morality in notions like Right or Good from those which look to the virtues, aspects of character, and leave talk of unified singular moral essences aside.

Any attempt to center everything on goodness as a fundamental

primitive normative atom faces two awesome tasks; namely, to characterize or define that primitive, and to show how other moral notions – such as the virtues – are constructs somehow built upon and so reducible to that primitive. At the very least, one would have to show how notions like "truthfulness" and "generosity" supervene upon ethical fundamentals like "good" or "right." As the history of ethics shows, there have been colossal problems with characterizing or defining such fundamentals that square happily and consistently with the richness of moral practice. The characterizations are either too narrow – for example, most naturalistic variants – to do all the theoretical work of integrating the variety of moral assessment, or they are too elusive – for example, most non-naturalistic variants. Hence these fundamental notions, designed to cut through seemingly extraneous details of real moral life, wind up thin, and offer little insight to those wanting to understand the moral life in their name.

As applied to performance, "authentic" has both thin and thick readings. The former, unlike the latter, leads to unsolvable and distracting philosophical puzzles. The issue about the possibility of experience seeks some metaphysical nugget about the absolute limits of experiential access and thus draws us into basic questions about how the world may and may not appear to some presently situated experiencing subject. Though this approach rejects the solipsism of the space-free and context-free pure subject (for whom no problems arise in principle about taking on *de novo* the mental states of any listener), it substitutes for it another solipsism, this time of the culturally embedded, historically sculpted, and analogously isolated experiencing subject who is inextricably burdened with vastly more cognitive and affective limitations than its leaner Cartesian cousin. Starting from this vantage point, altogether too many options are precluded. The model of experience not only makes all manner of rich re-constructive enterprises simply irrelevant; it also presumes that the only relevant experience is a kind of smart data-processing, and quite ignores the active exploratory physical interventions of which such subjects are capable. We do not just perceive, sort, and theorize in our re-constructive efforts. We experiment, build, tinker, and fit up models. If tinkering is a key technique by which we effectively acquaint ourselves with subatomic particles, surely such tinkering promises considerable success in acquainting us with vastly less elusive matters like past musical practice.[20] We make our own cultural-embeddedness, as well as sleeping in it. One

might just as well describe part of that culture-making as reflectively assimilationist. We absorb past conceptions and get some way, by so understanding them, to knowing what went on back then.

Closer yet to the thinness of certain approaches to morality is the stance concerning propriety which seeks a foundational core to the question: How ought this to be performed? To pursue this line whole-heartedly demands a faith in fixed criteria of rightness for music-making. Any such pursuit is even less likely to succeed than its ethical counterpart which seeks the fundamental right-making qualities of action in general. Given that any such effort must integrate the wealth of extant legitimate musical practice and judgment, it is vanishingly unlikely that any simple set of criteria will do as the basis for a general theory of musical value.

But once we abandon thin conceptions of musical experience or musical value, we must abandon any thinness in authenticity. Far from supervening upon any such sparse notions of experience or value, the notion is, like generosity and integrity, bound up in the dynamic of an ongoing and largely experimental and exploratory practice to find out more about what we are and once were like. Try as one might to clamp it all down with metaphysics and revealed norms, the prisoner is sure to escape. Thank heavens for that.[21]

## NOTES

1 The helpful distinction is from Bernard Williams, *Ethics and the Limits of Philosophy* (Cambridge, Mass., Harvard University Press, 1985) pp. 129, 143–45; also "Truth in Ethics" in *Truth in Ethics*, ed. Brad Hooker (Oxford, Blackwell, 1996), 19–34.

2 See Richard Taruskin, *Text and Act* (New York, Oxford University Press, 1995) for a lively account of the battles from the front.

3 An old friend and master builder, Michael Schreiner, described one of my first efforts as "very Canadian." Requesting elaboration, I got what I asked for. "Sort of a lumberjack lute," he replied.

4 Richard Taruskin, *Text and Act*, 218.

5 Hilary Putnam, "The Meaning of 'Meaning'," in *Philosophical Papers, vol. 2: Mind, Language and Reality* (Cambridge University Press, 1975), p. 227.

6 Donald Davidson "On the Very Idea of a Conceptual Scheme" in *Inquiries into Truth and Interpretation* (Oxford, Oxford University Press, 1985), pp. 183–98; especially 196–97 from which the paraphrase and quotations derive. See also Donald Davidson, "The Myth of the Subjective," in *Relativism: Interpretation and Confrontation*, ed. Michael Krausz (Notre Dame, University of Notre Dame Press, 1989), pp. 159–72;

and Alasdair MacIntyre, "Relativism, Power and Philosophy," *Proceedings and Addresses of the American Philosophical Association* (American Philosophical Association, 1985), pp. 5–22, reprinted in *Relativism*, ed. M. Krausz, pp. 182–204.

7 Salat – Recipe 44 from Constance Hieatt and Sharon Butler, *Pleyn Delit: Medieval Cookery for Modern Cooks* (Toronto, University of Toronto Press, 1979).

8 On a more contemporary note, one reads on packets of a line of New Zealand-made tortilla chips the following:

> *Sancho Tortilla Chips* offer the authentic taste of Mexico. They are made only from sun-ripened wholegrain kernels of corn. Stoneground, then shaped into convenient sized chips, baked lightly then cooked in vegetable oil and enhanced with flavourings and natural spice extracts.

No claim is made to transport one mentally to Mexico or to create in one the palate of a Mexican. This is the claim: these ingredients and manner of preparation correspond to Mexican practice. We may debate or deny the truth of this claim. That said, nothing is claimed about what one is supposed to experience, about how they taste to the eater. That is the chip-eater's problem. Further, any errors in ingredients or preparation are remediable by taking the right steps. Here we have an instance of *maker-centred* and not *experience-* or *consumer-centered authenticity*. To establish whether one is getting value for money, all one need do is to verify, as one can, the accuracy of the claim.

9 By no means was Bream the first or the best of the lutenists of that time. However, he was among the first to record on major non-specialist labels and already enjoyed an immense reputation as a musician of international standard. Hence, his influence in spurring further interest cannot be under-estimated. Two breakthrough recordings were "The Golden Age of English Lute Music" (1961) and "An Evening of Elizabethan Music" (1962) both under the Soria Series label of RCA Victor.

10 Representative studies include Ian Harwood, "A Fifteenth Century Lute Design," *The Lute Society Journal* (1960) 2, 3–8; Michael Prynne, "Lute Bellies and Barring," *The Lute Society Journal* (1964) 6, 7–12; Friedemann Helwig, "On the Construction of the Lute Belly," *The Galpin Society Journal* (1968) 21, 129–45; Robert Lundberg, "Sixteenth and Seventeenth Century Lute-Making," *Journal of the Lute Society of America* (1974) 7, 21–50; Friedemann Helwig, "Lute Construction in the Renaissance and Baroque," *The Galpin Society Journal* (1974) 27, 21–30. Among the invaluable compendia of lute facts is Ernst Pohlmann, *Laute, Theorbe, Chitarrone: Die Instrumente, ihre Musik und Literatur von 1500 bis zur Gegenwart* (Bremen, Editions Eres, 1975).

11 The variation in lute dimensions is much closer to the variation in electric guitars, though not nearly as extravagent.

12 John Baptisto Besardo, "Necessarie Observations belonging to the Lvte, and Lvte Playing," in Robert Dowland, *Varietie of Lute Lessons* (1610), facsimile edition with introduction by Edgar Hunt (London, Schott and

Co., 1958). This work also contains a masterful essay by Robert's father, John Dowland, entitled "Other Necessary Observations belonging to the Lvte," which is given over entirely to choosing lute strings, and fretting and tuning the lute.

13 David Lumsden, ed., *An Anthology of English Lute Music (16th Century)* (London, Schott & Co., 1954), from the Preface, p. iv.

14 So, for instance, regarding the authentication of sources for lute music, we note John Dowland's complaint in the preface to *The First Booke of Songes or Ayres* about William Barley, in whose *A new Booke of Tabliture* are "pirated" and "unauthorized" versions of Dowland's pieces which so upset the composer as to lead him to repudiate Barley in print. For details see John M. Ward, "A Dowland Miscellany," *Journal of the Lute Society of America* 10 (1977), 5–153, especially Appendix P.

15 A stunning re-assessment of the physiology of the dinosaurs as warm-blooded creatures with high metabolisms has overturned classical images of plodding, clumsy beasts just waiting for well-earned extinction. Recent re-creations of dinosaur life furnish vivid pictures of active lives on the move and thus force us to reconsider the supposed marvels of mammalian magnificence. On this shift, read Adrian Desmond, *The Hot-Blooded Dinosaurs* (London, Blond & Briggs, 1975) and especially Robert T. Bakker, *The Dinosaur Heresies* (New York, William Morrow and Co., 1986). On the strength of precisely this sort of work, we can judge Spielberg's fantasy reconstructions as considerably better versions of how the beasts were than previously less richly informed efforts.

16 Richard Taruskin, *Text and Act*, 92.

17 Richard Taruskin, *ibid.*, phrases respectively from pages 147, 187, 148.

18 Stan Godlovitch, "Innovation and Conservatism in Performance Practice," *Journal of Aesthetics and Art Criticism* (1997) 55, 151–68; also *Musical Performance: A Philosophical Study* (London, Routledge, 1998).

19 Bernard Williams, "Truth in Ethics" in *Truth in Ethics*, ed. Brad Hooker (Oxford, Blackwell, 1996), pp. 26–27.

20 On tinkering in science, see Ian Hacking, *Representing and Intervening* (Cambridge University Press, 1983).

21 Thanks to Richard Keshen for unmusical advice on the thick and the thin.

# Why is it impossible in language to articulate the meaning of a work of music?

JOSEPH J. KOCKELMANS

### INTRODUCTION

In this essay I take it for granted that for many people to listen attentively to a great work of music is an exciting, important, and meaningful event, and that they will describe their experiences with the work by saying, for instance, that they found it very beautiful. I also take it for granted that the "aesthetic ideas" which the work presents are such that to them "no determinate thought whatsoever, i.e. no concept, can be adequate, so that no language can express it completely and allow us to grasp it."[1] What I would like to accomplish in this essay is to present reasons for why this is so. But before turning to this task I first want to clarify more carefully what I do not mean to do, and precisely what it is that I wish to argue for. Furthermore, I also shall make a few remarks about certain assumptions which I have discussed already elsewhere and, therefore, need not repeat here in detail.

As for the first point, it is manifestly not my intention to claim that it would be impossible to say anything meaningful about music in general or about specific works of music in particular. For, first of all, the history of music has been able to unearth many important and interesting insights and ideas that can shed light on each given work of music. In addition, a person trained in music theory, analysis, and the various styles of composition can say very important and interesting things about the structure of a given work of music. In many instances it is also possible to speak eloquently about the social function of a certain kind of music or a particular musical work. And there may be other ways of speaking meaningfully about works of music. My real question here is the following: given that each genuine work of music in some form or other makes present some

175

meaning, why is it that this meaning cannot be articulated by means of language: why is it that whatever one says about a given work of music can never be a substitute for my listening to the work? Why is it that whatever a given work makes present, cannot be made present in any other way? How can music be an essential part of our world, even though its contribution to this world cannot be articulated except by the actual performance of the work? The question can be formulated in many variations, but for the time being I shall leave it at this.

In order to be able to define the issue to be examined carefully I would like to limit the kind of music I wish to talk about as much as possible. Thus, I shall not speak about folk music, songs, operas, oratorio, church music, other forms of religious music, but instead limit myself to "absolute music," that is, instrumental music of high quality written since the eighteenth century. This kind of music manifestly has no real function beyond itself. It is meant to be performed independently of any religious, public, or social context. Each work of instrumental music of this kind makes the claim of being a work of fine art that deserves its own independent place next to other musical works, next to other works of art, next to whatever can be brought to light by the sciences, and next to whatever comes to pass meaningfully in any other domain of our human experiences. It itself has its own place in "the progressive revealment" of the truth.[2]

To prevent misunderstanding I would like to add to this that in what follows I shall not be concerned with composers, nor with what he or she may have written or may have wanted to present. I shall not be concerned either with the performance of the work by the participating musicians and the great experiences that constitute an essential part of the actual performance of a great work of art music. Thus, I shall not speak about the conductor, not about the many things he or she will be able to say about how a particular work is to be performed. I am interested merely in the work itself, taken at the time in which it is actually being performed, during the time in which it actually is heard. I am not even concerned here with the important experiences someone has or goes through when he or she listens to a work. I am interested with what the work makes present, and why it is impossible to articulate the meaning it makes present by speaking or writing about it. I am concerned merely with the manner in which truth happens in and through this work at a level that appears to escape the possibility of conceptualization and linguistic articulation.

## I HOW AND WHY DID MUSIC BECOME PROBLEMATIC? FROM AESTHETICS TO ONTOLOGY OF ART WORKS

In the West, music has always been closely related to social phenomena such as liturgical ritual, official ceremony, public festivity, and recreational events. It was assumed then also that music has a world-constituting "function," insofar as music is "instrumental" in making available to a people a world in which they can dwell as humans. To be sure, music was never taken to be capable of constituting a world for a people all by itself alone and independently of the other arts and of all the other dimensions of man's experience. Yet, together with the other arts and together with religion, the social praxis, and "science," music too was at one time taken to have a world-founding "function."

Before the eighteenth century the relationship between music and meaning was not problematic and no philosopher thought it to be worthwhile to think and write about the meaning of music. Before that time there were few forms of art music that were originally meant to be performed "by themselves." Until then music had always been closely related to the social life of the community and particularly to its official public life. Most often it was an integral part of a social function that implied many of the other fine arts, in addition to one or more all-encompassing dimensions of the community's life, ranging from religion via the socio-political praxis to recreation and amusement.

Since the eighteenth century the unity of the communal world has been broken up and gradually the fine arts became separated from the life of the community, in much the same way in which science became separated from philosophy, morality, and religion. We now know of a great number of compositions that have no social function and which no longer explicitly refer to an all-encompassing setting. These works can be performed by themselves, so to speak, and for their own sake. Numberless people today enjoy musical works of art in the privacy of their homes in virtually total isolation. Yet they claim to have experiences with these works that are of great depth, power, and importance. It is particularly in this context that people started to wonder about what musical works are supposed to do as works of fine art, what they express, what they communicate, perhaps what they evoke; at any rate, what they make present.

The first philosophical treatises on the fine arts were written in the later part of the eighteenth century by rationalists such as

Baumgarten, empiricists such as Burke, and romantics such as Herder. Kant did make a careful study of these works and also borrowed a number of ideas that had been developed in their works. Yet the important point to be made here is that Kant gave these ideas a place within a systematic framework of meaning that was totally original on his part, and which gave these ideas a significance and meaning which they had not had before.

In his own philosophical aesthetics Kant turns to the typical characteristics of our judgments of taste as well as to the notion of the "beautiful." In his reflections on the distinction between the beautiful in nature and the beautiful in works of art Kant was led to a parallel distinction between the ideal of beauty toward which every judgment of taste must strive according to its very nature, and a normative idea of beauty.[3] As an autonomous phenomenon the work of art does not present the ideal of nature, but rather constitutes the self-encounter of man and nature within the human, historical world. That is why for Kant art is the beautiful presentation of some form, and through it the presentation of an aesthetic idea which lies beyond the realm of our categories and concepts. Through the beautiful presentation of an aesthetic idea the artist infinitely expands a given concept and, thus, encourages the free play of the faculties. This implies that art lies beyond the realm of reason and that the beautiful is and remains conceptually incomprehensible. The "irrationality" of the artist who freely creates ever new models and refuses to adhere rigidly to rules explains why it is impossible to lay hold on the meaning of the work of art, except through the work itself.

According to Kant, every art necessarily presupposes rules by means of which a work of art, if it is to be artistic, is represented as possible. In most arts these rules are determined by nature, yet in the fine arts these rules flow from a special disposition on the part of the artist. The innate disposition through which the rule is given to art is called genius. Fine arts must, therefore, necessarily be considered as arts of genius. Yet in order to make certain that the artist will not abuse the freedom, Kant felt he had to subordinate the creativity of genius to the judgment of taste.

It is only in the post-Kantian tradition that the concept of genius begins to occupy the central position in reflections on art and art works. Although Hegel had strongly objected to this move by claiming that art is not the work of genius, and that each work is to be understood as a manifestation of truth, the neo-Kantians main-

tained the concept of genius and with it the idea of the "creative."[4] They wanted to give aesthetics an autonomous base freed from the criterion of the concept and, thus, not to raise the question of truth in art. That is why they sought to base the aesthetic judgments on the subjective a priori of our feelings. This in turn led to the idea of giving the concept of *Erlebnis* the central place in philosophical reflections on art works.

The neo-Kantians saw a close relationship between the structure of the *Erlebnis* and the aesthetic experience with a work of art. This made it possible to say that the work of art itself is an expression of an *Erlebnis* and that it is intended to lead to an aesthetic *Erlebnis* in the beholder or the listener. The art work flows from an *Erlebnis* of inspiration of the artist's creative genius and then, in turn, leads to an *Erlebnis* in those who are beholding it or listening to it.

Elsewhere I have shown that all these claims rest on quite questionable assumptions. Neither the appeal to *Erlebnisse*, nor the concept of aesthetic consciousness that is presupposed in it, nor the opposition between appearance and reality which the theory implies, are acceptable. As for the latter, it is simply not true that where art rules, reality has been transcended. It certainly is not correct to characterize the "kingdom" of the arts by imitation, appearance, irreality, illusion, or fiction. These expressions suggest that the entire aesthetic domain is to be related to something which in itself is not and never will be. To the contrary, works of art, too, must let the truth of what is come to light.

As I see it, each art work inherently belongs to a given world. In addition, it lays claim to truth, even though this truth is not the kind found in the sciences or in our moral life. The relationship between the work of art, the world, and truth, as well as the typical form of understanding which every encounter with a work of art implies, has been explained in a remarkable way by Heidegger. In "The Origin of the Work of Art" in which Heidegger tried to show that art is an inherent element in man's efforts to come to genuine self-understanding, the claim is made that the origin, that is, that which makes it possible for a thing to rise up as what it itself is, of both the art work and the artist, is to be found in art.[5] To answer the question of what art is, we must turn to that being in which art manifests itself, the work of art. What an art work itself really is cannot be characterized by the essence and property of the thing as such. For first of all, the classical determinations of what a thing is are inadequate to define what things really are. What art works really are

can be shown only by turning to some examples and analyzing them from the perspective of the whole within which they meaningfully function. In so doing one can show that in a work of art the truth of beings comes-to-pass. Let us briefly explain this.

The art work cannot be taken as an object if one is to understand its own mode of being. Each art work stands by itself. And yet it also belongs to a world. As standing by itself it is also that through which this world is present. Standing in and by itself the work of art opens a world. To show this, one does not have to turn to the concept of genius, nor does one have to turn to the *Erlebnisse* of the beholders. Rather one must turn to the tension between earth and world as this shows itself in every work of art. For a world it is characteristic that it opens up and discloses; on the other hand the earth closes and shelters. Both are present in each art work.

Furthermore, one should realize also that a work of art as such does not refer to something else as a sign or a symbol does. Rather it presents itself in its own Being and invites the beholder to stay and dwell with it. It is present to the beholder in such a way that it gives the earth (materials, colors, words, sounds) the chance to be present as what it really it. Usually the earth is used for some purpose, for something. Then it does not show itself as what it really is. The earth is primarily thus not material and source of resources; primarily it is that from which everything comes and to which everything eventually will return.

Finally, the mode of Being that is characteristic of a work of art is not to be found in the fact that it can become an experience (*Erfahrung*). Rather it is what it is in and through its own self-presentation. It is an event which changes and upsets what is common and ordinary. In each work of art a world opens itself that without this work never would have been present. And yet this same event (*Ereignis*) in which earth and world are in constant tension also brings it about that the work can present something in an abiding manner.[6]

But the truth which the work of art reveals is always a finite truth. By describing some series of events, by depicting some being or beings, by presenting some ordered structure, the work reveals the truth of the whole of beings by opening up a world while reposing it in the earth. It is this world that invites each human being to enter it and "find oneself" in one way or another dwelling in it. Although both world and earth are complementary, in the work of art they are nevertheless always in continuous contention; the earth permeates

world and world is grounded in earth. And this constant contention reflects the coming-to-pass of the truth, the primordial discord between lighting and concealment, in the work. The truth that comes-to-pass in the work, however, does not consist in a meaning that lies in the open in an articulated form; rather it is a meaning which is fathomless and deep.

It is obviously true that the *fact* that in the work truth is at work in a finite manner is due to the effort on the part of the artist who produced the work. The artist stabilizes the fundamental contention between earth and world by making it manifest by means of the work's stable structure. By setting truth to work in the art work, the artist makes it possible for the work to bear witness of the fact that it is and can surprise the beholder with the startling revelation of itself as the coming-to-pass of finite truth. The *fact* that in the work truth is at work also implies an observer who is startled by the work and lingers and dwells in the openness that pervades it, that is, a world. In other words, in order for truth to come-to-pass on the work of art, conservation and beholding of the work are as essential as the effort of the artist who brought it about.

If we apply these ideas to a specific sonata or quartet then we can say that each work, while it is being performed, presents the listener with a world. By world we do not mean here the totality of all natural things, but rather a totality of meaning by means of which a human being gives to him- or herself the capacity of understanding the things one can behave towards. When a human being is confronted with one or more things and goes beyond these things toward the world, he or she understands these things. But by that same movement of transcendence each human being temporalizes him- or herself as a self. In and through transcendence one brings the world before oneself in order that one can relate to things from within the midst of things.

Now if it is true that the world is only as long as human beings let it come-to-pass, then the work of music does not reveal a world isolated from the self, but rather it presents that world as that toward which the human self can possibly surpass things. In other words, the musical work, taken as a "significant form," brings the self in a definite mood which offers the self a possible world, or at least a new perspective on the world in which we live. By making a world be present the work invites the self to enter it and make it into its own. While I am listening to a given string quartet the world presented by it invites me temporarily to "leave" the everyday world behind and

begin to "live" for some time in the possible world that the work makes present. The work invites me to move into that world and find myself there as attuned in a certain manner, depending on the nature of the composition involved. Since the orientation toward world is constitutive for the mode of being of humans, I find myself constantly in a world, attuned in some manner or other. The work of art music retunes me, as it were, and opens me up for the world that is its own.

Perhaps we could say that the composer creates a musical work in such a way that it itself can disclose a possible world to anybody who is willing to encounter it while the work is being performed. While it is being performed the work sets up a world "out of" the sounds of the earth. The world that has so been set up invites the listener to enter it and find him- or herself there properly attuned to the things which the world lets be. Leaving behind the entire material and spatial domain and moving into the essential temporal dimension of both sound and self, the composer and the performers grant measured tones and chords the possibility to follow each other in orderly and rhythmic fashion, and to sound well on the level of the tones' rhythm, melody, and harmony.

When we listen to a string quartet we do not feel the urge to give an interpretation of the work's meaning, even though the performers have to interpret the score. We, the listeners, feel rather impelled to accept what is being presented to us through the work and this is a possible world offered to each self. I feel impelled to enter this world and find myself properly attuned to the possibilities which this world offers me.

## II WHY IS IT IMPOSSIBLE TO SPEAK ABOUT THE MEANING OF WORKS OF ART MUSIC?[7]

Now some of my basic assumptions have been made explicit, we can now turn to the main issue that I wish to discuss in this essay. Let us begin by discussing a concrete example.

I have just gone to the concert hall where I shall be listening to some of the middle and late quartets of Beethoven. While one of these string quartets that is being played, unfolds, it gets me in its grip, and moves me deeply. I experience this event as a very meaningful one and yet, at the same time, I must admit that I am unable to articulate the meaning which the work makes present to me. True, one cannot deny that one could say many meaningful things that would indeed

be relevant to the event as well as to the work that is being performed. Yet all of this does not help me to articulate the genuine meaning that is presented to me in and through the work as such.

There are many reasons why it is impossible to speak about the meaning which works of art music make present. Some of these reasons hold for all works of art, others are typical for musical works as such. Although I am interested here in discussing mainly the latter, I shall nonetheless briefly mention some of the others as well insofar as they are particularly relevant to musical works.

Musical works of art have the typical characteristic that they cannot be made present in an instant. They are presented over time and thus are inherently temporal. And in their actual presentation there is constant movement and change. A work of music is in the full sense of the term only as long as it is actually being performed. The work and its meaning are present only as actually happening and coming-to-pass. A quartet has a form of presence that explicitly is experienced as enduring and lingering. There is retention and protention but there is no clear awareness of past and future. There is only a "flowing present" in which the other ekstases are still wrapped up, as it were. In music this "flowing present" is structured by the changing tension between meter and rhythm, melody and harmony. Rhythm is primary in this "flowing present." Yet rhythm has no meaning except for the one who "lives" it, and who lets him- or herself be carried by it, lets him- or herself be tuned by it. Music has in this regard much in common with lyric and dramatic poetry. Yet contrary to the arts of the word, music structures rhythm only with mere sounds, not sounds that have and communicate a meaning of their own.

Connected with this first characteristic, which to some degree explains why it is impossible to speak about the meaning of a work of art music, is the fact that music, like other arts, can be character-ized as a form of play. One should note that in this case the word "play" does not signify the attitude or state on the part of composer, performer, or listener, but to the mode of being of the musical art work itself. Thus one cannot relate to a work of art music as one relates to an object, just as little as play can be objectified. True, in every form of play one can distinguish the rules of the game from the actual performance. One can fully know the rules and yet have no knowledge of the meaning of playing the game. What the meaning of playing soccer really is, is known only by those who actually play or have played the game. Something similar is the case in music. Here,

too, there is some stable structure that gives the work its typical "reality," detaches it from the activities of performers and listeners, makes it both permanent and repeatable, and gives it its typical autonomy. Yet this stable structure of the score notwithstanding, the art work can never be isolated from the contingent circumstances and concrete conditions in which it is actually presented.

These reflections lead us to another reason why it is difficult to speak about the meaning of works of art music. The vast majority of musical works of art originated in a world that has passed. When we have these works performed today in a concert hall these works are taken out of "their time" as well as out of their "place." Thus, even though it is true that the presentation of the art work in each case must be characterized by contemporaneousness, and the actual being of the art work cannot be restricted to its own original historical horizon, it is equally true that all aesthetic differentiation notwithstanding, each work maintains its historical origin. Furthermore, the art work in each case presents itself to human beings whose mode of being is to be characterized by temporality and historicity. If, because of the essential historicity of its mode of being, each human being has to mediate itself to itself and to the whole of its experiences of the world, then its entire tradition belongs to it, so that each encounter with a work of art, in the actual presentation of the given work, continues to belong within the process of continuous integration which is involved in all human life that stands within a tradition. The typical contemporaneousness of the art work is thus to be attributed to the fact that as a work of art it is open in a limitless way to ever new integrations. The artist may first have addressed the people of his or her own time. Yet the true meaning of the work is what it is able to say, and this reaches far beyond any historical boundaries. It is and remains true that art works have a timeless present. Yet this does not mean that we still do not find its historical heritage in it. Thus even though each work of art is not meant to be understood historically and always offers itself in a timeless present, it nevertheless does not permit just any form of comprehension. Human beings must learn to understand what art works have to say. These reflections gradually lead us to what I take to be the heart of the matter.

For the preceding reflections suggest that part of the meaning of a work of art music is articulated in the very structure of the work taken as a "significant form," whereas another part of its meaning is merely presented, but not articulated. In other words, each work of

art music presents some meaning in an articulated form and about this meaning we can speak. But through this meaning it also makes present a certain "excess of meaning" which cannot be articulated. What the work presents and "says" precisely as a work of art, is the latter; the former is merely the means through which the work makes the latter be present.

Furthermore, the articulated structure through which the work of art music makes present what it truly has to say contains references to the world in which it originated. It also contains references to the attitude which the artist assumed in regard to that world. All of this, too, can be examined scientifically in the history of music, sociology of music, psychology of music, interpretation theory, criticism, etc. Whatever these sciences may be able to contribute to our ability to have a genuine experience with a work of art music, it never can be more than a condition for the happening of that experience. It can never become an essential part of that experience itself and most certainly it is never a substitute for it.

Taken as a work of art music, each work makes present an excess of meaning that reaches far beyond the meaning that is actually presented in the work's significant form. This excess of meaning refers to a world. This world cannot be that of the artist, because then the work would merely address the artist's contemporaries. It cannot be the world of the listeners either, because this world changes considerably over time. This world is rather a "universally" livable world, a world that *in principle* is a world of possibilities for everyone. Yet this world can be presented only through concrete presentations of the work.

One of the reasons why it is impossible to articulate the excess meaning of a work of art music is precisely connected with the fact that art works as such make present some whole, not the parts of which this whole exists. A work of art music makes present "a new world"; it does not present a particular event, thing, person, or community. Furthermore, it presents that world as inherently related to a self, *my* self, again taken as a whole. The work of music does not articulate world and self; rather, it provides the people who had an experience with the work with a perspective from which further articulations and interpretations of events, things, persons, or communities perhaps could be given. Yet the excess of meaning presented by each work does not directly address our understanding in a manner that can be conceptually articulated, but rather that form of understanding that is intrinsic in our dispositions.

185

The excess of meaning is revealed by attuning us to a world in which unexpected and surprising possibilities are being presented, possibilities in which a "new world" lets things be what they are in a truly novel manner, in which things can "bear" a new world, and in which each self can find new possibilities for its own self-realization. What the work thus inarticulately makes present in and through the excess of meaning, is a truth about a world and about those who, living in that world, are given the privilege of having an experience with the work.

But what has been said so far is true for all forms of art, not just for music. Yet it is true also that some of the issues discussed briefly are pertinent to music in a much more fundamental sense. This, in turn, is again intimately connected with what is typical for music as such, as I hope to explain in what follows.

Many authors have stressed the close relation between music and our emotions. This view has a venerable tradition which reaches back as far as Plato and Aristotle. Kant was one of the most eloquent defenders of the thesis that music is the language of the emotions.[8] The view has remained the dominant one in the eighteenth and nineteenth centuries. Even today there are still many people who defend the basic thesis in one form or another. At another occasion I have defended the view that music is not really a language and that the expression, the language of the emotions or affect is very ambiguous and misleading. I shall not return to this issue here. Yet the notion that there is a special link between music and our emotions or affections deserves special attention here. For if it were to be the case that there indeed is a *special* relation between music and our emotions, one not found or not found so strongly and clearly in the other arts as in music, then this would be another reason why it is impossible to speak about the meaning of musical works of art.

Instead of arguing the case in the abstract, let us turn to a concrete case. Let us return to one of the late string quartets by Beethoven that I mentioned earlier. Suppose I am now listening attentively to this great work of art. I find myself soon deeply moved by it; it seizes me; it has me completely in its grip, so to speak. When the last sounds have come to complete silence, I may say to myself: "What an experience!" In the work, precisely what is it that makes me say this and in what sense is it related to my emotional life?

It seems to me that the answer to these questions cannot be that the work gave me pleasurable experiences, because a string quartet by Beethoven cannot be characterized and distinguished from all

other things a human being can produce, provided one knows how to do it well, by the fact that it arouses pleasurable experiences in us. Furthermore, many other things and events, "bad" music not excluded, may give us pleasurable experiences. Finally, the experiences aroused by works of art music are often not pleasurable in any clearly definable sense.

One will perhaps say that I call a given quartet great because it is a significant form which has been presented to me with perfection. The perfection of the significant form itself and the perfection of its presentation would then evoke our "aesthetic enjoyment," and the latter would not have to be a pleasurable experience. But this way of speaking, too, is still not satisfactory. For as we have seen, in addition to the significant form there has to be some excess of meaning and it is precisely the latter that I am trying to understand. The inner perfection of the significant form as well as the perfection with which the musicians perform the work are to some degree conditions for my experience of it, but they do not constitute the meaning of the work in question.

It is quite commonly accepted that music touches both the intellectual and the emotional dimensions of our lives. Many authors have written about music in these terms. Hindemith explains this conception as follows. When one listens to a work of music, intellectually one builds up structures parallel to the actual musical ones, and these structures receive weight and moral meaning through the attitude we assume toward their audible or even imaginary originals: either we consciously allow music to impress us with its moral power, or we transform it into moral strength. Emotionally, we simply are the slaves of the musical impressions and we react to their stimulus, inevitably and independent of our own willpower, with memories of former, actual feelings.[9]

I must say that I cannot verify these claims on my immediate experience with a work of art music. analytic terms such as 'soul,' 'spirit,' 'body,' 'organism,' 'faculty,' etc. appear not to be relevant in any account of my immediate experiences with the work, and neither does the distinction between intellectual and emotional dimensions in man. True, I do not deny that one can adopt a theoretical, analytic attitude and then develop a regional ontology of musical phenomena in which such expressions could be meaningfully employed. Yet what such analyses would reveal is not given to me in my immediate experience as the meaning of the work, and it is

precisely the latter that I am trying to understand. Such analyses may perhaps be helpful to understand the musical structure of the work; yet they do not seem to be capable of making a substantial contribution to the solution of the question of precisely *what* and *how* musical works present meaning. The only thing that in this regard is obvious is that the work seizes me totally, spirit to toe, so to speak.

I am deeply moved by the work. This suggests that my experience with the work is nonetheless to be articulated with the help of some appeal to man's emotionality, as the preceding reflections show. I do not deny this; yet I still maintain that the expression "emotionality" cannot be taken here to refer to a certain faculty, capacity, or even dimension of man with the exclusion of others. Furthermore, some interpretations of this thesis given in the literature cannot possibly be correct. Thus if someone tells me that music evokes the emotions in me which the composer himself had, and that the performer trans- mits the feelings which originated in the composer, as many authors from Mattheson and Rousseau to Croce and Liszt have suggested, I have to say that I cannot possibly justify such claims on the basis of my experience with the work. The work that is now immediately present to me and lets me have the experience with it that I in fact have says nothing about these things; it does not even suggest them.

Again, when someone else tells me that music does not express the emotions of the composer or the performer, but is meant merely to evoke those emotions in the listeners which the composer in- tended the work to evoke in them, I still am unable to verify these claims on the basis of my experience with the work. Even granted the fact that music can evoke concrete emotions, one should still realize that this is not the prerogative of fine art music alone; "cheap" popular music does the same, and for some even more so. Furthermore, in most instances I know absolutely nothing abut the composer's intention. Finally, one and the same work may very well evoke different emotions at different times.

Suzanne Langer states that music is not really self-expression on the part of the composer or performer, but the formulation and representation of emotions, or feelings.[10] Music is a "logical picture" of sentient life, a source of insight, not a plea for sympathy. In Langer's view, feelings revealed in music are directly presented to our understanding so that we may grasp them, comprehend them without having to pretend to actually have them, or imputing them to anyone else. I can understand these claims; yet I still have

difficulty in relating them to my actual experiences with the work, because these claims, too, are still ambiguous and the work itself does not give me a clear hint as to how to interpret them.

When Langer specifies her position by adding that music is the logical expression of emotions and that music is the "language" of the emotions, just as a natural language is the language of our thoughts and ideas, then her position becomes even more ambiguous. As I have indicated already, in my view music is not a language. Furthermore, it is not clear to me precisely what is meant here by emotions. And, thirdly, it is not at all clear what the relationship is between emotion and work.

It seems to me that music is not intimately related to specific emotions of joy or sadness, but rather to our basic underlying moods. Everyone immediately knows what one means by a mood. When someone tells you that he is in a good mood, you immediately "know" in what state of mind he is. We also know that moods come over us in different forms: there are good moods and bad moods; we are also all familiar with the state of undisturbed equanimity, or the "pallid, evenly balanced lack of mood." We all know that a mood makes manifest how one is and how one is faring. But beyond these general observations it is very difficult to say precisely in what the basic structure of our dispositions consists because our thematic knowledge of all that is closely connected with a man's frame of mind is rather meager. Undoubtedly dispositions and moods communicate something to us about our own mode of being in relation to the world in which we find ourselves and in relation to whatever we find in that world. Yet it is very difficult to say why one is disposed or "tuned" in a determinate way and particularly what this disposition tells us about ourselves and the world. The basic disposition informs humans about their position in the midst of things in the world. Contained in this general "insight" are different elements that must be distinguished.

First, in our dispositions we are aware of our own mode of being and of the fact that we are. We appear to ourselves as living among fellow men and other beings and finding ourselves there in a given disposition.

Secondly, our moods disclose to us the world in which we find ourselves. Already in our everyday life we encounter the beings within the world as things emerging from the horizon of the world, taken as a system of references, as the "total-meaningfulness." But this is possible only if the world has already been disclosed to us as

such beforehand. Precisely because the world is given to us humans beforehand, it is possible for us to encounter the beings within the world as the things which they factually are. This prior disclosedness of the world is constituted by one's fundamental disposition. The fact that man is openness in the direction of the other in a pre-given world is given to us in the most original way, through the fundamental and primordial "feeling" of our "being there."[11] But if we have to leave the primary discovery of the world to "bare moods" then it is understandable that the disclosure of world which is the condition of possibility of all meaningful involvement with things in the world itself escapes our ability to articulate its meaning. Then it is equally understandable why it is not only difficult, but even simply impossible, to articulate the meaning which works of art music make present to us. That meaning, presented in the form of a "new" world, of a world of new possibilities is not to be articulated; rather it is to be accepted and "lived." It also constitutes a large horizon of meaning from the perspective of which possible articulations and interpretations can be developed.

But there is still more. For the condition of the possibility of having emotions and being subject to moods consists in the fact that humans are bodily beings, not pure spirits or intelligences. This leads to the idea that there must be a close relationship between being open to music and being bodily in nature. This idea is as old as there have been made claims about music. In some sense there obviously is a close link between all arts and the human body. For the arts were always closely tied to the beautiful whereas the beautiful is *quae visa placent*. And yet already the ancient Greeks were aware of the fact that the link between music and human body is much closer than that of any other art form. This explains why music leads to dance, march, procession. No other art form, except perhaps architecture, is so directly bodily, addressing itself to human beings in their bodily dimension, inviting the body to respond to the meaning presented with the proper movements or forms of action as music is. There is an equally strong link between architectural spaces and body; yet in this case there is no invitation to movement and action; rather there is the feeling of "finding-oneself-well," of shelter and security. Speaking about the play element in the arts, Kant once observed that in music this play proceeds from bodily sensation to the aesthetic ideas of the objects of affects, and from these back again to the body but with combined force.[12]

But although quite a number of philosophers have pointed to the

close link between music and body, as far as I can see not much can actually be learned from these references to this "obvious fact." The reason for this is that these philosophers never developed a thorough philosophical view of the human body. Since the time of Plato most philosophers have placed the body opposite to the soul and claimed that the soul is the ultimate source of all meaning that can be present to a finite self. In that perspective it did not make sense to turn to the body in a context in which one tries to understand the meaning of the arts. Kant is the first philosopher I know of who began to look at the human body in a quite different manner. For Kant the body (*Leib*) is that as which a human being belongs to nature and its lawfulness, whereas pure reason places each human being in the domain of the moral laws. That a human being can have access to nature is due to our bodiliness. Yet in some of his works Kant also added another dimension to this conception of the human body. For example in *Traumen eines Geistessehers* he describes the human body as the vehicle of reason, as expression and yet at the same time also as a factor of the subjective position of the subject, whose perspective on the world is determined by its bodiliness. Finally in his *Opus Postumum* Kant speaks of the aprioric bodiliness of the human subject, an idea that one also somehow finds in Fichte, who claims that the I has to become exterior (*entäusseren*), the I must a priori come to bodily appearance, it must appear with necessity as a material organ if the I is to relate to the things as the objects of its actions.[13] In other words, in order to be able as an acting subject to enter the domain of what is real and not just to remain in the domain of representations, it must make itself become a material body in order, in this way, to be able to bring about the products of its freedom. Hegel, too, sees the body, or better the bodiliness of the soul, as that in and through which it can establish a unity with the outer reality. In all these views the body–soul or body–spirit opposition is still maintained. Perhaps Nietzsche was the first one to reject the notion of soul altogether. He thus had then to rethink the meaning and function of consciousness. For him the body is the "great reason" and source of all meaning.

Merleau-Ponty has pursued the ideas of both Fichte and Nietzsche further and finally came to the view that the human body is the manner in which each human being relates to world, is being-toward-world, *être-au-monde*.[14] This is why the body becomes the domain in which perception, language, orientation toward world, and all action comes-to-pass. The position taken by Merleau-Ponty is

one that is usually understood in such a way that the body is characterized as a subject, a not-yet conscious and not-yet-free subject, yet a subject of meaning and action nonetheless. I find the conception of the human body very appealing when it comes to describing, interpreting, and explaining phenomena such as perception, association, spatiality, motility, sexuality, gestures, expression, and even speech. For it fully realizes that the body we experience as source of meanings and actions is not the body which we see and touch, and about which biology, anatomy, and physiology speak. For the latter body is already placed within a world of objects; it is something secondary; something deduced; it is not an original datum. And yet in the final analysis this conception of the body, too, is unacceptable in that, by making the body a subject, one opposes it without any justification to all other things as objects. This objectification may indeed occur in some instances; yet it is not essential to understand the human body as the source of meaning and action. It certainly has no place in reflections on the meaning of music. Instead of conceiving of the body as a subject, we must realize that my body is the transition from me to the world. My body is the place where I appropriate my world. My body grafts me on to the realm of things; it secures for me a solid or a labile standpoint in the world. My body, therefore, is *situated on the side of the self that I am*, and yet at the same time, it also involves me in the world of things. What I call my body is really my own self taken on a not yet conscious and free level. Yet it is also my own self as inherently open to the world. It is a "subject" in the sense that it is an agent, a source of meaning and action, but it is not a "subject" in the sense of that which stands opposite all objects. There is also the conscious, reflective, and free self; this is the same self as my body, but now taken at a "higher" level of functioning.

But even in this reinterpretation the conception of the body proposed by Merleau-Ponty still does not immediately explain the manner in which music affects us. For usually when we hear something, we hear sounds as the sounds of something, the horn of the car, the whistle of the train, the bells of the church, or the voice of a friend. But in the case of music there are just "mere" sounds, sounds that stand in, by, and for themselves, so to speak. True, I can hear them as the sound of a violin or a 'cello, but then I am no longer having an experience with the quartet I am listening to. In the case of art music I am presented with "mere" sounds that are structured and ordered into a significant form. The significant form is addressed to

me, but to me as this body. This is why it does not evoke images, representations, concepts, or thoughts. Rather it transforms me as this bodily self by bringing me to a different mood, in and through which it presents me with a "new world," or at least with a new perspective on the world; and this world, in turn, affects me in my being in the world. In many instances a work of art music affects us in such a manner that we feel invited to engage in some form of movement, but this movement has no meaning or purpose beyond itself. Usually it is not more than a vivid experience of tension and relaxation, or a slight movement pattern in hand or foot, a change in bodily rhythms; but in other cases it also may invite me to dance or to engage in other forms of movement.

I take it that the fact that music is addressed to me as this body, this bodily self, retunes me, and attunes me to a "new world," is the main reason why it is impossible to articulate the meaning of works of absolute music.

## CONCLUSION

In the preceding reflections I have brought together a number of reasons that may help us understand why it is impossible to speak about the meaning of a work of music. In order to give the paper a sharp focus I limited the discussion to works of "absolute music," where there are no elements involved except those which belong to music as such. In many instances I stressed the point that what was claimed here for music can also be held for some, if not for all, other fine arts. Yet I have made a special effort to show that my main interest nonetheless was in explaining why this is particularly the case for music. At first, it looks as if music, as a form of art, is in some sense "inferior" to other fine arts, particularly to the visual arts and above all to lyric and dramatic poetry. For one generally assumes that, in principle, it should be possible to articulate the "genuine" meaning of these works of art. Yet if my reflections hold a core of truth, it may very well be that reflections on the meaning of works of abstract music offer us a more direct path to an answer for the question concerning the meaning of all art works.

## NOTES

1  Immanuel Kant, *Critique of Judgement*, edited and translated by J. C. Meredith (Oxford, Clarendon Press, 1952), p. 134.

2 See "Preface," "Self Alienated Spirit: Culture" and "The Enlightenment" in G. W. F. Hegel, *Phenomenology of Spirit*, trans. A. V. Miller, with an analysis of the text and foreword by J. N. Findlay (Oxford University Press, 1977).

3 Kant, *Critique of Judgement*, sections 15–17.

4 See H. G. Gadamer, *Truth and Method* (New York, Seabury Press, 1975); Wilhelm Dilthey, *Von deutscher Dichtung und Musik: Aus den Studien zur Geschichte des deutschen Geistes*, ed. H. Nohl and G. Misch (Stuttgart, Teubner, 1957) and *Selected Works*, vol. 5, part II, edited by R. A. Makkreel and F. Rodi (Princeton University Press, 1985).

5 "Der Ursprung des Kunstwerks," in *Holzwege (1936–1946)* (Frankfurt, Klosterman, 1950). See also "The Origin of the Work of Art" in Martin Heidegger, *Poetry, Language, and Thought*, trans. A. Hofstadter (New York: Harper and Row, 1971).

6 *Metaphysische Anfangsgründe der Logik im Ausgang von Leibniz*, ed. Klaus Held (Frankfurt, Klosterman, 1978).

7 A "work of art music" was the phrase selected to exclude musical works that have no aesthetic value. Most contemporary popular music in my view falls within this category.

8 Kant, *Critique of Judgement*, sections 49–52; see also his references to music in his "Observations on the Feeling of the Beautiful and the Sublime."

9 Paul Hindemith, *The Craft of Musical Composition*, trans. Arthur Mendel (London, Schott, 1942), vol. 1, pp. 22 ff, 78 ff.

10 Suzanne Langer, *Feeling and Form* (New York, Scribner, 1953).

11 Martin Heidegger, *Sein und Zeit* (Tübingen: Niemeyer, 1953), pp. 134–38.

12 Kant, *Critique of Judgement*, p. 332.

13 Immanuel Kant, *Opus Postumum*, ed. and trans. Eckhart Forster and Michael Rosen (Cambridge, Cambridge University Press, 1993), pp. 65–66, 116–18; J. G. Fichte, *The Science of Knowledge*, ed. and trans. Peter Heath and John Lachs (Cambridge University Press, 1982), Part III.

14 See Maurice Merleau-Ponty, *The Phenomenology of Perception* (London, Routledge, 1962) and *The Primacy of Perception* (Evanston, Ill., Northwestern University Press, 1984).

# PART III

# Authenticity, poetry, and performance

# Inauthenticity, insincerity, and poetry

ALEX NEILL

Inauthenticity, whether in a person's character and attitudes, or in the arts and crafts, invariably marks a flaw or failing in whatever it characterizes. In a person's life, one manifestation of inauthenticity is that of insincerity: not meaning what one says or feels, pretending to have sentiments (I use the term in a Humean sense, to include beliefs and desires as well as less obviously cognitive feelings and emotions) that one does not in fact have. And it is sometimes said that there is an analogous case in the arts: that one way in which a work of art may be inauthentic is in virtue of being insincere, of expressing or articulating sentiments which are or were not in fact those of the artist. In what follows, I wish to consider whether this is correct; whether insincerity may indeed be a manifestation of inauthenticity in the arts, and in particular in poetry. Can the fact that a poet is insincere, in the sense that her poems express sentiments which she does not feel, make those poems inauthentic?

Needless to say, pretending to have sentiments which one does not in fact have is not the only way in which one may be insincere, far less the only way in which inauthenticity may manifest itself in a person's life. Nor, clearly, is the fact that the sentiments expressed by a poem are not those of the poet the only fact in virtue of which a poem may properly be characterized as insincere. But in poetry, as in a person's life, this is one sort of insincerity. And my question here is, how significant a sort is it in the case of poetry?

How, then, might the fact that a poet is insincere – in the sense that the sentiments articulated or expressed in her poem are not *her* sentiments – matter?[1] The question is complicated not least by the fact that insincerity of this sort may or may not be discernible in a poem, and by the fact that if it is, it may be so in a variety of ways – for example, in the poetic devices used, in the derivativeness of the

197

work, in the fact that the sentiments expressed are themselves in some way or other inadequate to the occasion. Most would agree, I suppose, that if a poet's insincerity *is* discernible in her poem, then that will very often matter; just how it will matter will depend on just how the insincerity is manifest in the poem. My concern here, however, is with the second possibility, where a poet's insincerity is *not* discernible in her poem, and in particular with the question whether and how indiscernible insincerity, as I shall refer to it, might matter to us in our engagement with a poem.

Poets, as well as critics and philosophers, have disagreed about this issue. With respect to what he called philosophical poetry, at least, T. S. Eliot held that a poet's insincerity "would annihilate all poetic values except those of technical accomplishment." He writes, "To suggest that Lucretius deliberately chose to exploit for poetic purposes a cosmology which he thought to be false, or that Dante did not believe the philosophy drawn from Aristotle and the scholastics, which gave him the material for several fine cantos in the *Purgatorio*, would be to condemn the poems they wrote."[2] In an earlier essay on Dr. Johnson, Eliot criticizes Johnson's satirical poem *London* for, among other failings, being insincere: "that Johnson should ever have contemplated leaving London for the remote promontory of St. David's is so inconsistent with his character, and his confessed sentiments in later life, that we cannot believe he ever meant it."[3] But Eliot's approach stands in sharp contrast to that of C. S. Lewis, who held that any concern with authorial sincerity "should be forever banished from criticism,"[4] and Monroe Beardsley, who argued that if sincerity is "defined in terms of some sort of correspondence between the regional qualities of the work and the emotions of the artist," then "its irrelevance to the value of the object itself is fairly plain, though of course insincerity might be taken as a ground of complaint about the artist."[5]

More recently, this debate has been joined by Colin Lyas and Malcolm Budd. Lyas writes that "A work of art *inter* (very much) *alia* records for us the complex response of a real person to a situation, real or imagined," so that "some at least of us could not be indifferent to a discovery that Picasso did not care about Guernica."[6] Now I take it that the "fact" that Picasso did not care about Guernica is no more discernible in his painting than the "facts" that Lucretius and Dante did not hold the philosophical views that their poems draw on and expound are discernible or manifest in those poems. That is, were we somehow to be convinced that these artists were

indeed insincere, we should not be able to see or hear that insincerity in their work – it would be indiscernible insincerity. And in sharp contrast to Lyas, who insists that such insincerity "would not be a matter of indifference," Budd claims that "if [a poet's] insincerity is not manifest in the poems she writes, it does not affect the value of her poems as poems" and "a reader may properly discount it."[7] He goes on:

One form of insincerity a poet can practise is the deliberate attempt to produce effects in the reader that do not happen for her: she attempts to kid others. She is not moved by the sentiments that her poem expresses in the manner she desires her readers to be ... Hence a judgement about a poem's sincerity might be only a certain kind of relational judgement – a judgement about the poet's relation to her product: whether she accepts the system of beliefs her poem expounds, or held the high opinion of a particular person her poem expresses, or is herself moved by the sentiments her poem is calculated to arouse in the reader, and so on. *Such a judgement is about the poet's sincerity only and can be discounted critically.*

(Budd, pp. 91–92, emphasis added)

There are certain sorts of poetry with respect to which Budd and Beardsley seem plainly to be right. For example, the fact that a poet laureate turns out to be secretly a committed republican with nothing but scorn for royalty *may* count against our judgment that his commemorative verse about royal events is excellent, but it need not do so. Again, comic verse is not flawed simply by virtue of the fact that the poet who produced it is not and never was amused by what he pretends to be amused by. And if we are interested in Roger McGough's lines –

away from you
i feel a great emptiness
a gnawing loneliness

with you
i get that reassuring feeling
of wanting to escape[8]

– as poetry (as opposed to as putative autobiography, say), then whether or not there was ever a particular "you" who inspired the sentiments articulated in the lines, and indeed whether or not the poet ever actually felt those sentiments at all (none of which is discernible or manifest in the lines themselves) is surely a matter of indifference. But there is a good deal of poetry with respect to which we are likely to be much less relaxed about the thought that the sentiments expressed were not those of the poet. Much of the poetry

inspired by experience in the First World War falls into this category: were we somehow to be persuaded that Siegfried Sassoon in fact secretly supported the tactics of the generals under whom he served, for example, that fact, though indiscernible in his poetry, would surely matter *somehow* in our engagement with that poetry; it would surely, as Lyas puts it, "not be a matter of indifference."

However, while a discovery of this sort about Sassoon might be disturbing in all sorts of ways, the question whether it would have any bearing on the value of his poetry *as poetry* remains open. And here it is important to notice that Budd makes two points about indiscernible insincerity: he claims both that it "can be discounted critically" – that it is critically irrelevant – and that "it does not affect the value of [the poet's] poems as poems" – that it does not amount to a flaw or failing in a poem. Budd himself runs these points together; Lyas, in his insistence that with respect to some works of art, at least, the discovery of indiscernible insincerity "would not be a matter of indifference" does not distinguish between them. But the points are distinct, for while it is true that nothing that is irrelevant to critical engagement with a poem can be a determinant of the value of that poem, it is not true that something which is not a determinant of value must thereby be critically irrelevant. (For example, the fact that a poem was written by one poet rather than another will almost certainly be critically relevant, but may equally well have no significant bearing on the work's poetic value.) Hence it might be false that a poet's indiscernible insincerity is irrelevant to critical engagement with his poem, yet true that such insincerity does not affect the value of the poem as a poem.

In one respect at least, the claim that a poet's indiscernible insincerity is critically irrelevant is more striking than the claim that such insincerity is not a determinant of poetic value. Given a conception of works of art as essentially autonomous objects of aesthetic experience, a conception which (despite being very recent and notably uncommon in discussions of art by artists) is widely held by philosophers and critics, we may be inclined to hold that ultimately the value of a poem lies in its arrangement of words and the experiences which that arrangement of words offers us, so that the circumstances of the poem's production (including the [in]sincerity of its author) are neither here nor there with regard to its value. But holding this sort of view is consistent with accepting Lyas's claim that the discovery that certain sorts of artwork are

indiscernibly insincere would hardly be a matter of *indifference*; indeed, with accepting that such a discovery might be extremely disturbing. And the claim that when we are engaged in criticism we should simply discount any such response on our part may seem strikingly counter-intuitive even to one who accepts that authorial sincerity is ultimately irrelevant to a poem's value. How might we respond to that claim?

In making the case for the critical relevance of a poet's (in)sincerity, Lyas proceeds in largely negative fashion, setting out to show that a number of more or less familiar arguments for its critical irrelevance do not stand up to scrutiny. But this negative case, while largely successful as far as it goes, does not go far enough. As Lyas himself recognizes, the case for the critical relevance of a poet's indiscernible insincerity will be much stronger if a positive argument for it can be found, and at the end of his article he attempts to produce such an argument, one based on the thought that what determines critical relevance is critical practice. Lyas writes, "if people do find sincerity and insincerity worth remarking on in art, and, more generally, if they find it worth noticing that the work is a real expression [i.e. of authorial sentiment], that establishes the art-relevance [i.e. the critical relevance] of these things" (Lyas, p. 32). And he suggests that people do indeed find "these things" worth noticing and remarking upon:

I wish to claim that where a clear intimation of the imitative status of a work is absent we are interested in whether it *does* express the attitudes, beliefs and feelings of its creator. We are interested, first, in whether these are adequately expressed, and we use terms like "mawkish," "pretentious," "sensitive," "mature," "intelligent" and a host of others to express our estimation of this. In addition we are interested in the fact *that* beliefs, attitudes and feelings of a work, where there is no evidence that these are pretended, are the beliefs, attitudes and feelings of its creator. If we discovered that Pasternak did not have the kinds of attitudes expressed by the controlling intelligence of *Dr Zhivago*, or that Solzhenitsyn did not have those expressed in *The Gulag Archipelago* this would not be a matter of indifference.

(Lyas, p. 33)

While I believe that Lyas's conclusion is right, the argument that he offers for it here is not compelling. It is true that in critically engaging with poetry, as with other forms of art, we use the sort of terms that he points to here, and that in doing so we indicate our interest in the adequacy of the expression of sentiment in a work. But this is not to say that our use of such terms in criticism in itself indicates any

201

concern with whether or not the sentiments expressed are actually those of the actual author of the work. To see this, consider the verses of the republican poet laureate to whom I referred earlier. Commemorative verses being what they are, there is a good chance that the sentiments expressed in these will be mawkish (particularly if their subject has anything to do with the Queen Mother): suppose that we judge them indeed to be so. Suppose also that we are unaware of the laureate's closet republicanism, and that there is no indication of it in the verses themselves – suppose, that is, that the verses are indiscernibly insincere. Now the question arises, how would discovering the laureate's anti-monarchist sympathies affect our judgment that the sentiments expressed in his verses, or the verses themselves, are mawkish? It seems clear that if the judgment was well-grounded in the first place – if it was defensible by pointing to features of the verses themselves – then it will stand, since it will *still* be defensible by pointing those same features of the verses. This suggests that our use of the term "mawkish" does not in itself demonstrate any interest on our part in whether the verses do as a matter of fact express the actual sentiments of the actual author. And similar arguments could be deployed to show that the same is true of the other "personal qualities" to which Lyas refers.

But there is more to Lyas's argument than the appeal to the role of "personal quality" terms in criticism. That we are concerned with whether or not the sentiments expressed in a work are indeed those of its actual author, he argues, is signaled by the fact that the discovery "that Pasternak did not have the kinds of attitudes expressed by the controlling intelligence of *Dr Zhivago*, or that Solzhenitsyn did not have those expressed in *The Gulag Archipelago*" would not leave us unmoved. Again, Lyas's appeal is to the primacy of critical practice: the fact that people would not be indifferent to the discovery that certain sorts of work are indiscernibly insincere demonstrates that the matter of indiscernible insincerity is indeed critically relevant. And again, the argument is less than compelling. For one thing, the fact that we would not be indifferent to the discovery that a particular work was indiscernibly insincere does not by itself indicate that we would regard the discovery as being of *critical* relevance. There are any number of ways in which such a discovery might concern us – it might challenge certain biographical assumptions that we have made and hold dear about the author, for example – which would not involve our regarding it as critically relevant. Furthermore, it is far from

clear that critical practice does in fact wholly determine what is of critical relevance. (Which is not to say, of course, that practice is irrelevant to the matter.) There have been times and places – indeed, doubtless there are still places – in which critics would have been far from indifferent to the discovery that the author of a work was of a different gender or race or religion from that which had originally been presumed. And the fact that critics regarded such facts as critically relevant does not establish that they *are* critically relevant. They may be so, of course; but whether or not they are cannot be determined solely by reference to the practice of critics. Finally, we should note that the appeal to critical practice may in fact work against Lyas rather than for him. For every critic who, as Lyas says, "refers to what this or that *artist* did, to the quality of the response of *the author*" there are others who will insist that such reference is critically irrelevant and naive if not politically degenerate. Indeed, it seems likely that in contemporary academic criticism, at any rate, practice is dominated by those who would reject the sort of critical writing appealed to by Lyas – which may or may not reinforce the point that critical practice is not a wholly reliable guide to critical relevance.

I conclude, then, that Lyas's positive arguments for the critical relevance of authorial sincerity are unsuccessful. And that brings us back to our question: is the fact that a poet is insincere, in the sense that the sentiments expressed in her work are not *her* sentiments, and where that insincerity is not discernible in the poetry itself, ever of any critical relevance? Would the information that Siegfried Sassoon never in fact knew the horror and despair given voice in his poem *A Night Attack* be any of the critic's business?

If we are to make any progress toward answering this question, we cannot avoid saying something about what the critic's business is. This is hardly an uncontentious matter, of course, but as a bare minimum we can surely say that the critic's business is to facilitate understanding and evaluation of the objects of his criticism. (And this *is* a bare minimum; it leaves open the highly contested question of what the point or purpose of this activity might be.) Now if the object of criticism is a (putative) work of art, what falls within the scope of critical understanding and evaluation? Until quite recently, the philosophically and critically orthodox answer to this question would have been "the work itself"; in the case of a poem, to put it at its starkest, a particular arrangement of particular words, nothing more or less. But in recent years this sort of answer has increasingly

203

come to seem inadequate, to be one that distorts our conceptions both of what art is and of how it matters to us. For example, consider Denis Dutton:

There are theorists who would of course insist on our distinguishing the song as an object of aesthetic attention from the circumstances of its origin. That such distinction is possible is self-evident. That we do not, and ought not, completely divorce these elements of appreciation is also clear. What *is* Schubert's "Erlkönig"? It is this pretty sonic experience, certain words strung together and sung in certain tones to piano accompaniment, and we can talk endlessly about the beauties of that aural surface just as we could talk of the appealing properties of the piece of driftwood. It is also a profound human achievement, something done by someone; it is precisely a setting of Goethe's poem, one of perhaps fifty other such settings produced in the nineteenth century. What is understood and appreciated about Schubert's "Erlkönig" is neither of these to the exclusion of the other: both are part of our understanding of this great work of art.[9]

Though Dutton is writing about a song here, the point has wider application. Recently it has been elaborated and defended with regard to painting by Michael Baxandall.[10] And it has been given further philosophical underpinning by Gregory Currie, who argues that it marks a feature of our engagement with works of art in general; as he puts it, "aesthetic judgements are, in part, judgements about the artist's achievement in producing the work."[11] It would take us too far from our topic to attempt to add here to the defence of this position that these and other philosophers, critics, and art historians have already offered, and in what follows I shall simply assume that it is correct: that part of what is to be understood, evaluated and appreciated when we understand, evaluate, and appreciate a work of art is the achievement that the work represents.

It follows from this that a fact about a work of art will be part of the critic's business − it will be critically relevant − if awareness of that fact contributes to our being able to understand and evaluate the work and the achievement that it represents. Our question about the critical relevance of authorial sincerity thus becomes the question whether the fact that a poet is insincere, where that fact is not discernible in his poem, may be such as to help us to understand and appropriately evaluate the poem and its achievement.

Now it seems clear that some facts about the origin of a work are indeed critically relevant, and would be so whether or not they were discernible in the work. Consider fakes: the fact that *Christ and the Disciples at Emmaus* was painted by Han van Meegeren and not by Vermeer is surely critically relevant − that is, awareness of the fact is

crucial if we are to understand the painting and evaluate it appropriately — *whether or not* the fact that the painting is not by Vermeer is discernible in it. As it happens, in this case, as in most cases of known forgery, the fact is — at least to those who are aware of it — discernible in the work. But it is clear that it would be critically relevant — part of the critic's business — even were it not so. Unless we know that the painting is a fake, we will miss much of what is valuable about it — for much of what is valuable in a fake Vermeer (for example, that it convincingly works within a style which is not the actual artist's own) will not be valuable in a genuine Vermeer. And unless we know that it is a fake, we will miss much of what flaws it — for what marks a failing in a fake (for example, not being true to Vermeer's style) may not mark a failing in the genuine article.[12] Again, consider a related sort of case: that of misattributed works. The facts that a picture was painted not by Rembrandt but by one of his apprentices, or that a poem was written by one poet rather than by another, may not be discernible in the works in question — that is, even when we are made aware of them, we may not be able to see or hear them in the picture or the poem — but they will certainly be critically relevant; that is, knowing them will be crucial to reaching a proper understanding and evaluation of the works in question and the achievements that they represent.

Some facts about a work's origin, then, will be critically relevant whether or not those facts are discernible in that work. But our question is whether the fact of authorial (in)sincerity may be of this sort. Can knowledge of whether a poet is or is not sincere, if that is not discernible in his poem, be relevant to our gaining an adequate understanding and evaluation of a poem? The answer is that it can; in some cases, that is, a poet's (in)sincerity, although it may not be discernible in his poem, is indeed critically relevant. Consider the following poem:

Man proposes, God in his time disposes,
And so I wandered up to where you lay,
A little rose among the little roses,
And no more dead than they.

It seemed your childish feet were tired of straying,
You did not greet me from your flower strewn bed,
Yet still I knew that you were only playing,
Playing at being dead.

I might have thought that you were really sleeping,
So quiet lay your eyelids to the sky,

So still your hair, but surely you were peeping,
And so I did not cry.

God knows, and in His proper time disposes,
And so I smiled and gently called your name,
Added my rose to your sweet heap of roses,
And left you to your game.[13]

Now clearly this is an awful poem, and, as Lyas points out, clearly it
is so at least partly in virtue of the quality of the sentiments it
expresses, which might in one sense or another be characterized as
insincere. But it is important to notice that the poem is not discern-
ibly insincere in the sense with which we have been concerned in
this essay; that is, the poem itself contains nothing to suggest that the
author did not actually and indeed intensely feel the sentiments
expressed in it. (It may be objected that the poem does indeed offer a
clue about this, inasmuch as the sentiments it expresses are so awful
that no one, or at any rate no one with the talent for writing that the
author of the poem evidently possesses, could possibly feel them.
Tempting though this suggestion may be, however, it is belied by the
human capacity for sentimentality.)

The important question here is, is it of any critical relevance
whether the poem is insincere in the sense that we have been
concerned with? Does it matter to our engagement with the poem
whether the sentiments expressed in the poem were those of the
poet? The answer, I suggest, is that it does. Suppose that the poem is
in fact insincere; suppose that we discover that it was originally
written as an entry for a competition where the challenge was to
outdo the sentimentality of Dickens's report of Little Nell's death, or
indeed (as Lyas suggests in passing) simply as an academic exercise
in sentimentality. Knowing that this is the case makes all the
difference to our engagement with the poem. What was at first
simply a dreadful poem now appears to be rather more than that: a
dreadful poem that is also a rather impressive achievement. Ignorant
of the facts about the poem's origin, we might have said that the
author has failed to write a good poem; knowing them, we shall say
that he has succeeded in writing a bad one. What before seemed
terribly heavy-handed ("So quiet lay your eyelids to the sky") now
seems rather deft. What before looked hideously inappropriate to the
occasion now strikes us as nicely judged – the point being, of course,
that we now take the occasion in question to be a quite different one.
Knowing that this poem is insincere, then, is crucial to knowing
what sort of achievement the poem represents; it is knowledge that

clearly bears on our understanding of the work and of how to approach it. In this case, then, the poet's insincerity is indeed critically relevant.

Suppose now that we were to discover that Sassoon's war poems are insincere in the sense with which we have been concerned. Suppose, that is, that Sassoon himself never felt the sentiments articulated and expressed in those poems – the horror of life in the trenches, the admiration for the infantrymen under his command, the disgust at those whom he believed were unnecessarily prolonging the war – and that he was in fact an enthusiastic supporter of *The General*'s "plan of attack." That fact is certainly not something that we can tell simply by reading his poems, and I suggest – though of course to *show* this would require close critical discussion of the poems themselves – that there would be little if anything in the poems that would strike us as a manifestation of insincerity even if we were convinced that as a matter of fact Sassoon was insincere in writing them. But the fact of his insincerity would be critically relevant – awareness of it would be crucial to achieving a proper understanding and assessment of the poems – nonetheless. For, taking his poems as a body, what we will now, believing them to be sincere, characterize in terms such as "courageous," "angry," and "unflinching," we would, if we believed them to be insincere, characterize in terms such as "callous," "cynical" and perhaps "voyeuristic." This is not to say, *pace* Eliot, that discovering that Sassoon was insincere would "annihilate" all value in his war poems other than their "technical accomplishment." We should continue, I think, to regard the poems as representing a considerable accomplishment, an awe-inspiring imaginative achievement – but it would now strike us as a very different, and in important ways as a rather repugnant, achievement. In short, then, knowledge of Sassoon's insincerity, though the latter is not discernible in his poems, would indeed be relevant to understanding his poems and assessing them appropriately: it would, that is, be critically relevant.

Having established that a poet's insincerity, even when it is not discernible in his poem, may be critically relevant to understanding and evaluating his poem and the achievement it represents, we are now in a position to return to the question of how such insincerity bears on the matter of authenticity. To characterize something as inauthentic is in one respect or another to mark a failing in that thing; if something is inauthentic, that is, that fact about it provides us with a reason not to value it, or to value it less highly than we

207

might otherwise have done. If a poem that is indiscernibly insincere is in virtue of that fact inauthentic, then, the fact that a poem is indiscernibly insincere will give us a reason at least to value the poem less highly than we would otherwise have done.

Now with respect to some indiscernibly insincere poems this will indeed be the case. As we have just seen, if Sassoon's war poems were insincere, they would be callous, among other things, and callousness in a poem is a failing, as it is elsewhere. But in other cases, indiscernible insincerity may not mark a flaw in a poem: it would not do so in the lines by Roger McGough that I quoted earlier, nor need it do so in the commemorative verses of our republican poet laureate. What makes these cases different? How does indiscernible insincerity mark a flaw in a poem, when it does?

The answer, I suggest, lies in the fact that certain poems (and indeed other works of art) matter to us, and are valued by us, partly as expressions of the actual artist's actual sentiments. Sassoon's war poems are paradigm cases of this sort of artwork: we value them partly as articulations and expressions of the actual author's responses to the hideous circumstances in which he found himself. Lyas is just right, I think, when he says that some works of art *"inter* (very much) *alia* record for us the complex response of a real person to a situation" (Lyas, p. 36), and, I would emphasize, some works of art are *valued* by us not least as such. And if it turns out that a work of this sort is insincere, that it is not in fact such a record, then that gives us a reason to value that work less highly – which is not to say, again, that it gives us a reason not to value it at all.

It is perhaps worth noting here that there is no "intentional fallacy" – at least in the classical sense of that term[14] – involved in this position. My claim is neither that the meaning of a poem is to be decided by reference to what the author intended it to mean, nor that the value of the poem is determined by whether or to what extent the author succeeded in realizing her intentions. The claim, again, is simply that certain works of art are valued by us partly as articulations and expressions of the actual sentiments of their actual creators. And indiscernible insincerity will be a flaw in a work of this sort; it will give us reason to value such a work less highly than we would have done were it to have been sincere.

But it will be objected that even if this position does not involve the intentional fallacy, it fails to respect what might be called the autonomy of art and of artistic value in another respect. To see this objection, consider a case which does not involve works of art.

Suppose that I inherit my grandfather's war medals. I value them highly; they are a symbol of what he achieved, of his loyalty, his bravery, and so on. Now if I later discover that the medals that I have inherited are not in fact my grandfather's after all, then of course that gives me reason to value them less highly than I did. (Though, again, this will not necessarily be a reason not to value them at all: they may still be rare, worth money, look pretty in their display case on the wall, and so on.) But the fact that I now have reason to value the medals less highly than I did before does not of course mark any flaw in the medals themselves; it is rather an indication that when I valued them as I did before I was not valuing them, or at any rate not valuing them solely, *as medals*. Similarly, it may be said, if I value a poem partly as a sincere expression of the poet's sentiments, and if the poem turns out to be insincere, then that is indeed a reason for me to value it less highly. But that no more marks a flaw in the poem than the fact that my inherited medals were not in fact awarded to my grandfather marks a flaw in those medals. It rather indicates that originally I was not (solely) valuing the poem as a poem.

In short, then, the objection to the position I have outlined here is likely to be that the fact that a poem is indiscernibly insincere may at most detract from its sentimental value, or its value as autobiography, or something of that sort. Indiscernible insincerity is not, however, something that can detract from the poetic value of the poem, from its value as a poem. And this, as we saw earlier, is just Budd's claim: as he puts it, "if [a poet's] insincerity is not manifest in the poems she writes, it does not affect the value of her poems as poems" (Budd, p. 89).

Now this objection raises the question of just what it is to value a poem as a poem – the question of what a poem's poetic value consists in. Budd argues that in general, "the value of a work of art as a work of art ... is (determined by) the intrinsic value of the experience the work offers" when the work is experienced with understanding. And "for you to experience a work with (full) under-standing your experience must be imbued with an awareness of (all) the aesthetically relevant properties of the work – the properties that ground the attribution of artistic value and that constitute the particular forms of value the work exemplifies" (Budd, p. 4). When he later suggests that "there is no compelling reason why we should not attempt to insulate our response to the poem from our knowledge of the poet's real beliefs" (Budd, p. 90), then, Budd implies that the fact that a poem is indiscernibly insincere, if it is, does not represent

an "aesthetically relevant property" of the poem; that the property of being indiscernibly insincere is not one that can ground the attribution of poetic (dis)value to a poem.

In light of his account of artistic value, Budd's claim that indiscernible insincerity cannot affect a poem's value as a poem – its poetic value – must amount to the claim that the fact that a poem is indiscernibly insincere cannot be such as to affect adversely (or indeed otherwise) the (intrinsic) value of the experience the poem offers. And if we accept Budd's account of artistic value, then to defend the claim that indiscernible insincerity may represent a flaw in a poem – the claim that it may detract from a poem's value as a poem – will involve showing that the fact that a poem is indiscernibly insincere may indeed detract from the (intrinsic) value of the experience that the poem offers.

Although he offers it in a rather different context, a suggestion offered by Lyas as to why and how an artist's insincerity may matter to us can be seen as an attempt to do just this. Drawing a distinction between what he calls "purely imitative imaginative works" – works which do not pretend to express the sentiments of the author – and "non-imitative" works – works which do pretend to express authorial sentiment – Lyas writes:

> The most that a purely imaginative work can tell me is how someone ... *might* respond to something . . . It teaches me nothing new, save in the sense that it reveals to me possibilities inherent in what I already know about human beings ... In a non-imitative work, however, I am, if the work is genuine, told not how someone *might have* responded, but how someone *did* actually respond. This *adds* to my knowledge of the functioning of human beings . . .
>
> Non-imitative art adds to my empirical knowledge of human nature. This is why we are unable to be indifferent when we discover that what we took to be sincere expression of an actual emotion is not so ... What I thought to be an addition to my store of empirical knowledge about human beings (knowledge in which I have an interest as a human being) turns out not to be so, and at the very least a different kind of response is called for.
>
> (Lyas, p. 35)

Authorial insincerity, then, detracts from the value of the experience offered by a purportedly "non-imitative" work inasmuch as it renders that experience less cognitively valuable than it would have been were it to have been sincere.

However, this suggestion does not get us very far here. For, leaving aside the question whether a work's cognitive effect is really part of the intrinsic, as opposed to the instrumental, value of the experience

that work offers, Lyas's suggestion depends on the thought that a work which adds to what he calls our "empirical" knowledge – knowledge of how a particular human being has actually responded to a set of circumstances – is more cognitively valuable than one which "reveals to me possibilities inherent in what I already know about human beings"; it is this difference in value that is supposed to explain our disappointment when we learn that a purportedly sincere work is in fact insincere. And this way of ranking the cognitive import of works of art is at least highly contentious, if not downright implausible. Aristotle, for one, appears to reverse it; he holds that poetry which "speak[s] ... of the kind of events which could occur, and are possible by the standards of probability or necessity" is "both more philosophical and more serious than history," which "speaks of events which have occurred."[15]

Lyas is closer to the mark, I think, in his claim that the discovery that a certain sort of work was insincere – and I take Sassoon's war poems to be exemplary instances of this sort – would mean that "at the very least, a different kind of response is called for." But the flaw in such works – what it is about them that adversely affects the intrinsic value of the experience they offer – is not, or at any rate not directly, a matter of their cognitive value or lack of it. It stems rather, I suggest, from the fact that those works which we characteristically value partly as expressions of the actual artist's actual sentiments are works that *present* themselves as sincere or, in Lyas's terms, as "non-imitative"; they present themselves as articulating or expressing the sentiments of their authors. And in doing so they ask to be treated, to be approached and responded to, as such. Now if a poem that presents itself in this way is not in fact sincere – that is, in effect, if it is not what it pretends to be – then it asks its readers to respond to it as something that it is not; it asks from them a response which it does not deserve. The experience that such a work offers, in short, is one in which we are misled into responding to something as something it is not, into responding to it in a way that it does not deserve. And that is surely an undesirable experience.

I would emphasize that the fact that a work is flawed in this way need not render it entirely without value. A work which we value partly as a sincere expression or articulation of its author's sentiments may well be valuable in all sorts of other respects as well, and although the discovery that such a work is not what it presents itself as being gives us a reason to value it less highly than we would have done otherwise, there may nonetheless be aspects or features of it that

211

we will still have reason to value. Once again, were it to turn out that they are insincere, Sassoon's war poems would nonetheless clearly represent a considerable imaginative and artistic achievement.

The question that arises at this point, of course, is what precisely is involved in the notion of a poem's "presenting" itself as one thing or another. In particular, what notion of "presentation" is being appealed to in the claim that certain works – such as Sassoon's war poems – present themselves as sincere expressions of authorial sentiment while other works – such as, typically, the verses in commemoration of royal occasions produced by poets laureate – do not? I cannot hope to provide an answer to this question here; it is no less complex nor likely to admit of a simple answer than the closely related question of how we are properly to distinguish between fiction and non-fiction in poetry. (Indeed, it seems unlikely that we shall be able to work out adequately the notion of presentation that I have appealed to here without first answering this latter question.) Furthermore, it seems clear that providing anything like an adequate account of the modes of presentation in poetry will involve close critical study of some particular works of poetry, study of a sort that goes far beyond the scope of this essay.

However, consideration of a likely objection to the position that I have sketched here, and to the strategy that I have adopted in sketching it, both reinforces my claim that the fact that a poem presents itself as sincere does bear significantly on the approach that we properly take to it, and suggests one avenue that might profitably be explored in attempting to work out an account of the modes of presentation in poetry. The objection, which has been lurking in the wings since the beginning of this essay, is that the use I have made of Sassoon's war poems is both ineffective and (at least) verging on the tasteless. It is ineffective, it will be said, inasmuch as the hypothesis that in writing these poems Sassoon was insincere, that he did not feel the sentiments the poems express, is simply a non-starter, since no evidence that Sassoon was insincere could possibly outweigh the evidence, constituted by the poems themselves, that he was sincere. Now I am not sure that this objection is correct, but the point I would emphasize here is that even if it is so, it tends rather to reinforce than to undermine my position. For it underlines the extent to which we do in fact take these poems to be sincere, and the significance which we attach to the fact that they are such. As to the charge that the use to which I have put Sassoon's poems verges on tastelessness, I suggest that that charge applies at least as well to the view that in

approaching these poems properly we will be indifferent to whether or not they are sincere in the sense I have been concerned with here. Lyas is right, I think, when he says that "It would ... be perverse to treat Swift's *Modest Proposal* as one might treat an imitation of outrage, pretended as an aesthetic feat, by one who felt no anger, and it seems tasteless to treat such poems as Cowper's *The Castaway* in this way" (Lyas, p. 31). To regard Sassoon's war poems as though it were a matter of no importance that they represent one human being's attempts to deal with the terrible circumstances in which he found himself, to treat them, so to speak, as "mere fictions" – that would indeed be tasteless. And working out why that is the case with respect to Sassoon's poems, for example, and not with respect to the lines from Roger McGough that I quoted earlier, nor to much of the commemorative verse produced by poets laureate, will be crucial to giving an adequate account of the modes of poetic presentation and their significance.

I have argued, then, that a poet's insincerity – in the sense that the sentiments expressed in her poem are not *her* sentiments – may indeed be critically relevant, even when that insincerity is not discernible or manifest in her poem. And I have argued that in certain cases where it is critically relevant, such insincerity may mark a flaw or failing in the poem; that it may give us a reason to value the poem less highly than we might have done otherwise. Insincerity in a poem of this sort, I suggest, constitutes one form of inauthenticity in art.[16]

## NOTES

1 In this essay I shall be concerned primarily with poems as written texts. Interesting and related issues about the significance or otherwise of a poet's sincerity arise when we consider poetry as public performance, in the context of poetry readings where the presence of the actual poet appears often to be a large part of the attraction for the audience. As Peter Middleton says, in such contexts "These words arise out of the speaker, whose bodily presence and identity is their warrant, and whose delivery shows what it means to think and say these words and ideas, indeed, shows what it means to live them for at least the moment of their delivery ... Authorial reading suffuses a text with the person and their relation to the listeners." ("Poetry's Oral Stage," published in this volume.) In contexts of this sort, the sincerity or otherwise of the poet-reader will clearly, though doubtless not in any very simple way, be a matter of some significance.

2 T. S. Eliot, "Goethe as the Sage," in *On Poetry and Poets* (London, Faber

& Faber, 1957), p. 223. I owe the reference to Malcolm Budd, who cites it in the work discussed below.

3 T. S. Eliot, "Johnson as Critic and Poet," in *On Poetry and Poets*, pp. 178–79. It should be noted that the insincerity that Eliot points to here is not the only feature of the poem that he takes to contribute to "a suspicion of falsity" about it.

4 C. S. Lewis and E. M. W. Tillyard, *The Personal Heresy* (Oxford, Oxford University Press, 1965), p. 120. I owe the reference to Colin Lyas.

5 Monroe C. Beardsley, *Aesthetics: Problems in the Philosophy of Criticism* (Indianapolis, Hackett Publishing Co., 2nd ed. 1981), p. 491.

6 Colin Lyas, "The Relevance of the Author's Sincerity," in *Philosophy and Fiction: Essays in Literary Aesthetics*, ed. Peter Lamarque (Aberdeen, Aberdeen University Press, 1983), pp. 36 and 34–35.

7 Malcolm Budd, *Values of Art* (London, Allen Lane, Penguin Press, 1995), pp. 89 and 91.

8 Roger McGough, *Summer with Monika* ( London, Whizzard Press, 1978), p. 19.

9 Denis Dutton, "Artistic Crimes: The Problem of Forgery in the Arts," *British Journal of Aesthetics* 19 (1979), 304–14. Reprinted in *Arguing About Art: Contemporary Philosophical Debates*, ed. Alex Neill and Aaron Ridley (New York, McGraw-Hill, 1995). The passage quoted is on pp. 25–26 of the latter volume.

10 Michael Baxandall, *Patterns of Intention* (New Haven and London, Yale University Press, 1985).

11 Gregory Currie, *An Ontology of Art* (Basingstoke and London, Macmillan Press, 1989), pp. 38–39.

12 For a very illuminating discussion of how the fact of forgery matters, see Dutton, "Artistic Crimes."

13 This poem is quoted by Lyas ("Author's Sincerity," p. 34), who says that he cannot supply the author's name. (I have my suspicions.) I make no apology for quoting it in full; it deserves to be better known.

14 See W. Wimsatt and M. C. Beardsley, "The Intentional Fallacy," in W. Wimsatt, *The Verbal Icon* (Lexington, University of Kentucky Press, 1954).

15 *The Poetics of Aristotle*, trans. Stephen Halliwell (London, Gerald Duckworth & Co., 1987), pp. 40–41.

16 Thanks to audiences at the Universities of Dundee and Nevada, and especially to Berys Gaut, Salim Kemal, and Aaron Ridley, for helpful discussion and comments.

# Poetry's oral stage

PETER MIDDLETON

## THE ORAL POETICS OF WRITTEN POETRY

One of the most famous of modern poetry readings took place at the Six Gallery in San Francisco on October 13, 1955.[1] To help launch the new gallery, an artists' co-op newly converted from a commercial garage, the poet Michael McClure, a friend of the organizers, arranged for six poets to read, and one of them, Kenneth Rexroth, then opted to act as master of ceremonies. The other five, Philip Lamantia, Philip Whalen, Michael McClure, Gary Snyder, and Allen Ginsberg, already formed a distinct group soon to be widely known as the Beat poets. About a hundred people turned up, and as the readings began, another writer, Jack Kerouac, who had been invited to read but was apparently too shy to do so, collected money for jugs of wine and then passed them around, becoming drunk and excitable himself and encouraging the audience to throw themselves noisily into the spirit of things. By the time Allen Ginsberg began reading his new, unpublished poem *Howl*, the audience were already very receptive. Ginsberg describes what happened then: "I gave a very wild, funny, tearful reading of the first part of 'Howl.' Like I really felt shame and power reading it, and every time I'd finish a long line Kerouac would shout 'Yeah!' or 'So there!' or 'Correct!' or some little phrase, which added a kind of extra bop humor to the whole thing. It was like a jam session, and I was very astounded because 'Howl' was a big, long poem and yet everybody seemed to understand and at the same time to sympathize with it."[2] Ginsberg's biographer, Michael Schumacher, pictures him beginning timidly, but "before long he gained confidence and began to sway rhythmically with the music of his poetry, responding to the enthusiasm of the audience."[3] Another biography describes him "chanting like a Jewish cantor, sustaining

215

his long breath length, savoring the outrageous language."[4] Afterwards Lawrence Ferlinghetti offered to publish the poem, and the success of the event sparked off a wave of poetry readings across the bay area.

The most notable feature of the entire reading was undoubtedly Allen Ginsberg's sheer presence as he performed his testimony, beginning with the emphatic first-person assertion: "I saw the best minds of my generation etc."[5] Ginsberg's magnificent assertion of prophetic judgment filled the first person with his substantial presence, closing the gap between author and text, saying in effect, "I, Allen Ginsberg saw these things and am telling you now." Much of what happened as he read must remain speculation. We can guess that as the anaphoric link word "who" was repeated again and again its polysemy was brought fully into play, and it shifted almost imperceptibly back and forth between relative and interrogative pronouns, making its audience question just who these unknown soldiers of the underground were. The listeners probably felt encouraged to admire and perhaps emulate the "best minds" even as they mourned them. Some members of the audience, Kerouac for example, who knew what Ginsberg meant when he said that his generation had "bared their brains to Heaven," were busy drinking assiduously enough to re-experience that mental disrobing as the reading proceeded. Audience participation must have had something of the force of a mass chorus brought into being by the poem in performance, as they created a litany in response to Ginsberg's delivery.

Performances like this are rare. What is the point of ordinary poetry readings in contemporary culture? What accounts for their popularity even when poets read material of such verbal complexity that only the cumulative intensities of silent reading would seem likely to do the texts justice? People commonly say they go to readings to see the poet and to hear the sound of the poem, but curiosity and a love of phonetic harmonies do not seem enough to justify all this activity. Is there something more? Is the meaning of a poem affected by performance in ways which make performance seem indispensable even for complex written texts? These questions address a heterogeneous scene ranging from academic gatherings, where a poet sits and reads from a book or manuscript, to club performances accompanied by music, a diversity that might seem to resist analysis. What unites them is that a written text is turned into a verbal performance in public by the author of the poetry. This

transformation becomes more puzzling if we consider the outlines of a history of poetry readings.

The *Howl* reading seems to have unintentionally played an inaugural role in the proliferation of contemporary poetry readings, but to make this claim would require research that is yet to be done. To the best of my knowledge no general history of poetry reading exists, although the diversity and complexity of oral poetics has been widely studied in the past thirty years.[6] In societies where there is partial or widespread literacy, and poetry is commonly written down, poems have still been read aloud to public audiences, circles of friends, and simply as part of ordinary social life, as well as fulfilling more specialized roles, such as those in education and in public rituals. Literacy itself has even sometimes been measured in schools by the ability to read poetry aloud effectively. Until quite recently this widespread, and largely unremarked reading of poetry aloud by all sorts of people was a common practice in English-speaking cultures. Today, such occasions as Maya Angelou's reading at President Clinton's inauguration are reminders of how unusual this now seems. The oral reading of poetry is no longer a common feature of everyday life and in its stead is the largely postwar phenomenon of the more formal poetry reading. Famous poets, like other well-known writers, have gone on speaking tours in the past (Dickens and Whitman are familiar examples), but these have been relatively exceptional, and even the major English-language poets of the early part of the twentieth century did not spend their time on reading tours. The contemporary poetry reading, firmly structured around the presence of the author, is a new variant on the old practice, made possible by social changes such as greater social wealth, leisure, mobility, and education, and more necessary in the face of the technological anonymity of mass culture.

The *Howl* reading also demonstrates another feature of these readings, their radicalism. Poetry readings since the latter part of the 1950s have been popular with dissident intellectuals who believe these events can make visible the power of hitherto alienated individual imaginations, passions, visions, and creativity. Yet such political aims on their own would hardly have generated the fervor of such readings as those at the Albert Hall in London in the late 1960s and in similar large, popular venues in America, which became iconic of the new poetries, or the continuing interest in hearing even the most textually elaborate poetries. Something else was going on at these readings besides the generation of collective

euphoria at the possibility of mass action, or the practice of a new cultural politics, something that depended on the poetry itself, and what happened when written poems were transformed by being read aloud in public performances. Of the many kinds of contemporary poetry reading, the avant-garde[7] readings of the past forty years are the most striking, because these poets have used all sorts of unfamiliar strategies to resist easy assimilation and to articulate new ranges of thought and experience, devices such as innovative page-layouts, diminished reference, and newly invented verse forms (many of which are very long, non-lyric structures), all of which would seem to make impossible demands upon performers and listeners. It is to these poetries that this essay is largely devoted (although many of its conclusions apply to other more traditional, politically activist, or entertainment-based poetries[8]) because in these readings the intransigent presence of the written text is most prominent and in need of explanation.

Exceptional in degree rather than substance, the Six Gallery reading in the newly converted garage shares many features with typical, less epochal poetry readings. It is a good place to begin considering the common elements of poetry readings and their significance. *Howl* was premiered at the reading. How, if at all, was it transformed by the reading of Ginsberg's? The best way I can answer this question at this point is to say that the semantic repertoire of the written text was extended by its performance in several notable ways: by the location of the poem in a particular place within a defined ritual, by the force of the poet's presence as he read, by the addition of sound to the act of reception, and by the enfolding intersubjective drama generated as the lines were spoken. The author read aloud work conceived and written elsewhere, giving special salience to the sound of the language, in surroundings temporarily borrowed as a performance space for poetry, to an audience who experienced some common purposes partially articulated through the poetry itself. Attempts to describe the event by the poet and his biographers reveal further aspects of it, not least by the differences in their accounts. Ginsberg, like many people who take part in poetry readings, emphasizes the importance of hearing the sound values of the text by comparing the event to a jazz session, in which voice plays a secondary or non-existent role compared to the non-linguistic communications of instrumental music. His biographer Miles recognizes that the event extends beyond the poem and implies a parallel with sacred ritual in which poetry is a means of

making God present. Both interpretations step away from the literary text as if that alone were not sufficient to sustain an explanation of what happened. The contradictions between these and other accounts (Ginsberg gives slightly different ones in different interviews reminding us that performance depends crucially on memory, whatever the technical means of recording), typify the problem of recreating and analyzing any performance, however much documentation is available. Analysis is always archeology. Performance events vanish as they occur, like the "best minds of my generation" who "vanished into nowhere Zen New Jersey," leaving behind such traces as polysemic texts, photographs, memoirs, and interviews, which are as slippery to interpret as the trail of mystifying postcards of Atlantic City Hall left behind by one of the beat heroes of the poem.[9] Any answer to the question of what happened to *Howl* when it moved from writing into speech must factor in its own reconstructive uncertainties, ambiguities already figured by the poem itself, as if it knew that collective memory would try to transplant the "absolute heart of the poem" from performance into text as it died into silence at the end of the reading, as all performances must.[10]

Literary theory, on the other hand, would say that its real life was only just beginning. Not until the City Lights edition appeared could the poem fully claim to be a text ready for reading and analysis. Theorists apparently see little of significance in the oral performances of poetry reading, because they assume that meaning arises solely at the interface between the subject and the linguistic structure represented by the written text, whether power is assumed to reside with the active, decoding subject or with the discourse of the text that produces the subjectivity of the reader. Poetry readings where a written text is read aloud seem no more than entertaining ornaments to the solid edifice of reading. As a result, poems like *Howl* lead a secret life. Walter Ong believes that "intertextual analysis has commonly paid relatively little attention to the interaction between texts and their circumambient orality. The orality of a milieu can deeply affect both the composition of texts and their interpretation."[11] His comment on the period when the Gospels were written might equally apply today. The effects of oral interaction on literary texts are ignored by literary theorists, perhaps because orality seems no more than an anachronistic survival from an earlier stage of social development, made even more redundant by the Internet and hypertext, although the official reason is linguistic. Saussurean linguistics, which has provided the skeleton for

structuralist and poststructuralist theory, downgrades speech in favor of the system of linguistic codes which supposedly govern it, and which most theorists regard as the proper subject of inquiry.

The term *poetry reading* contains an ambiguity which helps explain this neglect. In writing this essay I have to make clear by context when *poetry reading* refers to a public performance rather than a private, silent act of interpreting writing without audible sound, because this latter is the dominant meaning. Moreover, literary theory has widely used the term *reading* to mean *interpretation*, and critics describe their practice as readings of specific texts. For most literary critics, poetry readings are simply particular versions of reading, because they are committed to interpretative relativism. A public poetry reading is different only in the trivial sense that every reading is different because readers and communities of readers ultimately determine the meaning of what is read, and their differences produce different interpretations. These differences may be all too slight within communities of readers organized by ideology or other largely unconscious structures. The problem here is what is meant by "different." As Reed Way Dasenbrock points out, if this is taken to mean that different interpretations emerge from the incommensurable worlds of different interpretative communities, it would entail the absurd conclusion that one reader could not understand another's reading at all, even to establish incommensurability: "we cannot know whether we are seeing something different unless we can understand each other's perspective, translate each other's language; and if we can understand and translate another's perspective, it cannot have the radical otherness supposed" by some theorists.[12] Why does it seem so important to claim interpretative relativism in contemporary theory? The answer must surely be that it is part of the important commitment to recognizing diversity, difference, and marginalization, expressed in different interpretations which can be suppressed by hegemonic institutions which claim that there is only one proper meaning, their own. Interpretative relativism is made to do too much work, however, because other practices of difference have been elided from theoretical recognizance. Feminist linguists have pointed out a similar problem with theories that language is male, and women therefore need a female language, arguing against this theory that it mistakes the character of language entirely, and becomes a substitute for considering other social divisions in which power produces silence and distortion.

The seemingly important emphasis on different readings conceals an unwarranted homogenization of the heterogeneous concept of reading. Readings are assumed to be fundamentally one kind of process so that an ethnographic stance, for example, which places a text in a much wider network of systems of representation or active subjectivities, appears irrelevant to interpretation and reading. Such analysis of literary productions is rarely admitted within the charmed circle of the high art of first-world cultures, whose significant texts are imagined to transcend the contingencies of local cultural practices.[13] These limitations are the result of assuming that reading is a homogeneous, singular activity, whatever indeterminacies of language and subjectivity it produces. The implicit model of reading at work in most contemporary literary theory owes its outlines to the epistemological project of Kantian philosophy as it has been mediated through its encounters with science, positivism, and linguistics. A singular, autonomous subject is imagined to encounter a bounded instance of language in an ideal realm transcending ordinary material limitations. Ordinary acts of reading are approximations to this, limited by the everyday interruptions of concentration and textual presentation. Poststructuralist theory empties out the humanist interiority of the subject which is the stage for the encounter, only to reinscribe its contours via the putative actions of the signifying process and the positionalities of discourse. Writing and silent reading have helped create assumptions about reading which would not seem so obvious in an oral society, and theorists forget that reading depends on similar conditions to discourse and, like discourse, is always an uncompleted stage in heterogeneous transactions that exceed the moment of encounter, which is itself always taking place in a material space and time. The case of the poetry reading will show why recognizing the inescapably intersubjective, plural condition of reading is necessary for an understanding of the meanings which "Contemporary" poetries are allowed to produce.

## POETRY'S DREAM

Staging is the first element of poetry readings. Space, time, and poetry collude to produce a temporary dream of triumph for the power of poetry over the noise, routine, and institutions of everyday life, each time a poetry reading is held. Poetry readings are usually ragged affairs, taking place in venues temporarily liberated from other activities, pub rooms, arts centres, church halls, lecture theatres,

where poetry is only in the ascendant for a moment during which it is still in competition with many reminders of the everyday world waiting to rush back into its temporary space and expel it. The messy, incomplete, heterogeneous poetry reading is quite unlike the well-regulated art of opera for example, where everyone sits in specially designed seats in a specially designed auditorium, reading a program telling them the biographies of the stars and the significance of the plot, the event starts at the advertised time, and the performers are separated physically from the audience. Listening to poetry requires effort, and the audience's attentiveness is vulnerable to distractions of every kind (beer, traffic, hard chairs, comings and goings, even the very presence of the poet). The space is precariously and only partially transformed from its mundane uses as gallery, pub, or lecture hall, whose signs remain prominently in evidence throughout the scene of textual performance, and this transformation of the backdrop tells the participants that the everyday world, despite the way it is crowded with other activities and purposes, can still provide a space for poetry. Poetry becomes sonic performance in the face of considerable odds, a conquest of the resistant contingency of everyday life which provides a ground bass or insistent inescapable rhythm. Meaning arises out of the noise of the lifeworld, both as sign and other materially intelligible forms of order and significance.

The temptation is to set these imperfections against an ideal which is imagined to be the aim of the event, even if it can only be adumbrated by the flawed actuality. These flaws are really all part of the act, important constitutive elements of the performance event. The myriad distractions which mitigate against the ideal become players representing the resistant conditions of the contemporary culture in the drama of poetry's tentative appearance and overcoming of inertia and opposition. This is not only wish-fulfillment. Just as dreams help manage the psychic economy by drawing attention to what the ego wishes to forget, so poetry readings can also be moments when the discursive network of poets and poetries is encouraged to reflect upon the conditions under which its communications, writings, and publications necessarily occur.

## THE PERFORMANCE OF AUTHORSHIP

A specter is haunting poetry readings. The "dead author," risen from the text again and trailing the rags of the intentional fallacy, claims

to be the originating subject from which poetry is issuing right in front of your eyes. At most poetry readings the author, like Ginsberg, reads the poetry and firmly occupies the first person. This is all part of the drama of the poetry reading, an acknowledged illusion in which everyone participates. The poet *performs* authorship, becoming in the process a divided subject by reproducing language constructed into a poem at some time prior to the reading, while reading aloud as if it were a spontaneous speech act arising in the present. This is why the reader is almost invariably the author, although there would seem to be no good reason why accomplished readers and actors could not take their places. Only the dead are represented in this way, as if death for a poet meant that others had to represent you. When the words "I saw" rang out at the Six Gallery, the audience thought they knew that the speaker was the person who wrote these lines, and that the first person was there visible in front of them.

Modern print cultures allow a suprising number of opportunities for explicit reversion from text to speech, some by authors, some by other readers. What parallels are there between such occasions and the poetry reading? Writing is read aloud in situations ranging from church services and conference papers to bedtime stories for children. In both the formal events and the informal ones the person of the reader embodies an answer to a potential question: what does it mean to say these things to you now? Writing's iterability is put into tension with the contingency of the moment of production represented by the person of the reader, whose presence and delivery produces a reflexivity received as a penumbral commentary upon it. This process is perhaps most accessible in the ritual familiar to academics, the conference paper, which might also seem one of the most redundant. A complex conference paper could surely be read far more effectively by the audience beforehand in private, and the time which would have been devoted to the seemingly mechanical, oral act of delivering the paper, given instead to the all-important discussion of its contents. There are signs that this is indeed happening at some conferences. The generally accepted criteria for measuring a good delivery of a good paper suggests, however, why oral presentations may continue. The good lecturer addresses the audience directly rather than, as we say, simply "reading" the paper (an apparently paradoxical statement since reading is precisely what the lecturer is doing). This address, which is contingent upon the actual relation between speaker, audience, and site at a particular

time, can produce a continuous commentary on what is read aloud, through changes of tone and emphasis in the voice, through additional verbal annotation, asides which elaborate on the material, and body language; a commentary similar to the second voice of the footnote beloved of academics. Such a multi-layered commentary on the written text can indicate hierarchies of importance, affective investments, and relations to existing norms (using tones of voice to indicate irony, approval, a sneer). In this way it is not dissimilar to the possibilities of reading a story aloud to children and bringing it to life. If the speaker is also the author, a person well placed to produce such an interactive commentary anyway, this performance also produces an exaggerated, dramatized, picture of authorship. These words arise out of the speaker, whose bodily presence and identity is their warrant, and whose delivery shows what it means to think and say these words and ideas, indeed, shows what it means to live them for at least the moment of their delivery. The presence of a speaker is a reminder that the words are temporarily invoked from an individual with a particular point of view, a particular body, a particular experience and history. A parallel with the reading of the children's story makes this plainer. For young children, authorship is not a clear concept, and the parent or teacher who reads the story to them will become the author or originator of the narrative, permeating it with their own identity and acting as its warrant to them. Authorial reading suffuses a text with the person and their relation to the listeners.

Authorship and liminal commentary coalesce in a repertoire of asseverative gestures common to all performances of writing as speech, allowing a wide range of nuances of intensity, direction, and quality of assertion to be indicated. Most ordinary spoken utterances carry an implicit aura of assertion with them which depends on the presence of the speaker to the auditors, because this presence metonymically represents the individual origin of the utterance. The speaker endorses what is said by saying it, whatever the positivity or negativity of the utterance itself, in a process of embodied asseveration. A signal only needs to be amplified when it is not strong enough to resist the circumambient noise on its own, and the amplifying gestures of asseveration are often a sign of resistance to what is being said, actual and potential disturbances of authority. Indeed asseveration may be connected to problems of authority, especially moral authority.

Alasdair MacIntyre stigmatizes most modern ethical theories as

emotivist, and therefore based solely on personal assertions of value grounded in desires and affects,[14] because moral argument is understood as a competition between the authentic feelings of different people or groups. My authentic feelings are the ultimate basis for deciding the value of my moral position on a problem. His answer to this evacuation of ethical terms of all objective criteria is not to argue for some new system of constructing moral laws in the manner of Kant's categorical imperative, but to argue that the re-establishment of valid moral debate would depend on the creation of communities with the kind of densely experienced common language found in highly traditional societies. In such circumstances the language is tied almost completely to "a particular community living at a particular time and place with particular shared beliefs, institutions, and practices. These beliefs, institutions, and practices will be furnished expression and embodiment in a variety of linguistic expressions and idioms; the language will provide standard uses for a necessary range of expressions and idioms, the use of which will presuppose commitment to those same beliefs, institutions, and practices."[15] It is a community where a moral language would have foundations in actual common practice and understanding. In such communities, "by saying something a speaker or writer communicates more and other than he or she has actually said."[16]

Asseveration is a local, momentary attempt to draw listeners closer into such communities, however fragile and temporary, to provide partial foundations for ethical and aesthetic assertions and, at the same time, is a reminder of their partial absence, because its degree of emphasis is commonly in inverse relation to the degree of consensus. The poetry reading dramatizes authorship because the authority of the poet and poetry is so questionable in an age where the production of any kind of public discourse, especially ones which make any kind of statement about the way the world is or how we ought to act, depends for its legitimacy on institutional validation if it is to be any more than personal opinion, which itself depends for its significance on the status of the person. Academic conference-goers know all about the struggle for legitimation, and have many rituals besides the reading of conference papers to establish the credentials of what it is to be scientific, properly theorized, empirically established, and so forth. Unless poets are content to dramatize only their own inner struggles according to recognizable criteria of what counts as psychologically possible, they will be perceived as eccentric one-person research outfits, and will need to meet the

question of authority head-on. Lacking many of the other forms of legitimation available to the academics, poetry readings become another means of negotiating the authorization of the claim to a public voice and the right to state facts and make judgments.

Two examples of the ways poets do this will show how central this can be both to the performance and the writing of some contemporary poetry. A West Coast American poet, David Bromige, provides a rare instance of a full phenomenological account of a poetry reading in his critical report of the British poet Allen Fisher's 80 Langton Street (an arts centre in San Francisco) artist-in-residency in 1982. Allen Fisher's work is distinctive because of its conversance with a wide range of contemporary scientific discourses. Few poets use up-to-date knowledge from the natural sciences as part of their compositional strategy, not only because of its intrinsic difficulty, but because of problems of authority, their own and, more troubling still, the authority of the knowledge itself which has such a short half-life in most cases. In his recent poetry, Fisher had been working in this challenging area, with results that led Bromige to complain that Fisher attempted to present too much material in the four days of his residency, an excess symptomatic of a problem with the poetry itself: "the mimesis of information overload destroying any and all attempts at the discrete and limitable cannot take place on the scale of life without rendering itself defunct as art."[17] These problems the audience had with Fisher's work were, Bromige suspected, displacements of a more general problem with audiences in England: "Fisher has to use his poetry to tell a possible readership how it is to be read."[18] Fisher's difficulty, one might say, is how to perform authorship for his audience in a persuasive manner, and so Bromige takes up a role as representative naive American listener to Fisher in terms which overstate the audience's fascination with the hitherto unfamiliar poet. The report on the actual reading begins with the kind of attention given to film stars and royalty in the press: "Wearing gray shirt with red buttons, electric-blue baggies, shiny white shoes with red trim and laces, bright red socks, wristwatch with red strap, and browny-gray belt, and revealing himself to be a youthful 38, a little over six feet and lean, with dark hair and attractively limber wrists etc. . . . His voice – Denise Levertov as a light baritone – disguises the Olsonic address of his poetry."[19] This ironic imitation of the language of the journalist feature-writer works because we do indulge such inquisitiveness at readings. Emphasizing the audience's immediate reaction to the poet

is a means of reminding everyone of the importance of that relation. The hitherto unwitnessed writer reveals himself to be lean and limber, a sharp dresser, who reads in a tone of voice which reveals the anxiety of influence by merging the tones of two poet predecessors.

Bromige's witty account implies a critical point not only about the timbre of relations between performer and audience, but about the poetry itself which unintentionally makes the superficies of the performer too visible. He quotes some lines from the reading ("that poetry can medically do you good / through evoking deliberate shadow / of unmentioned imago / defeating expectations and stock responses") and comments that they posed a problem for this particular audience: "as so often, Fisher did not indicate where he stood with regard to this definition."[20] The unmentioned imago becomes the well-dressed person of the author which may defeat expectations and do the audience good, but does so without the poetry. By telling us what Fisher looked and sounded like, Bromige tells us too literally where Fisher stood, but of course this information fails to tell us where Fisher stood metaphorically with regard to such statements in the poetry. Fisher withheld the asseverations which Bromige wanted, so that the author he performed, the Fisher who stood in a known place, was (unusually) not immediately translatable into the Fisher in the discourse of the poetry, in the manner which Ginsberg triumphantly achieved. That Fisher might deliberately be attempting just such a diremption is not really considered. I would argue (making my own attempt at asseveration and an appeal to common values) that this uncertainty is a necessary element in the wider project of Fisher's poetry, which attempts to find an ethics of contemporary urban life by deliberately juxtaposing the many different knowledges used by the authorities as the basis of their decision-making, and then confronting them with ethical and aesthetic challenges, in an attempt to transform them into new, radical projects for the future.

Bromige criticizes Fisher for allowing authorship to fissure. My other example shows an author making her presence suffuse both presentation and poetic meaning, by anticipating relations with a live audience, and providing a metapoetic narrative of reception alongside its other narratives. Denise Levertov's poem, "The day the audience walked out on me, and why" (May 8, 1970, Goucher College, Maryland)[21] is available as part of a reading done as a studio recording specially for issue on tape, so is not quite the same as a

public reading, but nevertheless demonstrates one aspect of what would be likely to be its effect when performed at a reading. The poem is an account of how she read two poems against the Vietnam war in the college chapel at a ceremony to mark the killing of the students at Kent State by the National Guard, and then followed the poems with a reminder of all the other students, especially African-American students, murdered in the civil rights struggle. The audience gradually walked out on her as she spoke, and one man told her that "my words / desecrated a holy place." The man's denunciation implicitly acknowledges the power of her speaking, and her poetry, even if he sees it as evil.

Levertov's delivery deliberately blurs the boundaries between speech and writing, making her writing sound extempore, and making explicit reference to itself ("while I spoke"), particularly by referring to the speech that provoked the walkout as her "rap," associating it with oral African-American culture. As she reads the poem, Levertov keeps closely to the line breaks, yet manages to make them sound inevitable, as if she were just telling an anecdote. Her voice, which sounds unclear, thick, laden with some uncomfortable affect, suddenly clears and softens when she recalls the signs of May outside the door. Her lighter tone stands in the same relation to her earlier heaviness as the spring outside does to the dark cultural interior of this time, and prefigures the voice that would be possible if the audience for the new poem were able to meet her in her wish for them to form a group capable of mourning the murders in this intersubjective ritual, and vowing to make some form of reparations. This poem is about an audience, an audience that refuses to listen, because to their ears her "rap" illegitimately extends the occasion to a ritual observance for all the murdered students, black and white. Her talk had tried to conscript its white listeners into a ritual they would not accept, and so they left, refusing to be an audience at all. Her poem recounting this walkout is therefore itself a ritual made self-aware, a ritual of remembrance for another reading, as well as the murdered students. Anyone hearing her read the poem aloud would be constantly aware of the contrast (or possible similarity) of their own behavior and that of the complacent white chapelgoers of Goucher. The poem seems to be about one past incident, but when performed as a reading, even on tape, becomes, through the authority of the poet's voice, a challenge to the white listener to acknowledge the significance of African-American campaigns for justice. Levertov's poem is explicit about the way performance stages the presence

of the author as a challenge to the audience to listen and confront what it means to assert these words, or depart, literally or figuratively withdrawing from the negotiations enforced by the presence of the author alongside and not only within, the text.

## SPEECH AND WRITING

Are poetry readings logocentric? The *presence* of an *author* might seem already enough to indict poetry readings of irredeemable logocentrism. In addition they seem to be paradigmatic cases of the privileging of speech over writing, as a highly charged inversion of the history of language is placed centre-stage of the topos of the poetry reading. Writing becomes speech as the poet reads, hinting at a nostalgic return to an apparently lost oral culture. As I said earlier, however, it would be premature to say we have surpassed a culturally infantile oral stage. The passage from orality to literacy, and from conversation to print, is a transformation which is never complete: "orality insinuates itself, like one of the threads of which it is composed, into the network – an endless tapestry – of a scriptural economy."[22] Poetry readings could be imagined as attempts to perform a temporary reversal of this long revolution. Such oral backsliding could be interpreted as a collective yearning for an earlier era when the poet was a bard, a figure endowed with the powers of a shaman and leader, an era when, according to Eric Havelock[23] and others, poetry was the repository of history and knowledge for a community where written records did not exist. The contemporary oral poetry movement led by figures such as Jerome Rothenberg often talks as if this was so, invoking "older tribal cultures"[24] and valorizing the primitive, as if there were a direct continuity with this past. The vatic enthusiasm of some poetry readings in the 1960s and early 1970s (events at the Albert Hall, some of the readings associated with the anti-war movement in America for example) might suggest that poets and audience hungered for such a return to vanished poetic glories.

What then is the significance of this apparent logocentric demonstration? Could the poetry reading actually be a form of practical critique of certain aspects of logocentricism? Contemporary poets have certainly been very much aware of the anomalies of the standard poetry reading, so much so that some have tried to resolve them by abandoning one or other side of the process. A few even refuse to give readings, implying that oral performance in public is

irrelevant to their project. Others, like David Antin, have abandoned print for improvisation, although usually based on some prior written structure.

One way to begin to grasp the significance of the translation from writing to speech is to consider what would happen if something else were substituted for spoken words. Stephen Rodefer ends his poem "Pretext" with the sentence: "To my left is Philippa, who will be signing for me."[25] What *would* happen if the poet actually "signed" the poetry instead of speaking aloud? What relation do speech, sign language, and writing have to one another? Oliver Sacks, in his popular account of the sign languages of the deaf, says that today: "Sign is seen as fully comparable to speech (in terms of its phonology, its temporal aspects, its streams and sequences), but with unique, additional powers of a spatial and cinematic sort – at once a most complex and yet transparent expression and transformation of thought."[26] What does it mean to say that sign language is both "fully comparable" to speech and at the same time has "unique, additional powers"? This suggests that the signed reading would be different from the spoken one. According to a researcher into sign language, it "produces a structurally different approach" to an ordinary task like explaining the plot of a movie, because it is more "image-based," although it is just as capable of abstraction and complexity as spoken language.[27] Sign language is a reminder that phonetic language is not the only possible performative rendition of a written text, and that this is not the same as translation from one spoken language into another, say from English into German. Writing is no more written in speech than it is in sign, as any phonetician or conversation analyst knows. The oral performance of a poetry reading is not therefore a mechanically determined outcome of a written text, but involves a choice of medium and some form of transmutation.

Poetry readings make fleetingly perceptible the unstable transitions between different signifying media, as if the poem's significations could be best understood at the margins of signification where such radical transformation occurs. Poetic meaning is produced on the border of transition between sound and visual marks, oscillating back and forth, making evident by this interruption of the ordinary, imperceptible, smooth functioning of signification, the *responsibilities* of meaning-production to the audience and poet.

From the standpoint of deconstruction, a poetry reading would seem to be shirking these responsibilities and endorsing a belief in the power of speech which is no longer tenable. Textuality is the real

area of activity for deconstruction. Actual speech is only an uninteresting secondary phenomenon, an assumption already prefigured by Saussure's linguistic redirection of attention from actual utterances ("parole") to the codes ("langue") which make them possible. In his study of the relations between speech and writing, *Of Grammatology*, Derrida locates many of his arguments at just the margin between speech and writing that is activated in poetry readings, because he believes that it has given rise to many misapprehensions. One central argument isolates the moment when a speaker becomes her own listener, closing the circuit of language production, in a simpler version of the poet hearing herself read aloud poems she wrote on another occasion. This familiar self-conscious experience of simultaneously speaking and listening to oneself speak, has, according to Derrida, provided a misleading image of the relations between language and subjectivity for the Western philosophical tradition. Aristotle, for example, says that: "spoken words (ta en tē phonē) are the symbols of mental experience (pathēmata tes psychēs) and written words are the symbols of spoken words."[28] Derrida cleverly projects such assumptions into the situation of hearing oneself speak (*s'entendre-parler*), an experience which provides the basis for logocentrism: "that experience lives and proclaims itself as the exclusion of writing, that is to say of the invoking of an 'exterior,' 'sensible,' 'spatial' signifier interrupting self-presence."[29] When you hear yourself speak it is easy to assume that the language issues directly from the realm of thought without loss of immediacy. This closed circuit is an image of the supposed perfect self-reflexivity of consciousness, where consciousness in language becomes pure self-consciousness, a transparent self-relation of unalloyed self-presence. According to this metaphysical picture: "consciousness is the experience of pure auto-affection," and the logos "can be *produced as auto-affection*, only through the voice: an order of the signifier by which the subject takes from itself into itself, does not borrow outside of itself the signifier that it emits and that affects it at the same time."[30] Derrida's line of argument assumes tacitly that post-Cartesian philosophy always considers subjectivity as "self-presence" or self-reflection. He is then able to diagnose the overvaluation of speech at the expense of writing as a result of the way speech appeared to be a natural extension of thought itself, because such experiences as hearing oneself speak seemed to offer a confirming, experiential image of the reality of subjectivity. Language appears to be a phonetic structure for which writing is an incidental

addition, a mere system of marks transcribing its sounds. Derrida shows that a careful examination of the nature of writing shows first of all that it cannot simply be the direct expression of thought, and that this is why most thinkers have set it aside from their deliberations. By a deconstructive move of the kind he has made his own, he then claims that the characteristics of writing cannot be a simple transcription of speech either. Writing cannot be self-identical and produce fixed, clear meanings, but this must be true of all language because all forms of language can be redescribed as writing, and hence the "différance" of writing, its imbrication of absence and deferral, must be generally true, of speech as well as of writing. Therefore no language, not even the speech that hears itself, can be the matrix of transparent self-consciousness, and certain concepts, like "subject" and "meaning," are revealed to be metaphysical, despite their apparent tangibility. The term "subject," for example, "will refer, by the entire thread of its history, to the substantiality of a presence unperturbed by accidents, or to the identity of the selfsame [*le propre*] in the presence of self-relationship."[31] These arguments assume that experiences (however abstract and hypothetical) of hearing-oneself-speak actually can occur and result in (mistaken) conclusions about the relations between thought and language. This leads to the interesting possibility that certain rituals in everyday life might in part attempt to stage such experiences in order to sustain or challenge the crucial metaphysics. Derrida's own presentation of the argument seems to tacitly expect that, at the very least, the actions of analytic argument will take place, as can be seen in his discussion of literal meaning. The experience of hearing oneself speak functions as an anchor to the supposed capacity for literalness of language: "The literal [*propre*] meaning does not exist, its 'appearance' is a necessary function – and must be analysed as such – in the system of differences and metaphors. The absolute parousia of the literal meaning, as the presence to the self of the logos within its voice, in the absolute hearing-itself-speak, should be *situated* as a function responding to an indestructible but relative necessity, within a system that encompasses it. That amounts to *situating* the metaphysics or the ontotheology of the logos."[32] The exposure of this creation of the literal is an action, the action of philosophical argument, as the verbs "analysed," "situated," and "situating," as well as the injunction "should," all attest.

If we do not assume that philosophical action is the only possible response to such experience, then other kinds of action might also

create similar critical effects, and one of these could be the public performance of writing as speech, in which the "metaphysics of the logos" is situated in a specific history, place, and intersubjective relation. A wider narrative in Derrida's discussion places deconstruction in a history measured in self-important millennia, and uses the word logocentrism as the name for a historically locatable activity associated with Western thought. It follows that the "experience" referred to could itself be undergoing change, and more significantly, might be capable of acts or occasions of self-examination which create and test such experiences within delimited discursive events.

Poetry readings could be said to dramatize such anchoring experiences as hearing-oneself-speak, thus demonstrating pertinent complexities of language, subjectivity, and intersubjectivity that sometimes challenge existing descriptions offered by linguistics, philosophy, and literary theory for the production and reception of texts, because they provide experiences which do not always support the local metaphysics of the day. They resist attempts to constrain acts of reading and interpretation as either singular or generic processes. The poetic text in this situation sometimes exceeds existing explanations of its functioning and significance, and this excess forms one of the main reasons for their continuing success. Poetry readings present problems of contemporary language and communication in manageable but unresolvable form, problems which of course are often also active in twentieth-century philosophy, amongst other venues.

## THE SOUND OF SIGNS

"Words change in spoken language," as Ted Greenwald puts it.[33] Since most poets agree with the general sentiment of Louis Zukofsky's claim that "the sound of the words is sometimes 95% of poetic presentation,"[34] if not always about the exact percentage, it is not suprising that poets, and those who go to readings to hear them, generally agree that the opportunity to hear the poem vocalized is the usual justification for contemporary poetry readings. They say that hearing a poet read work aloud helps them comprehend it better because the author's oral interpretation of tone, gesture, and emphasis can clarify what was not always immediately perceptible on the page, providing a training session in the effective reception of the poems, especially how to hear the actual sound qualities of the

poem. Could this apprenticeship be equally well, if less readily, not be done on one's own? The perceived advantages of public readings of poetry depend to a large measure on the value attached to the sound of poetry as a cognitive element of the poetry. The problem has been that no discourse exists for analyzing and justifying this experience as more than the pleasure of sound for itself. Recent literary theory has sidelined the actual qualities of sound in language, because it leans heavily on Saussure's concept of the arbitrariness of the signifier, which has been taken to mean that the actual sound of a word is nothing more than an empty vehicle for producing signs. The differences between the phonemes are what count, not the quality of the actual sounds themselves. The result has been neglect of the theoretical possibility of semantic significance arising from sound in poetry, despite the wide agreement amongst writers about its deep significance to their craft.

The oral stage of psychic development is the earliest, according to psychoanalysis, and this sense of the primitive character of orality has sometimes been carried over into literary and cultural theory. Poets' insistent call to recognize a non-semiotic, and sometimes non-linguistic, dimension has often embarrassed modern critics trying to establish the intellectual gravity of poetry, especially after what have been widely perceived to be symbolist and Keatsian excesses of some late-nineteenth-century poets. Lacking theoretical resources to analyze its positivity, they have mostly sidelined it, treating it as an unwelcome distraction from the proper rigor of fully developed rationality, and the richness of distinctive voice. Even the high theorists follow this line. Julia Kristeva's association of sound in poetry with the unconscious chora is characteristic.[35] Her concept of the chora, the pre-semiotic space of rhythmically organized psychic drives characteristic of the oral stage, presupposes that the psychic experience of sound occurs on the far side of conscious rationality and representation. She describes the foregrounding of sound in poetry as a disruption of the political laws and orders of the symbolic, but in doing so sees only the destruction of sense and not the innovative constructions which the poetic virtuosity of phonic display can create according to poets. The oral stage is imagined as incapable of development without relinquishing orality itself. Literary theory has not provided an adequate account of sound in poetry, and hence a way of considering poetry readings, largely because of its somewhat unexamined reliance on Saussure's assumptions about sound.

Saussure's *Course in General Linguistics*, the primary source for a model of language in recent literary theory, is as much an account of how to study language as an account of what language is. In the following key passage where he underlines the importance of assuming that the linguistic sign is arbitrary, his reference to the collective action of the analysis is a reminder that this is a deliberate process of isolating and defining a phenomenon for a particular kind of study:

> The link between signal and signification is arbitrary. Since we are treating a sign as the combination in which a signal is associated with a signification, we can express this more simply as: *the linguistic sign is arbitrary*. There is no internal connexion, for example, between the idea "sister" and the French sequence of sounds s-"-r which acts as its signal. The same idea might as well be represented by any other sequence of sounds.[36]

This formulation is notoriously hard to give a rigorous interpretation of. What is meant by an internal connection? Many commentators have written as if the connection would be between a referent and the signifier, citing another of Saussure's examples, the word *arbre* and his accompanying diagrams. Yet he surely means that the idea of tree or sister exists independently of any particular signifier, and is only linked up to one by some arbitrary, unconscious, consensual process. A further uncertainty of great relevance to poets is that Saussure is not quite accurate to say that idea and sequence of sounds have no connection. Patterns of ideas often have corresponding patterns of phonemes. The words for family members, sister, brother, father, and mother, all end in -er, and the latter three share the ending -ther. In French a similar asymmetric pattern of endings links the last three and distinguishes them from the first. As the linguist Linda Waugh, who worked closely with Roman Jakobson, points out, such patterns mean that just any sound would not do as a representation of the idea of sister.[37] Saussure's remark that any sound would do as well to represent the idea of sister conceals a tacit assumption of great importance. He means that given a different cultural history in which sounds and meanings had come to be associated in different ways, then the idea of sister could have been marked by a different sound, but he makes it appear as if some kind of arbitrary decision, made independently of the rest of language and history, is the abstract paradigm for the signifying connection. The psychoanalyst Paul Kugler notes that such sonic isomorphisms occur even in different languages, and based on different root sounds. The pattern created by violet, violate, violent

seems to have counterparts with the German *Blut* (blood), *Bluten* (blossom), *bluten* (to bleed), the Hungarian *ver* (blood), *veres* (bloody), and *verag* (flower), and the English trio carnation, carnage, incarnation.[38] Kugler attributes these patterns to Jungian archetypes but they could be explained in less mystifying terms as resulting from culturally established patterns of association which have been common to related European societies. Such examples suggest that Saussure is wrong to claim that the whole sequence of sounds bears no relation to the idea. Can the principle of arbitrariness be rescued by moving the claim one step further down the chain and saying that the individual sound is arbitrary? According to the linguist Linda Waugh even this is not enough to account for the patterning or "iconicity" of language. Saussure himself seems to recognize this later in the *Course* in a passage less often cited: "A linguistic system is a series of phonetic differences matched with a series of conceptual differences."[39] This description does not assume that correlation takes place only at the level of a word, although some kind of mapping must occur between the two systems.

Derrida's deconstruction of Saussure takes up this point in the *Course* and argues that it exemplifies the metaphysical idea of the sign which has had a hold over the modern period. Derrida thinks that Saussure fails to sustain his arbitrariness hypothesis (which Derrida endorses) because of a competing claim that there is a natural bond between sound and sense. Although the link between a specific signifier and a specific signified is arbitrary, this is still governed by the natural relation between "phonic signifiers and their signifieds in general." This interpretation of Saussure depends on a tendentious reading of a passage that Derrida repeatedly cites. In a discussion of the proper object of linguistic study, Saussure argues that the prestige of writing has misled many linguists into making false generalizations about language chronology. Thinking of linguists, Saussure argues: "The written form of a word strikes us as a permanent, solid object and hence more fitting than its sound to act as a linguistic unit persisting through time. Although the connexion between word and written form is superficial and establishes a purely artificial unit, it is none the less much easier to grasp than the natural and only authentic connexion, which links word and sound."[40] Derrida picks up that last claim, "the natural and only authentic connexion, which links word and sound," and makes much of it: "This natural bond of the signified (concept or sense) to the phonic signifier would condition the natural relationship sub-

236

ordinating writing (visible image) to speech."[41] A critic of Derrida's commentaries on Husserl and Saussure, J. Claude Evans, argues that he is making an unwarranted leap from Saussure's point that linguists studying the structure of language should concentrate on the system of utterances, to the claim that Saussure, in common with modern philosophy, imagines that speech gives direct access to thought.[42] Evans is surely right about this specific reading. Saussure would seem to be saying something very similar to Derrida, that there is no such thing as phonetic writing, that the link between written word and spoken word is superficial, and that the proper or natural subject-matter of linguistics is the sign, which at this point in the course of lectures he has not yet clearly defined as a combination of concept and sound-image, or signifier and signified. However, Derrida's point is a broader one than Evans recognizes. Saussure does conceive of language as a system of sound-images linked to thoughts, as if sound were the inevitable first stage whereby thought develops into language. The difficulty of interpreting Saussure on this question of the pertinence of phonetic patterning in literary texts for the production of semantic effects underlines how much work remains to be done in this area. Existing theory does not make the discriminations necessary for the task.

Two recent essays indicate ways in which sound in poetry might be understood without simply turning our backs on Saussure and literary theory. In a pair of public lectures, the poet J.H. Prynne questions the dogmas of literary theory by demonstrating the range of ordinary interpretative strategies for reading poems which rely on the assumption that sound effects are "motivated" rather than arbitrary. Literary theorists claim to believe that: "If language is a system of meanings and meaning-relations, then any kind of efficient carrier which could encode and deliver its discriminations would be adequate to efficient performance; there is no need for an idea to be matched by a word-form at an individual level: the sign is *arbitrary*."[43] In practice almost everyone ignores the rigidity of this claim. Poets have always cared for the sound effects of their vocabulary, for its roughness and smoothness, its harmonies and tones, its rhymes, alliterations, and onomatopoeias, and so the sound quality of signifiers in poetry can be said to be at least partially motivated, and thickened with intention. Prynne argues that all language in use actually encompasses a dense texture of diachronic "secondary relations, allowing functional connection from sense to sound (violating one system-generated rule) and from sound to sense

(violating another); such connections may in intensely witty or language-conscious performance be recognised to run alternatingly back and forth, or even in both directions at once."[44] These secondary relations are historically local associations between sound values and both ideas and emotions, associations which are pragmatic rather than systematic, and do not therefore undermine the system itself. He makes this point because linguists have insisted on the arbitrariness hypothesis partly to retain the seemingly necessary concept of language as system. Prynne proposes that such poetic play with sound as sense can be a "complement to essentialist analysis of structure, not so much because it operates more in one dimension than another (e.g. historical space rather than conceptual space), but because it is an aggregating and proliferative instigation, recursively back-folding and cross-linking, and this kind of incorporative opportunism is idiomatic for a whole pattern of cultural practice in which language is a centrally-mediating agency."[45] Although Prynne wishes to retain the concept of system, he also recognizes that language is inherently performative – spoken, dialogic, contingent. He indirectly recognizes the potential of performance by emphasis the way signifying media extend beyond basic phonetic units: "If language is a social code of interactions, in which performance is an expressive procedure within a context of sense-bearing acts, then anything that *can* count toward meaning *may* do so: intonation, style-level, choice of words and of their sounds and echoes."[46] This leads him to be ambivalent about the status of the arbitrariness hypothesis, at once calling it into question and then backing off into qualifications which reduce the significance of sound pattern to contingent, occasional and local collaborations of interpretation. His discussion does recognize the difficulty of applying a theoretical method, designed to isolate the phenomenon of language for analytic study, to a performative event in which the boundaries between different structurings of significance, both linguistic and non-linguistic, become permeable and at times indistinguishable. His conclusions could be taken to mean that public performance is redundant, since if a poem is already an expressive interaction generating the tonal and decisionist range he mentions, then it might have no need for any additional resources. Indeed they might only obfuscate the intended field of readerly engagement. The continuing prevalence of poetry readings suggests that few poets and readers believe that poems are capable of achieving this ideal without further performative resources, in the contemporary scene.

Prynne's argument has affinities with the work of Roman Jakobson and Linda Waugh. In a recent article aimed at literary theorists Waugh argues that the concept of arbitrariness has led to confusion because it has been muddled up with the concept of conventionality. Words can have a phonetic form which is a matter of convention, without at the same time being arbitrary, something most evident in the way the sound forms of words exhibit relations amongst themselves which function rather like visual diagrams, and so can be called iconic. Saussure himself recognized that many words displayed what he called "relative arbitrariness," or "degrees of arbitrariness," because some signs are "motivated to a certain extent." The word "dix-neuf" is composed of two words whose meaning literally adds up to the meaning of the entire word. Waugh shows that this is only one of many kinds of iconicity and estimates that about 80 percent of all words are motivated in some fashion. Her range of examples and reports of linguistic research back up what poets have always said: that the sound of words within a specific language is highly significant, and their composition requires great artistry to create effective patterns of meaning. She says that "speakers of a language differ widely in how salient the associations are for them. There seems to be a continuum all the way from those who find such associations quite strong and important, to those for whom they are negligible, with many subtle differences in between."[47] One example of the kind of associative matrix that a poet might use can suffice. Linguists have described a link between high-pitched front vowels and the idea of smallness and light, and low-pitched back vowels and largeness and darkness (a chip is a small cut and a chop a large one). A poet might therefore manage to convey these ideas simply by some pattern of vowels which will convey this suggestion subliminally, or use words which do not use this kind of iconicity ("big" and "small" are familiar examples) in contexts where the lack is also significant.

These arguments made by Prynne and Waugh would require some extensive revision of current literary theory, but they would still not go far enough to satisfy many poets. Denise Levertov believes that "the sounds – the vowels and consonants, the tone patterns, the currents of rhythm – are the chief carriers of content."[48] Steve McCaffery goes even further, claiming that "it is energy, not semantically shaped meaning, that constitutes the essence of communicated data ... it is the scripted signifier, the phonematic unit that marks the crypt of a vast repression, where energy is frozen in the articulated

and subordinated elements of repression."[49] The hegemony of Saussure's argument that the sound values of a language are arbitrary mental images in recent literary theory has encouraged a general neglect of the pertinence of the aural qualities of language as any other than cues for signification. Waugh's discussion of the sound of poetry still considers sound as a code, just as Saussure does, but at least she recognizes that the pertinent signifying element of a word may be a small part of the overall sound of the word, or some combination of its sounds. Yet poetic sound need not be considered as an entirely semiotic phenomenon. Parallels with other kinds of performance, dance, and music, help illustrate how far poetic sound can exceed the Saussurean reduction.

Communication is not limited to mental acts mediated by language. It has many other material routes through matter and movement. Poetry readings are powerful reminders that sign systems are also dynamic material structures, because sound is a material phenomenon experienced as vibration in the body, as well as a mental perception. The audible sound of a voice performing a poem literally amplifies the words, and in doing so can make evident features likely to be less evident in the near-silence of private reading which will produce only mentally imagined sounds (or possibly words muttered quietly under the breath). When a word is vocalized, much more than the larynx and a small part of the mouth are involved: the entire body resonates with it, as it does with all audible sound waves (this must be one reason why the deaf percussionist Evelyn Glennie has been able to develop such a sophisticated art). The amplification is a bodily process common to all the live performance arts in which the performer uses the body directly and the audience "delegates its corporeality to the stage."[50]

The implications of this are easier to grasp in the case of other kinds of performance, such as dance. At a dance performance the audience does undoubtedly interpret specific movements as identifiable units, such as pliés, arabesques, and grandes jetés, for example, and then attributes symbolic significance to them, saying to itself perhaps that the dancer is sad, or greeting the dawn (in traditional ballet at least – the symbolism of contemporary dance is more localized). Alongside this conscious activity of semiotic interpretation is another kinesthetic response, equally cognitive, but not linguistic, in which the audience senses the movements of the dancers in terms of their own bodies, not as a possible action upon them, so much as an action they might be making. The watcher

dances with the dancer in an imaginative empathy which is not allowed to call the musculature to action. There is no necessary intervening stage of conscious interpretation between seeing the dancer and this inward imaginative movement, although many watchers will consciously consider what they see and reflect upon what they sense kinesthetically. Similarly, a sound heard as the voice of another also produces virtual responses throughout the bodies of the audience. When the speaker utters the poem, the listeners also speak it in virtuality.

The difficulty of describing performance has been extensively studied by those most concerned with the arts of sound, musicians and theorists of music, but despite the popularity of the parallel between music and poetry in modernist criticism, the differences make comparisons difficult. Music is precisely not linguistic despite its use of structured sound. Attempts to assess the significance of this difference illuminate the importance of sound in poetry if the other dimensions of poetry are not neglected. Faced with the absence of the usual markers of intellectual activity, representation and language, philosophers of aesthetics have disputed whether music is simply an expression or evocation of emotion, or it has some more cognitive, conscious, or rational elements. A tradition in German philosophy going back to Schelling argues that "music is a non-representational, non-conceptual form of articulation," not re-ducible to ethics, cognition, or emotion.[51] To call it articulation seems to insist on a similarity with language, while holding back from claiming that it is another language. This is a problem. What is a language that is not a language? Here there is no parallel to Prynne's "secondary relations" to fall back on as an explanation that keeps the semiotic intact.

The American poet, Louis Zukofsky, author of the long poem *A*, was fond of comparing poetic composition to Bach's art of the fugue, even citing Bach's suggestion that "the parts of a fugue ... should behave like reasonable men in an ordinary discussion."[52] For Zukofsky this was a literal possibility. Music's sound patterns could convey argument. This emphasis on argument is significant because it counters the usual tendency amongst non-musicians to equate the sound of poetry with its emotional, non-rational dimensions. Music theorists themselves have also had to resist this assumption that music is only patterned emotion, and the prejudices and suppositions this brings in its wake. Suzanne Langer understood this danger, and argued that music is a symbolic form different from language

241

and not translatable into it, a symbolism which "makes things conceivable."[53] Music is not simply a language of emotions even if it is capable of emotional significance. Literature too can be described as a symbolic form. Symbolism is a term relegated to the basement of cultural history at present, so it is encouraging to see the claim in a more recent study of the intersubjective processes at work in classroom teaching of literature, and hence in literary reception more generally, that the current trend to reduce all literature to ideology "lacks a sense of symbolic activity as a fundamental form of human self-knowledge and fulfilment,"[54] a point similar to Ricoeur's reservations about Freud's etiological approach to symbolism.[55] This is precisely Suzanne Langer's point, that symbolic activity is a primary human activity, but not therefore all reducible to one conceptual scheme or system of symbols, language, or whatever. Thought and communication are not only semiosis.

Sound, like the drama of authorship, and the tension between speech and writing, provides a resource for poets to extend the semantic range of their poems. It can add another level of conceptual complexity by creating complex networks of association via sound and iconicity, a kind of layering of ever fainter echoes and distant meanings. It can also open into the senses through the material experience of sound waves themselves, and the bodily knowledge of their production. David Michael Levin calls this aspect of sound, echoing Heidegger, the "dimensionality of Being."[56] For Levin, one important dimension of being in the world is sound itself, and it calls for an attention which is too often neglected in a culture which overemphasizes vision. He cites Merleau-Ponty saying that "in a sense, to understand a phrase is to welcome it in its sonorous being,"[57] a sentiment echoed by the voice coach Patsy Rodenberg, who writes from the experience of training actors to speak writing in more effective ways: "When we need a word – really connect with it and release it in a brave, physical sense – the experience is not just an act of intellect but a feeling act felt throughout our entire being."[58] Poetry readings strive to offer such a welcome to the sound of words in all their fullness, and to reflect on the consequences and responsibilities of the encounter.

## INTERSUBJECTIVITY

Poetry readings demonstrate that there is no Other – only others sustaining the textual economy. In all of the poetry readings I have

described so far, the audience has played a part in generating the poem in performance. Unlike the "reader" of a text in literary theory, this audience is irreducibly plural. When a poem is read aloud at a poetry reading, an intersubjective network arises that can become an intrinsic element of the meaning of the poem. The effects of this are already evident in my previous examples. Shouts of encouragement at Ginsberg's reading acted like a collective "amen." Levertov's anecdote about other listeners leaving forced the listeners to her poem to reflect on why and how they were listening, and what commitment they were collectively forging as an audience capable of remaining to listen and participate in the project proposed by her poetry. Fisher's audience became partially resistant to a demand by the poetry to take part in a large-scale evaluation of contemporary knowledges, and that resistance tended to reify the poet. Poetry readings are inherently collective events during which a text is the simultaneous object of attention by many participants. I have already considered some features of this process: the allegorical transformation of the venue and the tension between poetry and the surrounding reminders of what resists poetry; the intersubjective drama of authorship centered on the deceptive presence of the poet as origin of the poetry; the challenges to self-reflexive subjectivities maintained by the oscillations between speech and writing; and the kinesthetic, material relations created by sound waves. It is now time to consider this intersubjective drama as a whole. To do so it is necessary to discuss what is meant by intersubjectivity, and the problems of discussing it within frameworks derived from Saussurean linguistics.

Agreement that intersubjectivity is the relation between different subjects as subjects hides largely unarticulated disagreements about what exactly is related and how. Is intersubjectivity conscious or unconscious and is it a form of self-consciousness or not? How does it occur: through language, affect, recognition, imitation, or some other form of connection? Is it the result of subjects interacting with each other or is it a prior condition which makes individual subjectivity possible? Is it a conceptual delusion? Anglo-American philosophy has found the term useful to describe forms of collective agreement that are conscious but not necessarily arrived at by means of deliberative argument. Philosophers as different as Donald Davidson and Thomas Nagel recognize the importance of what Davidson calls "a largely correct, shared, view of how things are,"[59] and Nagel calls the "view from nowhere,"[60] for making sense of

objectivity. Husserl's late work was devoted to the problem of intersubjectivity and has been developed into various theories of the lifeworld. Intersubjectivity is a key term for Habermas's theory of communicative action: "To the extent that language becomes established as the principle of sociation, the conditions of socialization converge with the conditions of communicatively produced intersubjectivity."[61] This is a history still in need of its historians. My brief outline is sufficient only to indicate that although no working theory of intersubjectivity commands general assent the question of how people interact as conscious beings has been widely explored in modern thought, and that it is not an adequate response to dismiss the term merely on the basis of one specific interpretation. Derrida's confident assumption that intersubjectivity is always assumed to be an "intentional phenomenon of the ego" and to amount to no more than "the co-presence of the other and of the self,"[62] simply does not answer to the range of philosophical discussion beyond Husserl. Nor can intersubjectivity be dismissed because some linguists have understood it to mean a kind of pure communication.[63]

Derrida's dismissal of the term has a counterpart in Saussure's linguistics, and its inability to represent communication adequately. For that reason, the intersubjectivity of a poetry reading is hard to place within a Saussurean linguistics and the literary theory that springs from it. Roy Harris claims that the problem arises because Saussure has a mistaken concept of linguistic value.[64] Saussure tries to find a material embodiment of his key insight that language is a collective institution which is outside the control of the individual speaker, and does so by inserting a cognitive rule system, "la langue," into the mind of each individual speaker. Several philosophers and linguists have argued that this model itself is deeply flawed because it imagines communication rather like a transfer of something tangible, as if communication were a "conduit" channeling materials from one person to another, or a telephone line delivering packets of electrical information. Speakers understand one another because they have the same inner programing for dealing with what is sent. This model of intersubjectivity effectively sidesteps the problem by covertly assuming that everyone is the same on the inside and therefore intersubjectivity is inevitable under the right conditions. Communication is demonstrably unlike this, however, as even Saussure admits at times in the *Course*. Speakers infer what one another are saying in ways which inevitably result in misunderstanding, however limited or innovative, as many com-

mentators have observed.[65] The idea that communication takes place within a perfect circuit also gives a peculiar interpretation to his key theoretical proposition that "language is a system of pure values, determined by nothing else apart from the temporary state of its constituent elements."[66] The values must be fixed because otherwise communication would be impossible, a travesty of the working of values in an economic system. Harris argues that Saussure fails "to see that values are subordinate to transactions, not transactions to values," whether in monetary exchange or language.[67] The value of something is determined only by what value is attached to it in a particular transaction. Transaction is a pertinent term for poetry readings, where linguistic transactions occur in public situations capable of self-referential feedback about just such values. These are not primarily judgments of success or worth, as the term "value" might suggest, so much as self-reflecting investigations of the semantic values, or meanings, possible within this particular group of language-users comprising audience and poet. Such transactions are a form of freedom, a "poetic interaction" in the words of one philosopher,[68] and Saussure's description of them is remarkably relevant to the way poets create opportunities for interpretation to flourish. Discussing what he calls "associative relations" Saussure admits that "any given term acts as the centre of a constellation, from which connected terms radiate *ad infinitum*."[69] The problem with Saussure's general system, as Harris points out, is that it tacitly admits that speakers are not bound by fixed values in such cases. If this is so it is hard to see how *any* word can be said to have a fixed value, since under certain conditions at least, such as those occurring in the reading of a poem, all words are opened to infinity.

The intersubjectivity of the poetry reading offers important resources to poets (especially some contemporary avant-garde writers), although the actual reading is as much "uninterruptable discourse" as written poetry is, according to David Antin.[70] The utterances made during a poetry reading occur in a highly abstract, reflexive mode of speech which lacks the more direct answerability of ordinary dialogic speech, and permits the saying of utterances many of which would not ordinarily be intelligible, or even sayable, in conversation. As public utterance it sustains a reflexive intersubjective drama of central importance to the event that makes visible the readership of the poetry to itself, including the relations between readers. The audience experiences itself as not just the group of people present in the space, but as a group (not a singular) listener

brought into being by the performance of the poem, an audience created by the poetry, and it can therefore also, at least potentially, imagine how this might happen within individual acts of private reading.

A good example of the intersubjective transformations of a text during performance occurred when Susan Howe read *Thorow* at Southampton University in 1993. Susan Howe read her poems with a tone which conveyed surprise, wonder, sadness, nostalgia, and careful thought. One section which indicates the possibilities she could realize is the following:

> The Source of snow
> the nearness of Poetry
>
> The Captain of Indians
> the cause of Liberty
>
> Mortal particulars
> whose shatter we are
>
> A sort of border life
> A single group of trees
>
> Sun on our back
>
> Unappropriated land
> all the works and redoubts
>
> Young pine in a stand of oak
> young oak in a stand of pine
>
> Expectation of Epiphany
>
> Not to look off from it
> but to look at it
>
> Original of the Otherside
> understory of anotherword[71]

In the taped recording of the reading she enunciates individual words with extreme care, because these, rather than sentences, are her primary unit. The collective pronoun used in the presence of the audience includes her listeners, who become the "shatter of mortal particulars." For a moment it is the audience's back that feels the sun, feels lost in the unmapped America of the early settlers. The audience is offered a position of identification as a collective subject undergoing a disorienting exposure to a landscape whose meaning is not properly articulated, and struggling to fix its significance with abstract ideals such as Liberty. The slight fall in her voice in many lines suggests that this character she has put on by reading this

section is not optimistic about our enlistment. The words speak of exploration, of being unsure of location, of having the sun behind some collective identity. This collective she speaks for, this audience as it identifies itself in the collective pronoun, does not quite know where it is, but finds itself being spoken for by a visionary leader who for a moment articulates expectations of epiphany. Listeners wonder what enlightenment they can hope for, what understanding of their condition? A British audience is also aware of an imaginative distance distorting its participation because it is not American, and has not absorbed years of American patriotic history, years of images of discovery, exploration, and settlement in a new land. A few pages later in *Thorow* the text is scattered over the page, lines at skew angles and even upside down, as if the text had just fallen there, and she reads it with vigor, with a zest and light staccato emphasis that seems to indicate more freedom and hope, especially as she says: "cannot be everywhere I entreat." The "everywhere I" of the audience, the collective brought into line behind the poem earlier, is mirrored and scattered for a moment. Always the poem invites the audience to take compass bearings, to share in the search, not for a meaning denied by the performer, but meanings the situation seems to make stumble. Hearing the poem at the reading was to become a different kind of reader than the isolated private self who reads the published text in a journal or book.

Levertov's poem explicitly thematizes public listening to poetry, at the same time as it takes advantage of poetry's intersubjective possibilities, and in doing so is similar to many other contemporary poems which implicitly interpellate an audience, like the poem by Howe discussed earlier. What these examples cannot show is another dimension of listening which all poetry readings anticipate. Reception is not simply an addition of individual receptions, each autonomous from the others, because the performed poem both modulates existing networks of intersubjective relations and articulates new ones, so that the aggregate reception of the poem is not purely a series of independent auditions all directed only at the poem. If intersubjectivity were thought of as a field, it would be neither uniform throughout its range nor continuous, but such metaphors distort the activity of intersubjectivity. Intersubjectivity is only partly under the sway of the author and poem, and is turbulent, unpredictable, and capable of warping as well as amplifying texts. But this could imply that the poetic intersubjectivity of performance was passive, and this is not the case.

Just as the poet/author is a fiction actively performed by the reader, so the audience too is a performance, a staging of itself as an audience. Poetry readings delegate some of the constructional authority for this process to the poet at the front, whose poetry choreographs the semantic adventures of the listening witnesses, and contributes something as well. This process takes place largely beyond singular articulation and can only be inferred by the consequences of readings and such reflexive images as those provided in poems like Levertov's.

Performance is a moment when social interaction can study and celebrate itself and the poet is given significant new materials with which to extend the signifying field of the poem. Authorship and intersubjectivity collaborate with the implicit allegorization of poetry's potential and actual place in everyday life. The unstable balance between the mimicry of expressive utterance that occurs when a poet reads a poem as if it were only then being spoken for the first time, and the self-alienation of reading a text written at another time as if by another self, offers a wide field of social and semantic significance for active poetic construction. The dramatization of the moments at which subjectivity is generated in the relations between a speaker and an audience opens into a qualitatively different effect. The presentation of the poetry in a public space to an audience which is constituted by that performance for the time of the reading enables the poem to constitute a virtual public space which is, if not utopian, certainly proleptic of possible social change, as a part of its production of meaning. Part of what the poem means is what it means as an event in which individual identity is set alongside the group identification of an audience. Poetry readings foreground the ordinary processes whereby meanings are produced within linguistic negotiations between speakers in a textual culture, by balancing on the knife-edge boundary between two signifying media, sound and writing, at the moment of reception. Reading is made aware of itself as an activity organized by and within communities, and calling for a locally civic virtue.

## CONCLUSION

Poetry's oral stage is not therefore a childish regression to a mere babble of sound, because oral performance actually makes possible an extended semantic repertoire in which poetry fulfills more of its potentialities. Staging, authorship, sound, and intersubjectivity, are

constitutive elements of a poetry reading which are revealed as elements of reading itself, and reveal how much all reading, silent as well as public, depends on the network of hermeneutic communicative interactions within which we live. The different senses of the word "reading" turn out to be more than superficially related. Poems by contemporary poets use these resources projectively, just as composers anticipate performances in their scores, because these are the conditions of contemporary reception. Readings are only the most salient form of oral circulation for their texts however, and even poets who never read their work in public still produce work for a culture which is not simply engaged in the direct interpretation of written texts as if they were mute objects waiting for a fairy-tale reader to awaken them to life. Texts are already active projects, already on their way through an endlessly reconstitutive pattern of linguistic transactions which momentarily sustain meaning. The answer to my opening questions about poetry readings is, then, neither yes nor no. Poetry readings do not do anything very different to silent reading if we recognize how active a place that silence has in a wider dialogue of language and action. Such a recognition depends on acknowledging that subjectivity is neither singular, nor reducible to the act of self-reflection or linguistic cognition. Language shades away at the edges of the sign into significances which are not theorized. Poetry readings can operate in this territory, extending the meanings of written poems by providing a many-dimensioned experience of significance occasioned by the poem and inextricable from it, a semantic performance that could not be recreated even in the most perfectly eidetic and imaginative mental theatre.

Poetry readings are also far from perfect. By trying to show how poems are enriched by public reading I have overstressed the success of this, and its value, as if all readers managed as well as those I discuss here, and as if all poems were blueprints for a better society. Poetry readings, whatever their possibilities, can also be demonstrations of failure, acrasia, and disintegration. Like other public performances they can seduce, terrorize, and indulge their audiences, provoking outrage, dread, sentimentality, and fantasies of every kind. The oral life of poetry is not simply regression, any more than it is exempt from the vicissitudes of social relationships in the lives of performers and listeners. Yet each poetry reading represents a collective effort to create something out of wntten texts that is still unarticulated. There is no typical poetry reading. I hope that I have conveyed a sense of just how remarkable poetry readings are, given

that their very existence commonly depends on a few activists working without direct help from parties or institutions.

NOTES

I This account is based on Michael Schumacher, *Dharma Lion: A Critical Biography of Allen Ginsberg* (New York, St. Martin's, 1992); Barry Miles *Ginsberg: A Biography* (London, Penguin, 1990); Jane Kramer, *Allen Ginsberg in America* (New York, Random House, 1969). Further background can be found in Michael Davidson, *The San Francisco Renaissance: Poetics and Community at Mid-Century* (Cambridge: Cambridge University Press, 1989).

2 Kramer, *Allen Ginsberg in America*, p. 48.

3 Schumacher, *Dharma Lion*, p. 215.

4 Miles, *Ginsberg*, p. 196.

5 Allen Ginsberg, *Collected Poems* (Harmondsworth, Viking, 1985), pp. 126–33. Regrettably the fees for quotation from contemporary poets make it impossible to cite even a short section. Readers unfamiliar with the poem should read the opening twenty lines at least to experience some of the potential of this text as performance.

6 For bibliographies and introduction to the field see Walter Ong, *Orality and Literacy: The Technologizing of the Word* (London: Routledge, 1982); Ruth Finnegan, *Oral Poetry: Its Nature, Significance and Social Context* (Bloomington: Indiana University Press, 1992); Viv Edwards and Thomas J. Sienkewicz, *Oral Cultures Past and Present: Rappin' and Homer* (Oxford: Basil Blackwell, 1990). Since this essay was written, Charles Bernstein has edited a collection of essays entitled *Close Listening: Poetry and the Performed Word* (New York: Oxford University Press, 1998), which offers a wide-ranging discussion of the poetry reading. It includes my essay "The Contemporary Poetry Reading" which is a short history of the poetry reading.

7 Many poets would dispute the use of this term but there is no more commonly acknowledged term to designate the linguistically innovative modern poetries and their challenges to existing norms and beliefs. Terms like "new," "postmodern," and "experimental" are all too vague or caught up in other controversies.

8 These terms are used loosely to distinguish, say, the poets of the *American Poetry Review* and Faber and Faber from feminist and anti-war poets, from poets whose work verges on cabaret and comedy. In practice many poets cross these boundaries, but the categories do usefully distinguish different audiences and forms of reception.

9 Ginsberg, *Collected Poems*, p. 127.

10 *Ibid.*, p. 131.

11 Walter Ong, "Text as Interpretation: Mark and After," in *Oral Tradition in Literature: Interpretation in Context* ed. John Miles Foley (Columbia, Missouri: University of Missouri Press, 1986), p.164.

12 Reed Way Dasenbrock, "Do We Write the Text We Read?" in his, *Literary Theory after Davidson* (University Park, Pennsylvania, Pennsylvania State University Press, 1993), p. 25.

13 High-cultural writing is rarely given the same kind of treatment that popular literature receives in work like Janice Radway, *Reading the Romance: Women, Patriarchy and Popular Literature* (Chapel Hill: University of North Carolina Press, 1984). Shakespeare is a partial exception to this generalization. See, for example, Terence Hawkes, *Meaning by Shakespeare* (London, Routledge, 1992).

14 Alasdair MacIntyre, *After Virtue: A Study in Moral Theory* (London, Duckworth, 1985), pp. 23–35.

15 Alasdair MacIntyre, *Whose Justice? Much Rationality?* (London, Duckworth, 1988), p. 373.

16 *Ibid.*

17 David Bromige, "Allen Fisher," in *80 Langton Street Residence Program 1982* (San Francisco, 80 Langton Street Publications, 1983), p. 42.

18 *Ibid.*, p. 41.

19 *Ibid.*, p. 22.

20 *Ibid.*, p. 28.

21 Denise Levertov, *Footprints* (New York, New Directions, 1972), pp. 26–27.

22 Michel de Certeau, *The Practice of Everyday Life*, trans. Steven Rendall (Berkeley, University of California Press, 1984), p. 132.

23 Eric Havelock, *Preface to Plato* (Cambridge, Mass., Harvard University Press, 1963). See also "The Preliteracy of the Greeks," *New Literary History*, vol. 8/3 (1977), pp. 369–92.

24 Jerome Rothenberg, "From 'A Dialogue on Oral Poetry' with William Spanos," *Prefaces and Other Writings* (New York, New Directions, 1981), pp. 20–21.

25 Stephen Rodefer, "Pretext," *Four Lectures* (Berkeley, The Figures, 1982), p. 11.

26 Oliver Sacks, *Seeing Voices: A Journey into the World of the Deaf* (London, Pan, 1991), p. 90.

27 Jim Kyle, "Looking for Meaning in Sign Language Sentences," in *Language in Sign: An International Perspective on Sign Language*, ed. Jim Kyle and B. Woll (London, Croom Helm, 1983), p. 193.

28 Jacques Derrida, *Of Grammatology*, trans. Gayatri Chakravorty Spivak (Baltimore, Johns Hopkins University Press, 1976), p. 11.

29 *Ibid.*, p. 98.

30 *Ibid.*, p. 98.

31 *Ibid.*, p. 69.

32 *Ibid.*, p. 89.

33 Ted Greenwald, "Spoken," *L=A=N=G=U=A=G=E* 7, March 1979, no page no.

34 Louis Zukofsky, A *Test of Poetry* (New York, C. Z. Publications, 1980), p. 58.

35 I have discussed her concept in some detail in "On Ice: Julia Kristeva,

Susan Howe and Avant-garde Poetics," in *Contemporary Poetry Meets Modern Theory*, ed. Antony Easthope and John O. Thompson (Hemel Hempstead: Harvester Wheatsheaf, 1991), pp. 81–95. Kristeva's theory can be found in *Revolution in Poetic Language*, trans. Margaret Walker (New York: Columbia University Press, 1984).

36 Ferdinand de Saussure, *Course in General Linguistics*, trans. Roy Harris (London: Duckworth, 1983) p. 67 (p. 100 in French edition, hereafter indicated with square brackets).

37 Linda Waugh, "Against Arbitrariness: Imitation and Motivation Revived, with Consequences for Textual Meaning," *diacritics*, vol. 23/2, (1993), pp. 71–87.

38 Paul Kugler, *The Alchemy of Discourse: An Archetypal Approach to Language* (Lewisburg, Bucknell University Press with Associated University Presses, 1982), p. 23.

39 Saussure, *General Linguistics*, p. 118 [p. 167].

40 *Ibid.*, p. 26 [p. 46].

41 Derrida, *Of Grammatology*, p. 35.

42 J.-Claude Evans, *Strategies of Deconstruction: Derrida and the Myth of the Voice* (Minneapolis, University of Minnesota Press, 1991), pp. 152–65.

43 J. H. Prynne, "Stars, Tigers and the Shape of Words," the William Matthews Lectures delivered at Birkbeck College, London (available from Birkbeck College), 1992, p. 1.

44 *Ibid.*, p. 32.

45 *Ibid.*, p. 34.

46 *Ibid.*, p. 1.

47 Waugh, "Against Arbitrariness," p. 75.

48 Denise Levertov, "An Approach to Public Poetry Listenings," *Light Up the Cave* (New York, New Directions, 1981), p. 49.

49 Steve McCaffery, "Sound Poetry," *L=A=N=G=U=A=G=E* 7, March 1979, no page no.

50 William Fitzgerald argues that a musical concert is beset by a tension between cognitive and bodily responses in a manner which sounds similar to the complexities of the poetry reading. The concert may aim at a "spiritualized musing," but "paradoxically, it may be that the institution of the concert makes possible the very experience that it would repress. Once the audience neither dances nor talks during the music, but sits, watches and listens, it delegates its corporeality to the stage, combining the playing/feeling bodies of the performers and the sounding/responsive bodies of the instruments into a new corporeality. The de-corporealization of the concert listener is an unstable condition which may lead either to a spiritualized musing or to incorporation in the autoerotic body of musical 'feeling.'" William Fitzgerald, "'Music is Feeling, then, not Sound': Wallace Stevens and the Body of Music," *SubStance*, vol. 21/1 no. 67 (1992), p. 47.

51 Andrew Bowie, *Aesthetics and Subjectivity: From Kant to Nietzsche* (Manchester, Manchester University Press, 1990), p. 10.

52 Louis Zukofsky, "A-12," *A* (Berkeley, University of California Press, 1978), p. 127.

53 Suzanne Langer, *Philosophy in a New Key: A Study in the Symbolism of Reason, Rite, and Art* (Oxford, Oxford University Press, 1951), p. 244.

54 Ben Knights, *From Reader to Reader: Theory, Text and Practice in the Study Group* (Hemel Hempstead, Harvester Wheatsheaf, 1992), p. 8.

55 In *Freud and Philosophy*, Ricoeur argues that "the regressive genesis of our desires does not replace a progressive genesis concerned with meanings, values, symbols. That is why Freud speaks of 'transformations of instinct.' But a dynamics of affective cathexes cannot account for the innovation or advancement of meaning that is inherent in this transformation." Paul Ricoeur, *Freud and Philosophy: An Essay on Interpretation*, trans. Denis Savage (New Haven, Yale University Press, 1970), p. 512.

56 David Michael Levin, *The Listening Self: Personal Growth, Social Change and the Closure of Metaphysics* (London, Routledge, 1989), p. 7.

57 *Ibid.*, p. 17.

58 Patsy Rodenberg, *The Need for Words: Voice and the Text* (London, Methuen Drama, Reed Publishing, 1993), p.3.

59 Donald Davidson, "The Method of Truth in Metaphysics," in *Inquiries into Truth and Interpretation* (Oxford University Press, 1984), p. 199.

60 Thomas Nagel, *The View from Nowhere* (Oxford University Press, 1986).

61 Jurgen Habermas, *The Theory of Communicative Action, Vol 2, Lifeworld and System: A Critique of Functionalist Reason*, trans. Thomas McCarthy (Oxford, Polity Press, 1987), p. 93.

62 Derrida, *Of Grammatology*, p. 12.

63 See Talbot J. Taylor and Deborah Cameron, *Analysing Conversation: Rules and Units in the Structure of Talk* (Oxford, Pergamon Press, 1987).

64 Roy Harris, *Reading Saussure* (London: Duckworth, 1987), pp. 230–35.

65 See in particular Talbot Taylor, *Mutual Misunderstanding: Scepticism and the Theorizing of Language and Interpretation* (London, Routledge, 1992); Roy Harris, *The Language Myth* (London, Duckworth, 1981); John McCumber, *Poetic Interaction: Language, Freedom, Reason* (Chicago: University of Chicago Press, 1989). Taylor and Harris are both critics of current trends in linguistics. McCumber is reading aesthetics in the context of Habermas's insights into the significance of interaction for the constitution of society.

66 Saussure, *General Linguistics*, p. 80 [p. 116].

67 Harris, *Reading Saussure*, p. 232.

68 McCumber, *Poetic Interaction*, pp. 380–428.

69 Saussure, *General Linguistics*, p. 124 [p. 174].

70 David Antin, "what am i doing here," in *talking at the boundaries* (New York: New Directions, 1976), p. 23.

71 Susan Howe, *Thorow* in *Singularities* (Hanover, New Hampshire: Wesleyan University Press and University Press of New England, 1990), p. 50.

# True stories

## Spalding Gray and the authenticities of performance

### HENRY M. SAYRE

In a world that *really is topsy-turvy*, the true is a moment of the false.
Guy Debord, *Society of the Spectacle*[1]

There is a moment in Spalding Gray's famous performance piece, *Swimming to Cambodia*, where the fabric of its authenticity – the warp and weft of its reality and truth – appears to unravel before our eyes. And then, Penelope-like, Gray re-weaves the whole. As performance, the piece insists upon its authenticity. It is a one-man monologue, narrated by Gray, who for its duration sits behind a table in front of the audience. (The movie version begins with him walking down a Soho street, entering a performance space, sitting down before an audience that has been waiting for him, and, after taking a long drink of water, beginning to talk – this, it is clear, is his job. This is what Spalding Gray *really* does.) In the performance, he refers occasionally to maps and charts, but otherwise, for about one and a half hours, he tells the story of his participation in the filming of Roland Joffe's quasi-documentary film *The Killing Fields*, itself the true story of *New York Times* reporter Sidney Schanberg and his Cambodian photographer, Dith Pran, with whom Schanberg had stayed in Phnom Penh after the American embassy had been evacuated in 1975 because he wanted to witness the occupation of the city by the Khmer Rouge. Schanberg and Pran had sought refuge in the French embassy, where they stayed until the Khmer Rouge demanded the expulsion of all Cambodians, and Dith Pran was handed over, almost certainly to meet his death, since the Khmer Rouge were executing not only anyone who had associated with the Americans, but, the story goes, anyone with an education, any artist, any civil servant, anyone wearing glasses. Dith Pran was given up for dead by everyone but Sidney Schanberg, who located

254

him, three years later, in a Thai refugee camp and brought him back to America to work for the *Times.* So this performance of Gray's is the real thing – a real actor talking about acting in a real movie, live and in person (except, of course, in the movie version of the original performance).

Gray had landed a minor role as the American ambassador's assistant in *The Killing Fields*, and had gone to Thailand, where the movie was filmed "on location" – Thailand approximating, at least, Cambodia – and *Swimming to Cambodia* is, as Gray has described it, a record of "the so-called facts [of my experience] after they have passed through performance and registered on my memory."[2] The finished piece, published in book form in 1985, the same year that it appeared as a film, was the product of nearly two hundred performances, given over two years: an average of about one performance every three nights. "Each performance," Gray says, "becomes like another person whispering a slightly altered phrase. My job is then to let my intuitive side make choices – and there is never a lack of material, because all human culture is art" (xv–xvi).

At the moment in question – the moment when the performance's authenticity unravels before your eyes – Gray is describing his last big scene in the movie, a scene with Sam Waterson, who plays Schanberg. On August 7, 1973, a navigator on an American bomber, flying on a mission to bomb Vietnamese strongholds in Cambodia, made a dreadful mistake. For some reason, when the bomber locked in on the homing beacon situated in the Cambodian city of Neak Luong, simply a radar coordinate that was designed to help him home in on the real target, he ordered that the bombs be dropped. Around 200 innocent people were killed when the bombs dropped, not on Vietnamese strongholds but into the center of Neak Luong itself. The American embassy quickly sent in a team to pay the families of the dead $100 and those who had lost arms and legs $50. On a tip from Gray's character, the ambassador's assistant, Schanberg found out about the incident, and sneaked his way into Neak Luong with his photographer Dith Pran.

Gray has a simple set of lines to perform as he informs Schanberg of the accident. He has to say: "A computer malfunction put out the wrong set of coordinates. Seems a single B-52 opened up over Neak Luong. There's a homing beacon right in the middle of town. Check it out, Sid" (54). Gray relates how he remembered these lines: "So, 'a computer malfunctioned.' I had an image of a computer in my mind, spaghetti coming out of it – a malfunction. Put out the wrong

coordinates ...,' for coordinates I had an image of an oscillator from a seventh-grade science project, I don't remember who had one, but it was a grid-work oscillator. 'It seems a single B-52 ...' I remembered B-52s from many drunken dinners in front of the TV during That War. 'Opened up over Neak Luong ...' I was having trouble with Neak Luong. It was a night shoot and I was a little hung over. At times I was calling it Luong Neak. I was a little shaky from a heavy party the night before, and the dose of marijuana and booze. But I didn't feel too bad about it because Roland told me that my character would be drinking a lot because he was very guilty. So I thought, to some extent, I was in character" (56). As Gray describes his attempt to get this right, we join his narrative at take sixty-four:

I thought I had it down. "A computer malfunction put out the wrong set of coordinates. It seems a single B-52 open up on Neak Luong. There's a ..." and I couldn't get the image of the homing beacon. I said, "There's a *housing device* right in the middle of town."
"CUT. Okay, let's go back. Keep it together now."
I don't know why I was feeling so much pressure ...
"Okay, boys and girls, let's go. Take sixty-five."
"A computer malfunction put out the wrong set of coordinates. It seems a single B-52 opened up over Luong ... Neak ... sorry."
"All right, Spalding. Take sixty-six."
At last I had the image for homing beacon. I saw a pigeon, flying toward lighthouse beacon in a children's storybook. Got it.
"Let's go. Take sixty-six."
"A computer malfunction put out the wrong set of coordinates. It seems a single B-52 opened up over Neak Luong. There's a. . ." and I knew it would work. It didn't matter what I was thinking, so long as I was thinking something. Because everyone looking at the film would be thinking their own thoughts and projecting them on me.
"There's a homing beacon right in the middle of town. Check it out, Sid."
The entire crew burst into applause. Sixty-six takes later and five hours into the night we had finished the first scene of the evening. And I was told it would cost $30,000 to process it, including the cost of the film and crew. Then, when I got back to New York, I was called in to redub the entire scene anyway, because of the sound of crickets. So what you hear in the film is my voice in New York City, reacting to some black-and-white footage shot one hot summer night on the Gulf of Siam. (57–59)

Now, a lot is going on here. What we notice most of all is the way that Gray's admission of his method of acting revises our view of his performance in *The Killing Fields*, a comparison Gray invites by including, in the movie version of the performance, directly after the material quoted above, an outtake of the original scene. The "realism" of the movie is suddenly violated. True story or not, we

clearly see Gray, now, as an actor, playing a part. We revise our reading of the pregnant pause that interrupts his spilling the beans to Schanberg. "There's a ..." he says, and instead of seeing in his distant gaze a man moved to such a degree that he cannot even spit out the words, we get a vision of "a pigeon, a homing pigeon, flying toward a lighthouse beacon in a children's storybook" (58). Suddenly, we can see through the movie, recognize its artifice. Its status as a documentary is at this point completely undermined. Gray's pause is on the same level as Thai peasants throwing rubber on fires in the jungle to simulate battle, of real amputees covered with chicken giblets and fake blood lying in 110-degree heat in the streets to simulate battle's aftermath. It looks real, but it is not. It is even less real than this: it is redubbed, because of crickets. Sixty-six takes for Gray to get it right, and it is wrong.

II

Gray is caught, apparently, in the web of the spectacle. Watching him, we are aware that our own position is even more fragile than his, that we are unable even to speak, passive receivers, barely breathing versions of the television monitor before which we sit, watching Gray's performance now for the tenth or twelfth time, not "live" but on video, his talking head reflected vacantly in our eyes. We do not move. We do nothing. All we are is what we want to have, which is the life transmitted to us along the networks. We want to play, like Gray, to use the phrase that aspiring baseball players use to describe the major leagues, in "the show."

In *Monster in a Box*, the performance that followed *Swimming to Cambodia* and that opened in November 1990 at the Lincoln Center, Gray tells of getting a grant from the National Endowment for the Arts for a project called "Los Angeles: The Other." His idea was to ride the buses of Los Angeles interviewing people about what it is like to live there. There was only one condition: "These people could in no way be involved in the film industry":

I had no idea how difficult it would be to find people not involved in the film industry until I got out there and saw a special on television – in which they were interviewing people in the parking lot of a Shop Rite supermarket. As people came out with their groceries, the interviewer would go up to them and say, "Hi there, good morning! Tell us, how's your film script going?"

And everyone said, "What! How did you know?!" Right up to the cashier.[3]

In Los Angeles, at least, there is no "Other." Everyone is in "the show," or thinks so. And yet, watching Gray perform, out here in the real world, out here in the hinterlands, far away from the glitter and glitz of tinseltown, we know we are Gray's Other. We know that it is not our lives that are being played out before us, just as it is not his own he plays out on the screen in *The Killing Fields*. But it is as if he is *acting for us*. It is as if he is our stand-in. It is not, after all, *our* lives that we want, neither Gray nor ourselves. It is as if someone has scripted us into the wrong part. It is as if our lives, our *real* lives, have become mad aunts in our attics, or "monsters in a box."

The "monster in a box" to which Gray refers is a loosely auto-biographical, admittedly self-indulgent, 1,900-page manuscript of a novel called *Impossible Vacation* that Gray was trying to finish at the time he began performing *Monster in a Box* itself. *Monster in a Box* is a performance, in other words, about Gray's writing a novel about himself, though in the novel, Gray changes his name to Brewster North. There must be some play with "the truth" some-where in the piece – I suspect one line in particular, when the Brewster North/Spalding Gray character says that he knew he would be a good model given that he was "in good shape and had an almost classic body"[4] – but otherwise everything that happens to North has happened to Gray: his mother's suicide when he was vacationing in Mexico, his apprenticeship at the Alley Theater in Houston, his nervous breakdown after a visit to India. These are stories we have heard Gray tell again and again throughout his career. Brewster North is the final affirmation, perhaps, that Spalding Gray is, and has been for a long time, at least as much a character as a person. In his introduction to *Swimming to Cambodia*, the book, James Leverett puts it this way: "It has gradually become Gray's chosen lot simulta-neously to live his life and to play the role of Spalding Gray living his life, *and* to observe said Gray living his life in order to report on it in the next monologue. Perhaps this hall of mirrors, this endless playoff between performance and reality, has always been the situa-tion of the artist. It is certainly the quintessential perspective of the actor, though seldom dramatized so blatantly. But has it ever been more plainly the predicament of everyone else in this media-ridden age of instant replay?" (xii).

If authenticity is the name of what argues against this predicament, it is, today, a name usually invoked only as an absence, as something that has "withered away," in Benjamin's famous phrase, in an age of instant replays, an age in which all of Los Angeles is writing screen-

plays, an age of mechanical reproduction run amok, the all-consuming spectacle of inauthenticity. If, for Benjamin, "the presence of the original is the prerequisite to the concept of authenticity," then, in turn, "the authenticity of a thing is the essence of all that is transmissible," historically speaking, about it, and, finally, the loss of this "historical testimony" affects "the authority of the object." The entirety of what we have lost – not just authenticity, but the presence of the original, its history, and its authority – Benjamin subsumes in the term "aura." There is nothing to name "authentic" in a world filled with only "a plurality of copies."[5]

Of course, we cannot locate the "original" of either *Swimming to Cambodia* or *Monster in a Box*. Is there ever, in performance, something that can be called "the original"? The "script" has no "authority" – there is no "script," only an evolving story. There is only the plurality of perfomances. Nor can we locate, in the hall of mirrors between performance and reality, the "original" Spalding Gray. Elizabeth Lecompte, Gray's chief collaborator, has described the emergence of Gray's persona of himself as he worked with the Wooster Group at the Performing Garage in New York City in the late 1970s:

Spalding sits for a portrait that I paint ... There is a dialog between the sitter and the painter. The portrait, the persona that emerges is an amalgam of sitter's image of himself and the vision of him/her that the painter sees and constructs. When the painter and the one painted *both* recognize themselves in the final portrait, it is a perfect collaboration. The persona named Spalding Gray is made from this kind of collaboration.[6]

Roland Barthes has described posing for a photographic portrait in similar terms: "In front of the lens, I am at the same time: the one I think I am, the one I want others to think I am, the one the photographer thinks I am, the one he makes use of to exhibit his art."[7] So there is, in the Spalding Gray we see in performance, something of the "real" Spalding Gray, or at any rate, the Spalding Gray that Spalding Gray thinks he is, but also present before us are the "character" he wishes to project, the Spalding Gray his director, Elizabeth LeCompte, sees, and the Spalding Gray she makes use of to create the play. We have, on the one hand, lost the "original" Gray in a proliferation of performing persona. His own autobiography becomes, as he himself admits, "a group autobiography."[8] But it is as if, sensing that loss, Gray's project is to "find himself" by recovering, in the "historical testimony" of his narratives, what we should call "authority," but "authority" in its full sense – the authority of the

"author," from the past participle of the Latin *augere*, to augment or increase – the authority of one who *multiplies*.

For Guy Debord, "all of life presents itself as an immense accumulation of *spectacles*. Everything that was directly lived has moved away into a representation."[9] Gray's stories accumulate, multiply, as his life moves ever more deeply into the area of representation, into the space of performance. It is as if each of his performances is a play-within-a-play, a play within the performative space of his life. From a certain perspective – from Debord's, for instance – this web of inauthenticity, life in the society of spectacle, transpires across "the common ground of the deceived gaze and of false consciousness."[10] He is echoing Sartre – Debord's "false consciousness" is Sartre's "bad faith": both phrases refer equally to the inauthenticity of our lived experience. In fact, by the time Sartre wrote *Being and Nothingness*, he was so prepossessed by the predominance of "bad faith" around him that he referred to its opposite, authenticity, only once, in a footnote.[11] For Theodor Adorno, critiquing existentialism in a manner parallel to Sartre in the early 1960s and gazing particularly at the specter of Heidegger, the idea of authenticity had been reduced to "jargon." And so Adorno reduces Heidegger's authenticity to a joke:

For Heidegger, authenticity is no longer a logical element mediated by subjectivity but is something in the subject, in Dasein itself, something objectively discoverable ... Judgment is passed according to the logic of that joke about the coachman who is asked to explain why he beats his horse unmercifully, and who answers that after all the animal has taken on itself to become a horse, and therefore has to run. The category of authenticity, which was at first introduced for a descriptive purpose, and which flowed from the relatively innocent question about what is authentic in something, now turns into a mythically imposed fate.[12]

Adorno, in fact, attributes Benjamin's invention of the term "aura" to precisely his recognition that the concept of authenticity has emptied itself into a tired jargon:

The fact that the words of the jargon sound as if they said something higher than what they mean suggests the term "aura." It is hardly an accident that Benjamin introduced the term at the same moment when, according to his own theory, what he understood by "aura" became impossible to experience. As words that are sacred without sacred content, as frozen emanations, the terms of the jargon of authenticity are products of the disintegration of the aura. (9–10)

For Adorno, the very idea of "authenticity" survives only as a form

of "bad faith," an unexamined cultural myth: "Whoever is versed in the jargon [of authenticity] does not have to think properly. The jargon takes over this task and devaluates thought ... Communication clicks and puts forth as truth what should be suspect by virtue of the prompt collective agreement" (9).

In Gray's work, the jargon is omnipresent: in his search for "the Perfect Moment" in *Swimming to Cambodia;* in his visit, in *Impossible Vacation*, to the Dogon Zen center in the Poconos in search of the "Big Mind" and his consequent journey to India in search of "pure, isolated, uncomplicated, nonintegrated sex" (95) under the direction of the Bhagwan Shree Rajneesh; in his desire, described in *Monster in a Box*, "to pull back into my more introverted self and go back in and explore the private self, the shadow self, the part I hadn't been in touch with for twenty years" (6). But, ultimately, all of Gray's quests are attempts to confront the specter of death. In the jargon of authenticity, the ultimate authenticity, the most "authentic" fact, the moment of moments, is death. As Heidegger puts it in *Being and Time*, death is "the utmost possibility of that entity which each of us is" (quoted in Adorno, 147). Or, as Adorno himself puts it, "Authenticity ... has not only its norm but its ideal in death" (137). This is one of the screws upon which Gray's work turns: the desire, on the one hand, to confront death – the possibility of his own, but even more, the reality of his mother's suicide – with an aura, at least, of authenticity, and his realization, on the other, of death's inevitable inauthenticity in a society of spectacle. In *Monster in a Box*, Gray finds himself at the Museum of Modern Art under the gaze of "MacNeil Lehrer" – he does not know which one – "And he's taking notes. And what's amazing is that every time I notice a celebrity looking at me, and I'm in their gaze, I'm not afraid of death or dying" (34). As object of what Debord calls "the deceived gaze," Gray is freed to deceive himself.

But this is what acting is. In *Impossible Vacation*, Brewster North recalls his first acting job with the New Age Players in New Paltz, New York: "I didn't have to be me ... That's what I liked about acting in plays. I felt like no one; and I guess that in some secret way pretending to be someone else saved me from the giant fear of death. It allowed me the fantasy that I had to be someone in order to die, and that as long as I was no one, or just an actor, death would never find me; death would somehow pass me by" (46). Even more to the point, in light of his mother's suicide, is Brewster's desire to play Konstantin in Chekhov's *The Seagull*: "He likes the fact that Kon-

stantin gets to shoot himself in the head at the end of every performance and then come back the following night to play himself again" *(Monster,* 11). Such are the attractions of inauthenticity. It can save your life.

Of all the parts Gray has played over the years, probably the one that most problematizes the relative authenticity or inauthenticity of death, and defines the ambiguity of Gray's own response to it, is his role as Hoss in Richard Schechner's production, in the early 1970s, of Sam Shepard's *The Tooth of Crime.* As Florence Falk has pointed out, the play is a "perverse re-run of John Ford's *The Man Who Shot Liberty Valence* (1962), a film that plays nostalgic tribute to the 'lost machismo' of the Old West in the person of John Wayne, who kills the brutish, lawless Valence (played by Lee Marvin)."[13] In the play, Hoss is the John Wayne figure, and Crow his opposite, the Lee Marvin figure. Both are rock stars, but Hoss is nostalgic, disliking Crow for having forgotten his musical "origins," and lamenting the fact that the inauthenticity that his career has imposed upon him has transformed him into little more than a "fucking industry."[14] At the end of the play, in a reversal of the John Ford "original," Hoss kills himself: "A true gesture," he says, "that won't never cheat on itself 'cause it's the last of its kind. It can't be taught or copied or stolen or sold. It's mine. An original. It's my life and my death in one clean shot" (111). This is a classic Heideggerian moment, "according to which," says Adorno, "the subject is authentic insofar as it possesses itself" (127). Hoss is, at this moment, a "person who is sovereignly at his own disposal" (127). In this reversal of the "original," he commits an "original" act. Crow, on the other hand, does not quite see it in those terms. To his eye, Hoss's suicide is pure theater: "Perfect. A genius mark. I gotta hand it to ya" (111), he says to the corpse, with something approaching real admiration for the performance.

III

Gray is always playing Crow to his own Hoss, and vice versa, just as he is always playing Hoss, or Konstantin, at his own suicide, only to come back the following night and play it again. From Hoss's almost purely existential point of view, suicide is the one authentic gesture available. From Crow's point of view, Hoss's suicide is pure theater, his last great *act,* the ultimate inauthentic gesture. Their relationship is clearly parallel to Gray's own with his mother. As reported in the novel *Impossible Vacation* – in the novel, Gray only "changed the

names to protect the guilty" *(Monster,* 5) – his mother looked at him one afternoon clearly and directly, and said: "Oh, Brewster dear – how shall I do it? How shall I do away with myself? Shall I do it in the garage, with the car?" (31). These lines are at once entirely authentic and entirely theatrical. Even more to the point, as a writer, and as a performer, Gray has continually subjected them to his own theatrical ends.

There is, in Gray's work, the continual suggestion that in the most theatrical moment, in the most staged event, out of that inauthenticity, authenticity is born. In *Monster in a Box,* he describes going to Nicaragua with an American fact-finding team investigating the Contra war against the Sandinistas (the idea is to base a film script on his experiences), and while there, one hot afternoon after lunch, twenty-five mothers of the heroes and martyrs of the war address the fact-finding team:

I have to describe them as something like a combination of an A.A. meeting and a very perverse performance art piece, because they had been testifying innumerable times, about the horrors that had been inflicted on their loved ones. And, as far as I'm concerned, they don't have to speak anymore. There is an aura of grief that is coming off of them that is so strong that we could just sit there and meditate on that and get the message. (26)

The completely rehearsed performance is, miraculously, completely authentic. Somehow it possesses Benjamin's "aura." And its effect is something that Gray himself strives for in all his own work.

*Rumstick Road,* first performed at the Performing Garage in New York in 1977, is his earliest theatrical confrontation with his mother's suicide, the centerpiece of his New England trilogy, *Three Places in Rhode Island.* Named for the street he grew up on, the piece is, in his own words, an attempt "to put my own fears of, and identification with, my mother's madness into a theatrical structure,"[15] and, in this sense, it is confessional in a way that reeks of the jargon of inauthenticity. In 1982, Herbert Blau noted that Gray's New England trilogy is one of the best examples of what he called "the most seminal theatre" of recent years, a theater that – "as if in response to the age of coverup" – turned to "the disciplined advocacy of confession in acting." The danger of such a form, he is quick to point out, is that it often appears to be little more than "the mere transitory spilling of superficial guts on a vacuous stage." But in Gray's work he sees something more: "It is not mere authenticity we're talking about ... the self-indulgent spillover of existential sincerity, but a *critical* act as well, *exegetical,* an urgency in the

mode of performance ... part of its meaning, that the Text be *under-stood*, though the meaning be ever deferred."[16]

What makes *Rumstick Road* more than merely confessional is the play between what might be called the "staginess" of its presentation and the "authenticity" of what it presents. The set itself is divided into three sections, two-more-or-less square proscenium spaces separated from each other in the center by a square control booth in which the piece's technical director manipulates the work's sound and lighting in full view of the audience. Action takes place in the two side spaces, both of which are designed with angled walls exaggerating their perspectival depth, and the cast regularly disappears from the audience's view as it passes behind the control booth at center-stage. This set announces, in other words, the staged nature of the performance. It is theater we are at, not real life.

But it is real life that this theater presents to us. With some few exceptions, all of the language in the piece consists of tape-recorded interviews Gray made with his father, his two grandmothers, and the psychiatrist who treated his mother during her nervous breakdown:

> I asked them questions about my mother's nervous breakdown and about how her "madness," and eventual suicide, had affected them. I might never have asked had there not been a tape recorder present. The tape recorder became a medium, a way of relating and dealing with these very powerful and painful questions. It was also a way of preserving the recorded material so that I could go over it again, reflect on it, and try to have a sense of it. As I look back on this process, it seems that I was trying to develop some meaningful structure into which I could place the meaningless act of this suicide. Perhaps it was the hope that his newly created structure would somehow redeem and put in order the chaos of my mother's world.[17]

These tape-recordings function as a kind of testimony. They have the force of *evidence*. At the end of *Camera Lucida*, Roland Barthes describes the attraction he feels for the so-called "Winter Garden" photograph of his mother, not so much as a function of its capturing any sense of her "unique being," but rather as a result of the fact that it "possesses an evidential force," the incontestable testimony that she was there, "on that day."[18] This evidential force – the traces of an anterior moment, that *remainder* – is precisely what Gray turns his attention to in *Rumstick Road*. The tape-recordings are all that remains of his mother. They are, even, her very *remains*, her *corpus*. They are, perhaps it is better to say, the *corpus delicti*, the body of the offense, the scene of the crime.

But what, precisely, is the force of their evidence, the force of

evidence in general? How "authentic" can "evidence" ever be? Consider one of the most widely known, and troubling, pieces of evidence of recent times, the videotape of a group of Los Angeles police officers beating and kicking Rodney King, 56 times in 81 seconds, as he lay beside his car in the street at just about 10 minutes before 1.00 a.m., March 3, 1991. Writing in the *New York Times*, photography critic Charles Hagen has commented on its evidential force: "The tape has a directness and gut-wrenching horror that is seldom found in the routine and closely formatted stories of television news. Moreover, much of the power of the tape comes from its sheer duration – the fact that the assault goes on and on, blow after blow. A single photograph, no matter how powerfully composed, would show only one blow, one kick, and could never adequately convey the shock of the event." As Hagen goes on to say, "the sheer density of detail in a videotape seems to insure its authenticity, its integrity," and yet, in the subsequent trial of the police officers, defense attorneys were able to transform the tape's evidential force: "The jury was shown the tape more than 30 times in the course of the trial, projected at various speeds. The tape was even broken down into a series of still frames, each of which was then subjected to lengthy analysis by defense witnesses and attorneys. As a result the defense was apparently able to deaden the impact of the tape, separate it from its reference to reality. The effect of all this was probably like saying your own name over and over until it begins to sound strange, and loses any link to meaning."[19] In another analysis of the tape in the *Times* that appeared almost a year after Hagen's piece, Patricia Greenfield and Paul Kibbey put it this way: "Slow motion minimizes the violence. In the real world, a faster blow is a harder blow; a slower blow is softer ... Slow motion also makes the beating seem less real and more fantastic."[20]

Most recently Rudolf Arnheim has returned to the example of the Rodney King tape to argue that the photographic media – by which he means photography, video, and film – possess "two authenticities," each of which contradicts, or at least compromises, the other. In Arnheim's words, the photographic media "are authentic to the extent that they do justice to the facts of reality, and they are authentic in quite another sense by expressing the qualities of human experience by any means suitable to that purpose." These two types of authenticity are at odds with one another throughout the entire history of the figurative arts: "To the extent that the arts were representational, they aspired to a faithful rendering of the

facts of reality; but in order to make their images comprehensible to the human mind they had to select and shape and organize the material taken from reality – they had to find and impose form. By doing so, they had to partially reshape the facts of nature perceived by the eyes." Arnheim points out, "the latter hampers rather than supplements the former: the fancies and liberties of the human imagination are anything but authentic when taken as documents of physical reality."[21] In the case of the Rodney King videotape, the defense attorneys, acting as artists, modified and composed the tape by means of slow motion and stop action in order to make the tape more comprehensible. But in doing so they inevitably reshaped the episode.

The tension between these two authenticities is, of course, foregrounded by Gray in *Rumstick Road*. On the one hand, we have the authenticity of the tapes, their documentary reality. On the other, we have the play's art:

*Rumstick Road* is in no way an attempt to enact my mother's madness or to enact or recreate the experience I had of that madness. *Rumstick Road* is something else. It is a piece of art, an entirely new thing that stands on its own. Finally, if it is therapeutic, it is not so much so in the fact that it is confessional but in the fact that it is ART. The historic event of my mother's suicide is only a part of the fabric of that ART. Finally the piece is not about suicide; it is about making ART.

All of Gray's later works similarly revolve around the dialogue – and the tension – between Arnheim's two authenticities. *Swimming to Cambodia*, for instance, is about the way that *The Killing Fields* modified, reshaped, and composed the events surrounding the takeover of Cambodia by the Khmer Rouge in 1975, an attempt to make sense of what Gray calls "the worst auto-homeo-genocide in modern history" (22). The possibility of making any sense of the event, however, is "a task equal to swimming there [i.e., to Cambodia] from New York" (xvi). As his continuing struggle, since *Rumstick Road*, to come to grips with his mother's suicide demonstrates, it is similarly impossible "to put in order the chaos" of his mother's world.

And yet Gray goes on, telling stories, employing, as he says, "the old oral tradition [as] a fresh breath in these high tech times."[22] In fact, it is not the events of his life that so much interest Gray; it is the stories those events generate. In *Rumstick Road*, it is not, finally, the event of his mother's suicide that is the focus of the piece, but the stories his family has to tell about it. In his analysis of the Rodney King videotape, Charles Hagen puts it this way:

As the verdict in the case demonstrates, the videotape [like Gray's tape recordings] remains open to interpretation. While most Americans still regard the tape as irrefutable evidence of police brutality, the jury that acquitted the indicted officers obviously saw it differently. This puzzling fact goes to the heart of the matter: that photographic images [like all documentary evidence] ... remain essentially ambiguous, and must be anchored in a convincing narrative before they take on specific meaning. And most images can be made to fit into a number of widely disparate narratives.[23]

It is worth rereading, in this context, Walter Benjamin's famous argument, in his 1936 essay "The Work of Art in the Age of Mechanical Reproduction." Though it is usually read in light of what photographic reproduction does to the work of art – that is, cause it to lose its "aura" – it is worth repeating that the essay defines the authenticity of the work of art in terms neither of its expressive authority nor of its aesthetic accomplishment, but in terms of its history, the narrative of its life in the world. For Benjamin,

the presence of the original is the prerequisite to the concept of authenticity ... *The authenticity of a thing is the essence of all that is transmissible from its beginning, ranging from its substantive duration to its testimony to the history which it has experienced ... What is really jeopardized when the historical testimony is affected is the authority of the object.* One might subsume the eliminated element in the term "aura" and go on to say: that which withers away in the age of mechanical reproduction is the aura of the work of art ... the technique of reproduction detaches the reproduced object from the domain of tradition. By making many reproductions it substitutes a plurality of copies for a unique existence.[24]                    (my emphasis)

What is at stake is history, and the possibility of historical testimony, narrative. Benjamin recognized in photography, if not the aura of the original, the presence of a certain evidentiary force. He discovered, in some photographs at least, a "tiny spark of chance, of the here and now, with which reality has, as it were, seared the character of the picture."[25] He recognized such imprints in the work of "Atget, who, around 1900, took photographs of deserted Paris streets. It has quite justly been said of him that he photographed them like scenes of crime. The scene of a crime, too, is deserted; it is photographed for the purpose of establishing evidence. With Atget, photographs become standard evidence for historical occurrences ... They demand a specific kind of approach; free-floating [aesthetic] contemplation is not appropriate to them."[26] They demand, in other words, that they be understood historically, that

the narrative of history (of the crime of history, even) be constructed around them. In the mid-1930s, in fact, Benjamin began to collect photographs for inclusion in his never-completed *Passagen-Werk*, his study of the Arcades of nineteenth-century Paris. He thought of these photographs, as he put it in a letter of 1935, as "the most important illustrative documents." They were evidentiary in force, "small, particular moments," in which "the total historical event" of nineteenth-century French social life was embedded.[27] As Susan Buck-Morss has put it in her seminal study of the *Passagen-Werk:* "Like dream images, urban objects, relics of the last century, were hieroglyphic clues to a forgotten past. Benjamin's goal was to interpret for his own generation these dream fetishes in which, in fossilized form, history's traces had survived."[28] But it is not just a question of recuperating history, reconstructing "what actually happened." It is a question, rather, of creating a narrative, in the present, that will suffice for the present, a question of interpretation. Defining himself as an historical materialist, as opposed to an historicist, Benjamin writes: "Historicism presents an eternal image of the past, historical materialism a specific and unique engagement with it ... the task of historical materialism is to set to work an engagement with history original to every new present. It has recourse to a consciousness of the present that shatters the continuum of history."[29] So, it is no longer the "unique existence" of the work of art that matters to us; it is our "unique engagement" with it. It is no longer the "original" upon which we focus our attention, but the "history original" to our present. We no longer turn to events *per se*, or to the documents that survive them, but to the stories they let us tell. This is the *authority* of the *author – to originate* stories, and let them multiply.

Gray, finally, is Benjamin's "storyteller," a man at the scene of the crime, studying the *corpus delicti* for what it reflects on the present scene. In the essay called "The Storyteller," written in the same year as "The Work of Art in the Age of Mechanical Reproduction," Benjamin bemoaned the fact that the art of storytelling, like so many things, seemed to be coming to an end. "Was it not noticeable," he writes, "at the end of the war that men returned from the battlefield silent – not richer, but poorer in communicable experience? ... And there was nothing remarkable about that. For never has experience been contradicted more thoroughly than strategic experience by tactical warfare, economic experience by inflation, bodily experience by mechanical warfare, moral experience by those in power."[30]

Working against the social muteness of the mechanical age, the storyteller engages us in a performance, draws us in so that we might retain what we are told, assure ourselves of "the possibility of *reproducing* the story" (97, my emphasis). His gift lies in his "ability to relate ... life ... This is the basis of the incomparable aura about the storyteller"(108–09). It is in this, too, that we find the final authenticity of Spalding Gray.

At the end of *Swimming to Cambodia*, Gray recounts a dream. He is babysitting a boy in a cabin in the woods, and the boy keeps running into the fireplace and getting partially consumed by the flames, and then running out, and running back in again, until finally he is completely consumed and reduced to a pile of gray ash on the hearth. In the corner of the cabin, however, is a straw effigy of the boy, and Gray takes the ashes and blows them over it and the boy comes slowly back to life, smiling but shaking his head, and Gray realizes the boy had not wanted to come back to life at all. With this realization, the spirit of the boy fades away and Gray is left wondering "how am I ever going to tell this story to his mother?" (126). In the dream, he goes searching for someone to tell the story to and meets an old friend from the Wooster Group who, upon hearing the tale, says: "You should have called the police right away. You need a witness with authority. There's no way you're going to prove this happened and there's no way you can reenact it" (126). Gray may, in fact, be his own best witness, with all the authority he needs, but in the dream he goes on until he finally finds the boy's mother sitting beside a Hollywood pool with Elizabeth LeCompte (who is, we recall, almost as responsible as Gray himself for creating "Spalding Gray"). He tries, but fails, to tell them the story. Instead he maniacally recounts how he had just starred as Konstantin in a new Peckinpah movie of Chekhov's *Seagull* but cannot remember playing the part: "And I knew all the time I was telling this story that it was a cover for the real story, the Straw Boy Story, which, for some reason, I found impossible to tell" (127). All of Gray's stories – not only *Swimming to Cambodia*, but also *Rumstick Road*, and *Monster in a Box*, and *Impossible Vacation* – are covers for "the real story" as well, which is the story of Gray's life. He is the Straw Boy, running in and out of his own narratives, always at risk of being consumed by them. But if he cannot tell "the real story" to the people in his dream, he has told it, continually, to us. And it is a true story, or true enough.

## NOTES

1 Guy Debord, *Society of the Spectacle* (Detroit, Mich.: Black and Red, 1977), section 9. This edition of Debord's text has no page numbers, only 221 brief sections.

2 Spalding Gray, *Swimming to Cambodia* (New York: Theatre Communications Group, 1985), xv. All subsequent quotations from "the performance" refer to the "book version" of the "original," a textual version that differs, sometimes substantively, from even the "movie version," let alone from each instance of its "live" performance.

3 Spalding Gray, *Monster in a Box* ( New York: Vintage Books, 1992), 8–9. All subsequent quotations from this performance also refer to this book version of the always-evolving original.

4 Spalding Gray, *Impossible Vacation* (New York: Vintage Books, 1992), 43–44. All subsequent quotations refer to this edition.

5 Walter Benjamin, "The Work of Art in the Age of Mechanical Reproduction," in *Illuminations*, trans. Harry Zohn, ed. Hannah Arendt (New York: Harcourt, 1968), 222–23.

6 Quoted in James Bierman, "Three Places in Rhode Island," *The Drama Review*, 29 (March 1979): 13–14.

7 Roland Barthes, *Camera Lucida: Reflections on Photography*, trans. Richard Howard (New York: Hill and Wang, 1981), 13.

8 Spalding Gray, "About *Three Places in Rhode Island*," *The Drama Review*, 29 (March 1979): 34.

9 Debord, *Society of the Spectacle*, section 1.

10 *Ibid.*, section 3.

11 Jean-Paul Sartre, *Being and Nothingness: An Essay in Phenomenological Ontology*, trans. Hazel E. Barnes (New York: Philosophical Library, 1948), 70.

12 Theodor W. Adorno, *The Jargon of Authenticity*, trans. Knut Tarnowski and Frederic Will (Evanston, Ill.: Northwestern University Press, 1973), 126–27. Subsequent citations to this edition occur in the text.

13 Florence Falk, "Men without Women: The Shepard Landscape," in *American Dreams: The Imagination of Sam Shepard*, ed. Bonnie Marranca (New York: Performing Arts Journal Publications, 1981), 93.

14 Sam Shepard, *The Tooth of Crime*, in *Four Two-Act Plays by Sam Shepard* (New York: Urizen Books, 1980), 101, 87. Subsequent references in the text refer to this edition.

15 Spalding Gray, "About *Three Places*," 38.

16 Herbert Blau, *Blooded Thought: Occasions of Theatre* (New York: Performing Arts Journal Publications, 1982), 41–42.

17 Spalding Gray, "About *Three Places*," 38.

18 Roland Barthes, *Camera Lucida*, 82, 87–88.

19 Charles Hagen, "The Power of a Video Image Depends on the Caption,' *New York Times*, May 10, 1992, Section H, page 32.

20 Patricia Greenfield and Paul Kibbey, "Picture Imperfect," *New York Times*, April 1, 1993, Section A, page 19.

21 Rudolf Arnheim, "The Two Authenticities of the Photographic Media," *Journal of Aesthetics and Art Criticism*, 51 (Fall 1993): 537.

22 Spalding Gray, "Perpetual Saturdays," *Performing Arts Journal*, 6:1 (1981): 48.

23 Hagen, "The Power of a Video Image," 32.

24 Benjamin, "The Work of Art in the Age of Mechanical Reproduction," 222–23.

25 Walter Benjamin, "A Short History of Photography," trans. Stanley Mitchell, *Screen*, 13 (Spring 1972): 7.

26 Benjamin, "The Work of Art in the Age of Mechanical Reproduction," 228.

27 Quoted in Susan Buck-Morss, *The Dialectics of Seeing: Walter Benjamin and the Arcades Project* (Cambridge, Mass.: MIT Press, 1989), 71.

28 *Ibid.*, 39.

29 Walter Benjamin, "Edward Fuchs, Collector and Historian," in *One-Way Street and Other Writings*, trans. Kingsley Shorter (London: New Left Books, 1979), 352.

30 Walter Benjamin, "The Storyteller," in *Illuminations*, 84. Subsequent page references appear in the text and refer to this edition of the essay.

# Index of names

# Index of names